POP ART AND VERNACULAR CULTURES

D1628614

York St John

3 8025 00544568 2

POP ART AND VERNACULAR CULTURES

EDITED BY KOBENA MERCER

YORK ST. JOHN
LIBRARY & INFORMATION
SERVICES

WITHDRAWN

0 1 MAY 2023

Iniva
(Institute of International Visual Arts)

The MIT Press
Cambridge, Massachusetts
London, England

Copublished by Iniva (Institute of International
Visual Arts) and The MIT Press

© 2007 Iniva
Texts © 2007 the authors
Images © 2007 the artists (unless stated otherwise)

Every effort has been made to trace copyright
holders, but if any have been overlooked inadvertently,
the publisher will be pleased to make the necessary
arrangements at the first opportunity.

Any copy of this book issued by the publisher is
sold subject to the condition that it shall not by way
of trade or otherwise be lent, resold, hired out or
otherwise circulated without the publisher's prior
consent in any form of binding or cover other than
that in which it is published and without a similar
condition including these words being imposed
on a subsequent publisher.

All rights reserved. No part of this publication may
be reproduced or transmitted in any form or by
any means, electronic or mechanical, now known or
hereafter invented, including photocopy, recording
or any other information storage and retrieval system,
without prior permission in writing from the publisher.

ISBN: 978-1-899846-44-3 (Iniva)
ISBN: 978-0-262-63350-5 (The MIT Press)

A catalogue record of this book is available from
the British Library

Library of Congress Cataloging-in-Publication Data

Pop art and vernacular cultures / edited by Kobena Mercer.
 p. cm. — (Annotating art's histories—cross-cultural
 perspectives in the visual arts ; v. 3)
 Includes bibliographical references.
 ISBN 978-0-262-63350-5 (pbk., alk. paper)
 1. Pop art. 2. Art, Modern—20th Century. I. Mercer, Kobena,
1960–

NX456.5.P6P65 2007
700.9'045—dc22
 2006039111

10 9 8 7 6 5 4 3 2 1

Editor: Kobena Mercer
Coordinating Editor: Rebecca Wilson
Copyeditor: Linda Schofield
Designed by Untitled
Production coordinated by
Uwe Kraus
Printed in Switzerland

Front cover (detail) and back cover:
Barkley L. Hendricks, *North Philly Niggah*, 1975
Acrylic, oil and magna on canvas,
72 x 48 inches (182.9 x 121.9 cm)
From the collection of Barkley L. Hendricks
Courtesy of the artist and ACA Galleries, New York

Supported by The Getty Foundation

To find out more about Iniva publications or to place
an order, please contact:

Iniva (Institute of International Visual Arts)
6–8 Standard Place
Rivington Street
London EC2A 3BE
UK
Tel +44 20 7729 9616
Fax +44 20 7729 9509
Email booksales@iniva.org
www.iniva.org

MIT Press books may be purchased at special quantity
discounts for business or sales promotional use. For
information, please email special_sales@mitpress.mit.edu
or write to Special Sales Department, The MIT Press,
55 Hayward Street, Cambridge, MA 02142.

CONTENTS

POP ART AND
VERNACULAR
CULTURES

INTRODUCTION
KOBENA MERCER

Pop art defined a watershed moment in 20th-century culture. Making use of recognisable imagery drawn from commonplace sources in their everyday environment, many artists were not only fascinated by the expanding range of visual media that surrounded them – film, television, magazines, billboard advertising – but were also equally concerned to question the insularity and élitism associated with the institutional presentation of modern art. Although pop was only one among many artistic movements in the post-1945 period that sought to reach beyond the white cube of the conventional gallery setting, it played a leading role in what might be called the 'democratisation' of art and culture that became such a characteristic and inescapable feature of late 20th-century life.

Taking a fresh look at the turning point from modernism to post-modernism, this collection casts new light on the aesthetics and politics of pop by bringing cross-cultural perspectives to bear on the shifting boundaries of 'high' and 'low' in different national and international contexts. Artists have long turned to vernacular elements in popular culture in order to challenge the discourse of officialdom: but how does pop art translate across cultures? What exactly does pop art look like when viewed through a post-colonial lens? Examining what happens when everyday objects are taken out of one context and repositioned in the languages of art, the contributors to this book explore how various artistic strategies have also questioned the categories of 'folk', 'nation' and 'people' in the visual culture of global modernity. Or should that be 'modernities' in the form of a plural noun?

To say that art acquired the hallmark of pluralism from the 1960s onwards, in which no one single style could predominate, is to observe that the post-modern condition did not arrive in a neat historical break, along the lines of a 'before' and 'after' narrative, but rather emerged out of the protracted crisis of modernism in which an entire universe of intellectual convictions and cherished beliefs was gradually thrown into doubt. Pop art is indeed a curious historical phenomenon in this respect for it has enjoyed not one but several lives. Historically embedded in the 1960s as an answering response to the cycle of modernisation that introduced mass consumerism, youth culture and anti-establishment attitudes into the mainstream of western capitalist democracies, pop art made a return during the 1980s as a key reference point for artistic practices and theoretical debates that introduced concepts of appropriation, bricolage and deconstruction into the vocabulary of cultural commentary. Covering a wide international terrain that addresses the project of socialist modernisation in post-independence India, the twists and turns of apartheid in South Africa, and the fate of revolutionary modernity in post-communist China, *Pop Art and Vernacular Cultures* expands our understanding of the multiple modernities in which 20th-century art has taken shape by bringing the historical focus closer to the contemporary moment. Introducing a comparative dimension that connects studies of different national and regional contexts in the developing world to 'minority' formations within the West itself, the linear narrative transition from modernism to post-modernism is re-routed by an awareness of the contradictory dynamics of popular culture when viewed in a global perspective. Far from resulting in a populist celebration of multicultural pluralism, the themes and questions that emerge in this re-examination

begin to confront pop art with the vernacular dialects of the post-colonial condition.

Bringing the post-colonial and the post-modern into dialogue, contributors to this book each illuminate a central paradox that has so far gone unnoticed in the art historical literature. When he described the open-ended mindset that informed the discussions held by the Independent Group that met at the Institute of Contemporary Arts in London from 1952 to 1955, the critic Lawrence Alloway (1966) wrote:

> We felt none of the dislike of contemporary culture standard among most intellectuals, but accepted it as a fact, discussed it in detail, and consumed it enthusiastically ... We assumed an anthropological definition of culture in which all types of human activity were the subject of aesthetic judgement and attention.[1]

Pop art signalled an epistemological break in the very conception of 'culture' by overturning vertically hierarchical definitions with a horizontally inclusive alternative. One might imagine, however, that an anthropologist who revisited the 20th-century archive from some point in the future might nonetheless get the impression that pop art is mostly presented in museums and textbooks as though it were an exclusively First World phenomenon. If the process of 'democratisation' sparked anxiety among conservative critics who felt it threatened the total levelling of cultural distinctions, it may be said that equally narrow, parochial and provincial accounts arose among doctrinaire leftists who rejected pop as a manifestation of capitalist realism. Where pop art pointed to the blurring of 'high' and 'low' boundaries as a

sociological feature of modern democracies, it thereby encouraged greater recognition of the cross-over traffic in signs and symbols that constitutes the field of cultural production as a whole. What this book adds to the available literature is the further recognition of the different cultural, national and ethnic identities that participated in the process of 'democratisation' as an equally significant factor in re-shaping the texture of day-to-day life in the latter part of the 20th century. To be sure, what results is not an anthropological treatment of pop art, nor a culturally diverse 'version' that merely aims to make an agreed narrative more accomodating, but a thorough re-appraisal of the conceptual grounds upon which this relatively recent art historical episode continues to speak to a range of ongoing debates that define 'the contemporary' as an agonistic space where ideas are engaged in permanent dispute.

Far from being hermetically sealed in the archive as a quaint historical relic, pop art exerts a quality of radioactive contamination in contemporary art and among its global audiences. Recent exhibitions that revisit the 1960s and the 1980s to reopen the cross-over interplay between 'high' and 'low' include *East Village USA* (2004), *Back to Black* (2005) and *Tropicalia!* (2006), each of which adds new insights into the plural condition of late 20th-century art by focusing on different cultural and regional specificities.[2] To say that pop art is still 'popular' as an accessible point of entry into the experience of art is to say that each of the questions it raised – about recognition, about participation, about art's autonomy in an age of mass reproduction, and about the limits of the public sphere in modern democracies – are still with us as unresolved, and possibly unresolvable,

issues that all bear upon the experience of 'art' as a unique domain of sensual pleasure and cognitive knowledge. Having opened art to the fluctuating world of everyday life, pop art continues to undermine authoritative definitions of what constitutes aesthetic value.

What further distinguishes the points of view put forward here, moreover, is the quality of attention that is given to the vernacular, a term that is not quite synonymous with 'mass' or 'popular' because what it foregrounds is not the numerical or demographic aspect of collective identity but the quality of antagonism that arises in the social division between 'the people' as a collective noun of group belonging and the rules and norms of 'officialdom' that delimit what is and what is not permissable in public life. The OED traces the etymology of 'vernacular' to the Latin *verna*, meaning a 'home-born slave', with -*cule* as a diminutive suffix. In linguistics, the study of vernaculars gives priority to the native, the local and the indigenous. The sense of the vernacular as 'the language or dialect of a country', that is held to be 'not of foreign origin or learned formations', is both grounded in the class distinction between literate and illiterate, and is also rooted in the hierarchical differentiation between Latin as the official language of imperial Rome and the regional dialects of subordinate peoples – Celtic, Saxon, Teutonic, among them – once subjected to the authority of the dominant code. Spatial metaphors of 'high' and 'low', it would seem, are fully of a piece with the vocabulary in which colonialism and imperialism assign differential value to 'centre' and 'periphery'.

Widening the parameters of debate by asking what is at stake when artists choose among 'folk', 'mass' and 'popular' sources in their practices and strategies, contributors explore the porous spaces of the vernacular as a heterogeneous site of aesthetic invention. The apparently clear-cut distinction between 'pop' materials derived from the anonymous realm of industrial mass manufacture and handmade 'folk' objects associated with pre-modern craft traditions is complicated by the process of hybridisation and stretched into unexpected directions by intermediate terms such as the category of 'transitional' art that emerged in the semi-urban townships of South Africa. Indeed, the dichotomy that is often assumed between 'artifice' and 'authenticity' in matters of art and identity is pushed and pulled into alternative configurations by the cardinal emphasis that pop art gave to irony and ambivalence. Adopted among Euro-American artists to accentuate their irreverence towards the ethos of high seriousness surrounding the modernist canon, what happened when ironic and ambivalent attitudes were brought to bear on 'official' discourses of nationalism or populism in Third World settings such as Brazil? Where popular iconography was incorporated into the nation-building apparatus of the state, as in the Cultural Revolution in the People's Republic of China from 1966 to 1976, what options were open to an avant-garde that sought to articulate political and ethical dissent?

Making use of interpretative methods put into place when pop art was re-viewed through the lens of post-structuralist theories, contributors return to one of the central questions raised by western pop – was it critique or compliance with the market economy in which images are exchanged as commodities? – by breaking out of the dichotomies of 'either/or' thinking so as to foreground the agency of radical ambivalence among critical practices that demand to be

viewed in terms of a 'both/and' approach. In this way, the interdisciplinary framework of post-colonial re-vision that is gradually assembled in these chapters begins to reveal how the modernist interrogation of the *formal* relations of representation associated with avant-garde practices in the first half of the 20th century opened out into a broader critique of the *social* relations of representation during the post-1945 period by virtue of a double-sided engagement with both the materials of popular culture and the official ideologies of bourgeois institutions of art. Where various anti-colonial movements inspired the numerous social movements that entered the public sphere during the same period in which pop art began to cast doubt on the canonical values of institutional modernism, each chapter touches on the vexed question of how to define (or re-define) 'post-modernism' by approaching the local and the global as interdependent axes of artistic and cultural production. Exploring the vernacular as an entangled space in which 'popular' and 'official' world-views are constantly antagonised in shifting patterns of authority and subversion, these critical perspectives demonstrate how pop art strategies 'gave permission' to dissonant viewpoints that came into visibility as a result of the de-centring and fragmentation of monocultural consensus in the 1960s.

Because the period in question is relatively close to hand, there is the danger of merely appropriating the recent past as a mirror image of the present. But rather than comfortably confirm 'the contemporary' as a terminal ending for the story of 20th-century art, the contributors to this book turn instead to the slow and patient work of writing up a worldly genealogy of the multiple trajectories in which the 'post' now

circulates as the sign of an unfinished conversation on the mutually enmeshed histories of modernism and colonialism. Whereas the first two volumes in the Annotating Art's Histories series addressed this nexus in relation to practices grounded in the first half of the century, this third volume spirals back over the past 50-year period in a reiterative logic that 'defamiliarises' our received account of art and politics across the entire post-war era. Highlighting the ways in which artistic practices and cultural theories have approached popular culture as a field of critical enquiry, and showing how debates on image and identity have transformed the account of social class as an anchoring point for vertical distinctions between 'high' and 'low' culture, one of the key themes in this introduction is the crisis of the concept of the avant-garde as it unfolded in the face of the troublesome ambiguities of art and politics that were brought about by 'democratisation'.

Popular Culture as Modernism's Other
Exploring Shirley Clarke's cinéma vérité depiction of hustler Jason Holliday, Gavin Butt reveals how the modernist commitment to 'authenticity' came to be fraught with moral ambiguity during the transition from Beat-era bohemianism in the 1950s to the political ferment of the 1960s, when *Portrait of Jason* (1967) was made. Writers such as Jack Kerouac and Norman Mailer adopted a romantic identification with the black hustler as a social outsider, but while such representations had merely updated primitivist constructions of the 'Negro' as embodying all that was held to be *other* to the White Anglo-Saxon Protestant norms of 'squaresville USA', Clarke's subject enacts a queer identity that draws upon references to Hollywood films and

Broadway musicals in a style of self-fashioning that sidesteps the bohemian romance of 'folksy' authenticity.[3] By way of a close reading of the director's filmic choices, in which the 'realness' of Jason's life story is evoked by apparently unedited footage, Butt draws attention to an implicit contest among authorial voices: Jason's testimony appears spontaneous, but his interaction with off-screen voices stages an inter-subjective encounter that subverts the distinction between 'seriousness' and 'theatricality' as a consequence of the way in which his performative self-representation switches between heartfelt sincerity and camp irony. Clarke's avant-garde methods thus undermine expectations of narrative catharsis and closure which results, as Butt suggests, in a queering of the viewer's affective disposition towards the very idea of documentary 'truth'.

By treating 'film as film' underground cinema explicitly rejected the codes of representational realism and thus acquired the status of an avant-garde by virtue of its departure from the conventions of narrative cinema. Placed within the political context of 1950s America, dominated by Cold War anxieties and post-war consumerism, the formal experimentation of independent filmmakers such as Kenneth Anger, Jack Smith and Jonas Mekas was fully of a piece with various collaborative practices among artists and writers of the Beat generation. The contextualist approach taken by the exhibition *Beat Culture and The New America: 1950–1965* (1996) highlights the 'inter-media' orientation of artistic collaborations that flourished across East and West Coast scenes, and also points to the ways in which the formalist stress on artistic 'purity' – which accompanied the institutional validation of high modernism during the 1950s – was creatively besmirched by

the countervailing thrust towards a mixed-media aesthetics of collage and montage that can be found across, for example, the 'cut-up' technique from which William Burroughs composed his first novel, *Junkie* (1950), the assemblages of Edward Kienholz and installation works such as Allan Kaprow's *Words* (1962).

As a specifically American development, the Beats engaged with the expressive sources of the African American vernacular to articulate an anti-conformist relationship to mass culture, as can be seen in the 'otherness' of the quotidian world that Robert Frank evoked in his photographic essay *The Americans* (1958). Against the background of the Civil Rights Movement, the re-discovery of indigenous American folk music traditions acted as a similar resource for the anti-commercialism of the emerging counter-culture, but whereas the expressive 'purity' of folk music was valued as a sign of authentic opposition to the standardisation of 'average' tastes, the heterodox alignments of the Beat sensibility led to an over-identification with the 'otherness' of marginal social groups such that in Ned Polsky's study of *Hustlers, Beats and Others* (1967) the avant-garde artists based around Greenwich Village circa 1960 were seen as forming merely one more deviant sub-culture among several others. The Beat's interracial milieu nurtured the hybrid idiom in which figurative painter Bob Thompson (1937–1966) abstracted works from the western canon into a palette of highly anti-naturalistic colours, much as avant-garde musician Ornette Coleman – placed at the centre of *The Garden of Music* (1960) and seen in conversation with Thompson in his Bowery studio – abstracted melody and harmony to explore hidden expressive potential. Thompson had participated in Kaprow's

Bob Thompson and
Ornette Coleman in
Thompson's studio on
Rivington Street, New
York, 1965

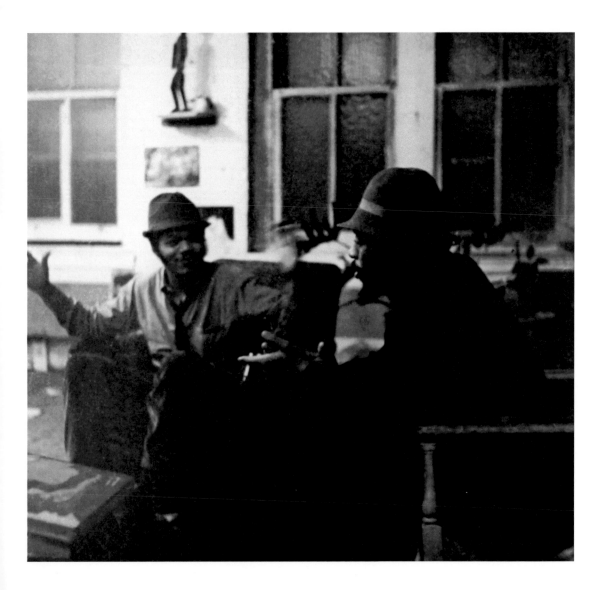

18 Happenings in 6 Parts (1955) and The Burning Building (1955) by Red Grooms, but it was precisely the mélange of cross-cultural elements mixed into the Beat-era critique of post-war culture that New York artists of the early 1960s effectively distanced themselves from in establishing pop art's 'cool' rapprochement with the seductive imagery of mass-produced commercial culture.[4]

Despite the stark contrast provided by the social conditions of post-war Europe, two salient connections are important to make. On the one hand, an interest in 'junk' materials featured prominently among the Nouveaux Realistes in France, including Arman and Christo, and as this strand was further extended by Italian artists associated with 'arte povera', the issue of whether such practices constituted a 'neo-avant-garde' was thrown into relief by debates on 'anti-art' as a critical reaction to institutional modernism.[5] Where the arts were institutionally separated on the basis of medium-specificity (with the struggle for the recognition of film and photography continuing well into the 1970s), one might posit interdisciplinary working methods as a further strand of trans-Atlantic comparison. At Black Mountain College in Vermont, Merce Cunningham, John Cage, Charles Olson and Robert Rauschenberg participated in the happening, Theater Piece No. 1 (1952), and with the mid-1960s development of minimalism and performance art, such inter-media dialogues formed a kind of penumbra to American pop as a challenge to the homogenising tendencies of modernism as an official discourse.

The British painters, sculptors, photographers, critics and architects who formed the Independent Group were also consistently interdisciplinary in their outlook, although in contrast to the kinetic exuberance of the American avant-garde, their approach to the materials of popular culture – on the other hand – was altogether more detached or even ethnographic in its analytical emphasis. With a word-bubble that inscribes 'Pop!' across a pulp magazine cover, Eduardo Paolozzi's collage I Was a Rich Man's Plaything (c.1947), has been regarded as the putative origin of British pop, but the constituent elements of his collages were initially presented in his ICA lectures on an overhead projector, just as Alison and Peter Smithson showed materials from magazines that were then discussed in their essay, 'But Today We Collect Ads' (1956), whose title reads as a diminutive rejoinder to the grandiose aims of modernist architects of the pre-war era. In his 1957 letter to the Smithsons, Richard Hamilton took stock of the IG's previous exhibitions, including Parallel of Life and Art (1953) and Man, Machine and Motion (1955), which had been conceived as 'investigations' into disparate genres of imagery – archaeological, technological, commercial – made available through photographic reproduction. It was in this context that he defined 'pop art' not with reference to fine art practices but in terms of identifying the characteristics of mass culture itself:

> Pop Art is: Popular (designed for a mass audience), Transient (short-term solution), Expendable (easily-forgotten), Low cost, Mass produced, Young (aimed at youth), Witty, Sexy, Gimmicky, Glamorous, Big business.[6]

Given the broad base of its members' interests, as shown in the landmark exhibition This is Tomorrow (1956) – whose constructivist

section included work by Guyanese artist Dennis Williams, who had studied at the Slade School of Fine Art in the 1940s – the IG's relationship to the history of modernism was conciliatory rather than confrontational. Their exploratory approach created a conceptual scaffolding for dismantling 'high' and 'low' boundaries rather than an outright demolition of modernist discursive categories. However, in so far as the IG's critical investigations crossed paths with the emergence of British cultural studies, it is instructive to observe how this shared focus on the reading and interpretation of popular culture gave rise to significant intellectual divergences.

In *The Uses of Literacy* (1956), Richard Hoggart counterposed the communal order and organic cohesion of his working-class childhood with the world of 'the juke box boys' listening to music in milk bars 'with drape suits, picture ties and an American slouch', and wrote: 'Compared even with the pub around the corner, this is all a peculiarly thin and pallid form of dissipation, a sort of spiritual dry-rot amid the odour of boiling milk.'[7] Regarding imported American forms of mass culture as a 'myth world' that threatened the cultural subordination of the working classes, Hoggart's judgemental position reprised the views that Q.D. Leavis voiced in the 1930s, when mass literacy was perceived as undermining the authority of 'the minority, who had hitherto set the standard of taste without any serious challenge.'[8] Although opposing class interests were being defended, the dualism of mass and minority remained the same: the nostalgic view of a bygone social order now being lost to standardisation and uniformity was espoused by conservative and leftist intellectuals alike. It was the vertical logic of these conceptual terms that was overturned by the horizontal alternative

Lawrence Alloway put forward in 'The Long Front of Culture' (1959), when he argued that 'the aesthetics of plenty oppose a very strong tradition which dramatizes the arts as the possession of an elite.' Facing the issue of 'democratisation' head on, he developed his reasoning along the following lines:

> To approach this exploding field with Renaissance-based ideas of the uniqueness of art is crippling. Acceptance of the mass media entails a shift in our notion of 'what culture is.' Instead of reserving the word for the highest artifacts and the noblest thoughts of history's top ten, it needs to be used more widely as the description of 'what a society does.' Then, unique oil paintings and highly personal poems as well as mass-distributed films and group-aimed magazines can be placed within a continuum rather than frozen in layers in a pyramid.[9]

Alluding to the definition of culture as 'the best that has been thought and said in the world', which Matthew Arnold put forward in *Culture and Anarchy* (1869) as a response to the political enfranchisement of the urban working classes, this new model revealed how the Marxist tradition of studying popular culture as a site of ideological manipulation – which prompted the hostility to 'kitsch' on the part of Dwight Macdonald and Clement Greenberg in the US[10] – shared many key assumptions with the defensive élitism of the Leavisite tradition. Characterising *The Popular Arts* (1964) by Stuart Hall and Paddy Whannel as a break with previous generalisations about mass culture that sought instead to encourage a critical awareness which would

'discriminate between what is good and what is bad *within* popular culture',[11] John Storey shows that the inclusive conception of culture as a 'whole way of life' proposed by Raymond Williams (1961) provided the framework in which structuralist semiotics were imported into the Centre for Contemporary Cultural Studies under the directorship of Stuart Hall between 1968 and 1978. Taking in the 30-year period in which the so-called 'Birmingham School' of cultural studies broke through the 'mass versus minority' dichotomy of the 1950s, the summary of the neo-Gramscian perspective provided by scholar Tony Bennett draws out the contradictory dynamics of culture as 'what a society does' that were hinted at, but undertheorised, in the writings of the Independent Group:

> The field of popular culture is structured by the attempt of the ruling class to win hegemony and by forms of opposition to this endevour. As such, it consists not simply of an imposed mass culture that is coincident with the dominant ideology, nor simply of spontaneously oppositional cultures, but is rather an area of negotiation between the two within which ... dominant, subordinate and oppositional cultural and ideological values and elements are 'mixed' in different permutations.[12]

Writing out of this lineage, Dick Hebdige brings us full-circle for his study of *Sub-Culture: The Meaning of Style* (1979) translated concepts of bricolage that were first developed in art criticism on the post-war avant-garde to the succession of youth cultures that appropriated consumer objects against their intended uses in order to encode gestures of resistance and subversion. In a logic of delayed recognition, his 1988 essay 'In Poor Taste: Notes on Pop' re-appraised the IG's ideas as simply ahead of their time in their understanding of the 'mixed' qualities of popular culture, a view that was underscored by the four-part exhibition project directed by Tom Finkelpearl, *Modern Dreams: The Rise and Fall and Rise of Pop* (1988), which re-assessed the IG as a far-reaching anticipation of post-modernist strategies among American conceptual artists of the early 1980s.

Against this wide-ranging historical purview, how might we situate pop art's relationship to questions of 'race' and ethnicity in popular culture? In the sense that pop encouraged audiences to look again at everyday images that were mostly overlooked on account of their 'ordinariness', it is striking that Richard Hamilton's collage, *Just what is it that makes today's homes so different, so appealing?* (1956), has acquired canonical status even though art historians have tended to overlook the significance of what we see in the exterior view that the window opens onto: the blacked-up minstrel figure of Al Jolson in the 1927 'talking picture', *The Jazz Singer*. Placed on the 'outside' of a domestic space studded with icons of Americana, Hamilton seems to be making a subtle acknowledgement of the multicultural character of the modern city. Fast forward by some twenty-odd years to the *Dirty Words Pictures* (1977) by Gilbert and George, and we note the presence of Afro-Caribbean youth as a visual signifier of the multi-racial society that Britain had become in the intervening period. This is a telling detail reinforced by the high-angled observational views of Bangladeshi men on Brick Lane also seen in this series, glimpsed as though seen from the window of the artists' Whitechapel studio in

Richard Hamilton,
*Just what is it that makes
today's homes so different,
so appealing?*, 1956

London's East End. Where Hamilton essays the 'otherness' of an American modernity that post-war Europe saw as an exotic spectacle, the conceptualist framework of Gilbert and George's 'neo-pop' approach enters into the vernacular spaces of the inner city streets to observe an 'otherness' that is anxiously equated with the gritty realities of immigration as an endogamous element of post-imperial Britishness.

The image of the black as 'other' often played an emblematic role for Euro-American artists and theorists who sought to express their own antipathy to bourgeois norms. However, the 'innocent' fandom proclaimed in Peter Blake's *Bo Diddley* (1964), like the 'novelty' of the black chauffeur in Ken Russell's *Pop Goes the Easel* (1962) – a television film featuring Derek Boshier, Peter Phillips and Pauline Boty – gave way, during the mid-1960s, to the political desire for metaphorical equivalence. The romantic idealisation of the 1964 Watts riots as a 'potlatch' of squandered wealth in Guy Debord's *The Society of the Spectacle* (1967) seems to reprise Roland Barthes' discussion of the Negro soldier saluting the French flag on the cover of *Paris-Match* in 'Myth Today', a key text in the effort to de-mystify the workings of hegemony, even though Barthes may have chosen this example to rhetorically convey his own anti-imperialist credentials.

The politics of 'race' certainly made an appearance within the canon of classic American pop – Andy Warhol's *Red Race Riot* (1963), Robert Indiana's *Alabama* (1965) and Duane Hanson's hyper-realist *Race Riot* (1968) sculpture each being a case in point – but the 1960s social movements pulled in converse directions with regards to matters of identity and representation. The distinction curator Dan Cameron (1991)

makes between formalist and regionalist tendencies in American art, describing the former as 'those who see in Pop the seeds of Conceptual Art because of its elimination of subjectivity and the gradual replacement of the art object with language and event', and the latter as those who take a 'populist, seemingly naive, colourful and broadly humorous' approach,[13] not only carries an echo of Marshall McLuhan's distinction between 'cool' and 'hot' mediums, but also relates to the distinction that contributors to this book make between popular and vernacular sources.[14] Working independently of one another, New York artists such as Roy Lichtenstein, Tom Wesselman and James Rosenquist engaged formalist procedures that used significant elements of abstraction in relation to figurative sources derived from the authorless realm of mass media, creating a 'cool' indifference towards subject matter that eliminated readable markers of expressive intention or subjective positioning. Warhol's use of repetition in his silkscreens and unedited footage in his films prefigured the 'death of the author' thesis put forward by post-structuralists, and yet it was precisely the urgent demand for access to the apparatus of representation, and for the recognition of expressive visual languages hitherto excluded from the metropolitan institutions of modernism, that gave birth to the regional scenes – in California, Chicago and New Jersey – of the US Black Arts Movement.

In works such as *Flag is Bleeding* (1967) and *Flag for the Moon (Die Nigger)* (1969) Faith Ringghold operated in-and-against pop's repertoire of commonplace signs to accentuate the authorship of a militant black consciousness. Where her later shift into the medium of quilting was influenced by feminist debates on the 'low'

status ascribed to craft practices, such a vernacular turn was of a piece with the dialogic strategies adopted by Betye Saar, Robert Colescott and David Hammons, which are examined in my chapter through the concepts of 'carnivalesque' and 'grotesque' that Mikhail Bakhtin developed in his semiotics of the sign as an arena of social struggle. The dialogical relation to the stereotypical codification of blackness has been a defining feature of African American art history, as scholars such as Michael D. Harris (2002) have shown, but by drawing on the cultural studies framework that Peter Stallybrass and Allon White laid out in *The Poetics and Politics of Transgression* (1986), my aim is to suggest how the aesthetics of assemblage, parody and performance that emerged during the 1970s constituted an avant-garde rather than modernist formation in the sense that, as cultural theorist John Docker argues, the subversive logic of the 'carnivalesque',

> [...] offers an ongoing challenge to the narrowly conceived forms of reason of the 'public sphere' as well as to modernism desiring to legislate, in an equally imperial way, single standards for all culture: what's good for the modernist avant-garde is good for the world. In relation to both, carnivalesque remains an always dangerous supplement, challenging, destabilising, relativising, pluralising single notions of true culture, true reason ... true art.[15]

Where African American social movements activated the symbolic trans-coding of 'blackness' as a signifier of democratic antagonism, influencing each of the liberation struggles of the time, it is revealing that expressive forms of semantic inversion also underpinned the US Chicano movement, which reclaimed and re-signified an initially derogatory term for Mexican American identity into a badge of affirmation and pride.

First published in 1988, '*Rasquachismo*: A Chicano Sensibility' by humanities scholar Tomás Ybarra-Frausto takes on added resonance in light of debates on hybridity and syncretism in post-colonial criticism. Addressing the improvisational re-combination of 'found' materials among working-class migrant communities of the west coast and south-west regions, Ybarra-Frausto identifies a distinctive 'structure of feeling' in which the logic of make-do-and-mend, although necessitated by economic conditions, cannot be reduced to its social determinants. As an adjective that refers as much to objects as to attitudes, to be *rasquache* is to embody a witty, irreverent and open-ended outlook in which humorous irony and bittersweet sincerity are not mutually exclusive but merely different facets of a 'bicultural' sensibility shaped by the cross-cultural traffic of the US/Mexico border. Considering the vernacular as that which is local and indigenous, it seems remarkable that Reyner Banham's (1971) expansive account of Los Angeles as a modernist cityscape could overlook the stylistic shape-shifting performed by Chicano 'low riders' – obsolescent vehicles customised with decorative excess that reversed the freeway ethos of speed by moving slowly in a dance-like display of semiotic inversion.

Offering a commentary that places Ybarra-Frausto's insights into historical context and updates upon the further debates they inspired, Holly Barnet-Sanchez draws attention to the cross-cutting ambiguity of the border as a structuring term of Chicano/a art practice and

criticism. Numerous 'minority' formations have directed their critique of being marginalised by modernist discourse towards the Euro-American 'centre', although when the syncretic forms of Mexican American hybridity are mis-recognised from the viewpoint of the institutional prestige of Mexican modernism in the early 20th century, the North/South divide must also be taken into account in mapping a viable alternative to the limitations of nationalist or regionalist narratives. Where artists and scholars such as Guillermo Gómez-Peña and James Clifford[16] highlight 'border culture' as a two-way street that undermines the centripetal mythologies of national identity on all sides, *Pop Art and Vernacular Cultures* extends such concerns to investigate the faultlines that cut across the distinction between modernism and avant-garde in the geo-political contexts of India, Brazil, South Africa and China.

Third World Modernities

Following Raymond Williams' (1989) critique of neo-conservative definitions that had anchored the 'post' in post-modernism to support an anti-modernist agenda which saw the pluralist character of art since the 1960s as evidence of an 'end' to aesthetic innovation, his call to 'search out and counterpose an alternative tradition taken from the neglected works left in the wide margin of the century',[17] has been reiterated by Geeta Kapur in her keynote essay, 'When was Modernism in Indian Art?', to foreground the disjunctive terrain of post-colonial time. Because 'the nationalist narrative of identity' was mostly secured during de-colonisation by a realist emphasis on authenticity in which 'folk/tribal/ popular art becomes a heritage that can stand in for, even usurp, the vanguard forms of the

modern', innovative practices in film, theatre and literature did indeed break with the 'brahminical/ sanskritized resources privileged as the Indian tradition', so as to avoid 'being trapped in the citadel of high art', although Kapur notes:

> it should be mentioned however that though 'the people' are invoked in the discourse and practice of Indian leftwing movements in the arts [...] the Indian left produces its own conservatism. [...] Thus while it is modern and in the Indian context avant-garde, the movement represents itself as realist and progressive and tilts the definitional balance of Indian modernism.[18]

These observations on leftist adherence to 'progressivist' definitions of modernism illuminate the limits to the otherwise clear-cut distinction that film scholar Paul Willemen deploys with reference to the Euro-American context. Arguing that, 'modernism emerged in the latter half of the 19th century, when a radical industrial bourgeoisie sought to establish its ideological ascendancy over a weakening aristocratic absolutism', Willemen contrasts 'modernisation [as] a procedure to increase efficiency within a given framework [...] of values', and the historical avant-garde of the early 20th century that sought, 'a politics of negation and transformation aligned with a process of change in a socialist direction, that is to say, a transformation instead of a modernisation.'[19] This distinction underscores a split 'between the avant-garde and modernism as opposing tendencies within the middle-class intelligentsia',[20] but the absence of a cross-cultural dimension underplays the contradictory ways in which the

drive towards modernisation in ex-colonial societies was also linked to a non-aligned politics of socialist democratisation in many cases. As Kapur observes, the predominance of realism in the formation of 'the national/modern' in India created a 'double bind of authenicity' in the paradoxical form of left-wing conservatism. With the advent of post-modernism, 'older terminologies of representation and identity connected with the modernising function have become seriously problematised', and Kapur is adamant on the issue of historical specificity that comes into the foreground of her global perspective when she argues that:

> [...] by maintaining, even in rhetoric, the notion of a people's 'authentic' culture, we may jeopardize avant-garde interventions based on surreal and other interventions. So that indeed one might ask again, *when*, if the avant-garde has been thus blocked or deferred or deviated by what one may call the national cause, was modernism in Indian art?[21]

Bearing in mind that there have been many different colonialisms, the mediating role of the 'national cause' in the dynamics of modernisation among Third World societies emerges as a common thread that further complicates our understanding of how avant-garde practices have addressed art's 'autonomy' within the field of cultural production and the converse issue of how ideologies 'incorporate' and absorb sources of dissent.

Rejoining the critique of anti-modernist tendencies that promoted a triumphalist definition of post-modernism in the 1980s, Sônia Salzstein undertakes a symptomatic reading of pop as a crisis of the public sphere. Agreeing in principle with the view that, as Andreas Huyssen put it, 'the avant-garde posited the reintegration of art and life as its major project',[22] Salzstein notes the conservative synthesis achieved by what she calls 'global neo-populism', which has indeed integrated contemporary art into the market economy by equating the aesthetic dimension with forms of information or entertainment. Pursuing this retroactive trajectory in agreement with the view that, 'Pop in the broadest sense was the context in which a notion of the postmodern first took shape',[23] the crisis of modernisation signalled in the Brazilian context by the military coup of 1964 is opened up for examination by way of a case study interpretation of the work of Antonio Dias. As a manifestation of collective disillusionment with the developmentalist project of the 1950s, the political conditions of this period did not repress artistic innovation in the cultural sphere but paradoxically exacerbated the 'internationalisation' of Brazilian culture in the form of the Tropicalia movement. Teasing out the significance of the shifts in Dias' work from the 1960s to the 1970s, Salzstein approaches the combined presence of absurdist and neo-concrete elements as an allegory of the archaic and the ultra-modern in a new 'state of culture' conditioned by the collapse of territorial boundaries. Far from resulting in the egalitarian forms of sociability envisaged by the 1960s social movements, the fragmentation of public space into competitive group enclosures intensifies the entry of consumerist values into more and more areas of (art and) everyday life.

In the light of Fredric Jameson's (1984) influential account, which saw realism as the cultural paradigm of market capitalism,

modernism as the answering response to the alienation of individuality under the bureaucratic norms of monopoly capitalism, and which saw pastiche, quotation and 'depthlessness' as features of post-modern art in an age of multinational capitalism, it is intriguing that the post-colonial emphasis on disjunctive temporalities finds an echo in Hal Foster's (1996) criticism that Jameson's approach is, 'too spatial, not sensitive enough to the different speeds as well as the mixed spaces of postmodern society, to the deferred action as well as the incessant expansion of capitalist culture.'[24] Where Geeta Kapur argues that, 'The continuing debates on the avant-garde cannot [...] claim a determining discourse on the avant-garde *elsewhere*', for, 'once they are unstrung from the logic of a Euro-American master discourse [...] third-world vanguards can be seen to be connected with their own *histories* and mark that disjuncture first and foremost',[25] her take on post-modernism as a 'periodising concept' re-evaluates the watershed moment of the 1960s to examine the multi-directional dynamics of artistic influence and borrowing in such a way that also reveals what had been hidden and repressed by the modernising aspirations of the official national élite in India.

In the richly-detailed study of the life and work of Bhupen Khakhar she contributes to this book, Kapur reveals a situated eclecticism that quotes from multiple sources – sacred and profane, popular and vernacular, indigenous and imported – in a practice of narrative figuration that was seen as incompatible with the sanctioned abstract art of Group 1890, whose 1963 exhibition catalogue was introduced by the then Mexican ambassador Octavio Paz. When Clement Greenberg visited India in 1967 to accompany a travelling MoMA exhibition, his purist strictures were equally at odds with the heterodox image-world Khakhar had assembled in such paintings as *Pan Shop* (1965) that revelled unapologetically in the brash contingency of street life in the provincial town of Baroda, his adopted home. Kapur's fine-grained reading of Khakhar's self-representations from the 1960s to the 1980s stories the queer citizenship he gradually asserted as a gay artist who chose a provincial place of belonging in subtle dissent from his counterparts who saw themselves as a heroic national vanguard. What emerges in this vivid account of Khakhar's double-sided critique of international modernism of the Euro-American variety and of the post-independence narrative of national identity is a local cosmopolitanism whose radical vision of the self-governing city-state took as one of its key sources the pre-modern paintings of 14th-century Italian primitives. By 'going backwards' to this extent in the range and scope of his chosen quotations, Khakhar seems to confirm the 'perverse dynamic' that queer theorist Jonathan Dollimore describes as subverting the linear developmentalist narratives that attempt to equate ideologies of family and nation in the normative reproduction of social authority.[26]

Offsetting the risks of economic determinism, which threaten to occlude the micro-politics of subjective agency enabled by the social contradictions that arise in the multi-directional flows between 'centre' and 'periphery', the linguistic model of pidgins and creoles provides a framework that is especially relevant to the uneven histories of artistic production in African societies. Whereas export-driven trade determined the colonisation of consumer markets in west and central regions, South

Richard Fosso,
*Mr Post: Ghanaian Born
Artist*, c.1991

Africa's historical status as a settler society differentiated the material conditions under which markets for art and artefacts were created. Starting with archival evidence that shows the inclusion of a commercial brand – Mr Peanut – in the geometric design of a Ndebele wall painting in the 1940s, Colin Richards takes the figure of the wall as a signifier of boundary-marking that opens up new depths of complexity in our understanding of the semiotic ambivalence set into motion by symbols of 'difference'.

The wall is emblematic of the official lines of separation instituted by Afrikaner nationalism, but what Richards demonstrates by tracing its figurative presence through four decades of South African art history is a dialectic of power and resistance in which the antagonism of 'popular' and 'official' discourse is dramatised across the essentialist identity categories that the politics of apartheid sought to impose. Ndebele wall painting was promoted in the 1950s as a form of 'tourist art' with official government patronage, but as motifs such as light bulbs and airplanes began to make an appearance, the process of urbanisation and modernisation created forms of 'transitional art' that went beyond the restricted pidgin idiom to reveal how black South Africans perceived their own experiences of modernity under apartheid. Drawing on the linguistic model, Peter Wollen (1993) proposed the notion of 'para tourist gallery art' in examining the work of painters such as Diouf Kabamba and Cheri Samba in Zaire and Twins Seven Seven in Nigeria. His argument that, 'catastrophic contact with Western culture leads at first to the reduced "tourist art" forms typical of pidgin and then, drawing on both surviving indigenous elements and on the foreign target culture, artists can

begin to expand the formal language and produce new and innovative work',[27] is enriched by the insights Richards brings to the overlay of local and global elements in the development of urban vernaculars, but complicated by the ways in which the access to fine art production offered by the Polly Street Arts Centre and the Thupelo workshop in the 1950s and 1960s brought new pressures upon black South African artists to produce 'township art'. When Clement Greenberg lectured in Cape Town and Pretoria in 1975 his views seemed only to entrench the walls that divided the options explored by such artists as David Koloane and Durant Sihlali, whose abstract and figurative practices negotiated the conflicting demands of a white minority arts community during the emergency period of the Soweto uprisings.

Despite major sociological differences across post-colonial African contexts, one key factor that has held back the critical understanding of artistic agency under conditions shaped by colonial trade is the gate-keeping concept of 'authenticity'. As Sidney Kasfir (1992) shows in her important essay on the implicit ideological demands that western gallerists, collectors and curators bring to the perception of African art, the categorical antimony between 'tribal art' and 'tourist art' often plays an over-determining role in the misapprehension of modern African art as somehow 'inauthentic'. If tourist art is deemed 'inauthentic' and unworthy of museum collections on account of its client-driven character as a product of markets aimed at foreigners, in contrast to indigenous tribal art (which is nonetheless often reproduced in the form of 'fakes'), then gallery art by either self-taught or art school-trained practitioners that displays western borrowings is likewise often deemed

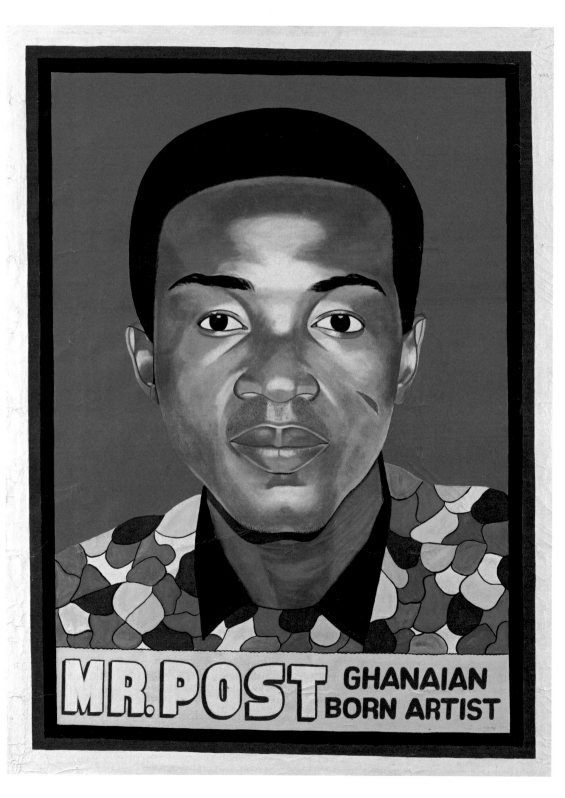

Gavin Jantjes,
*The First Real Ameri(k)an
Target*, 1974

inauthentically 'African' on account of exogamous elements. The denial of authorial intentionality on the part of non-western practitioners that is built into the founding categories of what James Clifford (1988) calls the 'art and culture system' as 'a machine for making authenticity'[28] is both predicated on the modernist ideology of 'autonomy' in which material artefacts intended for sale in the marketplace are demoted as 'non art', and also reproduces the Eurocentric polarity between 'the West' and 'the rest' by foreclosing the recognition of art's commodity status within the West itself. When pop art practices of the 1960s updated the avant-garde usage of readymades to question the 'aura' attributed to the rarity and uniqueness of hand-crafted 'masterpieces', the impact of mass reproduction technologies upon the hierarchy of values maintained by bourgeois institutions of art was dramatically acknowledged – but in one and the same move pop art strategies of simulation and mimicry also laid bare the inner workings of the capitalist art market as a system of commodity fetishism in which art's 'auratic' value is held in place by monetary as well as 'civilisational' criteria.

How far has post-modernism resolved the double-bind of 'authenticity' that African artists once faced? Consider the self-portrait produced by the Ghanaian sign-writer Richard Fosso, who trades as 'Mr Post' in a small-scale enterprise near Cape Coast. Where photomechanical or electronic forms of reproduction are available, but out of reach to low income groups, Fosso competes in a local economy where sign-writers using recognisable skills in verisimilitude are in demand, and his painting was 'intended' to advertise his business and attract customers – shop owners, lorry drivers, private households –

to the reprographic services he provides as a commercial artist. From a modernist standpoint, because it was created for the market, his painting would be seen to lack 'autonomy' as an entity in its own right and the axiomatic distinction between 'art' and 'artefact' would identify this work as kitsch. Acquired during fieldwork, did my act of purchasing the canvas turn it into a commodity, or was it already a commercial object serving Fosso's purposes as a sign? From the post-modern standpoint that regards 'commodification' as a negation of the authenticity ascribed to the expressive values of 'folk art' of the pre-industrial era, my translation of Fosso's self-portrait from its intended purpose would be an act of de-contextualisation. Nostalgic lament for the loss of authenticity often remains a feature of reductive versions of post-modernist criticism (as in early versions of cultural studies) in which the idealistic quest for a 'purity' untainted by market forces retains aspects of the primitivist fantasy of absolute 'otherness'.

Returning to Peter Wollen's approach, which regards the 'provincial debate about "postmodernism"' as 'stifingly Eurocentric',[29] an alternative view would be to consider Fosso's painting as an example of how 'creoles […] develop out of pidgins to form complete new vernacular languages.'[30] Whereas pidgins are 'other-directed' as simplified languages that facilitate communication between disparate cultural identities, creoles 'relexify' an eclectic combination of indigenous and acquired elements in 'self-directed' forms of expression that generate their own complex vocabularies. On this view, Richard Fosso both creolises pop's dialogue between painting and photography, for his source was a passport picture, and also

25

THE FIRST REAL AMERIKAN TARGET

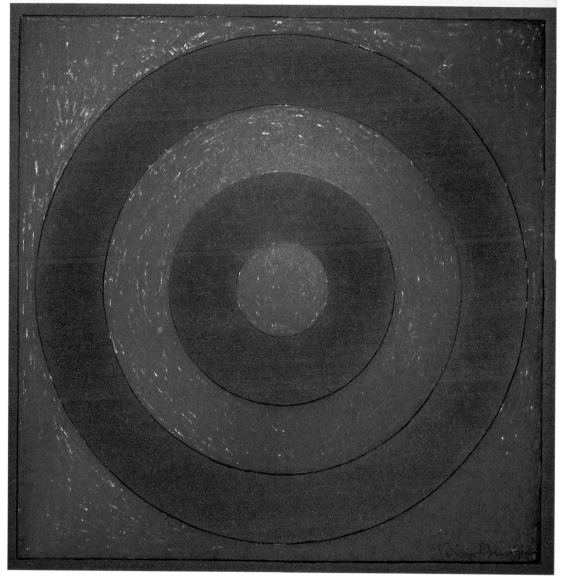

reiterates Andy Warhol's emphasis on the artist as *selecting* from a pool of available images rather than *originating* an expression of innermost subjectivity. In light of pop's ambiguity on issues of authorial intention, the question philosopher Kwame Anthony Appiah asked – is the 'post' in post-colonial the same as the 'post' in post-modern? – meets with an eloquently undecidable reply in Mr Post's visual statement about how a Ghanaian artist sees himself and how he chooses to be seen by others within his own social context.[31]

As local cultures interact at different speeds and in multiple directions, Wollen's prognosis that, 'we can be sure, however, that these changes will take place along the triple axes of migration, urbanisation and culture contact',[32] already applies to the recent past. Having graduated from the Michaelis School of Fine Art in Cape Town in 1969, Gavin Jantjes won a scholarship to the Horschule für Bildende Kunst in Hamburg in 1970 and it was under these migratory conditions that he produced *The First Real Ameri(k)an Target* (1974) as part of a body of work in the silkscreen medium. Instantly recognisable as a political parody of Jasper Johns' *Target with Four Faces* (1955), it substitutes the plaster casts with photographs of Native North Americans. The conceptual terrain upon which Jantjes doubles back upon the iconic target – reinscribing connotations of colonial violence in US history that had been drained off by the way in which Johns had formally detached the sign from its referent – also alluded to Peter Blake's *The First Real Target?* (1961) to question the social relations of representation that had been written out of pop's formalist strategies. While the meta-referential aspects of parody bring us back to the semiotics of intertextuality that were

privileged by the earliest forms of post-modernist criticism, it is revealing that Jantjes did not see these as mutually exclusive to the political concerns that led to his participation in the mid-1970s Artists for Democracy initiative led by Philippines-born and London-based artist David Medella. Indeed, where artist and arts activist Rasheed Araeen explicitly addressed 'images of Coca-Cola, Marylin Monroe, Pin-ups, the American flag, Hamburgers, etc' as 'the *ethnic* images of American culture', in the first issue of the *Black Pheonix* journal in 1978, his anti-imperialist reading of pop heightens rather than diminishes the polysemic qualities of *The First Real Ameri(k)an Target* as a harbinger of critical post-modernism.[33] Relocating to London in 1982, Jantjes' circulatory migration from South Africa and Germany into the emergent spaces of 'black Britain' – where South Asian identities were included in political definitions of blackness – testifies to a nascent post-colonial outlook shaped by a set of inter-cultural alliances that had traversed disparate Third World origins to create new forms of belonging under conditions of exile and diaspora.

Image and Identity

The new world order inaugurated by the break-up of the Berlin Wall and the events in Tianamen Square in 1989 reconfigured the tripartite division that Roosevelt, Churchill and Stalin had presided over at the Yalta conference of 1945, but the differential speeds with which artistic and cultural practices have reckoned with the repercussions of global realignments undermines a simple one-to-one correspondence between the 'post' in post-modernism and the 'post' in post-colonialism. While the critical post-modernism advocated by scholars such as Angela McRobbie

(1986), Dick Hebdige (1988) and Andrew Ross (1988) issued a long-distance reply to the term's first appearance in a 1968 lecture by American critic Leo Steinberg (1972), and a similar time-delay was built into the gap between Stuart Hall's initial contributions to the study of 'race and class in post-colonial societies' in 1978 and his theoretical reflections on the question, 'When was "the Post-colonial"?' (1995), it is significant that the timing of the exhibition and research project initiated by Russian philosopher Boris Groys on *The Post-Communist Condition* (2004 and 2005) further emphasises the jagged timeline of deferred action that arises 'after' monolithically consensual constructions of reality have become irrevocably de-centred.[34]

Examining 'post-pop' strategies among Chinese artists in the late 1980s and early 1990s, Martina Köppel-Yang acknowledges the impact of the process of modernisation that began with the policy of 'opening' announced by Deng Xiaoping in 1978. However, in the compressed period of the decade during which new artistic tendencies culminated in the controversial *China Avant-garde* exhibition of 1989, artists such as Wang Guanygi, Wu Shanzhuan and Xu Bing not only negotiated an altered relationship to western art history, but also addressed their own critical re-reading of the visual culture of the Cultural Revolution, which had been a formative experience among their generation. Observing how the goals of propaganda art in the Cultural Revolution sought to abolish the gap between art and everyday life, as western pop had also aspired to do, Köppel-Yang draws attention to the paradigmatic reversal whereby the latter aimed to subvert the status quo, while the 'culture of the masses' promoted under Mao's leadership confirmed the state's official

discourse. Exploring the translation of folk, popular and vernacular elements into aesthetic strategies of appropriation and deconstruction that articulated an avant-garde critique of the politics of internal reform during the 1980s, Köppel-Yang argues that far from being obsolete or irrelevant, the pool of recognisable imagery associated with 'revolutionary modernity' acted as a critical resource that enabled Chinese artists to address their relationship to western modernism on their own terms. What was often perceived as a critique of communism when exhibited in the West, was a recapitulation of cultural history and an adjustment of cultural identity that encoded dissent from the prevailing direction in which the process of modernisation in China was being driven.

The specific conditions under which popular and official discourse antagonised one another in the Chinese context – where 'avant-garde' and 'modern' are often interchangeable in the absence of an equivalent category of 'the contemporary' – are heightened by Wu Shanzhuan's apparently contradictory notion of 'serious absurdity', but the role of pop art as a catalyst for the crossing of classificatory boundaries pinpoints one of three recurring themes in all of the contributions to this book. Bahktin saw the exclusion of 'carnival laughter' from the ritual solemnity of high church as one of the founding acts of Europe's Reformation and, taking up this view, literary historian Allon White argued that, 'the social reproduction of seriousness is [...] perhaps *the* fundamental [...] hegemonic manoeuvre' for 'once the high language has attained the commanding position of being able to specify what is and what is not to be taken *seriously*, its control over the language of society is virtually assured.'[35] If the impulse to

Detail of poster designed
by Bhupen Khakhar for
his solo exhibition at
Kunika Chemould Gallery,
New Delhi, February 1970

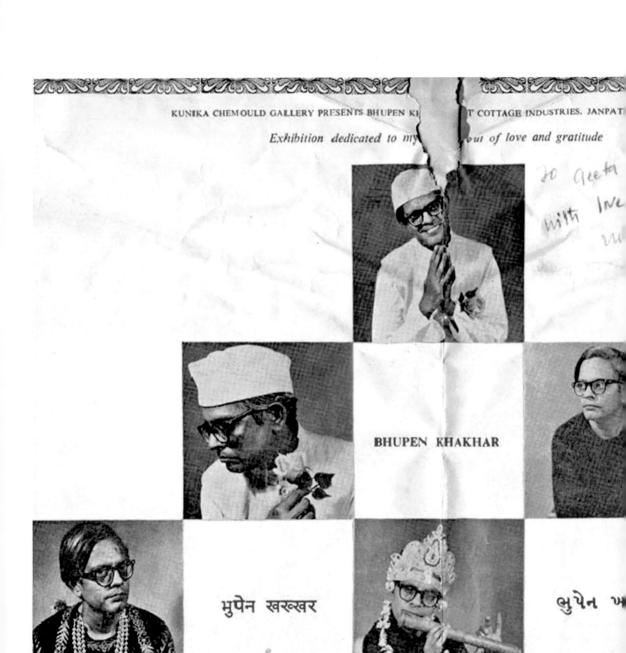

produce a more inclusive understanding of 20th-century art has often been characterised as a 'serious' matter of redeeming artists who were once overlooked, perhaps there is also a 'false solemnity' to the official ideology of contemporary multiculturalism when pleasurable laughter is felt to be out of the question. By showing how vernacular sources have been employed to generate ambivalence rather than 'oppositionality', the studies gathered in this collection reveal how humour, irony and frivolity endlessly renew art's essentially open-ended character as a practice of questioning what are deemed to be sacred 'truths'.

Marcel Duchamp and Andy Warhol showed an inclination towards masquerade in the form of cross-dressed gender drag, but the role-playing Bhupen Khakhar performed in his poster for a 1970 solo exhibition at the Kunika Chemould Gallery in New Delhi – mock-acting as a prince adorned in velvet, tinsel and pearls, or as Lord Krishna playing his intoxicating flute, or then again, parodying an ingratiating politician from the Congress Party of India – is all the more subversive of the dour rigidity of high seriousness by virtue of the way he includes himself among the figures he has spoofed. Unlike the mocking laughter of satire, which assumes moral superiority, the all-inclusive character of carnival laughter is a vital component of the wit and humour that artists such as David Hammons and Robert Colescott activate in critical strategies of debasement in which the 'high' is brought 'low' to confront an otherness that is structurally excluded from the self-importance often associated with the institutions of the modern art world.

If transgressive forms of masquerade such as drag 'dramatise the signifying gestures through which gender itself is established', then the view

put forward by philosopher Judith Butler, that to be in drag is not to copy an original gender identity but is to 'imitate the myth of originality itself',[36] provides an example of how pop art's far-reaching displacement of modernism's foundational categories has filtered out into numerous domains of contemporary critical theory. Warhol famously adopted an unreadably blank persona in his transition from commercial art to the 'serious' realm of fine art practice, and an anecdote from Emile de Antonio – 'Rauschenberg and Jasper Johns didn't want to meet Andy at the beginning ... Andy was too effeminate for Bob and Jap ... I think his openly commercial work made them nervous ... They also, I think, were suspicious of what Andy was doing – his serious work – because it had obvious debts to both of them in a funny way'[37] – indicates how closely gender matters to the social reproduction of seriousness. Where Warhol's use of camp subverted the depth-model of bourgeois subjectivity to undermine the common-sense dichotomy of essence and appearance, Butler's analytical distinction between expressivity and performativity applies to the evidential 'truths' of visual representation that pop art had cast into doubt:

> If gender attributes ... are not expressive but performative, then these attributes effectively constitute the identity they are said to express or reveal. The distinction between expression and performativeness is crucial. If ... the various ways in which a body shows or produces its cultural signification are performative, then there is no pre-existing identity by which an act or an attribute might be measured; there would be no true or false, real or distorted

acts of gender, and the postulation of a true gender identity would be revealed as a regulatory fiction.[38]

Produced during the post-Factory period when it seemed the artist had become wholly assimilated into corporate celebrity culture, what makes Warhol's *Ladies and Gentlemen* (1975) a remarkable work is not the choice of African American drag queens as subject matter but the implication that 'race' and ethnicity are co-extensive with gender and sexuality as differential attributes of identity that make bodies 'readable' and culturally intelligible on the basis of their performative rather than expressive character.

The critical displacement of essentialist models of identity was a key achievement of the post-colonial breakthrough initiated by black diaspora artists in the 1980s, which is to say that the discrepant chronometry of belated recognition emerges as another common thread across the contribution made by this book to an expanded and revised appreciation of pop art's continuing agency as an interruption of dichotomous boundaries. Frequently included in surveys on the dramatic changes in African American self-representation in the aftermath of the Black Power era, the unique photo-realist depictions of vernacular style produced by painter Barkley Hendricks (b.1945) participate in the self-conscious 'superficialism' that pop artists had utilised as a strategy to explore the visual seduction of the viewer's gaze. Isolating his subjects from their social environments in works such as *North Philly Niggah* (1975) (see front cover), *Tuff Tony* (1978) and *Afro-Parisian Brothers* (1978), our attention is drawn to the language of clothes. As Mary Schmidt-Campbell notes in the case of *North Philly Niggah*,

Andy Warhol,
Ladies and Gentlemen,
1975

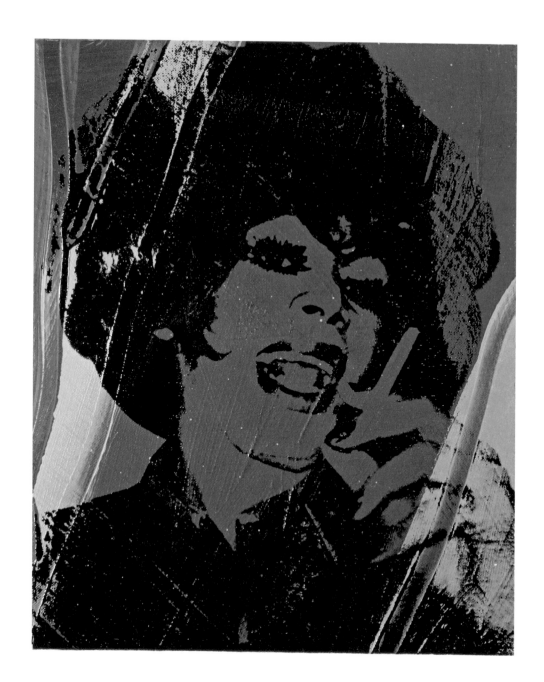

'the body, a primary expressive element, is hidden and the coat is either the expression of a lifestyle and an attitude to life [...] or it shields the body ... providing a protective shell for the subject.'[39] However, once we factor in the crucial signifying gestures that selected fashion items perform in the wit and insight Hendricks brings to his portrayal of black male nudes – the woolly hat and sunglasses in *Brown Sugar Vine* (1970), the athletic footwear, the baker's boy cap and aviator-frame glasses in *Brilliantly Endowed (Self Portrait)* (1977) – then the coy reading of the latter as merely referring to the praise which the artist had received in an article by Hilton Kramer is somewhat off-message.[40] Where the politics of sexuality were seen as mutually exclusive to the identity politics of 'race' in the either/or universe of black cultural nationalism, the erotic and libidinal investment in the gaze that Henricks lays bare with such 'cool' analytical precision had to wait until Thelma Golden's acclaimed *Black Male* (1994) exhibition before it could be recognised as revealing the ways in which clothes function in the construction of subaltern masculinities as ambivalent signs that both attract the gaze of others and defend the subject from the unconscious projection of primitivist fantasies.[41] Suffused in pink, what makes *North Philly Niggah* especially noteworthy is the phallic armour provided by the fur-lined overcoat, which makes it a fetish that simultaneously wards away the fears and desires associated with black male identity while at the same time provoking curiosity about the body wrapped within it.

The way in which questions of sexuality leak out of the performative embodiment of social identity, which is a third connective strand in this enquiry, adds a twist to the official discourse of multiculturalism in light of the unruly materials of vernacular cultures. Just as art historian Sarat Maharaj (1991) widened our understanding of 1960s pop by drawing on the double-edged concept of the 'pharmakon' – a substance that is both poison and cure – to deconstruct the 'overwhelming tendency to read [pop art] in terms of strict, reductive oppositions, as either truth-drug or the opiate of mass culture, as critical purge or kitsch palliative',[42] the 'post' involved in post-colonial revision merely extends the timeline of delayed recognition into the future by exploring the mutually constitutive entanglement of sexual *and* cultural difference in art's changing relations with popular culture. Where the 'both/and' ambiguities of pop art practices had to wait until the arrival of post-structuralist theories to fully reveal the consequences of their unsettling insights, as Australian critic Paul Taylor (1989) suggested, the Dionysian agency of eros abrades upon the ways in which neo-pop or 'post-pop' ambivalence registers 'something of [an] unease about consumerist excess.' 'As the orders of consumerist representation close in on Pop Art by the 1990s', Maharaj suggests, 'our attention shifts to focus on waste, the excremental, precisely what consumerism – as a vast digestive, gustatory system – finds too disgusting to mention openly.'[43] Such an observation not only applies to the 'leftovers' of modernist (and post-modernist) historiography, for as Wollen agrees,

[t]he modern movement was always a battlefield on which purists endlessly struggled to expel difference, excess, hybridity and polysemy from their brave new world[44]

but also disorders the redemptive programmatics of official multiculturalism, for the precedence of 'polymorphous perversity' over the acquisition of autonomous selfhood deranges the rigid boundaries of national, cultural and ethnic certainties. The 'Spanglish' word *rasquachismo* is strictly untranslatable but insofar as it refers to the 'leftovers' of popular culture it rejoins the unwieldy mix of heterogeneous elements that are routinely expelled and cast out of encyclopaedic systems that seek to 'master' the worldly materials they survey by establishing official rules of law and order. In their own way, each contribution to this book confirms Peter Wollen's prescient view that:

> Modernism is being succeeded not by a totalising Western postmodernism, but by a hybrid new aesthetic in which the new corporate forms of communication and display will be constantly confronted by new vernacular forms of invention and expression. Creativity always comes from beneath, it always finds an unexpected and indirect path forward and it always makes use of what it can scavenge by night.[45]

NOTES

1. Lawrence Alloway, 'The Development of British Pop', in Lucy R. Lippard, *Pop Art*, London and New York: Thames and Hudson, 1966, 32.
2. Dan Cameron ed., *East Village USA*, New York: New Museum of Contemporary Art, 2004; Richard J. Powell, David A. Bailey and Petrine Archer-Straw eds, *Back to Black: Art, Cinema and the Racial Imaginary*, London: Whitechapel Gallery, 2005; Carlos Basualdo ed., *Tropicalia! Revolution in Brazilian Art and Culture*, London: Barbican Arts Centre, 2006.
3. Jack Kerouac, *On The Road*, New York: Viking Press, 1957; Norman Mailer, 'The White Negro: Superficial Reflections on the Hipster', *Dissent*, 4, Summer 1957, 276–93, reprinted in Norman Mailer, *Advertisements for Myself*, New York: Andre Deutsche, 1964.
4. See Judith Wilson, 'Garden of Music: The Art and Life of Bob Thompson', in Thelma Golden ed., *Bob Thompson*, New York and Berkeley: Whitney Museum of American Art/University of California, 1998, 27–80, esp. 'Bob Thompson and the Avant-garde Critique of Contemporary Culture', 46–59.
5. See Alfred Pacquement, 'The Nouveaux Realistes: The Renewal of Art in Paris Around 1960', in Marco Livingstone ed., *Pop Art*, London: Royal Academy of Arts, 1991, 214–18, and Germano Celant ed., *Arte Povera*, Milan, New York and London: Gabrielle Mazzotta/Praeger/Studio Vista, 1969.
6. Richard Hamilton, 'Letter to Peter and Alison Smithson' (1957), reprinted in David Robbins ed., *The Independent Group: Postwar Britain and the Aesthetics of Plenty*, Cambridge, MA and London: MIT, 1990, 181.
7. Richard Hoggart, *The Uses of Literacy*, Harmondsworth: Penguin, 1956, 248.
8. Q.D. Leavis, *Fiction and the Reading Public* (1932), London: Chatto and Windus, 1965, 187.
9. Lawrence Alloway, 'The Long Front of Culture' (1959), in Clocktower Gallery and Institute of Contemporary Art Boston, *Modern Dreams*, Cambridge, MA and London, 1988, 31.
10. Dwight Macdonald, 'A Theory of Mass Culture', in B. Rosenberg and D.W. White eds, *Mass Culture: The Popular Arts in America*, New York: Macmillan, 1957, 59–73, and Clement Greenberg, 'Avant-garde and Kitsch' (1939), in John O'Brian ed., *The Collected Essays and Criticism: Vol. 1 1939–1944*, London and Chicago: University of Chicago, 1986, 5–22. On cultural studies in America, see Andrew Ross (1989).
11. John Storey, *Cultural Theory and Popular Culture: An Introduction*, Harlow: Prentice Hall, 2001, 56.

12. Tony Bennett, 'Popular Culture and the turn to Gramsci', in Tony Bennett, Colin Mercer and Janet Woolacott eds, *Popular Culture and Social Relations*, Milton Keynes: Open University Press, 1986, 12.
13. Dan Cameron, 'Neo-This, Neo-That: Approaching Pop Art in the 1980s', in Livingstone, 1991, op. cit., 261.
14. Marshall McLuhan, *Understanding Media*, Harmondsworth: Penguin, 1967.
15. John Docker, *Postmodernism and popular culture*, Cambridge: Cambridge University Press, 1994, 284.
16. See Guillermo Gómez-Peña, *Dangerous Border Crossers: the artist talks back*, New York and London: Routledge, 2000, and James Clifford, *Routes: Travel and Translation in the Late Twentieth Century*, London and Cambridge, MA: Harvard University Press, 1997.
17. Raymond Williams, 'When Was Modernism?', in Raymond Williams, *The Politics of Modernism: Against the New Conformists*, London: Verso, 1989, 35.
18. Geeta Kapur, 'When was Modernism in Indian Art?' (1992), in Geeta Kapur, *When was Modernism: Essays on Contemporary Cultural Practice in India*, New Delhi: Tulika, 2000, 299 and 301–2.
19. Paul Willemen, 'An Avant-Garde for the 90s', in Paul Willemen, *Looks and Frictions: Essays in Cultural Studies and Film Theory*, London and Bloomington: British Film Institute/Indiana University Press, 1994, 145–46.
20. Ibid.
21. Kapur, 2000, op. cit., 300.
22. Andreas Huyssen, 'Mapping the Postmodern', *New German Critique*, 22, 1981, 11.
23. Andreas Huyssen, 'The Cultural Politics of Pop', in Andreas Huyssen, *After the Great Divide*, London: Macmillan, 1986, 188.
24. Hal Foster, 'Whatever Happened to Postmodernism?', in Hal Foster, *The Return of the Real*, London and Cambridge, MA, 1996, 207.
25. Geeta Kapur, 'Dismantled Norms' (1996), in Kapur, 2000, op. cit., 376.
26. Jonathan Dollimore, *Sexual Dissidence: Augustine to Wilde, Freud to Foucault*, London and New York: Oxford University Press, 1991, esp. Part 8 'Transgressive Reinscriptions, Early Modern and Post/Modern', 279–325.
27. Peter Wollen, 'Into the Future: Tourism, Language and Art' (1990), in Peter Wollen, *Raiding the Icebox*, London and New York: Verso, 1993, 201–2.
28. James Clifford, 'On Collecting Art and Culture', in James Clifford, *The Predicament of Culture*, London and Cambridge, MA: Harvard University Press, 1988, 224.
29. Wollen, 1993, op. cit., 205.

30. Ibid., 196.

31. Kwame Anthony Appiah, 'The Postcolonial and the Postmodern', in Kwame Anthony Appiah, *In My Father's House: Africa in the Philosophy of Culture*, London and New York: Oxford University Press, 1992, 137–57. On the concept of 'afro-kitsch', see two distinct approaches in Don Cosentino (1991) and Manthia Diawara (1992).

32. Wollen, 1993, op. cit., 204.

33. Rasheed Araeen, 'Preliminary Notes For a Black Manifesto', *Black Pheonix*, 1, 1978, reprinted in *Studio International*, 194, 988, 58–67, 62.

34. See Ann Von Der Heiden ed., *Privatizations: Contemporary Art from Eastern Europe*, Berlin: Revolver Verlag, 2004, and Boris Groys, Anne Van Der Heiden and Peter Weibel eds, *Back from the Future: Eastern European Cultures in an Age of Post-Communism*, Berlin: Suhrkamp Verlag, 2005.

35. Allon White, '"The Dismal Sacred Word": Academic Language and the Social Reproduction of Seriousness' (1983), in Allon White, *Carnival, Hysteria and Writing*, London and New York: Oxford University Press, 1993, 134.

36. Judith Butler, *Gender Trouble*, London and New York; Routledge, 1990, xxviii and 176.

37. Emile de Antonio, in Patrick Smith, *Andy Warhol's Art and Films*, Ann Arbor: UMI Research Press (1986), 294–95, cited in Benjamin Buchloh (1987), 60.

38. Butler, 1990, op. cit., 180.

39. Mary Schmidt-Campbell, *Barkley L. Hendricks*, exh. cat., New York: Studio Museum in Harlem, 1980, n.p.

40. Ibid.

41. Thelma Golden, 'My Brother', in Thelma Golden ed., *Black Male: Representations of Masculinity in Contemporary American Art*, New York: Whitney Museum of American Art/Abrams, 1994, 42.

42. Sarat Maharaj, 'Pop Art's Pharmacies: Kitsch, Consumerist Objects and Signs', in Livingstone, 1991, op. cit., 20.

43. Ibid., 23.

44. Wollen, 1993, op. cit., 206.

45. Ibid., 209–10.

POP ART AND
VERNACULAR
CULTURES

'STOP THAT ACTING!': PERFORMANCE AND AUTHENTICITY IN SHIRLEY CLARKE'S *PORTRAIT OF JASON*

GAVIN BUTT

In her landmark study, *Greenwich Village 1963*, the dance historian Sally Banes describes how the New York avant-garde of the early 1960s remodelled itself as a particular kind of folk culture. As her title suggests, this was in part because avant-garde production was embedded within the overlapping social networks of artists, dancers, poets, filmmakers, theatre practitioners and composers resident within the bohemian locale of Greenwich Village. Setting its face against the big museums, corporatism and almost anything formal and professional, avant-garde output was often staged in small local venues, with readings and screenings in coffee bars and makeshift theatres. This avant-garde was folksy, Banes argues, because the art it produced was made '*by* the community *for* the community'.[1] Indeed the avant-garde community *itself* is likened by Banes to a 'folk' given that it comprised a relatively close-knit community of bohemians whose values were at odds with those of mainstream American society. This sense of the 1960s avant-garde as an *alternative* community was an important aspect of its overall political ethos, she argues, leading it to find value in its own intimate networks of friends, lovers and neighbours as much, if not more than, the established society circles associated with high culture. This emphasis on informality, Banes goes on, was instanced in the nature of much of the art produced under its name. Happenings, for example, borrowed from folk and popular performances like civic pageants and vaudeville; in underground film there was a deliberate turn to amateur and popular techniques like that of the home movie; and there was a general preference for using non-professional participants, whether in Yvonne Rainer's dance or in Andy Warhol's films. These choices testify to what Banes calls the 1960s avant-garde's 'standard modernist ... primitivist strategy that had begun with the Romantic movement of the nineteenth century'.[2] Such a strategy was one that saw the New York avant-garde valorise popular and folk traditions on moral and political terms, for their purported authenticity, egalitarianism and community centred values.

I shall return to the problematic idea of the avant-garde community as itself a 'folk' later, but to begin with I want to consider how this 'primitivist' strategy is played out in respect of two specific vernacular cultures – one black, the other queer – both of which had a degree of avant-garde currency in the New York art world of the 1960s. Much work has been done already on the appeal of 'blackness', and particularly black jazz culture, to an earlier avant-garde – to the 1950s beats and the wider subculture of 'hip'. Kobena Mercer, for instance, has pointed to how the white hipster's identification with a primitivising image of 'the negro' makes of him a 'white negro', as made famous by Norman Mailer's 1957 essay.[3] We are familiar with the ways in which Mailer, and other white hipsters, idealised the black man's supposed 'existential' condition – a life brought about by the deleterious effects of racism – by celebrating it as a life of vital experiences, as a life 'on the edge'. All of this was supposedly given expression in jazz improvisation and in the African American vernacular of 'hep' talk. This primitivising perspective can been seen as analogous to the valorisation of queer sexuality and culture in 1950s bohemia. In my own work on the painter Larry Rivers, for example, I have explored how 'queerness' – in addition to 'blackness' – came to be coded as hip, and thereby came to accrue a desirable transgressive aura especially for

straight, or nominally straight, bohemians like Rivers. In my book, *Between You and Me*, I have explored the ways in which Rivers makes himself over into a gay-acting straight artist by emulating the trivialising exchanges of a campy queer vernacular in the production of his paintings, described by Rivers himself as a 'visual gossip column'.[4] Relatedly, Catherine R. Stimpson has usefully pointed out the hesitations and ambivalences that often attended this valorisation of the queer as an icon of sexual freedom, and of queer culture as a model of alternative social and artistic possibilities.[5] What emerges from these enquiries is a picture of how some white heterosexual avant-garde artists and writers in the 1950s, alongside gay and non-white ones, turned to black and queer vernacular traditions as resources supposedly productive of *authentic* expression. This was important given that the lauded value of authenticity was no longer taken to be inherent in the 'square' art produced by the artistic and literary Establishment. Nor was it to be found in the products of the culture industry, such as Hollywood cinema, or in the popular paintings of artists like Andrew Wyeth, which, in the eyes of the New York avant-garde, were seen as offering only a facsimile of genuine artistic expression and affect.

While it may seem understandable to think of avant-garde perspectives on black culture in this period as 'primitivising', it may seem odd to understand the celebration of queerness under the auspices of such a colonialist metaphor. However, I want to insist on using this term here in *both* contexts in order to foreground the ways in which primitivist approaches were productive of an avant-garde 'outsiderism' in the post-1945 US art world, just as they were in European artistic

culture in the 19th and early 20th centuries. The main difference is that rather than the European investment in non-western cultures, it is the USA's *internal* minority others – both sexual and racial – that provided the resources for reshaping avant-garde production in the 1950s and 1960s. In this respect, I am interested in how an avant-gardist embrace of black *and* queer vernaculars comes to be generative, especially for white and non-queer artists, of a 'liberated' artistic agency that is supposedly freed from the restrictive values and conventions of the 'straight' western mainstream. More particularly, in this essay I consider what happens to avant-gardist identifications with such minority cultures as we move away from 'hip' in the 1950s to 'pop' in the 1960s. What happens when hip culture, which prized dropping out of media and consumer culture altogether in favour of living a vital and libidinous life, cedes ground to a pop appreciation of commodity spectacle, and an engagement, albeit knowing or ironic, with those very forms of mass culture that hip took to be responsible for the hollowing out of contemporary existence in the first place? What happens to the primitivising gesture, then, when filtered through a pop sensibility? How did the primitivist celebration of minority cultures as 'authentic' alternatives to capitalist commodity culture fare in the face of the increasing imbrication of black and queer cultures *within* the sphere of popular culture during the 1960s, for example, in the 'black' musicals of Langston Hughes, or in the camp and queer appreciation of film and celebrity culture in the work of Andy Warhol?

Making a Scene: From Hip to Pop

The focus for my deliberations is Shirley Clarke's 1967 feature film, *Portrait of Jason*, a cinéma vérité study of an ageing African American gay hustler, Jason Holliday. Clarke began her career as a choreographer and switched to filmmaking in the early 1950s, when she made her name with short experimental films such as *Bridges Go Round* (1959), which featured footage of New York bridges that were made to 'dance' by dint of Clarke's editing and other filmic manipulations. By the 1960s, Clarke had developed a rather different reputation as a counter-cultural filmmaker, chiefly as a result of her groundbreaking feature films that addressed issues of heroin addiction and black street culture. *The Cool World* (1963) focused on the criminal world of a gang member who was also a participant in the Black Muslim Movement, and it was the first commercial film to be shot on location in Harlem. Clarke's earlier film, *The Connection* (1961), based on Jack Gelber's eponymous play about heroin addicts awaiting a fix in a Manhattan loft, incorporated a group of addict jazz musicians and starred the black actor Carl Lee – Clarke's then boyfriend. By the time she made *Portrait of Jason* in 1967, Clarke was certainly no stranger to black culture – indeed her work testifies to white avant-garde film culture's continued, and developing, fascination with it. On the other hand, *Portrait of Jason* marked Clarke's first foray into the subject of homosexuality, even though Andy Warhol, Jack Smith and Kenneth Anger had all predated her by a number of years in their own filmic treatments of queer sexuality within the context of underground cinema. Nonetheless, in the context of her earlier 'black' films, and as a relatively novel female and heterosexual perspective on male

homosexuality, Clarke's *Portrait of Jason* provides an opportunity to explore the straight white avant-garde's fascination with both blackness and queerness as it continued into the mid-1960s, and invites us to examine what was at stake in Clarke's particular interest in the marginal cultures of the hep cat and the camp queen.

These latter terms are important because the film's subject, Jason Holliday – born Aaron Payne in 1924 – would have come of age during the late 1940s and early 1950s when the bebop era in jazz was at its height. This was also the period in which Larry Rivers and other bohemians discovered the vernacular speech of black 'hep' and queer 'camp' talk for the first time. Jason's mode of speaking is peppered throughout the film with hep terms like 'groovy', 'swinging', 'balling', 'hip cat', 'cool' and so forth, as well as with the terms of a camp queer argot, such as 'bitchy bag', and phrases like 'I'm the bitch'. Filmed over the course of an evening, and stretching long into the night, Clarke's film records Jason talking to camera as he tells anecdotes about his life: these include stories about his hustling; his time as a house boy; his abusive homophobic father; his desire to perform a nightclub act; and his stint as a psychiatric patient at New York's Bellevue Hospital. Occasionally, the voices of Clarke and her boyfriend Lee – who had introduced Jason to the filmmaker – interject from off-camera. The only face and body we see, however, are Jason's, and as the filming rolls on into the night, and more whiskey is drunk and more dope is smoked, the film's durational aspect draws attention to the facial expressions and body language that register Jason's inevitable slide into intoxication.

At a number of points in the film, Jason talks proudly and approvingly about how he has been

responsible for 'making a scene' of one kind or another. For instance, he recounts a tale of how, in 'bothering' what he calls a couple of 'headshrinkers' – that is, two psychiatrists at the Bellevue Hospital – he has 'made a scene' with them. He mocks their medical interest in his sex life and the questions they ask him about it, and, laughing as he tells us that he has not returned their recent telephone calls, Jason telegraphs his evident delight in challenging their authority and their attempts to pathologise him. This clues us in to the kind of 'scene' that Jason takes ritualistic pleasure in making: that by acting up, by testing and teasing figures of institutional authority, he gets himself noticed and thereby makes himself over into spectacle – a spectacle, that is, of a counter-cultural, rebellious subject. This, presumably, is the reason why Clarke takes him to be remarkable enough and worthy of feature-length treatment: Jason provides a ready embodiment of marginal subjectivity in mid- to late 1960s culture, doubly marginal by dint of his blackness and queerness, or even quadruply so if we also take into account his hustling and what may be evidence of a drugs and drink problem (why, we are left asking ourselves, has he been going along to the Bellevue in the first place?). By 'making a scene' – in speaking and acting in the way that he did – Jason would likely have been viewed by white bohemians as more than just an attention-seeking misfit and rather more as an embodiment of *dissident* subjectivity. The humour and word play of Jason's vernacular speech highlight his antagonistic mockery of the 'serious' world of officialdom, making him into an iconic figure of resistance towards 'square' norms.

To contemporary eyes, Clarke's film seems to reiterate well-worn stereotypes of the entertaining minstrel and the drama queen in the way it represents its subject. It appears to foreground Jason as exotic naïf, revelling in his life of hard knocks marked by poverty, racism and homophobia, and in the wiliness, wit and wisdom that seem to have made it possible for him to endure his 40-something years in New York. Indeed, in many ways *Portrait of Jason* is a portrait of a survivor. This is not to suggest, however, that the film is a harrowing viewing experience. Far from it. The film, or more specifically the film's subject, is nothing if not funny and entertaining. Jason camps and preens before the camera, at one point appearing with a feather boa archly reciting dialogue from the musical *Carmen Jones*; at another he regales us with amusing tales of his hustling: 'I spent a lot of time in parties and gardens', he drawls, 'I became a garden queen. I was hoe-ing … and digging it'.

Indeed it may be the degree to which Clarke's lens renders comic the pathetic, if not tragic, figure of Jason which has led some liberal commentators to be critical of the film's politics. According to Tom Sutpen, the film's initial critics largely wrote it off as 'yet another no-budget Underground freak show, the kind of movie Andy Warhol and Jack Smith and the Kuchar brothers might have conjured if they'd all somehow hooked up at the right time'.[6] This underlines the degree to which one might read Clarke's filmic representation to be of a piece with primitivising perspectives that make a freakish and entertaining spectacle of racial and sexual otherness. But I think it would be a mistake, and too reductive, to completely and summarily dismiss the film on these grounds. This is in part because we need to remember that during the 1960s the criteria of 'otherness' still largely influenced the terms on which the white

American avant-garde came to imbue such marginal identity categories with value and counter-cultural currency, even though alternative modes of self-representation among African Americans were being forged from the mid-1960s onwards within the increasingly separatist tendencies of black nationalism and the developing Black Arts Movement. For the playwright and critic Amiri Baraka (formerly LeRoi Jones), for example, the 'white' perspective on blackness offered by Clarke's film would likely have been seen as part of the problem of racist society rather than any solution to it, providing a stumbling block on the road to self-discovery for peoples of the African diaspora concerned to find their supposedly essential and 'true' blackness that, according to Baraka and others in the Black Arts Movement, was to be found in an idea of pan-African culture and history.[7]

However, in my view, it is precisely the degree to which *Portrait of Jason* fails to offer up acceptable 'positive images' of minoritarian identity that makes Clarke's film intriguing. The film's representation of blackness may skirt uncomfortably close to racist stereotyping at various points, but it offers us neither a liberal, integrationist approach to racial difference (Clarke's camera clearly celebrates Jason's vivid *difference* from a presumed white, 'square' norm), nor an essentialising Black Africanist perspective. This is because Jason's flaming faggotry would not only disqualify him from being regarded as a 'respectable' minority figure (as portrayed by Sidney Poitier in Hollywood cinema, for example), but would also place him beyond the pale of the black nationalist construction of blackness put forward by advocates such as Eldridge Cleaver, who largely

traded on a phobic, and normatively masculine, construction of the black body politic, as scholar E. Patrick Johnson has argued.[8] The 'problem' with Jason is not that he was simply homosexual but that he appeared to be too *queerly theatrical* to make him assimilable to extant models of 'authentic' black subjectivity. My argument in what follows is that it is the ambiguous aspects of Jason's peculiar filmic *performance* which trouble the normativising compulsions to be 'authentic' that were visited upon black male bodies by white bohemians and black activists alike at this time, from primitivist curiosities about the 'negro' to black nationalist celebrations of an authentically 'Africanist' manhood. In this way, the 'scene' that Jason makes in Clarke's film is troublesome not only for the 'headshrinkers' at New York's Bellevue Hospital, but also for the discourses of both white avant-gardism and black pan-Africanism as well.

A Life in Performance

Early on in the film, Jason reveals he has been working on a nightclub act. We learn that he has been counselled by friends about the necessity of having the raw material of life experience in order to undertake a stage act of this kind. 'If you haven't had any experiences', Jason recalls one piano player friend of his saying, 'you have to go out and get some'. On this basis, Jason ventures that he is already more than qualified to take to the stage since, he wryly quips, 'I've been getting experience *coming* and *going*'. He then describes the tripartite structure of his prospective act, telling us, firstly, how he would perform as a 'real swinging hep cat that's been around', letting 'his modesty blaze' through dance and song. Then he outlines how he would segue to what he calls a 'bitchy bag', in which he would recount tales

about his time as a houseboy, before finally moving on to his finale as a clown, which would evoke both the happiness and the sadness in his life. In short, Jason conveys his intention to turn his life story into a stage act that will sell 'sex, comedy, and tragedy', because, as he drawls in conclusion, 'people love to see you suffer'.

Such on-camera testimony is noteworthy in demonstrating Jason's knowledge of nightclub conventions for cabaret and solo stage acts. In particular Jason seems to be self-consciously aware of the ideological assumptions which underpin such popular forms of entertainment: namely, that it is the *remarkable life* which guarantees the expressive power and authenticity of its representation in performance – that it is this lived experience which gives rise to the stage act and which is a prerequisite *for* it. Jason astutely realises that his *own* life is suitably eventful and remarkable to make it ripe for dramatic presentation, making him over into some sort of 'character'. Above all, he understands that there is an audience and a *market* for the representation of his individual life and, given his hustler outlook, he is alert to making an asset of his own image and life story as a marketable commodity.

But what turns out to be even more noteworthy, however, is that, towards the end of his description of his nightclub performance, he moves into an enactment of the kind of bittersweet torch song with which he would like to close the act. As Jason rises to his feet and embarks on an impromptu, but nevertheless bravura, performance of 'The Music that Makes me Dance' from the Broadway musical *Funny Girl* (1964), we soon become aware that we are not only witnessing Jason's narrative testimony of his desire to stage a nightclub act, but that we are also, simultaneously, watching those desires realised *as performance*. Jason's notional nightclub

Shirley Clarke, still from
Portrait of Jason, 1967

act is made flesh before our eyes through the medium of Clarke's lens. The slippage from verbal description to vocal enactment not only introduces popular performance alongside autobiographical narrative into the film's mode of representation of Jason's life, but also brings about a dizzying and ambiguous play between different levels of performance *of* that life. This critical moment in *Portrait of Jason* produces a filmic document about what Jason's nightclub performance might be like, but, *as a performance in its own right* taking place before Clarke's camera, it also raises questions of authorship and spectatorship in relation to the cultural codes of avant-garde cinema.

The filmmaker's authorial intentionality appears to be to allow her subject the freedom to 'speak for himself' with only minimal intervention by the filmic apparatus. This is evident in Clarke's relatively simple framing of her subject. Whether sitting or standing, Jason appears framed for most of the film by lingering talking head shots, with occasional close-ups. Alongside these there are a few views offered of the full length of Jason's body as he reclines on the floor in front of the filmmaker's rather elegant and semi-ornate fireplace and surrounding soft furnishings. The effect of this largely 'face-to-face' encounter with the film's subject – one between Jason and filmmaker and, by extension, between Jason and the spectator – is to grant him a rather large degree of agency in authoring his own representation in *Portrait*, as well as in determining what kind of a spectacle we might behold within avant-garde cinema. Jason's recital of the song from *Funny Girl* takes its place alongside other subsequent performances in the film, including campy enactments of fictional characters such as Scarlett O'Hara and screen goddesses like Mae West, in which theatrical props including an assortment of female dress hats and a feathered boa are employed.

At one level then, Jason's performances – and his reflections upon them – could be read as sophisticated meta-commentaries *on the popular pleasures to be gained from watching avant-garde film*. The slippage from testimony to performance seems to imply that, as viewers of Clarke's film (and perhaps Clarke too as its author), we are expecting to see – or desire to see – the unfolding of a calamitous and dramatic life story that is similar to those made available within mainstream theatre and film. If this is 'what sells', as Jason so sagely informs us, then it may cause us to reflect on the narrowing of the gap between avant-garde and popular representations that was a stark feature of US culture in the 1950s, but which became less so by the mid-1960s. Although relatively un-commercial itself (the film only had a limited theatrical release and distribution), Jason may underline for us how Clarke's film nevertheless acknowledges and embraces popular and mass pleasures – of the nightclub act, of Broadway musical and Hollywood film – as part of its 'pop-ish' mode of appreciation of its subject. As has been remarked upon before, this pop appreciation of the pleasures of mass-market culture can be said to overlap with a queer, camp and subcultural mode of appreciation but does not entail a straightforward *collapse* of the popular into the work of the avant-garde.[9] Rather, what Jason brings to Clarke's film is popular culture as mediated through the lens of camp irony, thereby helping to bring about a significantly closer relationship between popular and avant-garde forms than was hitherto the case in the 1950s.

Furthermore – and in a curious reversal of the idea that one first needs to have experienced an eventful life in order to have 'something to say' in a film or performance – *Portrait of Jason* presents us with the spectacle of a minoritarian life *already mired in the artifice of performance*. Indeed, in contrast to the 'real' life experiences undergone by Norman Mailer's 'negroes' in the late 1940s and early 1950s – whose lives are said to be 'vitalised' by the harsh realities of racist society – Jason's life appears in Clarke's film to be scripted instead, at least in part, by the narratives and fictions of Broadway and Hollywood. Such a comparison might seem to disavow the 'reality' of the difficulties that Jason encountered in his life as a working-class black gay man, but my aim rather is to suggest that Jason is able to *survive* homophobic and racist society precisely through appropriating the fictions of symbolic culture; through his campy appreciation of, and identification with, such forms of mass-produced artifice and song.

To say that Jason's life appears scripted might seem a perverse assertion in relation to such an evidently unscripted film as *Portrait of Jason*, in which the pro-filmic content appears to unfold spontaneously without the contrivances of narrative editing. Reels of film are simply allowed to run through, leaving the passages between reels blank, with only the sound connecting one to the next. These avant-garde devices serve to remind the viewer of the real-time duration of the documenting technologies of moving image and sound recording and, while departing from the codes of narrative realism, they imply that what we see on screen *really* happened in *real* time, such that 'real' and 'reel' have become indistinguishable. However, the irony that *Portrait of Jason* exhibits is that even though

such aesthetic strategies were customarily deployed to evoke an 'authentic' and 'spontaneous' sense of vérité, life and actuality, the life of Jason Holliday appears to be already steeped in artifice in advance, folded as it is into various fictionalised lives derived from popular culture. Again, this irony is one that may not have been fully intentional on the part of the filmmaker and may point to the degree to which Jason's performance to camera is *competing* with Clarke's directorial strategies such that the question of who controls the apparatus of cinematic representation is rendered – interestingly – ambiguous and unclear.

It is almost as if Jason Holliday's life is *based on* another popular American ethnic minority success story, namely that of Fannie Brice in *Funny Girl*. Played by Barbara Streisand in the original Broadway musical, Brice struggles out of the Jewish slums of the Lower East Side to the height of her career with the Ziegfeld Follies, just as *Portrait of Jason* tells the story of Jason's struggle from a poor Alabama upbringing, through his time as a houseboy and hustler in San Francisco and New York, to the imagined moment of his own Ziegfeld Follies, as it were, in Clarke's film. Like Brice, it also appears that Jason is happiest when he is on stage performing. Indeed *all* he wants to do, he repeatedly tells us, is perform. Once Fannie Brice steps off-stage and is no longer the successful comedienne, she cries the tears of a clown: behind the comic performance lies the tragedy of her disastrous love life. But what lies behind Jason performance? What tragedy resides there? Is that what keeps the viewer watching? That we might see something 'real' and that we might see the artifice of his performance crack as we catch a glimpse of the 'authentic' life – the ugly truth of his minoritarian

Bill poster for a stage act,
c.1969

existence – that we secretly believe to be there and which the viewer desires to see?

To pose the problem of 'authenticity' in avant-garde aesthetics in this way is to ask the question: where does Jason Holliday's life stop and his performance begin? In some ways it may be argued that all we see in *Portrait of Jason* are a number of *rehearsals* for Holliday's nightclub act, which he went on to undertake after the release of Clarke's film. Though little is known of what happened to Holliday after *Portrait of Jason*, it seems clear from a late 1960s bill poster that he did indeed appear in a stage act under his own name, at least in small independent and counter-cultural venues in London and New York. However, to understand his depiction in *Portrait of Jason* as nothing more than a rehearsal for these subsequent acts would be to interpret the idea of performance too narrowly and would miss out on a more profound understanding of the *theatricalised* minoritarianism that we might identify as represented within Clarke's film. I suggest that Jason's campy put-ons and evident performances to camera, as well as his theatrically delivered anecdotes and lines, clue us in to a kind of minority life whose 'outsider' value resides precisely *in its very performance.* This is a marginal life that seems predetermined *to be seen* and represented as a visual spectacle precisely because of its exceptional difference from normative, humdrum lives. Jason's life is celebrated as the very subject of Clarke's film by virtue of taking place outside of the structures of normative family and professional life ('I don't wanna punch the clock', Holliday says), and outside of the formal genres of 'high' art and culture (Jason is informally speaking to camera in the drawing-room of a New York apartment, even as he is simply 'being' himself).

So *Portrait of Jason* provides a case study in which the celebrated folksy authenticity of the minority subject had, by 1967, become so steeped in artifice, mediated through the forms of a burgeoning culture industry, as to make of him a ready object for the culture of spectacle. Undoubtedly Jason was no pin-up boy for mainstream Hollywood film at this time, but what his appearance in Clarke's film suggests is that the hep-cat queen was a troublesome presence when rendered as a representation in avant-garde culture, troublesome precisely because his performances undermined the very 'authenticity' that avant-gardists, paradoxically, sought to find in him.

Crocodile Tears?

But what keeps me further intrigued by Jason's performance before Clarke's camera, despite its evident artifice, is that the promise and possibility of seeing something 'real' take place does not diminish as the film rolls on. Does *Portrait of Jason* deliver in the same way as other near-contemporary durational avant-garde films such as Warhol's *Empire* (1964), which captures the 'event' of the Empire State Building's lights going on, or his *Chelsea Girls* (1966) which documents 'Pope' Ondine's speed-fuelled, and all too real, violent outburst at a female sidekick? At first glance, the answer appears to be 'yes'. Towards the end of the film, Jason bursts into tears. Coming after nearly one and a half hours of on-screen testimony about his life, it's almost as if this is what the viewer has been waiting for. At this point, Jason's entertaining performance finally appears to *crack* before our eyes. It is as if his life finally catches up with him, overwhelms him and registers itself through this involuntary irruption of emotion. As a cinéma vérité study,

this is the film's 'money shot'. The 'truth' of Jason's testimony, it seems to suggest, lies in these tears. In coming at the end of the film – if you'll forgive the pun – Jason's tears provide us with a narrative closure of sorts: one which purports to offer up the substance of the film's realist conceit of an unmediated representation of its subject's psychically, socially and emotionally troubled condition.

What brings about this tearful episode is Carl Lee's aggressive and sadistic off-screen taunting of Jason, who stares flirtatiously in Carl's direction and coos as he looks into Carl's eyes. This brings about the following exchange:

Carl: Oh come on don't get cute with me ... got a long memory man.
Shirley [to Jason]: Did you ever do something real bad?
Carl [viciously]: Remember those dirty rotten letters [muffled by Jason's cries of disapproval] you wrote about me to [muffled again] laying in the Bowery as a bum? What did you tell those lies for? Why'd you do that to me? Rotten Queen!
Jason: Oh, I couldn't have been that low. Oh I didn't Ca ... Ooooh no [clutches his forehead and slips down in his seat].
Carl: Just 'cos I wouldn't lend you a few lousy dollars ...
Jason: Oh that's where it's at ...
Carl [accusingly]: You had to pull your usual evil shit.
Jason [breaks down]: Oh Carl, Carl without you ... I wouldn't know anything about anything. And if you don't know ... that I love you ... then, man, you don't know anything ... about anything.

Watching this scene has the effect of making Jason a more empathetic character than hitherto in the film, principally because of the viciousness with which Carl (and to a lesser degree the filmmaker herself) suddenly turns on the star and reduces him to tears. But what is more remarkable is how Jason's apparently sincere expression of genuine pain and upset is then taken by Carl as simply co-extensive with his campy put-ons. Carl violently dismisses the outburst of tears as yet another part of Jason's performance, as 'manufactured' emotion, as equally artificial as his campy enactment of Scarlett O'Hara. As Jason looks into Carl's eyes, he goes on to say that all he wants to do is to tell the truth. Apparently infatuated with Carl at the time, Jason tells him – amidst the rest of the film's campery – to *believe* him in his declaration of his feelings for him, about his love for him, and that what he speaks is love's truth.

In my view, these declarations appear to have a heartfelt and *sincere* affect. Carl, on the other hand, is having none of it and his reaction takes us by surprise by dint of the viciousness of his tone. 'Bullshit', he shoots back, 'Be honest, mother fucker. Stop that acting'. What makes *Portrait of Jason* especially interesting in this scene is how the idea of 'seriousness' in art and performance is challenged or even subverted as Carl refuses to take the outward signs of Jason's emotional state *seriously*. Carl dismisses Jason's sincerity as yet another campy pose, all surface and no depth. Since this whole exchange is set off by Jason staring into Carl's eyes, one might suggest that Carl's cruel dismissal may be inflected by a homophobic appraisal of Jason's seemingly earnest proclamations as the essentially phoney performances of an 'inauthentic' masculinity.

Shirley Clarke, still from
Portrait of Jason, 1967

What comes to light in this revealing exchange is how the film comprises a representation of the whole scene of utterance in which speech acts – including outward bodily signs of emotional states – are commonly assessed and judged according to overlapping binaries of sincere/insincere; authentic/fake; honest/dishonest; real/theatrical; serious/ trivial. Although *Portrait of Jason* is ostensibly a depiction of a singular individual, towards the end of its duration the film delivers a representation of the social theatre in which the values of the sincere and the authentic are reproduced and contested. Generally speaking we identify 'sincerity' when there is congruence between outward expression and inner feeling or intent. Such congruence – or lack thereof – is what determines whether or not sincerity is present in any act of face-to-face communication. When someone deliberately, or mischievously, says or does something at odds with what they 'really' feel inside, this is when we say that they are being dishonest or insincere.

However, this individualistic 'depth' model of sincerity – where sincerity is dependent upon the matching up or otherwise of an individual's exteriority with his/her interiority – is displaced somewhat by a more social and historical model suggested by the work of literary historian Lionel Trilling. In his 1972 study, *Sincerity and Authenticity*, Trilling writes,

[s]ociety requires of us that we present ourselves as being sincere, and the most efficacious way of satisfying this demand is to see to it that we really are sincere, that we actually are what we want our community to know we are. In short, we play the role of being ourselves, we

sincerely act the part of the sincere person, with the result that a judgement may be passed upon our sincerity that it is not authentic.[10]

Evoking Judith Butler *avant la lettre*, Trilling argues that sincerity is a moral cultural ideal – and a relatively recent one at that – which society invariably compels us to inhabit. It is a 'demand' (his word) that has us striving to comply, as we reiterate ourselves as ourselves through what we might call, in more Foucauldian mode, a technology of sincere behaviour. Interestingly, of course, in playing 'the role of being ourselves', in acting 'the part of the sincere person', any absolute binary opposition between sincerity and acting is undone because sincerity becomes a kind of acting of sorts. But this 'acting' is one that is judged, according to Trilling, less in terms of any intra-subjective ontological dynamic but rather in terms of social perceptions, in terms of whether others perceive and believe the subject to be acting sincerely or not, and therefore whether to take him/her seriously or not. Hence any purported performance of sincerity calls for an act of judgement through which it comes to be completed, and through which it comes to be recognised – or not – *as* sincere. In the making of such a judgement, we distinguish between an acting that might be deemed to be a 'happy' sincere performativity, and one that is 'unhappy' and insincere by dint of being deemed to be too theatrical or too over-the-top to be taken seriously.[11]

This is how we may read Carl's reprimands to Jason: that Carl brings to bear a normative technology of discrimination – common to a culture of compulsory earnestness and sincerity – in admonishing Jason for his unhappy

performance of sincere affect. But Jason appears as a wildly unruly subject for whom such distinctions between sincere/insincere, authentic/fake and so forth, have little or no bearing. Jason himself testifies to this, and indeed appears to bemoan his condition of being so remote from the morality of sincere culture by imploring Carl to teach him how to go straight, so that he can cease damaging his friendships: 'Teach meeee!' he implores, '*Tell me where to stop Carl!*'. The reason why Jason is in such desperate need of pedagogic attention is that, as he freely admits, he 'would always forget where to draw the line'. This utterance goes right to the heart of what I am trying to get at here: for despite Jason's performance of self-hatred in the final reel of the film, despite his own admission that he's a lying, duplicitous 'vicious cunt' who needs to be told where to stop, the affect of his tears and his apparently heartfelt pleas will not go away or be diminished by Carl's admonishments, and this is simply because the labels of inauthenticity do not appear to apply in Jason's case.

Although Jason appears to be always 'on' – to be always performing – this should not blind us to the ways in which his speech-acts and other actions before the camera slide almost imperceptibly between the heartfelt and the playful, sincerity and theatricality, so as to make such distinctions blur and the affects of one bleed into those of the other. This is what I want to suggest comprises the film's *queering* of affective viewing, one which, like Jason, seems unable to draw conventional lines between social categories – in this case between supposedly discrete and distinct affectual states. In the film's closing reels there are a number of points where Jason's testimony and behaviour flips abruptly

between the reality affects of serious discourse and sincere expression on the one hand, and comedic narrative and admissions of playing up on the other. For instance, no sooner does Jason tells us that he's suffered ('oh your mother's suffered'), than he's then recounting how this suffering is all a con devised in order to get welfare ('I told them I was sick queen'). Similarly, Jason moves alarming quickly from a wracked, pathetic, abject figure imploring Carl to teach him right from wrong, to matter-of-factly resigning himself to agreeing with Carl's accusations that his desperation to go straight is all a sham ('haa you're right again'). This unpredictable sliding from pathos to bathos means that the viewer is never allowed to dwell in one frame of reference or the other for very long. Rather than pathos *or* bathos, then, perhaps we might say it is something like 'quathos' that we experience in watching Clarke's film: a queer emotion resulting from some ambiguous and ambivalent mixture of the two.[12] This mixed feeling is summed up in Jason's last line at the film's close which, after everything that Jason has undergone, and after all the harrowing tales he has recounted about his life in the eight hours or so of filming, simply announces, 'That was beautiful, I'm happy about the whole thing' – a happiness, an uplifting lightness of affect, which is ambivalently shot through with the pain and suffering of his entire life story.

Conclusion: The Trouble with Folk

We can see, therefore, that any idea of a straightforward 'celebration' of folk traditions is rendered problematic by the date of Clarke's film. Jason's expressly performed life, and in particular its trickster-ish playfulness with conventional modes of sincere presentation, would have

proved troublesome for anybody concerned to celebrate the moral probity and authenticity of folk and minority cultures. Indeed, Jason's unruly, *queer* brand of authenticity hardly counts as authenticity *at all* to some. On a number of levels Jason seems far too wise to commodity culture, too caught up in it and 'on the make' to embody any idealised image of a would-be 'noble savage'. He represents instead how minority cultures had developed during the 1960s *in relation to* the mass cultural mainstream, rather than comprising a-historical, or traditional, ethnic cultures separated off and distinct from it. This is what makes of Jason's performance in Clarke's film a peculiarly 'pop', even post-modern, form of minoritarianism.

By the last reels of the film, it is not only Jason's would-be 'folksy' authenticity that is in doubt, however, but also Banes' idea of the avant-garde itself as comprising some kind of 'folk'. What *Portrait of Jason* makes palpable are some of the social tensions underlying the apparent cohesiveness of the non-conformist art scene *as* a folk, particularly as these are brought out by the spectacle of blackness and homosexuality in avant-garde cinema. Indeed, it could be said that such tensions become the very *subject* of the film, as Jason is latterly usurped as sole focus of the viewer's attention by the uneasy off-screen exchanges between him and the filmmaker's boyfriend. In this way, the film telegraphs how a heavily masculinised heterosexual blackness came to disassociate itself from the products of white avant-garde culture from the mid-1960s onwards, when separatist and nationalist politics deemed that male homosexuality was more often than not seen as a white thing.[13] Larry Rivers, for example, recalls how Amiri Baraka (then LeRoi Jones)

changed his outlook after 1964: 'suddenly he decided to come out of some closet with the most intense hatred of every white person he knew ... I was shocked and upset, and that began the deterioration in our friendship. Finally, he told me I was just painting for a bunch of uptown fags'.[14] Similarly, it seems that, whilst not being dismissed outright, Jason's penchant for being a drama queen was too much for Carl Lee to take seriously and was just too wide of the macho ideal that became the prevailing representation of black masculinity in the late 1960s and beyond.[15] In the 1970s, Carl Lee himself went on to star in the film *Superfly* (1972) which, along with other blaxploitation films, have been as celebrated for their depictions of an empowered black machismo as they have been criticised as sexist and homophobic.[16]

Portrait of Jason also stands as testament to what the representation of a black gay man might have meant for a white *female* filmmaker in the 1960s. As I have indicated, Clarke's output throughout the 1960s was characterised by its attention to the minority cultures of drug-taking and blackness and – in *Portrait of Jason* – male homosexuality. During the 1970s, Clarke became active in the women's movement, but *Portrait of Jason* can also be read as an example of how a feminist film was made *before* the second wave of the women's movement got underway. Moreover, Clarke's was a feminism that was made principally out of an identification with the lives and political urgencies of minorities. The filmmaker herself has been quoted as saying:

> For years I'd felt like an outsider, so I identified with the problem of minority groups ... I thought it was more important to be some kind of goddamned junkie

who felt alienated rather than to say I am an alienated woman who doesn't feel part of the world and who wants in.[17]

Elsewhere, in a similar vein, Clarke has stated:

I identified with black people because I couldn't deal with the woman question and I transposed it. I could understand very easily the black problems, and I somehow equated them to how I felt. When I did *The Connection*, which was about junkies, I knew nothing about junk and cared less. It was a symbol – people who are on the outside. I always felt alone, on the outside of the culture I was in. I grew up in a time when women weren't running things.[18]

Clarke became a high profile filmmaker at a time when women faced difficulties in gaining access to most spheres of creative endeavour, particularly cinema. This was because the film industry was dominated by male producers and, given that there was a culture of institutional sexism, it was difficult for women to raise money for production costs. The general culture *was* beginning to change somewhat by the mid-1960s with the publication of Betty Friedan's *The Feminine Mystique* in 1963, and the establishment of the National Organisation of Women in 1966. But it wasn't until the later 1960s, and on into the 1970s, that second wave feminism really began to take hold. Clarke was thus part of a generation of women who began to challenge gender orthodoxies for themselves in advance of the more established movement. Clarke had been active in the art world context as one of the only women involved in the setting up of the filmmaker's co-op in New York in 1962, which was devised to break the stranglehold of corporations on experimental film distribution and promotion. However, as we can glean from her statements above, the feminism of Clarke's films resided in a female identification with minorities rather than with any depiction of women's lives and bodies or other recognisably 'feminist' subject matter.[19] For whatever reason, Clarke felt unable to 'deal with the woman question' directly and instead 'transposed' her feelings about female political marginalisation onto the bodies of others. Some may baulk at Clarke's forthright admission that she 'knew nothing about junk and cared less' when making *The Connection*, suggesting that her subjects interested her as allegory of her own position as a woman in patriarchal society rather than as people in their own right. Junkies were representative of a more generalisable experience of marginalisation, a 'symbol [of] people who are on the outside'. On the one hand, this might be seen as a continuation of a standard primitivising manoeuvre in which the body of the peripheral non-white (and, in Jason's case, non-straight) other is identified with, and incorporated, as a useful fiction that signifies the straight white subject's own alienation.

On the other hand, however, Clarke's psychic and social cross-identifications with others can be seen as part of an historically specific political affiliation that eschewed 'positive images' – so typical of identity politics in the 1970s and 1980s – in favour of the fraught negotiations of difference that we see played out between *Portrait of Jason*'s on- and off-screen protagonists. As Jennifer Doyle has persuasively argued in her book, *Sex Objects*, there is a whole – and, until recently, rather unacknowledged – feminist

history to be written concerning the role women have played, both straight and lesbian, in gay male culture. As far as Doyle is concerned, this is a history from which women emerge not just as desexualised fag hags or maquettes for gay male effeminacy, but one in which women are able to refashion themselves anew outside of heterosexist and patriarchal compulsions to be the object of desire. She writes, for instance, of how women such as Viva and Valerie Solanas are as much the *subject* of Warhol's films as their gay male counterparts.[20] This, she argues, constitutes the history of a *queer* feminism – queer not only because it tells the story of female detachment from heterosexual contexts, but also because it frames a feminism that foregoes the identitarian forms of woman-centred action and affiliation.

We might therefore add Shirley Clarke to Doyle's canon of queer feminism, for *Portrait of Jason* might equally be thought of *as a portrait of its maker*. This approach resonates in the light of Clarke's self-description, and also if we think of Jason as iconic of effeminate survival in a macho world. That Holliday was able to playfully negotiate the violent and dismissive attitudes of others, as well as make his distinctly non-serious and over-the-top persona into a spectacular asset, may have appealed to a woman contending with patronising and dismissive male attitudes in the 1960s art and film worlds. Of course, this would not have been an egalitarian liaison: Clarke's investment in the image of Jason is fraught with the politically dubious investments that might be associated with the daughter of a wealthy New York family making a filmic spectacle of a poor black gay man forced to live a hand-to-mouth existence. The problems of social class are, as much as anything else, played out in the film's inter-

subjective *mise-en-scène*. Such 'imperfect' and troublesome relationships are the very stuff that makes *Portrait of Jason* a compelling and important work of avant-garde film. Such fraught relationships were the glue that heldthe divergent members of a burgeoning counter-culture together at this time – a togetherness perhaps best described as an *apart*-togetherness: a queer folk indeed.

NOTES

1. Sally Banes, *Greenwich Village 1963: Avant-Garde Performance and the Effervescent Body*, Durham and London: Duke University Press, 1993, 83.
2. Ibid., 82.
3. Kobena Mercer, 'Racial Difference and the Homoerotic Imaginary', in Bad Object-Choices ed., *How Do I Look?: Queer Film and Video*, Seattle: Bay Press, 1991, 207–8. Norman Mailer, 'The White Negro: Superficial Reflections on the Hipster', in Norman Mailer, *Advertisements for Myself*, London: Panther, 1961, 269–89 (orig. *Dissent*, 4, Summer 1957, 276–93).
4. Gavin Butt, *Between You and Me: Queer Disclosures in the New York Art World 1948–1963*, Durham and London: Duke University Press, 2005, 74–105.
5. Catharine R. Stimpson, 'The Beat Generation and the Trials of Homosexual Liberation', *Salmagundi*, 58–59, Fall 1982–Winter 1983, 373–92.
6. Tom Sutpen, essay in booklet accompanying Second Run DVD reissue of *Portrait of Jason*, 2005, 6. Originally published on www.brightlightsfilm.com.
7. For more on the Black Arts Movement see James Edward Smethurst, *The Black Arts Movement: Literary Nationalism in the 1960s and 1970s*, Chapel Hill: University of North Carolina Press, 2005; and Kalamu ya Salaam, 'Black Arts Movement', on the African American Literature Book Club website, http://aalbc.com/authors/blackartsmovement.htm.
8. E. Patrick Johnson, *Appropriating Blackness: Performance and the Politics of Authenticity*, Durham and London: Duke University Press, 2003, 52–57.
9. See Susan Sontag, 'Notes on Camp', in *A Susan Sontag Reader*, introduction by Elizabeth Hardwick, London: Penguin, 1983, 105–19 (orig. *Partisan Review*, 31, 1964, 515–30; John Adkins Richardson, 'Dada, Camp, and the Mode Called Pop', *Journal of Aesthetics and Art Criticism*, 24, 4, Summer 1966, 549–58; Moe Meyer, *The Politics and Poetics of Camp*, London: Routledge, 1994; and Matthew Tinckcom, *Working Like a Homosexual*, Durham and London: Duke University Press, 2002.
10. Lionel Trilling, *Sincerity and Authenticity*, Oxford: Oxford University Press, 1972, 10–11.
11. For a discussion of 'happy' and 'unhappy' performatives, see John Langshaw Austin, *How to Do Things with Words*, Oxford and New York: Oxford University Press, 1976, 12–52.
12. I derive this wonderful neologism from my friend, the writer and teacher Jon Cairns.
13. See Johnson, op. cit., 52–57.
14. Larry Rivers with Carol Brightman, *Drawing and Digressions*, New York: Clarkson N. Potter, Inc., 1979, 94–95.

15. However this does not imply that the developing discourses of identity within the Black Power Movement in the late 1960s were *uniformly* homophobic. Edmund White relates an interesting account of the Black Panther's relationship to the issue of homosexuality, and particularly to the notorious homosexual and writer Jean Genet, in *Genet*, London: Chatto & Windus, 1993, 600–28.
16. For a recent reappraisal of blaxploitation from a queer perspective, see Joe Wlodarz, 'Beyond the Black Macho: Queer Blaxploitation', *The Velvet Light Trap*, 53, Spring 2004, 10–25, and the film installation *Baltimore* (2003) by British artist and filmmaker Isaac Julien.
17. Obituary by Myrna Oliver, 'Shirley Clarke; Oscar-Winning Filmmaker', *Los Angeles Times*, 24 September 1997, Metro section, 8.
18. Cited in DeeDee Halleck, 'Interview with Shirley Clarke', 1985, *The Early Video Project* website, http://207.56.97.90/shirleyclarkeinterview.html.
19. 'I like to see feminist films, but I've never been able to make one', Clarke told DeeDee Halleck in 1985, ibid.
20. Jennifer Doyle, *Sex Objects: Art and the Dialectics of Desire*, Minneapolis and London: University of Minnesota Press, 2006, 71–96.

CHICANO/A CRITICAL PRACTICES: REFLECTIONS ON TOMÁS YBARRA-FRAUSTO'S CONCEPT OF *RASQUACHISMO*

HOLLY BARNET-SANCHEZ

This chapter reprints the essay 'Rasquachismo: A Chicano Sensibility' by Tomás Ybarra-Frausto with a newly-commissioned interpretative commentary by Holly Barnet-Sanchez. First published to accompany the 1988 exhibition, Chicano Aesthetics: Rasquachismo, held at MARS ArtSpace in Arizona and subsequently expanded for the 1991 exhibition, Chicano Art: Resistance and Affirmation, 1965–1985, held at the Wight Art Gallery, UCLA, the historical importance of this unique text lies in its eloquent crystallisation of an entire world-view that has informed aesthetic strategies among Mexican American artists over the past three decades. The inter-disciplinary scope of Ybarra-Frausto's wide-ranging insights across art, film, literature and theatre not only reflects his pioneering role as a humanities scholar in the field of Chicano studies but also underlines his distinctive profile as a public intellectual with a life-long commitment to policy innovation among arts institutions such as the Rockefeller Foundation and the Smithsonian Institution.

Illuminating the impact of Ybarra-Frausto's contribution to the study of Chicano art history, Holly Barnet-Sanchez reveals the dynamic agency exerted by vernacular materials in diverse practices that critically engage with the cross-cultural dimensions of Mexican American experiences in the United States. Showing how 'found' objects are re-articulated in assemblage, performance and installation works that renew the legacy of pop art in unexpected ways, her exposition of the concept of rasquachismo highlights major blind spots in prevailing accounts of modernism and post-modernism, while adding fresh layers of analysis to debates on syncretism and hybridity in post-colonial criticism.

Tomás Ybarra-Frausto was, until retirement in 2005, Associate Director for Creativity and Culture at the Rockefeller Foundation, New York. A former professor of literature at Stanford University, he edited Modern Chicano Writers: A Collection of Critical Essays (1979) with Joseph Sommers and has contributed numerous essays on the subject of Chicano art and culture. He compiled and introduced Arte Chicano: A Comprehensive Annotated Bibliography of Chicano Art, 1965–1985 with Shifra Goldman and contributed 'The Chicano Movement/ The Movement of Chicano Art' to Exhibiting Cultures: The Poetics and Politics of Museum Display, edited by Ivan Karp and Steven Lavine. Most recently, he co-edited Museum Frictions: Public Cultures/Global Transformations for Duke University Press. In 1998, he was awarded the Joseph Henry Medal for 'exemplary contributions to the Smithsonian Institution'.

RASQUACHISMO: A CHICANO SENSIBILITY[1]
TOMÁS YBARRA-FRAUSTO[2]

One is never *rasquache*, it is always someone else, someone of a lower status, who is judged to be outside the demarcators of approved taste and decorum. Propriety and keeping up appearances – *el qué dirán* – are the codes shattered by the attitude of *rasquachismo*. This outsider viewpoint stems from a funky, irreverent stance that debunks convention and spoofs protocol. To be *rasquache* is to posit a bawdy, spunky consciousness, to seek to subvert and turn ruling paradigms upside down. It is a witty, irreverent, and impertinent posture that recodes and moves outside established boundaries.

 Rasquachismo is rooted in Chicano structures of thinking, feeling, and aesthetic choice. It is one form of a Chicano vernacular, the verbal-visual codes we use to speak to each other among ourselves. Chicanos theorize about their creations and their lives through vernacular idioms like *rasquachismo* that encode a comprehensive worldview.

 Rasquachismo is a sensibility that is not elevated and serious, but playful and elemental. It finds delight and refinement in what many consider banal and projects an alternative aesthetic – a sort of good taste of bad taste. It is witty and ironic, but not mean-spirited (there is sincerity in its artifice). A random list of *rasquachismo* might include the following: Mario Moreno Cantinflas, The Royal Chicano Air Force, the early actors of El Teatro Campesino, the *No Movies* of Asco, paintings on velvet, the *calaveras* of José Guadalupe Posada, and the movie *Born in East L.A.*[3]

Medio *rasquache* (low)	Muy *rasquache* (high)
Microwave *tamales*	Frozen *capirotada*
Tin-Tan	Cantinflas
Shopping at K-mart	Shopping at J.C. Penney's
The Menudo Bowl	The National Chicharones Council
Pretending you are Spanish	Being bilingual and speaking with an accent in both languages
Tortillas de harina made with vegetable oil	*Tortillas de harina* made with lard
Portraits of Emiliano Zapata on velvet	Portraits of Francisco Villa on velvet
Chanclas	*Chanclas*

Amalia Mesa Bains,
Altar for Dolores del Rio, 1988

Rasquachismo is neither an idea nor a style, but more of an attitude or a taste. Taste cannot be codified as a system with comparative proof. As Susan Sontag affirms,

> There is something like a logic of taste. The consistent sensibility which underlines and gives rise to a certain taste. A sensibility which can be crammed into the mold of a system or handled with the rough tools of proof is no longer a sensibility at all. It has hardened into an idea.[4]

The stance of *rasquachismo* is alive within Chicano communities, but it is something of an insider private code. To name this sensibility, to draw its contours and suggest its historical continuity, is to risk its betrayal. Yet, as the dimensions of *rasquachismo* expand to include public art, the private aspect of the sensibility alters, while remaining essentially the same. The tension between public and private is central to *rasquachismo*, and the critical codifying of this phenomenon is but an extension of the paradox. This essay, by seeking to define the sensibility publicly, operates on the borders of the public and the private. The critical need for public definition prevails.

Rasquachismo is a visceral response to lived reality, not an intellectual cognition. To encapsulate a sensibility into words is to short-circuit its dynamism. What follows, then, is a nonlinear, exploratory, and unsolemn attempt to track this irrepressible spirit manifested in the art and life of the Chicano community:

> Very generally, *rasquachismo* is an underdog perspective – a view from *los de abajo*, an attitude rooted in resourcefulness and adaptability, yet mindful of stance and style.
>
> *Rasquachismo* presupposes the worldview of the have-not, but is also a quality exemplified in objects and places (a *rasquache* car or restaurant) and in social comportment (a person who is or acts *rasquache*).
>
> Although Mexican vernacular traditions form its base, *rasquachismo* has evolved as a bicultural sensibility among Mexican Americans. On both sides of the border, it retains its underclass perspective.

Both in Mexico and the United States, *rasquachismo* suggests vulgarity and bad taste, a sense of being cursi (tacky). This connotation emanates from those in control, who proclaim and enforce their own aesthetic norms as standard and universal. Social class demarcates *rasquache*, which is a working-class sensibility (a lived reality) only recently appropriated as an aesthetic program of the professional class (for example, the film *Born in East L.A.*). *Rasquachismo* is brash and hybrid, sending shudders through the ranks of the elite who seek solace in less exuberant, more muted, and purer traditions.

Those newly anointed members of the emerging Chicano middle class are the first to deny a connection with anything remotely *rasquache*. Hints of such an association too readily evoke the rough-and-tumble slapdash vitality of *barrio* life-styles recently abandoned in the quest for social mobility.

To be *rasquache* is to be down, but not out (*fregado pero no jodido*). Responding to a direct relationship with the material level of existence or subsistence is what engenders a *rasquache* attitude of survival and inventiveness.

In an environment always on the edge of coming apart (the car, the job, the toilet), things are held together with spit, grit, and *movidas*. *Movidas* are the coping strategies you can use to gain time, to make options, to retain hope. *Rasquachismo* is a compendium of all the *movidas* deployed in immediate, day-to-day living. Resilience and resourcefulness spring from making do with what is at hand (*hacer rendir las cosas*). This use of available resources engenders hybridization, juxtaposition, and integration. *Rasquachismo* is a sensibility attuned to mixtures and confluence, preferring communion over purity.

Pulling through and making do are no guarantee of security, so things that are *rasquache* possess an ephemeral quality, a sense of temporality and impermanence – here today and gone tomorrow. While things might be created *al troche y moche* (slapdash), using whatever is at hand, attention is always given to nuances and details. Appearance and form take precedence over function.

Rasquachismo is a vernacular system of taste that is intuitive and sincere, not thought out and self-conscious. It is a way of putting yourself together or creating an environment replete with color, texture, and pattern: a rampant decorative sense whose basic axiom might be 'too much is not enough.' *Rasquachismo* draws its essence within the world of the tattered, shattered, and broken: *lo remendado* (stitched together). The visual artist Ramses Noriega recalls a *barrio* character from the border who exemplifies this attitude:

> Around the years of 1949–54 in Mexicali, a small border town at that time, there lived a man who would walk through the impoverished neighborhood of 'Barrio Loma Linda.' He dressed in a tuxedo, used a cane, and wore a hat of the type that Charlie Chaplin used in his films. He was a sight to see, not so much for the tuxedo he wore but for the material he used to sew it together. This man collected small pieces of colorful cloth he found at the local dump, he sewed them together with thread and needle and created a unique patch quilt effect over an old coat and pants someone had thrown away.
>
> Don Rascuachi, as we called this man in the *barrio*, walked like a true gentleman of wealthy nobility you might say. He never talked and there was no need to either. He lived, people said, in one of the caves in the wall of a twenty foot precipice of the canyon that intersects Mexicali.[5]

Dressing (putting yourself together) with whatever is at hand does not make you *rasquache*, but it is a gesture in the right direction. In the realm of taste, to be *rasquache* is to be unfettered and unrestrained, to favor the elaborate over the simple, the flamboyant over the severe. Bright colors (*chiliantes*) are preferred to sombre, high intensity to low, the shimmering and sparkling to the muted and subdued. The *rasquache* inclination piles pattern on pattern, filling all available space with bold display. Ornamentation and elaboration prevail, joined to a delight for texture and sensuous surface. Witness the cumulative, organic ensemble of home altares (which juxtapose plaster saints, plastic flowers, bric-a-brac, family photographs, and treasured talismans). The composite organization has a sort of wild abandon yet is subtly controlled with precise repetitions, replications, and oppositional orders of colors, patterns, and designs.

Paradoxically, although elaboration is preferred to understatement, high value is placed on making do, *hacer rendir las cosas*. Limited resources mean mending, refixing, and reusing everything. Things are not thrown away, they are saved and recycled, often in different contexts (automobile tires are used as plant containers, plastic bleach bottles become garden ornaments, discarded coffee cans are reelaborated as flower pots). This constant making do, the grit and obstinacy of survival played out against a relish for surface display and flash, creates a florid milieu of admixtures and recombinations.

The visual distinctiveness of the *barrio* unites the improvisational attitude of making do with what's at hand to a traditional and highly evolved decorative sense. In the *barrio*, the environment is shaped and articulated in ways that express the community's sense of itself, the aesthetic display projecting a sort of visual biculturalism.

In yards and porches, for example, traditional items like religious shrines (*capillas*) and pottery mingle with objects from mass culture, such as pink plastic flamingos or plaster animal statuary. Throughout, there is a profusion of textures and colors and a jumble of things weathering and discolouring. The visual interplay of these accumulations evokes a funky, *rasquache* milieu.

Historical Continuity

Although the attitude of *rasquachismo* is best exemplified in the everyday practices and forms of popular culture, the sensibility was codified in the novel by Daniel Venegas, *Las aventuras de Don Chipote, o, cuando los pericos mamen: Novela*, published in Los Angeles in 1928.[6] This early Chicano novel chronicles the trials and tribulations of a Mexican laborer as he maladapts to life in the United States. Entangled in economic and social predicaments of basic survival, Don Chipote fends for himself using his wits and a robust stoical humor as aids for learning and living.

As an errant rogue (*picaro*), Don Chipote meets life head on, slipping and sliding in and out of travels and adventures. The loosely episodic narration of *Las aventuras de Don Chipote* is a rich compendium of the dialect, customs, and worldview of the Chicano urban working class of the period. In his attitudes, Don Chipote epitomizes a *rasquache* stance. His tenacity and adaptability are laced with a certain *locura*, a devil-may-care sense that is serious enough about life to delight in it and frivolous enough to scoff at it.

During the 1930s and 1940s, popular forms of theater like the *carpa* (tent shows) and the *tandas de variedad* (vaudeville shows) became the standard-bearers of the *rasquache* aesthetic. The raggle-taggle bands of itinerant actors traversing the Southwest presented bawdy sketches acted in a broad, comedic style. Action was underscored by pratfalls, and the robust dialogues were laced with sexual innuendo.

In ensemble, the *carpa* sketches are some of the earliest artistic projections of the *rasquache* sensibility. Through the characters of the *peladito* and the *peladita* (penniless urban roustabouts), one enters a lively picaresque world of ruffians who scamper through life by the seat of their pants. Always scheming and carousing, the *pelados* personify the archetypal Chicano everyman and everywoman who live out a life-one-the-margin sustained by laughter and a cosmic will-to-be.

A typical *carpa* skit recalled from memory circa the 1930s deploys a *rasquache* spirit in its deft encapsulation of immigrant life in the metropolis:

A Cup of Coffee and Cake

1: ¡Ay compadre! Que gusto encontrarlo. A ver, quiero aprender inglés … Quiero comer bién en este país.
2: ¡No se preocupe, compadre, nomás pida cup of coffee and cake!
1: Gracias compadre. (a sí mismo: ¡cup of coffee and cake, cup of coffee and cake!)

1: Hello, compadre. Am I glad to see you. Listen, I want to learn English. I want to eat well in this country.
2: Don't worry, compadre, just ask for a cup of coffee and cake!
1: Thanks, compadre. (mutters to himself: cup of coffee and cake, cup of coffee and cake!)

Una semana después …

1: ¡Ay compadre! Que gusto encontrarlo. ¡Quiero comer bien en este país, pero estoy cansado de cup of coffee and cake!
2: ¡No se preocupe, compadre, nomás pida ham sandwich!
1: Gracias compadre. (a sí mismo: ¡ham sandwich, ham sandwich!)

One week later …

1: Hello, compadre. Am I glad to see you. I want to eat well in this country, but I'm tired of cup of coffee and cake!
2: Don't worry, compadre. Just ask for ham sandwich!
1: Thanks, compadre. (mutters to himself: ham sandwich, ham sandwich!)

En el restaurant

Mesera: Good morning. May I help you?
1: Ham sandwich.
Mesera: Wheat or rye?
1: Ay caramba! … Cup of coffee and cake.

In the restaurant

Waitress: Good morning. May I help you?
1: Ham sandwich.
Waitress: Wheat or rye?
1: Oh, Gosh! … Cup of coffee and cake.

In their grossness, the *peladitos* underscore the elemental impulses such as eating, laughing, and fornicating as primordial sources of vitality and power. As purveyors of a *rasquache* sensibility, *peladitos* remind us to draw sustenance from fundamental life processes and to use them for surmounting adversity.

The Chicano Movement of the 1960s reinvigorated the stance and style of *rasquachismo*. The very word Chicano, with its undertow of rough vitality, became a cipher repudiating the whiteness of experience. If some deemed it a term of denigration and coarseness, many others gave it the authority of authenticity and self-referentiality. From the vantage of the stable and conservative Mexican American citizenry, the Chicano Movement itself trespassed the acceptable lines of demarcation and codes of decorum and politesse. Those who labeled themselves Chicanos were regarded as *malcriados* (ill bred), as malcontents who spoke too brashly, carried on too passionately, and persistently shattered the norms of acceptable behavior, especially in relations with dominant groups and institutions.

Turning inward to explore, decipher, and interpret elements from the Chicano cultural matrix, artists and intellectuals found strength and recovered meaning in the layers of everyday life practices. The very essence of a bicultural, lived reality was scorned as un-American by the dominant culture.

A necessary response was to disown imposed categories of culture and identity and to create a Chicano self-vision of wholeness and completion. Signs and symbols that those in power manipulated to signal unworthiness and deficiencies were mobilized and turned into markers of pride and affirmation. Cucaracha Press, El Teatro del Piojo, El Malcriado, and many other titles and names of groups and organizations reflect this process of molding worthiness out of perceived deficiencies. *Rasquachismo* as a sensibility of the downtrodden mirrored the social reality of the majority of Chicanos who were poor, disenfranchised, and mired in elemental daily struggles for survival.

Luis Valdez and El Teatro Campesino were among the first to recognize and give universal significance to the multifaceted, bittersweet experiences of *la plebe* (the working class). A *rasquache* sensibility both deliberate and unconscious marked the presentational style, tone, and worldview of El Teatro Campesino. Achingly beautiful theatrical *actos* (skits) captured the tragicomic spirit of *barrio* life. In a dialectical interplay of social fact and mythic-religious overtones, *actos* became scenarios of ethnic redemption and social resurrection.

The rough-and-tumble performance style of El Teatro Campesino echoed the acting traditions of traditional *carpa* productions, which had been staple *barrio* entertainment from the turn of the century to the advent of the mass media in the 1940s. Campesino performance styles, like those of *carpa* productions before, emphasized rapid corporeal movements interlaced with slapstick actions and pratfalls; they were grounded in verbal virtuosity.

The *carpa* tradition also provided El Teatro Campesino with an array of traditional characters, especially the *peladitos(as)*. These picaresque character types formed a rogues' gallery of robust, bawdy urban roustabouts who meet life head on. In countless scenarios, the *peladitos(as)* outsmarted adversity through personal wiles, cunning, and street smarts. As they pranced about with an indomitable will-to-be, the *peladitos(as)* reflected the stoicism, human grit, and spunk of the Chicano community itself. The ensemble of communal values and aesthetic choices anchored in everyday life struggles forms the core of a *rasquache* sensibility … *pujando pero llegando!* … . Articulating and visualizing this working-class sensibility in dramatic form, El Teatro Campesino bared the Chicano soul and touched the hearts of international audiences.

Beyond the *actos*, El Teatro Campesino brilliantly deployed *rasquachismo* as a self-conscious aesthetic strategy in its film version of Rodolfo 'Corky' Gonzales's epic poem, 'I Am Joaquin.' Not having the financial or technical resources necessary for producing a standard animated film, the Teatro activated a simple slide presentation around a highly charged reading of the poem by Luis Valdez. Enlivened with music, historical photographs, and scenes from the various political fronts of el Movimiento, the filmed version of 'I Am Joaquin' was technically rudimentary, yet its very crudeness captured the spunky spirit of the time. Unabashedly melodramatic with a clear moral conflict at its core, the film invited the audience to join emotionally in the clash of good and evil. It spoke with electrifying potency and generated a primal response through its resonant documentary impulse and its stirring and prophetic tone. Immediately accepted as a vibrant and living testimonial of the period, the film *I Am Joaquín* became a necessary component of Chicano Movement meetings, rallies, and mobilizations throughout Aztlán.

While the Teatro Campesino infused many of its productions with an aesthetized form of its *rasquachismo*, the more natural and spontaneous *rasquache* impulse rooted in the practices of everyday life became especially pronounced in politicized sectors of the Chicano community.

Throughout the country in the 1960s and 1970s, sustained by a grass-roots sociopolitical movement, an alternative circuit for creating and disseminating Chicano cultural production was articulated and maintained by Chicano cultural workers. As impertinent outcasts, they resurrected symbols of negation, redeemed them with positive connotations, and mobilized them as tools in the struggle. Cartoons, murals, posters, melodramas, and *barrio* rituals, the diverse genres traditionally stigmatized as lower-class expressions, gained potent relevancy within the context of a massive and national working-class mobilization and in middle-class spheres like the university. Chicano artists placed vernacular art forms and sources in the foreground and investigated the *rasquache* modality in ephemeral instinctive actions: lettering a picket sign with house paint on a discarded bit of

cardboard, creating a roadside altar during a *campesino* pilgrimage along a dusty road, and improvising a *corrido* sung by an elder to commemorate a student educational walkout. A paramount impulse was to *hacer de tripas corazón* (to make the best of what you have). This primal sense of survival combining grit, guts, and humor lies at the heart of *rasquachismo*. When asked to define *rasquachismo*, a *teatro* performer responded that '*rasquachismo* is when you use a loaf of bread as a prop, and somebody eats it!'.

The *rasquache* sensibility informed and gave impetus to diverse aspects of the Chicano cultural movement articulated in poetry, music, and the visual arts. The title of Zeta Acosta's novel, *The Revolt of the Cockroach People*, captures the mood exactly.[7] It was a lusty, eruptive coming to political consciousness of the dispossessed. The very titles of some Chicano art exhibitions – Quemadas y Curadas, Dále Gas!, Capirotada, Arte Picante – reflect the revindication of humble, everyday traditions as sources for anchoring artistic production.

As a way of being in the world, *rasquachismo* assumes a vantage point from the bottom up. It proclaims itself from the margins and borders of the culture. Often it is the disenfranchised subgroups within the Chicano community who best exemplify a *rasquache* sensibility.

In the metropolis, the urban youth cultures, whether *cholos, ponqueros* (punkers), or low riders, all present profoundly dissident attitudes at the superficial level of style. The meticulous attention given to the presentation of self, the in-group fashion statements signaled by headbands, hairstyles, tattoos, and makeup, form codes of negation, of refusing to conform. Fracturing the myth of consensus with a defiant Otherness, Chicano youth cultures stand proudly apart in stance, style, and attitude.

A common strategy is to subvert the consumer ethic of mainline culture. In fashion, the retro look of the past, *pachuco* styles circa the mid-1940s, are preferred over the latest trend. Other consumer icons, the automobile, for example, are recontextualized with oppositional meaning and function. Low riders reverse the mania for speed by recycling car models of the past, customizing them, and driving them 'slow and low.' Through such strategies of appropriation, reversal, and inversion, Chicano youth cultures negate dominant models and values. *Rasquachismo* feigns complicity with dominant discourses while skillfully decentering and transforming them.

Among urban youth cultures, a source of style and attitude, the essence of pride, defiance, and self-identity, is encoded in the ubiquitous sign of *con safos* (c/s). Often scrawled, painted, or incised on *barrio* walls, *con safos* is a central *rasquache* symbol. It is the ever-present voice of the downtrodden safeguarding its presence and point of view. *Con safos* placed next to a name is a talisman and a safeguard. It means, whatever you think or say about me, you get back double (even in my absence). The symbolic meaning of *con safos*, like the essence of *rasquachismo*, is a melding of style, stance, and attitude.

The recuperation and recontextualization of vernacular sensibilities and art forms extend to the present. A work of art may be *rasquache* in multiple and complex ways. It can be sincere and pay homage to the sensibility by restating its premises (for example, the plebe worldview actualized in ideas and behavior in the dramatic presentation, *La carpa de los rasquachis* (by Luis Valdez)).

Another strategy is for the artwork to evoke a *rasquache* sensibility through self-conscious manipulation of materials or iconography. One can think of the combination of found materials and the use of satiric wit in the sculptures of Ruben Trejo or the manipulation of *rasquache* artifacts, codes, and sensibilities from both sides of the border in the performance pieces of Guillermo Gómez-Peña. Many Chicano artists continue to investigate and interpret facets of *rasquachismo* as a conceptual life-style or aesthetic strategy.

Apropos of this ongoing investigation, an artist recently remarked to the author, 'Sometimes I think that all Chicanos are *rasquache* except you and me, and sometimes I wonder about you!'.

Glossary

Altares	Home altars.
Al troche y moche	Slapdash.
Arte Picante	Art that rouses conscience and consciousness.
Calaveras	Skeletons made famous by José Guadalupe Posada, Mexican graphic artist during the Porfiriato.
Mario Morena Cantinflas	Mexican film star famous for his use of verbal virtuosity as a comedic tool.
Capillas	Domestic religious shrines erected in people's yards.
Capirotada	Lenten dish made with meat, rice, cheese, and spices (often used as a metaphor for the heterogenous Chicano community).
Carpa	Tent show.
Chanclas	Sandals, *huaraches*, or any sort of well-worn shoe.
Chiliantes	Brilliant, shocking.
Cholo	*Mestizo* of Indian and Spanish descent.
Con safos (c/s)	Signal that a name is protected, a sign that means, whatever you think or say about me you get back double (even in my absence).
Corrido	Mexican-U.S. border ballad.
Cucaracha	Cockroach.
Cursi	Tacky.
Dále Gas!	Go to it!
El qué dirán	What will the neighbors say.
Fregado pero no jodido	To be down, but not out.
Hacer rendir las cosas	Make do with what you have.
Locura	Craziness.
Low rider	Chicano youth who customizes old cars with hydraulic lifts and rides 'slow and low.'
Malcriado	Ill-bred or malcontent.
Pelado, peladito	Penniless urban roustabout.
Piojos	Head lice.
La plebe	The working class.
Ponquero	Punker.
Pujando pero llegando	Huffing and puffing but getting there.
Quemadas y curadas	Wounded but healed.
Tanda de variedad	Vaudeville show.
El Teatro Campesino	Luis Valdez's Farmworkers Theater.
Tin-Tan (Germán Valdez)	Mexican film star who introduced the figure of the *pachuco* in Mexican films.
Tortillas de harina	Flour *tortillas*.
Francisco Villa	Hero of the Mexican Revolution.
Emiliano Zapata	Hero of the Mexican Revolution.

A COMMENTARY ON ASPECTS OF CHICANO/A AESTHETICS

In *rasquachismo*, the irreverent and spontaneous are employed to make the most from the least … one has a stance that is both defiant and inventive… In its broadest sense, it is a combination of resistant and resilient attitudes devised to allow the Chicano to survive and persevere with a sense of dignity. The capacity to hold life together with bits of string, old coffee cans, and broken mirrors in a dazzling gesture of aesthetic bravado is at the heart of *rasquachismo* … [it] is an obvious, and internally defined tool of artist-activists.
Amalia Mesa-Bains [8]

The essay '*Rasquachismo*: A Chicano Sensibility', by cultural critic and historian Tomás Ybarra-Frausto, is a text with many past and future lives. Those of us who study the praxis and history of Chicano/a art continually draw upon its insights – and its effective and affective use of language – in the construction of our own interpretive, analytical studies of the multiple aspects of Chicano/a visual, performing and literary arts. This commentary sets forth some of the conditions of existence for the essay – those practices and images that led the author to his observations and conclusions – and cites a few of its significant effects upon cultural criticism, the discipline of art history and its impact on the artistic production of younger Chicano/a (and other) artists.[9]

Rasquache is a virtually untranslatable term referring to things left over or of no value.[10] It is not equivalent to 'kitsch', but is often incorrectly so defined. And although it is also not directly akin to the idea of camp, there are resonances between the two concepts. Ybarra-Frausto's articulation of *rasquachismo* is indebted to

Susan Sontag's 1964 essay 'Notes on Camp', an earlier effort to capture the slippery and somewhat elusive qualities of what makes up a marginal, yet knowing, sensibility.[11] The term *rasquachismo* describes the aesthetic sensibility of *los de abajo*, of the underdog, a 'visceral response to lived reality', as Ybarra-Frausto puts it. It refers to a strategy of survival found among working-class Mexicans and Mexican Americans and the term evokes a particular set of aesthetic sensibilities for, and approaches to, living that are fundamentally coping mechanisms. What happens when these sensibilities and approaches become both the subject of art and the ways and means by which it is produced? What happens when the term enters public discourse? Ybarra-Frausto argues that as an, 'attitude rooted in resourcefulness and adaptability, yet mindful of stance and style', *rasquachismo* continuously undermines the idea of 'aesthetic norms as standard and universal'. In other words, it contradicts the notion of aesthetic autonomy.

As a 'visceral response to lived reality' *rasquachismo* in art practice became one avenue by which Chicano and Chicana artists of the 1970s and 1980s incorporated many of the objects of their daily lives (consumer and otherwise) into the works of art they created or performed – often to establish a different artistic vocabulary that reflected who they were and what they wanted to say about the times and places in which they were living. Perhaps more important is the fact that – by being *rasquache* in their practice – Chicano/a artists were also *making* art by using some of the same strategies and materials by which they *lived* their daily lives (alongside their friends, family members, neighbours). Art and life continually intersected and overlapped through visceral, aesthetic and

carefully considered, deliberate pathways. Choices were made to create art through these everyday processes for living, using the materials with which artists were familiar growing up in the *barrios* and *colonias* of Mexican America. There was a deliberate choice to question hierarchies between art and life, to collapse boundaries between high and low, and to challenge differently perceived, categorised and valued forms of art-making that were not readily accommodated within high art seriousness.[12] There is too much humour and irony, too much pleasure, fun and even poignancy in being *rasquache* for it to fit the demands of élitist forms of seriousness.

Contrary to much that has been written about Chicano/a artists of the *movimiento* generation (those who came of age either before or during the period of 1965–1985), the majority received university or art-school educations, and many practising artists taught or currently teach art in schools, colleges and universities. In this sense, choosing to be *rasquache* in art-making – for those Chicano/a artists who work with this sensibility and this sense of aesthetics – is both comfortable and familiar on the one hand and, on the other, is a consciously selected pathway to make art and to be an artist who operates both within Chicano/a communities as well as in other art world contexts. To be *rasquache*, therefore, constitutes a particular engagement with the world, and with many art worlds as subsets of the larger world, from a position close to home; it is grounded in the vernacular forms of Mexican American working-class experience, whether urban or rural. Being *rasquache* or engaging with *rasquachismo* is about the mechanisms for using whatever is at hand to live and create as best as one can, 'from a stance both defiant and irreverent', as Ybarra-Frausto states.

Ybarra-Frausto's 1988 essay gave voice to the already long-extant attitude of *rasquachismo* in a text that was first published as a thought-piece that led to the exhibition, *Chicano Aesthetics: Rasquachismo* (1988) at the MARS ArtSpace in Phoenix, Arizona, curated by Ybarra-Frausto, Lenee Eller and Rudy Guglielmo. The venue was a Chicano/a *centro* or alternative arts space that housed the activities of the Movimiento Artistico del Rio Salado. The essay was almost immediately reprinted in *Le Demon des Anges* (1989), a catalogue for an exhibition collaboratively organised by Le Centre de Recherche pour le Developement Culturel in Nantes and the Centre D'Art Santa Monica, Departament de Cultura, Generalitat de Catalunya, in Barcelona. The exhibition travelled through Spain and France and the catalogue provided all texts in Spanish, English, French and Catalán translations. Ybarra-Frausto's text was then expanded and reissued in the catalogue for *Chicano Art: Resistance and Affirmation* (1991) (aka *CARA*), an interpretive exhibition of the Chicano Art Movement, 1965–1985, that was organised by the Wight Art Gallery at the University of California, Los Angeles. The first audience for Ybarra-Frausto's concept of *rasquachismo* was, therefore, a regional, almost exclusively Chicano-based, arts community (although the text soon entered national circuits of informal distribution among interested readers); its second audience was formed by the various arts communities in continental Europe who were intrigued by Chicano/a artists and their work. Ybarra-Frausto's essay maintained its ongoing currency via the *CARA* exhibition and catalogue, and this has expanded its audience to the general museum public in key US cities, including Los Angeles, Denver, San Francisco, Fresno,

San Antonio, El Paso, Tucson, New York City and Washington, DC.

As an articulation of both an aesthetic discourse and a mode of artistic practice, the concept of *rasquachismo* does not claim to address all Chicano/a art – primarily because there can be no single critical structure that embraces the entirety and variety of Chicano/a art-making – but rather it addresses a specific, highly visible and frequently misread segment of Chicano/a practice. At the time it was published, Ybarra-Frausto's essay was a rare contribution to the small but expanding bibliography on Chicano/a art, art criticism, and now, art history. It remains one of the very few pieces of writing on Chicano/a art and culture that neither assumes a defensive stance in its description and analysis nor an offensive attack in its criticism. Ybarra-Frausto's entire oeuvre as a critic sets forth a deep understanding, respect and appreciation for Mexican American culture. In this particular text, he writes from a place of sheer pleasure about the physicality and details of material objects; he delights in the humorous, ironic and poignant resonances of lived experience; and he analyses art and culture on their own terms, while also indicating the tendrils of more widely shared forms and viewpoints, while continuing to search for the broadest possible connections. His essay on Chicano/a aesthetics brings delight to the reader and elicits the 'ahas' of recognition with regards to both the bravado it takes to transform bits of nothing into riotous, often playful, even raunchy effects, and the very real pathos of historical circumstances that trigger the necessity for re-using the detritus of US consumerism.

Secondly, the text is unique because although written as recently as 1988 it provided the first analytical mechanisms by which to interrogate the specificities of *what we see when we look* at certain kinds of Chicano/a works of art – and it did so from an expressly formal perspective. The text provides a means for formal analysis that is completely integrated with the content of these works of art and that foregrounds the historical, economic, political and cultural particularities of the Chicano/a lived experience as primarily working-class, bi-cultural, bi-lingual and resistant to assimilation within the United States. Thirdly, I would argue that Ybarra-Frausto's text is also unique when seen in light of the majority of writings (and discussions) about Chicano/a art that have side-stepped a direct approach to aesthetics and to the integrative analysis necessary to connect issues of form, style and content. In the main, writings on Chicano/a art have, with notable exceptions, been devoted to the identification and elucidation of subject matter, and other substantive issues that have located, grounded and defined Chicano/a art's parameters and roles within the civil rights, labour and anti-war movements; its sense of both resistance and affirmation, its working-class origins, its rural and urban roots, its complex historical and cultural connections to Mexico and the United States; its separatism from the mainstream and its internationalism; its mediums, forms and iconographies; its border consciousness, its strong feminist presence in the face of sexism and its organisational and institutional practices.[13]

One further set of terms must be addressed before entering into an exploration of Ybarra-Frausto's essay and its role in Chicano/a art and art criticism: the gender specific designations indicated by Chicano and Chicana.[14] In dealing with the history of the civil rights and arts

movements, one of the most important issues is that of terminology and the continual process of clarifying definitions as they circulate both within Latino communities and across US society as a whole. By the early 1970s, two of the basic definitions of the term Chicano (Chicana was conspicuous by its absence in these early writings) were put forward by the late Rubén Salazar, a *Los Angeles Times* journalist, who wrote, 'A Chicano is a Mexican American with a non-Anglo image of himself', and the Texas-born and Minnesota-based artist Santos Martinez, who referred to a Chicano as 'a politicized Mexican American'.[15] Where the first shifted emphasis to differentiate Mexican American identity from the dominant Anglo society, the second separated Chicano/as from their Mexican American elders. 'Anglo' in this context refers to anyone in the United States who is both 'white' and of European descent. When the Chicano comedy troupe, Culture Clash, included a glossary in their published collection of performances entitled *Culture Clash: Life, Death and Revolutionary Comedy* (1998), under the term 'Chicano' – and only partly in jest – was the phrase, 'still trying to figure that one out'.[16] One must keep in mind, therefore, that all definitions dealing with the term Chicano have real historical specificity, have changed over the years, and are still open to discussion. For the purposes of consistency, this commentary utilises the two early definitions cited above from Rubén Salazar and Santos Martinez, because it was during those early years that the *rasquache* sensibility first appeared in Chicano/a art in both its most unselfconscious and deliberate manifestations.

Chicano/a Art in Histories of Modernism and Post-modernism

Chicano/a art emerged in the late 1960s as a direct outgrowth of, as multiple responses to, and as active and visible support for the Chicano Civil Rights Movement. It developed into a non-monolithic national art movement in its own right by the early 1970s and this *movimiento*-based period could be said to fade at some time in the late 1980s or early 1990s, although such views are widely debated. Chicano/a art has been theorised and critiqued from its first appearances most prominently by the artists themselves.[17] Since the early 1970s, some of the practitioners who have also written and debated on issues in Chicano/a art criticism include Judy Baca, Santa Barraza, Harry Gamboa Jr, Rupert Garcia, Ester Hernandez, Carmen Lomas Garza, Yolanda Lopez, Cesar Martinez, Amalia Mesa-Bains, and the brothers Jose and Malaquias Montoya.[18]

More than 20 years after the art movement's mid-1960s emergence with the Teatro Campesino's (Farm Workers' Theatre) efforts to get workers out of the fields of the Central Valley of California to strike and march with Cesar Chavez, Dolores Huerta and the United Farm Workers' Union, Tomás Ybarra-Frausto articulated certain aspects of a general Chicano/a sensibility in setting forth his conception of *rasquachismo*. Growing up in San Antonio, Texas, Ybarra-Frausto's appreciation of the vernacular was influenced by early experiences of homemade *capillas* in neighbourhood yards, *altares*, *ofrendas* and *nacimientos* in local homes, and the extraordinarily decorated tombstones in cemeteries (many produced by his uncle). He received the education and intellectual grounding that deepened such knowledge during his undergraduate years at the University of Texas,

Austin, where he studied with Americo Paredes and Roger Abrams, renowned scholars of folklore, oral histories and traditional ballad and *corrido* forms from Appalachia, African America and Mexican America. A study of Ybarra-Frausto's writings indicates his life-long engagement with the vernacular and its various contributions to 20th-century literature and the visual arts.[19]

The conceptual system set forth in his 1988 essay has elicited considerable discussion within Chicano/a artistic circles, in part, to demarcate the limits of its applicability. At the same time, notions of *rasquachismo* have also been affirmed and sometimes applied uncritically as if it were a familiar, broadly understood and collectively shared sensibility that did not require discussion or debate by Chicano/a scholars and critics in academic or arts communities. Frequently, this tendency has included lengthy quotes from the essay, but without further elaboration or analysis. It is as though Ybarra-Frausto's eloquent articulation and analysis constitutes *the* definitive statement on Chicano/a aesthetics. This reading has occurred, in large measure, because the essay (and its subject matter) is perceived to be the most comprehensive articulation of an acknowledged and recognisable, if not universal, Mexican American and Chicano/a experience. As such, the qualities of *rasquachismo* have also been located and analysed within Chicano/a theatre, film, music and literature.[20]

In this respect, in contrast to the writings of movement-based artists and critics, art historical discussions of style and aesthetics in Chicano/a art have mostly come from outside the community, and have tended to be timid, misplaced or frequently derogatory. This is notable in the writings of the 1980s and much of the 1990s. Historically, Chicano/a art has often been examined for what it is not – for absence and lack – rather than for what is present and what is of substance. Often such critiques derive from either a mainstream art world perspective, or from the perspective of the history of Mexican art, that is, a view from the South to the North, that often foregrounds a comparative or diasporic approach that seems to leave Chicano/a art diminished and always 'less than'.

The art historian and critic, Shifra Goldman, was one of the first scholars to champion Chicano/a art and to examine it in a serious and sustained manner.[21] Since the early 1970s she has written numerous articles that have essentially provided both the foundations of this discursive field and a continuing engagement with the materials. Her early groundwork is important to our understanding of what constitutes Chicano and Chicana art and where it is located, although it can also be said that Goldman's work has (often inadvertently) contributed to its articulation as 'less than' – as opposed to 'different from' – the traditions it is compared to. This latter aspect of her criticism derives from the combination of her own early political sensibilities and labour activism in Los Angeles in the 1940s and 1950s, and her graduate studies in the late 1960s and early 1970s in both 20th-century Mexican Art and Euro-American Modernism. In other words, Goldman first studied Chicano/a art from the outside in, and with a strong set of specific expectations of what constitutes appropriate political action and its affiliated efforts to create grandiose, all-encompassing (national) experiments in artistic practice in the service of social change. She was one of the first scholars to compare the cultural explosion in the aftermath of the Mexican Revolution of 1910–1920 (one that also contained a strong engagement with

contemporary modernist art practices in Europe) with developments that brought together art and social action in the Chicano/a art and civil rights movements. Despite these critical aims, however, she helped to establish an erroneous, flawed and distracting comparative structure between Mexican and Chicano/a art (and histories) from which the study of Chicano/a art has yet to recover.[22]

Goldman's substantial account of some of the multiple sources for Chicano/a art effectively positions the artists as passive rather than active, and thus interprets their practices as derivative rather than appropriative. She identifies key sources such as Mexican precedents in muralism, print-making and *arte popular*, Cuban poster design, as well as US and Mexican American popular culture imagery, but her viewpoint does not recognise or fully acknowledge the ways in which those sources have been incorporated and manipulated – sometimes transformed, sometimes embedded raw. And yet, Goldman has also written on *rasquachismo* in an essay entitled 'Assembling the *Capirotada*' that responded to Ybarra-Frausto's essay, which was also published in the 1988 exhibition at MARS in Phoenix. Indeed, Goldman places the concept of *rasquachismo* in an international context of shared vernacular sensibilities located among working-class peoples around the world. The conceptual leap she does not seem to make, however, is that being *rasquache* became a very deliberate, resistant and defiant strategy for Chicano/a artists as they made their choices in the social contexts of US society in the 1970s and 1980s. Instead of seeing this as a strategic decision, Goldman positions this more deliberate *and self-conscious* use of a *rasquache* aesthetic as an elegiac and nostalgic 'nod' to a vanishing

world. Although many artists deliberately turned their backs on the US art world and what they perceived to be the mainstream status of élite modernist art practice, their choices and efforts can be more clearly understood within the notion of 'multiple modernisms' articulated by Stuart Hall, who suggests that, 'In reality, the world is absolutely littered by modernities and by practicing artists who never regarded modernism as the secure possession of the West, but perceived it as a language which was both open to them but which they would have to transform.'[23]

When one-to-one comparisons between Mexican and Chicano/a art are undertaken, or when Chicano/a art is simply positioned as Mexican art made across the border, or viewed as Mexican art in exile, such approaches often cause more confusion and mis-readings than relevant or illuminating analyses or observations. Such comparisons also result in another layer of pejorative evaluations about Chicano/a art when some critics argue that Chicano/as have never attained the power, originality and aesthetic or political sophistication of the great Mexican artists. From this viewpoint, Chicano/a art and culture is often implicitly denigrated for coming from predominantly working-class backgrounds, and the status of Chicano/a artists from immigrant families, or as first and second generation Mexican Americans, is often put forward as an explanation for why Chicano/a art fails to resemble either Mexican high art or US mainstream art, or to 'measure up' to the criteria of established modernist values. Such presumptions have prohibited or sidetracked the development of perspectives that allow for the actualities of intellectual, political and cultural knowledge among Chicano/a artists and critics.[24]

Where other US 'minority' movements have targeted Anglo Eurocentrism as a barrier to critical understanding, it may be said that the misperception of Chicano/a art from Mexican perspectives highlights issues that arise when élitist views of modernism as high culture are articulated in nationalist discourses that are voiced from the South or Third World.

Chicano/a art has rarely been compared to that of US Anglo artists or examined alongside international art movements such as pop art. For reasons best explained within the context of post-colonial discourse (although the position of Mexican American identities *vis-à-vis* the United States as an imperial 'centre' has been in continual dispute), Chicano/a art has rarely been positioned within debates on modernism and post-modernism either, even though aspects of Chicano/a practice are frequently identified as post-modern. For example, art historian Ondine Chavoya has written about Chicano/a artists as the orphans of modernism due to their continuing erasure from the histories of contemporary and avant-garde art.[25] In 'Orphans of Modernism: The Performance Art of Asco', he focuses on the pioneering public, performance and conceptual work of the Chicano/a collective Asco (1971–1987), formed by Harry Gamboa Jr, Gronk, Willie Herrón and Patssi Valdez in East Los Angeles that 'set out to test the limits of art – its production, distribution, reception, and exhibition'.[26] Asco's 'no-movies' or their 'art of false documents' epitomised their simultaneously playful and deadly serious *rasquache* guerrilla tactics. As Chavoya writes, 'The "no-movie" was Asco's signature invented medium – conceptual performances that invoked cinematic codes but were created for a still camera. [They] were staged events in which performance artists

Asco,
Walking Mural,
24 December 1972

played the parts of film stars in photographs that were distributed as film stills from "authentic" Chicano motion pictures.'[27] In one instance, Asco staged the aftermath of a gang shooting in a performance entitled *Decoy Gang War Victim* (1974), which was 'designed to provoke the viewer to commit acts of perceptual sabotage', and the group then distributed the resulting photograph to wire services, where it was picked up by 'the local media as a real scenario of violence'.[28] Asco's 'no-movies' innovations were a *rasquache* intervention that combined interests in activism and cultural production, and were the ideal solution to the problem of having no money for a movie camera or film production.

Asco's earlier interventionist performances in the commercial centre of East Los Angeles, Whittier Boulevard, featured the *Walking Mural* (1972), in which they replaced the recently cancelled annual East Lost Angeles Christmas parade by becoming both the performers on the 'floats' and the participants on the streets.[29] Patssi Valdez transformed the sacred image of the Virgin of Guadalupe by dressing herself as *la Virgen* ready for a night on the town in a black tulle cocktail dress; Gronk became a living, decorated Christmas tree; Willie Herrón was the Walking Mural, bored with being required to remain static, permanently affixed to a wall; and Harry Gamboa provided the 'press' documentation. With costumes constructed from bits and pieces of cloth, discarded decorations, paint, glue and cardboard, Asco thus created a *rasquache* spectacle that simultaneously critiqued city officials *and* their fellow Chicano/a artists whom, they felt, had narrowed the possibilities of Chicano art by privileging murals as the primary medium of cultural intervention.

While Chavoya has sought to bring such critical practices into the historical record, the reasons for the broader neglect of Chicano/a aesthetics in debates on post-modernism are at least three-fold.[30] First, in the early years of the Chicano/a movement, there was a self-imposed politically motivated separatism adopted by many artists who wished to have their art considered only within the community or *el movimiento*, or related contexts such as international resistance and activism, Latino art or international Third World art. This has been and continues to be a hotly contested issue. Second, among Chicano/a artists and critics it could be said that there has been a historical squeamishness about engaging with the mainstream art world since mainstream critics have consistently missed the point of Chicano/a art. In the past, few critics learned about Mexican American culture and history or went beyond US stereotypes of inner city youth gangs, low-rider culture and graffiti as vandalism. Many reviewers and critics also frequently missed the humour and irony of much Chicano/a art – particularly that which is *rasquache*. When critics and scholars assume that high art must exhibit high seriousness (one of the issues faced by critics of pop art) there is also the danger that Chicano/a art is simply seen as a kind of kitschy folk art to be studied by anthropologists.[31]

Understanding the *rasquachismo* sensibility and how it functions in Chicano/a art provides one potential solution to the problem of such mis-readings of vernacular signs and symbols. Ybarra-Frausto takes one to and through the stereotypes and helps to crack them open, making sense of *rasquache* elements within the broader structures of Chicano/a cultural production. The issue of stereotypes brings us

to the third reason why Chicano/a practices seem to be ignored in debates on post-modernism, and this is a direct outgrowth of the second. Much of Chicano/a art, particularly from the generations from the late 1960s to the early 1990s, has been captured within and limited by discourses of identity politics. Such discourses worked with assumptions that the materials Chicano/a artists had drawn upon were confined to a specific and narrow understanding of what constituted Mexican American (read Mexican or Mexican-derived) cultural forms. The level of deliberation, active engagement or agency demonstrated by the artists in the choices they made in their creative processes was thus downplayed. When identity politics ignores the hyphenated character of Chicano/a's conscious engagement with, and lived experience in, the United States, it further downplays the complexity of Chicano/a experience as it is negotiated in and through the United States for Chicano/a identity *is* an American experience – in both the national and hemispheric definitions of the term. As Mesa-Bains has observed:

Operating as an internally colonized community within the borders of the United States, Chicanos forged a new cultural vocabulary composed of sustaining elements of Mexican tradition and lived encounters in a hostile environment. Fragmentation and recombination brought together disparate elements such as *corridos* (Mexican historical ballads), images of Walt Disney, Mexican cinema, and mass media advertising, and even Mexican *calendario* graphics and American Pop art. This encounter of two worlds could only be negotiated through the sensibility of *rasquachismo*, a survivalist

irreverence that functioned as a vehicle of cultural continuity.[32]

Survival and Inventiveness: Translating Life into Art

It is important for emphasis to draw out some of the implications of *rasquachismo* when this complex sensibility is introduced in Ybarra-Frausto's own words as follows:

To be *rasquache* is to be down, but not out (*fregado pero no jodido*). Responding to a direct relationship with the material level of existence or subsistence is what engenders a *rasquache* attitude of survival and inventiveness.[33]

An example of this mix of attitudes was embodied by the United Farm Workers' newspaper entitled *El Malcriado* (the ill-bred). Among serious articles on union organising, farm worker activism, the Teatro Campesino and prints from the Taller de Grafica Popular in Mexico, *El Malcriado* featured the cartoon figure of Don Sotaco, a modest *peladito* farm worker (who looks a bit like Cantinflas) whose unlikely heroism prevailed against state police, hired thugs and the Teamsters. While the cartoon character of Don Sotaco shows that *rasquachismo* involves humour to present the social and political struggles of farm workers with regards to the state or the US economy, Tomás Ybarra-Frausto reveals that it is not a reactive or resentful stance, but rather involves a world-view in which humour and irony are part of the resilience and inventiveness shown by everyday coping strategies or *movidas*. Ybarra-Frausto continues:

In an environment always on the edge of coming apart (the car, the job, the toilet), things are held together with spit, grit, and *movidas*. (*Movidas* are the coping strategies you can use to gain time, to make options, to retain hope.) *Rasquachismo* is a compendium of all the *movidas* deployed in immediate, day-to-day living. Resilience and resourcefulness spring from making do with what is at hand (*hacer rendir las cosas*). This use of available resources engenders hybridization, juxtaposition, and integration. *Rasquachismo* is a sensibility attuned to mixtures and confluence, preferring communion over purity...[34]

Rasquachismo is thus a world-view and strategy for survival, but *how* does it translate into specific approaches to art-making and into the formal and conceptual elements of Chicano/a art? Ybarra-Frausto refers to the 'recuperation and recontextualization of vernacular sensibilities'.[35] Accordingly, there are 'multiple and complex ways' for an artwork to be *rasquache*. 'It can be sincere and pay homage to the sensibility by restating its premises',[36] and as an example Ybarra-Frausto points to the *plebe* or working-class world-view embodied in the theatrical skit or 'acto' entitled *La carpa de los rasquachis* (The Tent Theater of the Underdogs) (1971), by Luis Valdez, co-founder of the Teatro Campesino.[37] An additional example of this 'sincere' mode, 'can be seen in the pastel by Ester Hernandez from 1987, entitled *California Special*, one of the artist's most evocative works, in which a very young Ester is seen in a brightly coloured and patterned dress sitting atop bags of flour. These very same bags serve not only to hold flour, but also to provide fabric for the child's clothing. This work embodies a transformative act, learned as a small child, that embraces both a frugality necessitated by a farm worker's life, and a dignified pursuit of familial caring and beauty.'[38]

A second strategy presented by Ybarra-Frausto is for the 'artwork to evoke a *rasquache* sensibility through self-conscious manipulation of materials or iconography'.[39] There are numerous examples of this approach. *Chili Chaps*, a cardboard 'cut-out' 'sculpture' created by Teddy Sandoval in 1978, looks like a life-size paper-doll costume. At 101.6 x 91.4 cm (40 x 36 inches), the chic black paper chaps present an ephemeral antithesis of the original – the rough leather garment cowboys (or *vaqueros*) wear over their jeans when herding cattle to protect their legs from chafing and other more serious damage. Sandoval's chaps are not only un-wearable and non-protective, but they are also coyly decorated with numerous red-cloth chillies, paper cut-outs of typical travel or story-book depictions of Mexican scenery (cacti and cow skulls) and activities in which Mexican men are supposed to be engaged – such as sleeping or resting in *sombreros* and *ponchos*. They are also stylishly bordered by hard, uncooked beans – another necessary ingredient for the staple chilli stew with beans – making a fashion statement from gastronomic necessity. The *pièce de résistance* is the combination of the cardboard fringe and the plastic buckle belt. Altogether we have an extraordinary (and inexpensive – in terms of materials) work of art (whose title is spelled in English rather than Spanish) that plays on the multiple and macho US stereotypes of 'cowboys and Indians', of Mexican *vaqueros* and pejorative references to them in American literature and cinema, topped by playful and pointed allusions to homo-sociality and

Teddy Sandoval,
Chili Chaps, 1978

Larry Yañez,
Hey Zeus, 1983

homosexuality both in the contemporary urban world and the almost exclusively male domain of the cattle ranges of the western United States and of Mexico. *Hey Zeus* is an altar or *ofrenda* from 1983, built by Arizona-based artist and musician Larry Yañez. This is another work of art that pulls from some of the same stereotypical depictions of Mexicans and artful use of mundane materials as has Sandoval's for an equally humorous and ironic object that both diverges from and overlaps with *Chili Chaps*' specific references and connotative layers. While the title involves word-play on the Spanish pronunciation of Jesus, the materials consist of an old table, broken-down orange crates and kitschy 'sleeping Mexican' figures (Yañez explains these figures as dreaming up the future). These figures face a candle in the shape of a saguaro cactus (an icon of the Arizona desert) and are set in front of an inexpensively ornate framed chromo-lithograph of the face of the crucified Christ looking heavenward – toward a slightly toasted *tortilla* that resembles a full moon or a halo. The current location of *Hey Zeus* is unknown, and according to the artist it has probably disintegrated, a fact that places this artwork in the tradition of both the home altar (which changes over time) and of *rasquachismo* itself, where objects are thought of and treated as ephemeral.[40]

The Snow Queen (1985), another ephemeral object, is a paper fashion outfit designed and executed by artist Diane Gamboa, modelled by Kelly Sena, with accompanying elaborately jewelled paper hat, necklace and sheer lace gloves, that graced the cover of the 'Nuevo Latino!' issue of *High Performance* magazine in 1986. Constructed from rolls of inexpensive butcher paper, wire, glitter and glue, this artwork existed only for the duration of the photo-shoot, in what appears to be a Christmas setting turned magical forest.[41] Here we have the ephemeral fantasy of a beautiful Latina Snow Queen that on the surface suggests a more innocent world than the numerous, often ironic, sexually suggestive and power-laden works created by Gamboa over the years. However, *The Snow Queen* also alludes to a more sinister, disruptive and artificial reality for it evokes the necessarily fake snow found on some Los Angeles holiday decorations, especially the artificial Christmas trees often favoured in the mansions of Beverly Hills, Brentwood and Malibu. Diane Gamboa's 'idyllic' scene is not located in such privileged surroundings, but rather in a temporary gravel lot, presided over by a glamorous young 'princess', who, at the time the photograph was taken, would most likely have been considered to be 'out of place' in any of the élite locales of Los Angeles.

An artist who did not work with ephemeral materials as such, but who chose *rasquache* materials and subject matter, was the late Luis Jimenez whose favourite medium as a sculptor was fibreglass. In a television interview, Jimenez spoke about his materials and why he made the kinds of sculptures for which he is acknowledged:

> The technical aspect of making the sculpture is also philosophically a part of the work in the sense that the material that I am using is the same material that is used in making boat bodies, car bodies, Mack truck bodies, etc. It's the same material that you associate with surfboards, that you associate with carnivals, that you associate with popular culture, really.[42]

In the mid-1980s, Jimenez focused in his sculptures, drawings and lithographs on the iconography of dancers, whether honky-tonk or fiesta. His figures evoke the pleasure of moving and the heat and sweat of bodies that are 'alive' and 'in the moment'. The large-scale fibreglass sculpture *Fiesta Dancers* (1985) brings together the beauty of the Mexican tradition of *Ballet Folklorico* and the Mexican American traditions of fiestas in Arizona, Texas and the Southern Valley of New Mexico. This is both a bawdy and graceful version of the *Jarabe Tapatía* – the Mexican Hat Dance – that also synthesises honky-tonk sensuality with the energy of flamenco passion and elegance. Jimenez's figures are not youthful – the man has a bit of a belly and the woman 'has been around the block'. They are Nuevo Mexicanos – Indo-Hispanos – who dance in towns like Hondo and Roswell, and here such 'ordinary people' are monumental, garish, glossy and elegant in their joy and energy.

The work of Larry Yañez, Diane Gamboa and Luis Jimenez is among the kinds of practice that led Ybarra-Frausto to his essay: but how does *rasquachismo* play out in 21st-century Chicano/a art? Among younger artists who see their elders as representing both role models to emulate and precedents against whom they work in their own creative expression, there is an ongoing interest in the *rasquache*, whether articulated as such or not. Artist Ruben Ochoa has used a white 1985 Chevy van that was formerly a *tortilla* delivery truck (that belonged to his parents' restaurant) to create a mobile gallery 'complete with white walls, fake wood floors and track lighting'[43] that now delivers art. Ochoa curates the exhibitions held inside or on the outside of the van and drives them to various locales in Southern California for presentation in neighbourhoods, parks and parking lots. He and his compatriots continue the tradition of creating their own spaces in unlikely and often cast-off locations. Finally, if one were to Google the terms *rasquache* or *rasquachismo*, the numerous citations include the website – rasquache.com – which suggests that the ideas explored by Ybarra-Frausto may yet extend further into the virtual worlds being created by contemporary technology.

One of the tasks to be accomplished in the study of *rasquachismo*, both the general concept and Ybarra-Frausto's individual perspective, is a more thorough elaboration of the variations of this sensibility in the visual arts. The limits and subtleties of Ybarra-Frausto's essay were tested and expanded in the view of *domesticana* put forward by the artist Amalia Mesa-Bains. Mesa-Bains published her important essay '*Domesticana*: The Sensibility of Chicana Rasquache', in *Distant Relations: A Dialogue Among Chicano, Irish and Mexican Artists* (1995), an exhibition catalogue for an innovative project curated by Trisha Ziff that travelled from Santa Monica in the United States and Birmingham in Britain, to Dublin and Mexico City, between 1995 and 1997. One of Mesa-Bains' goals for her participation in this project was to dispel Mexican misconceptions and misperceptions of the Chicano/a experience in the United States.

In her essay, she elaborated and particularised Ybarra-Frausto's basic structures within the arenas of feminine and feminist Chicana representation, which she theorised as *domesticana*. This term refers to a conceptual and formal sensibility through which certain women artists articulate the domestic sphere as a place of both paradise *and* prison, of 'constriction, subversion, emancipation, and ultimately redemptive enunciation'.[44] In exploring both '*barrio* life' and

'family experience', Mesa-Bains included home embellishments, home altar maintenance, healing traditions and feminine pose or style as key sites of representation in Chicano homes. *Domesticana* is thus positioned as a form of resistance to 'majority culture' and as an affirmation of Mexican American cultural values, yet it is also as a critique of the restrictions placed on women within that same culture and by the way Latinas are perceived within Anglo-American society. Suggesting that, 'techniques of subversion through play with traditional imagery and cultural material are characteristic of *domesticana*',[45] Mesa-Bains argues that it articulates a critique of the domestic sphere as constructed through patriarchy. Where 'the bedroom and the kitchen convey a centrality but also an imprisonment', the concept of *domesticana* also opens interventions to change such everyday structures.[46] Drawing on the views of Griselda Pollock, who has written that, 'The spaces of femininity are those from which femininity is lived as [a] positionality in discourse and social practice. They are a product of a lived sense of social [locatedness], mobility and visibility in the social relation of seeing and being seen [...] Femininity is both the condition and the effect',[47] Mesa-Bains responds that representation must relocate or reposition the feminine as the goal of Chicana artists who employ *domesticana* (or feminine *rasquachismo*) in their work. Mesa-Bains cites contemporary artists, including Santa Barraza, Carmen Lomas Garza and Patssi Valdez, as key practitioners in this regard, although *domesticana* also casts light on Mesa-Bains' own oeuvre. Looking at the formal and conceptual properties of several of Mesa-Bain's altar-like installations within the discursive space of *domesticana*, the

scholar Andrea Quijada has made several important observations:

> In her celebration of women, both past, present, and future, Mesa-Bains is commenting on the deliberate erasure of women (particularly women of color) in history, and works to reaffirm the contributions of women throughout time... Amalia Mesa-Bains is a writer, critic, educator and artist – all elements of which appear in her works. Her pieces operate on an extremely emotional and spiritual level, while tapping into her intellectual and psychological insights. It is in this intersection between these several planes that her work becomes its most subversive and challenging to her audience. Her works, with their hyper-femininity, function similarly to the gender construct of the lesbian femme in the Latina/Chicana community... Although not lesbian-identified, Mesa-Bain's works also 'pass' as something they are not, and are pointedly directed towards the female members of her audience. She, too, reclaims femininity and in doing so, her works transcend borders and enter into spaces – physical and psychological – which were previously reserved for something less than her resistance. Through a casual and calculated re-evaluation of gender, women, and femininity, Amalia Mesa-Bains re-educates her audiences to recognize that Chicanas, in being whoever they are or choose to be, function as living strongholds of cultural, historical, and spiritual survival and revolution.[48]

Conclusion

As stated at the outset, the concepts of *rasquachismo* and its elaboration in *domesticana* have not been set forth as comprehensive structures of analysis and criticism applying to all Chicano/a art,[49] but rather have been offered as pathways into understanding both the conceptual and visual elements of certain art practices and their connection to the communities out of which they came. These concepts have enabled critics to understand how Chicano/a art has contributed a means of constructing and redefining – not merely reflecting – identities, world-views and ideologies, to paraphrase Mesa-Bains.[50] As cultural studies scholar George Lipsitz has argued, in a slightly different context, Chicano art constitutes a form of *art-based* community-making, and not just *community-based* art-making.[51] These critical mechanisms have helped not only Ybarra-Frausto and Mesa-Bains, but also other scholars and critics, first to recognise certain prominent and seemingly ubiquitous aesthetic and visual properties, and then second, to theorise how and why they came to be foregrounded by so many Chicano/a artists. Third, by determining the edges of what *rasquachismo* and *domesticana* are, we will be able to see what they are not, and the ability to determine when works of Chicano/a art do not have a *rasquache* or *domesticana* sensibility is significant for the further analysis of Chicano/a art. Fourth, and perhaps most important, *rasquachismo* and *domesticana* provide the tools for connecting form, content and context in an interplay that bounces back and forth between artist, community, work of art and the individual viewer. As a result, these concepts can help in understanding processes of reception such as the 'instant recognition' of Chicano art within Chicano communities, and its relative inaccessibility for – and resulting misrepresentation by – the majority of mainstream Anglo critics and other participants in the art world, including those from Latin America. Through these and other analytical discourses we have the means by which to critically engage with Chicano/a artistic production both within its own communities and histories and in conversations about the transnational interplay between local and global cultural practices.

NOTES

1. Originally published in Richard Griswold del Castillo, Teresa McKenna and Yvonne Yarbro-Bejarano eds, *Chicano Art: Resistance and Affirmation, 1965–1985*, exh. cat., Los Angeles: Wight Art Gallery, University of California, 1991, 155–62.

2. Many friends have helped me to focus and expand my understanding of the *rasquache* sensibility. Thanks to Peter Rodriguez, Miguel Méndez, Victoria Diaz, Armando Valdez, Antonio Castañeda, Rudy Gulielmo, María Sandoval, José Antonio Burciaga, Ruben Trejo, Rosalinda Fregoso and Teresa McKenna.

3. Examples of the *rasquache* sensibility in this exhibition include the following: José Montoya, *Untitled*, from the *Pachuco* series (cat. nos 34–38); Teddy Sandoval, *Chili Chaps* (cat. no. 70); Ruben Trejo, *Birth of the Jalapeño* (cat. no. 83); Carlos Santistevan, *Santo Niño de Atocha* (cat. no. 75); David Avalos, *Hubcao Milegro #3* and *Donkey Cart Altar* (cat. nos 95, 122); Linda Vallejo, *Food of the Gods* (cat. no. 94); Diane Gamboa, *Snow Queen* (cat. no. 119); Larry Yañez, *Hey Zeus* (cat. no. 91).

4. Susan Sontag, 'Notes on Camp' (1964), in *Against Interpretation and Other Essays*, New York: The Noonday Press, Farrar, Straus & Giroux, 1966, 275–92.

5. Letter from Ramses Noriega to Rudy Gugliano, Phoenix, Arizona, 11 February 1988, explaining the source of Noriega's painting *Don Rascuachi*.

6. Daniel Venegas, *Las aventuras de Don Chipote, o, cuando los pericos mamen: Novela*, Los Angeles: El Heraldo de Angeles, 1928.

7. Oscar Zeta Acosta, *The Revolt of the Cockroach People*, San Francisco: Straight Arrow Books, 1973.

8. Amalia Mesa-Bains, '*Domesticana*: The Sensibility of Chicana *Rasquache*', in Trisha Ziff ed., *Distant Relations*, New York: Smart Art Press, 1995, 156–57.

9. Several of the ideas in this commentary are derived from earlier projects including a paper delivered at the 28th Annual Conference of the Association of Art Historians, Session 'Latin American Art: The Critical Discourse from Within', organised by Alejandro Anreus and Juan Martinez, Liverpool, UK, 6 April 2002; 'Tomás Ybarra-Frausto and Amalia Mesa-Bains: A Critical Discourse from Within', one part of a multiple-authored position piece, 'Forum on Latin American Art Criticism', in *Art Journal*, Winter 2005, 64, 4, 91–93; a presentation given at inIVA in February 2006; and conversations with Tomás Ybarra-Frausto.

10. '*Rasquache*, a Spanish word meaning leftover or of no value', from 'Preface and Acknowledgements', for 'Chicano Aesthetics: *Rasquachismo*', MARS, Phoenix, Arizona, 1989. The word is difficult to locate in Spanish/English dictionaries.

11. Susan Sontag, op. cit.

12. As noted by Cecile Whiting, 'The widespread debate about Pop Art's definition that took place in both art journals and the popular press in the early 1960s attests to Pop's ability to ride the line between high art and consumer culture, and hence to the permeability and instability of cultural boundaries during this period.' (in *A Taste for Pop: Pop Art, Gender and Consumer Culture*, Cambridge and New York: Cambridge University Press, 1997, 4). Chicano/a art accomplished or made visible something comparable in its efforts to collapse, elide or destabilise the boundaries between high art and vernacular culture.

13. See Philip Brookman and Guillermo Gómez-Peña eds, *Made in Aztlan*, San Diego: Centro Cultural de la Raza, 1986; several essays in Richard Griswold del Castillo, Teresa McKenna and Yvonne Yarbro-Bejarano eds, *Chicano Art: Resistance and Affirmation, 1965–1985*, exh. cat., Los Angeles: Wight Art Gallery, University of California, 1991, especially, Shifra Goldman and Tomás Ybarra-Frausto, 'The Political and Social Contexts of Chicano Art', 83–96, and Victor A. Sorell, 'Articulate Signs of Resistance and Affirmation in Chicano Public Art', 141–54; Karen Mary Davalos, *Exhibiting Mestizaje: Mexican (American) Museums in the Diaspora*, Albuquerque: University of New Mexico Press, 2001; María Ochoa, *Creative Collectives: Chicana Painters Working in Community*, Albuquerque: University of New Mexico Press, 2003.

14. During the early years of both the civil rights and arts movements, the male-gendered term 'Chicano' was used to signify all forms and persons, sometimes even when specifically addressing art or activism by women. This seemed to work because the English language rarely genders its nouns with either articles or word-endings. However, it did not accurately reflect the participation of women in all aspects of these movements or society in general. Since Spanish provides the opportunity to more accurately reflect gender specificity, feminist artists, activists and scholars began to use both terms, 'Chicano' and 'Chicana', simultaneously to provide a more balanced representation. These terms became 'Chicano/a' or 'Chicana/o' when referring to such entities as movements and culture that encompass everyone.

15. Rubén Salazar, 'Who is a Chicano? And What Is It The Chicanos Want?', *Los Angeles Times*, 6 February 1970. Salazar was killed in East Los Angeles by a sheriff's tear-gas projectile on 29 August 1970, during the riots that followed the National Chicano Moratorium March Against the Vietnam War. Santos Martinez Jr, *Dále Gas: Chicano Art of Texas*, Houston: Contemporary Arts Museum, 1977, frontispiece, 'Chicano – A Mexican-American involved in a socio-political struggle to create a relevant, contemporary and revolutionary consciousness as a means of accelerating

social change and actualizing an autonomous cultural reality among other Americans of Mexican descent. To call oneself Chicano is an overt political act.'

16. Richard Montoya, Ricardo Salinas, Herbert Sigüenza, *Culture Clash: Life, Death and Revolutionary Comedy*, New York: Theatre Communications Group, 1998, xxii.

17. Since the early years of the *movimiento*, there have been numerous conferences and symposia bringing Chicano/a artists, writers, activists and educators together to discuss and debate the issues of what constitutes Chicano/a art and activism, many of them sponsored by the various alternative arts and theatre organisations that were created throughout the country, frequently co-sponsored by local colleges and universities. Often, they were organised in conjunction with an art exhibition, such as *CALIFAS* and its seminar, at the Mary Porter Sesnon Gallery, Porter College, University of California, Santa Cruz, 16–18 April 1982.

18. Harry Gamboa Jr, 'Interview with Gronk and Gamboa', written in collaboration with Gronk and Willie Herron, 1976, in Harry Gamboa Jr, *Urban Exile: Collected Writings of Harry Gamboa, Jr.*, edited by Chon A. Noriega, Minneapolis: University of Minnesota Press, 1998, 27–31; Jose Montoya, 'Chicano Art: Resistance in Isolation' ('Aqui Estamos y No Nos Vamos'), unpublished paper delivered at the symposium, Art and National Consciousness in Latin America, UCLA, 21 and 22 November 1981; Judith Francisca Baca, 'Our People are the Internal Exiles', from an interview with Diane Neumaier, in Douglas Kahn and Diane Neumaier eds, *Cultures in Contention*, Seattle: The Real Comet Press, 1985, 62–75; Harry Gamboa Jr, 'In The City of Angels, Chameleons, and Phantoms: Asco, a Case Study of Chicano Art in Urban Tones (or Asco Was a Four-Member Word)', in Richard Griswold del Castillo, Teresa McKenna and Yvonne Yarbro-Bejarano eds, op. cit., 121–30.

19. Joseph Sommers and Tomás Ybarra-Frausto eds, *Modern Chicano Writers, A Collection of Critical Essays*, Englewood Cliffs, New Jersey: Prentice-Hall, Inc, a Spectrum Book, 1979. Tomás Ybarra-Frausto, 'The Chicano Movement/The Movement of Chicano Art', in Ivan Karp and Steven D. Lavine eds, *Exhibiting Cultures; The Poetics and Politics of Museum Display*, Washington: Smithsonian Institution Press, 1991, 128–50. Tomás Ybarra-Frausto, 'Arte Chicano: Images of a Community', in Eva Sperling Cockcroft and Holly Barnet-Sanchez eds, *Signs from the Heart; California Chicano Murals*, Venice, California and Albuquerque, New Mexico: Social and Public Art Resource Center and University of New Mexico Press, 1990, 54–67.

20. See Yolanda Broyles-Gonzalez, *El Teatro Campesino: Theater in the Chicano Movement*, Austin: University of Texas Press, 1994, 35–58.

21. Art historian, Jacinto Quirarte, is the other scholar acknowledged for his early studies of Mexican American and Chicano art. See *Mexican American Artists*, Austin: University of Texas Press, 1973, and Jacinto Quirarte ed., *Chicano Art History: A Book of Selected Readings*, San Antonio: Research Center for the Arts and Humanities, The University of Texas at San Antonio, 1984. See also 'Confluencia de Culturas: An Interview with Jacinto Quirarte', *The Archives of American Art Journal*, 45, 3–4, 2005, 2–24. A third, early writer on Chicano art is Mildred Monteverde who curated an exhibition and wrote the eponymous, bi-lingual catalogue, *chicanos gráficos..california*, Pueblo, Colorado: Southern Colorado State College, 1974.

22. Shifra M. Goldman, 'Resistance and Identity: Street Murals of Occupied Aztlán', in Shifra M. Goldman, *Dimensions of the Americas: Art and Social Change in Latin America and the United States*, Chicago: University of Chicago Press, 1994, 118–22. This was first published as 'Resistencia e identidad: Los murales callejeros de Aztlán, la ciudad ocupada', in *Artes Visuales*, Mexico City, 16, Winter 1977, 22–25, 47–49.

23. From Stuart Hall, 'Museums of Modern Art and the End of History', in Stuart Hall and Sarat Maharaj, *Modernity and Difference*, inIVAnnotations 6, edited by Sarah Campbell and Gilane Tawadros, London: inIVA, 2001, 19.

24. *Art of the Other Mexico; Sources and Meanings*, curators: René H. Arceo-Frutos, Juana Guzman, Amalia Mesa-Bains, Chicago: Mexican Fine Arts Center Museum, 1993; Shifra Goldman, 'Response: Chicano Art and the Neo-Mexicanists', unpublished paper, given in response to 'La historia de amores, resentimientos y olvidos: El arte chicano y la pintura neo-mexicanista' (A Story of Love, Resentment and Oblivion: Chicano Art and Neo-Mexicanist Painting), presented by Amelia Malagamba at 'Representing Latin American/Latino Art in the New Millenium: Curatorial Issues and Propositions', international symposium held at the Jack S. Blanton Museum of Art, University of Texas at Austin, 20 October 1999.

25. Ondine Chavoya, 'Orphans of Modernism: Chicano Art, Public Representation, and Spatial Practice in Southern California', unpublished doctoral dissertation, University of Rochester, Department of Art and Art History, Program in Visual and Cultural Studies, 2002.

26. Ondine Chavoya, 'Orphans of Modernism: The Performance Art of Asco', in Coco Fusco ed., *Corpus Delecti: Performance Art of the Americas*, London: Routledge, 2002, 240–63.

27. Ibid., 246.

28. Ibid., 246–47.

29. The Christmas parade had been cancelled as a result of the police riots that had occurred on the occasion of the 29 August 1970 National Chicano Moratorium March Against

the Vietnam War, the same altercation in which the journalist Rubén Salazar was killed.

30. Prior scholarship on Asco includes the article by Marcos Sanchez-Tranquilino, '*Murales del movimiento*: Chicano Murals and the Discourses of Art and Americanization', in Eva Sperling Cockcroft and Holly Barnet-Sanchez eds, op. cit., 84–101.

31. Misperceptions of Chicano/a art as ethnography were further highlighted by the reception of the *CARA* exhibition in mainstream journalism as recently cited in Ondine Chavoya, 'Chicano and Latino Art in the 1980s: From *de Regional* to *de National*', Chapter One of 'Orphans of Modernism', 2002, op. cit., 75, 79–80. Under the headline, 'Resisting Modernism: Chicano Art: Retro Progressive or Progressive Retro?', Ralph Rugoff wrote in the *L.A. Weekly*, 'If you're addicted to the thrill of the next new thing, it's difficult to enjoy art that is stubbornly non-experimental. For this reason, much contemporary Latino works seems anachronistic to the *gringo* art world. The aesthetic traditionalism of much Latino art renders it irrelevant, not to mention downright boring, when judged by a Modernist program that prizes formal innovation, or by the terms of Postmodernism's self-conscious criticality … [the question] inevitably raised … and inadequately answered' was whether Euro-American and Chicano culture 'harbor[ed] irreconcilable ideas about art', 1990, 43.
 Chavoya goes on to cite and analyse the article written by William Wilson (79–80). 'Senior *Los Angeles Times* art critic, William Wilson, was ostensibly infuriated that a "non-Eurocentric culture" was presented in a mainstream venue "on its own terms." Wilson contended that Chicano art "works among the home folks," but what piqued his anger was that this style of "neighborhood art" had moved into an institution that "once housed a retrospective of Henri Matisse." … Wilson warned that failure to achieve the correct "balance between ethnography and art" was a symptomatic danger shared by these initiatives to "nurture understanding between diverse cultures." Wilson also implied that to exhibit "art made to be shared with friends and family without considering the larger audience" was divisive. "In an epoch when polarization runs high and skins rub thin … CARA's collective look becomes a simile of a stay-with-the-gang-subculture."', *Los Angeles Times*, 1990, 7.

32. Mesa-Bains, op. cit., 158.

33. Ybarra-Frausto, 61 (in this publication).

34. Ibid.

35. Ibid., 67.

36. Ibid.

37. Ibid. Luis Valdez, *Early Works, Actos, Bernabe, Pensamiento Serpentino*, Houston: Arte Publico Press, 1971,

12–13. 'It [the *acto*] evolved into a short dramatic form … the following are some of the guidelines we have established for ourselves over the years: *Actos*: inspire the audience to social action. Illuminate specific points about social problems. Satirize the opposition. Show or hint at a solution. Express what people are feeling … the major emphasis in the *acto* is the social vision, as opposed to the individual artist or playwright's vision. *Actos* are not written; they are created collectively, through improvisation by a group. The reality reflected in an *acto* is thus a social reality… .'

38. Holly Barnet-Sanchez, 'Transformations: The Art of Ester Hernandez', in *Transformations: A 25-Year Retrospective*, curated and catalogue essay by Holly Barnet-Sanchez, San Jose, California: MACLA, San Jose Center for Latino Arts, 1998, n.p.

39. Ybarra-Frausto, 67 (in this publication).

40. Interview with Larry Yañez, November 2006. It is interesting in this context to think of murals as *rasquache*, particularly those by Gronk who specialises in ephemeral murals that exist for a few weeks only.

41. It was reconstructed for the *CARA* exhibition in 1990.

42. Luis Jimenez, '¡Colores!', Albuquerque: KNME-TV, 1991.

43. Josh Kun, 'The New Chicano Art', *Los Angeles Times Magazine*, January 2005, 31.

44. Andrea Quijada, 'Amalia Mesa-Bains: Positions of Paradise and Prison', unpublished paper written for a graduate seminar, Sources and Transformations in Chicano/a Art, Professor Holly Barnet-Sanchez, University of New Mexico, Spring 1999, n.p.

45. Mesa-Bains, op. cit., 160.

46. Ibid., 161.

47. Griselda Pollock, *Visions of Difference: Feminity, Feminism and the History of Art*, Routledge Press, 1988, 66, cited in Mesa-Bains, ibid., 161–62.

48. Quijada, op. cit., n.p.

49. If one studies the two catalogues, *CARA* and *Distant Relations*, it is possible to discern certain developments. *Rasquachismo*, in the context of *CARA*, is introduced into the analytical discourse to facilitate possible 'readings' of Chicano/a art. *Distant Relations* enables the reader to 'compare and contrast' (to use the standard art history slide exam terminology) *rasquache* Chicano/a art practices with cultural negotiations from elsewhere.

50. Mesa-Bains, op. cit., 158.

51. George Lipsitz, 'Not Just Another Social Movement: Poster Art and the *Movimiento Chicano*', in Chon Noriega ed., *¿Just Another Poster? Chicano Graphic Arts in California*, Santa Barbara: University Art Museum, University of California, and Seattle: University of Washington Press, 2001, 84.

POP AS A CRISIS IN THE PUBLIC SPHERE

SÔNIA SALZSTEIN

Since the 1980s, pop art has become a recurring topic within the re-examination of modernity and its ideologies.[1] Such a precocious act of stocktaking prior to the closure of the 20th century was compelled in light of the contentious debates on politics, economics and social issues, brought to the fore by the exhaustion of the cycle of modernisation associated with the 1960s. In so far as pop was itself an emblematic culmination of the experience of modernity 30 years ago, it became a privileged figure within this re-examination. It was not by chance, then, that one of the most revealing events of that period emerged from the field of art, when Andy Warhol famously pronounced 'Business art is the step that comes after Art'.[2] Subsequent events would seem to confirm this state of affairs, as the period of the 1980s was characteristically marked by a surge in Europe and North America of new art museums and cultural complexes. Indeed, one of the primary novelties of this new configuration was the grandiose insertion of art – under the auspices of architecture – into the arena of high-level culture as a global entertainment business.

Evidently, the revelation of culture's omnipresence within the contemporary context was a novel historical phenomenon: as far as the implications for the artistic debate are concerned, it is worth noting that it was no longer the case of the renowned modernist polarity between art and culture, where the contradiction between the poles was precisely what continuously nourished each side and maintained their very (separate) existence without concealing their reciprocal fascination and repulsion. In the 19th century, Baudelaire could thus celebrate beauty in the bastard-nature of the streets because it was there that the poet found the height of *lived experience* and because art's most sublime face would only show itself through its unreserved immersion into vulgarity. In other words, the cultural climate that emerged in mid-19th-century Paris, and that brought new ingredients into the bourgeois public realm, could not socially legitimate itself without its 'other', that is, the illegitimacy and vulgarity of the streets. Bastardisation, vulgarity and bohemianism – these key terms in the modern formula with which art and culture contaminated themselves without losing their respective jurisdictions – were at once a sub-product of the bourgeois public sphere and elements that actually presupposed its normative power. Such 'illegitimate' elements testified to the universality of bourgeois norms while concurrently recommending a continuous process of negotiation, because the possibility of transgression would always be there; they would stalk art from the shadows, in order to obtain no more than tacit recognition. At least since Courbet, modern art always knew how to extract its most radical results from this inherent ambiguity of the bourgeois public sphere, appropriating permissive material from popular life, albeit in a cryptic guise that was forged by the new technical rationality to which artistic style had been reduced.

Once seen in a long-range perspective, the idea of culture as a mediation between art and social space – as an 'impure' matter, yet that which is alive and indispensable to art – was not historically a new phenomenon. What in fact emerged for the first time in the late 20th century was the perfect and reciprocal adherence of art and culture whereby nothing was left aside – a form of conservative synthesis that had finally reached its 'absolute' stage, or, in other words, achieved its positive 'resolution' in the dialectics of modernity.

During the 1980s, the view was frequently expressed that a new and distinctive cultural era had begun, or according to another point of view, that Art – with a capital 'A' to signal that it was now emancipated from its objects[3] – amounted to nothing more than pouring a shovel of lime over the corpse of art, whose death had already lasted long enough. This modern leitmotif concerning the 'death of art' had proved to be highly stimulating for the most radical aspects of 20th-century art: the more excruciating the agony of art appeared to be, the more it seemed possible to prolong it.[4] What changed during the 1980s, however, was that the overcoming of historicism was proclaimed with great euphoria such that from this moment onwards one supposedly lived in a 'post' era where art had finally been subsumed into a 'state of culture'.[5] Although the imagery of the death of art had persisted through the years, something had changed. The excruciating experience of that continuously deferred death had become an irremediably banal theme. Art that had pretensions towards a heroic elegance showed itself, at best, to be an ersatz form of high culture, a nostalgically affected commentary on the idea of modernity. For other currents in the artistic debate, that experience of disillusionment had been decanted into a sophisticated resentment against art, or at least against the 'autonomous' art forged by 'western culture'.[6]

For those cautious before the (professional) hyper-ideologisation of the times, the debate on post-modernism as the new 'state of culture' recommended an austere effort of comprehension. Contrary to what the post-modernists would have us believe, the question of 'art's death' still remained as a central point in the contemporary agenda. In fact, it re-emerged in broad daylight – as in a Brechtian didactic epic drama – but was nevertheless incapable of providing an enlightened outcome because it was ironically presented as the 'resolved' ending to the history of modernity that now rescinded the liberating critical omniscience of the 'epic narrator' (in Brecht's terms). The 'post' was thus a re-emergence without pathos. This 'epic theatre' of debate spoke about the present only in the third person, and instead of awakening the contemporary spectator towards activity or an illuminating thought (as Brecht would have expected), it led the spectator towards a state of stupefaction and a stasis of ideas. Today, we are a bit more distant from the discourse of the spectacular 'end of times' and the climate of economic, political and social *arrivisme* that had marked the 1980s. I believe it is more or less from this point that we should re-assess the debate about art and culture initiated in that decade in order, amongst other issues, to enquire about all that was said on behalf of post-modernism concerning the significance of the 1960s.

In any case, it may be said that the modernist watchword of forging art into life had been largely achieved as a state of affairs in the 1980s – it does not matter for our purposes here if this had been done as an imperative of the very process of modernisation, and not exactly as once glimpsed by an emancipatory modernist horizon. In that moment in which many found themselves existing 'after art' – in a present without chronometry – one would breath culture, or Art, all around. We cannot deny the fact that the renewed interest in pop that emerged in the 1980s was to a large extent a self-justification of the 'run-for-your-lives' climate that characterised the high tide of the neo-liberalist moment, whose

parodies of radicalism *pour épater le bourgeois* (a 'class' that historically had long disappeared) scarcely disguised the (petit bourgeois) contentment of the industrialised nations' urban middle classes with their newly found well-being (where art had become a sort of lifestyle). With the passing of almost 30 years, it now seems clear that, for good or bad, something was taking place that could be described as a process of 'cultural democratisation' (at least at the level of the new culture now being produced on a global scale), and that this process also managed to transform anything that denied the appeal and vitality of this new 'state of culture' into a ridiculous and snobbish attitude.

Despite a lot of ideological mystification, we might acknowledge, however, that the renewed interest expressed during the 1980s towards pop contained a hint of revelation. The paradox is that the essentially inclusive attitude of the new international artistic circuit was nonetheless exerted within a re-hierarchisation of power structures at a global level, according to which strategically diffused decision centres continued to rule the form and quality of the appearance of 'peripheral contexts'. In fact, in the course of the subsequent decades, the audiences that would follow the vertiginous rise of world-wide artistic events and biennials[7] demonstrate that art's public had expanded far beyond the urban middle classes polished by formal education, and that the market for cultural products had indeed *internationalised* itself by de-canonising the frontiers of the hitherto well established hegemonic poles. After all, in this new all-inclusive 'state of culture', was there anything what would not, sooner or later, be liable or susceptible to the global process of becoming 'cultural'?

As one of the central lines of enquiry developed in this chapter, these remarks on the shifting relationships between art and culture also lead onto the following questions: what social and political shifts were announced by this new public for global art? To what extent could 'pop culture', now decanted into a globalised world, be equated with that longed-for universalisation of modern taste as a phenomenon that was now finally appropriated and reinvested by the collective imagination? Would modernity, in these terms, have inaugurated a 'multicoloured' modern vernacular culture for the first time, however problematic this term might be?[8] And how does this new historical situation – living in an *image* era that is exponentially experienced via the internet (were text could also be understood as *image*) – oblige a redefinition of the classical notion of public space?[9] Refusing the essentialist and historicist visions of post-modernism, we may speculate that instead of representing an absolute rupture with the process of modernity, this situation was in fact a moment in which the metastatic process of opening of opportunities initiated by modernity itself reached such an acute level – or re-potentialisation – that their total possibilities could not be revealed all at once to contemporary consciousness. In this respect, it is worth digressing into some of the aspects relating to the emergence of the new cultural system during the 1980s, precisely because these issues not only inform us about the contemporary transfiguration of art's public but also indicate major shifts in the actual domain of art itself.

Art and Culture in a Global System

Within the large scale reorganisation of the western cultural system – in which changes in the field of art were a mere facet – one cannot ignore the fact that there existed an indirect effect upon it stemming from demands made by regions that until then had been marginal to this system. These demands placed pressure on the 'developed world' by requesting their part in the process of modernisation. Such demands were expressed from regions that during the 1980s and 1990s had become politically emancipated (in the African continent); that had reorganised their internal political, economic and social dynamics following long periods of military dictatorships (in Central and South America); or, further still, that aimed for a strategic integration into the global economy despite being led by so-called non-aligned governments that held aggressive modernising policies (India, Taiwan, China and Korea).

It is certainly the case that the world-wide spread of the notion of multiculturalism played an important role in the recognition of the political legitimacy of these demands. Produced in the context of the world-wide flux of capital, such demands are inextricably connected to an inequality of positions: developing countries reached the centre of the global cultural system symbolically (since the 'physical presence' of such regions had long been marked by continuous waves of immigrants whose very presence, based on penury and sub-citizenship, constituted living proof of the dysfunctions of modernisation), and the historical novelty of their affirmation in this system was also responsible for defrocking imperial power of its devices. Neither can we underestimate how much multiculturalism was part of the denunciation

(and revision) of the rigid hierarchy of power that had governed such a system, at least since it achieved, through the North American hegemony, a complete international jurisdiction after 1945. Additionally, multiculturalism was important in the promotion of civil rights as it enlarged this classical notion to the point of achieving the rights of subjectivity – which means that from now on it had to comprehend the rights of marginalised groups (women, blacks, homosexuals, ethnic minorities) in diverse parts of the world.

However, with regard to the multiculturalist discourse (and perhaps against the grain of the efforts of many of its theoreticians), the doubt remains as to whether it has suppressed the complexity and the historical diversity of debates that had already advanced a long list of political and social re-vindications. It is highly pertinent to remember the academic and theoretical origins of this discourse. The impression today is that multiculturalism has assumed for itself the merits of experiments towards new forms of political expression that had grown out of diverse historical trajectories in various locations around the planet, whereas these diverse experiments had, in fact, matured as answers to the collapse, from the late 1960s onwards, of traditional political forms hitherto at the core of social movements. It is thus relevant to raise a question first of all about the ideological homogenisation that fatally occurred following the moment in which multiculturalism emerged as the representative for all claims made in the name of difference. Second, it is important to ask to what extent multiculturalism, in its global *modus operandi*, mimes the totalising and fragmentary procedures that this current itself had denounced on the part of modernity, and why

it neglected to criticise the process of globalisation within which nevertheless it had been able to take shape. Thirdly, by longing for a globalised community that is transparent to itself – redeemed in a culture finally rediscovered as 'nature,' *a fortiori* as a state where 'natural individuals' can be redelivered to an 'original' private ethics – to what extent does multiculturalism contain an idea of tutelage and the infantilisation of the masses?

With regard to the first issue, one need only remember the legacy of emancipatory experiments pursued by the black, women and youth movements that date from the late 1960s – well before anyone would have heard of multiculturalism – as platforms that were distinguished from traditional political forms by going beyond the classical claim for civil rights. In a new and provocative manner, these movements brought to light an implacable critique of bourgeois subjectivity and an invitation to new forms of sociability. In Brazil, the Landless Rural Workers Movement (popularly known as MST) that was formed in the late 1970s and which emerged outside traditional political parties and institutions was one such extraordinary experiment in contemporary social movements. Although the MST has now lost much of its experimental drive, it doubtlessly marked contemporary social history – above and beyond denouncing persistent Brazilian social injustice – with cultural experiences that led to the politicisation of everyday life among marginalised communities, popular education and the emancipation of women from working-class backgrounds. The MST also brought a drastic renewal in the world-wide public perception of the *image* of poverty in Brazil. From the 1980s, dispossessed people began to

emerge in the media as organised and self-confident masses that stood in stark contrast to the figures of victimisation, stupidity and of the biblical damnation of the *poor devil* that is so ingrained in the national imaginary.

However, in light of the ethnic, political and religious fundamentalisms that have emerged in the 1990s, it becomes urgent to re-evaluate the compensatory strategies that often arise as emulations of multiculturalism. Unlike the experiments of the past, these strategies depend on the capacity for individuals to organise themselves into interest or lobby groups that subsequently compete amongst each other in the fight for the fulfilment of their interests and corporate necessities. Such corporative developments raise doubts as to whether multiculturalism is essentially an ethical and moral requirement in the encounter with the Other (which presupposes a reciprocal disposition for a process of change), or if the rhetoric of multiculturalism now amounts to a formidable ideological passport for the affirmation of origins and identities at whatever price (for when identities exalt or deny the present, this is where the clash with the Other occurs *par excellence*).

Returning to the equally problematic contribution of multiculturalism to the reconfiguration of the field of art during the 1980s, the following observations can be made. I have already referred to the new types of artistic and cultural 'institutions' that now appear in global culture, and we should note that the inverted commas remind us of the origins of the term in the 18th-century Enlightenment – which posited *institution* as an invention of bourgeois modernity – and in this sense it is probably inadequate in describing such new spaces.

Contemporary museums of art and the emergence of 'flexible' or 'multi-use' cultural spaces tend to favour an intense circulation of works at an international level. By virtue of an efficient politics of exhibitionary practice, for the first time such institutions now include itineraries for artistic productions – from Latin America, the Middle East, Africa and Asia – that were all hitherto unthinkable in this circuit. This phenomenon has been further accompanied by a curatorial apparatus based on interactive technologies and institutional administrative strategies aimed at creating empathy between the objects exhibited and the public, and to generate a complicity between them. In this new global scenario, the artistic experience has became a 'service provider' in that the administration of global circuits for art and culture makes it indispensable for institutions to produce measurable performances as far as the public is concerned, who are then required to process it as 'information', while severely liquidating the distance that is installed around art's constituent operation as poetic praxis.

Almost three decades after the advent of pop art, it is compelling to think that these contemporary developments are indicative of the appearance of a new public for art and, moreover, of a new and extraordinarily all-inclusive public space for art. But if the idea of an art dissolved into the demands of culture (and naturalised as 'life') was again the order of the day in the 1980s, it is improbable that the art milieu, with its eyes directed towards pop art, could have ignored the explosive arsenal of ideological contradictions that had provided ammunition to such an idea in the most radical sectors of the artistic production of the 1960s. The ambition to fuse art and life had not only

instigated Andy Warhol's form of malign realism as well as Guy Debord's and the Situationists' romantic revolt, but had also informed the hyperbolic adventure of the Brazilian Tropicalists who sought to fuse mass culture and national traditions in works that resulted in refined and violent poetic constructions of the most pure ideological ambiguity – not to mention the trance of debauchery and consumerist fetishism performed in Antonio Dias' works of the period.[10] What kind of art therefore, was then being prescribed behind the scene by the cultural apparatuses precipitated in the 1980s to a public that, in its turn, was expected to be spared from the mediations of cognitive processes? Besides, what kind of public space was it, which in the name of the new globalised partnerships, and the proclaimed efficacy of these new horizontalised, instantaneous communities, that repressed the long decanted presence of historical formations, including national ones?

It is also disquieting that in the 1980s the debate around art had sublimated the provocative and problematic cognitive dimension that mass culture should reveal when turned against itself (this was the gamble of the most radical art of the 1960s – including the examples just mentioned). The contrary was in fact the case, whereby mass culture was acknowledged in its 'facticity' as an outcome brought into the sphere of art by technological progress. The idea of a community of culture that was always transparent towards itself, amongst its members, can be seen to entail the moralism accompanying the notion of an absolute accessibility of art, which buries the very possibility of questioning how a given object or process becomes 'art', which, after all, concerns the ontological dimension of what constitutes art's language or form as a poetic praxis.

Equally disturbing is the fact that these aspects of debate remained inhibited over two decades, such that it was only with the turn of the millennium that the triumphant discourse of post-modernism in the 1980s began to be questioned. In actual fact, in the wake of the sanctified multiculturalism that also emerged over the past 20 years, a new type of populism has arisen, this time extravagantly[11] global in nature. This global neo-populism addresses all social strata in a diffuse manner, positioning itself within new forms of sociability brought about by information technologies. It has great confidence in the new public space that is unveiled by the media and that is practiced – and here is the worrying trend – not just by individuals self-understood as groups of consumers or marginal social groups, but by governments, transnational corporations, and by an array of non-governmental organisations (NGOs) that are not only beyond public scrutiny but which are also capable of attracting the interest of high level capital and that prosper as compensatory mechanisms for the contemporary dismantling of public policies.

This jet-propelled populism promises nothing more than the promotion of the masses (including the impoverished masses of industrialised periphery countries) through the consumption of culture and art. Art is now institutionally presented as a 'quality of life' issue; as a promise to novice militants of a more attractive life ruled by subjective primacy; or as a compensatory mechanism offered in light of the ongoing decomposition of social bonds. We have not yet touched on the most urgent question of whether the capital that today sponsors art on a global scale or that promotes 'culture' with transnational width and breadth – in the case of

biennials, art fairs, international festivals, travelling blockbuster exhibitions and other cultural events – could ever direct itself towards the social world? If it did, it would no longer have to deal with well-intended novice militants, but instead with infuriated and depoliticised masses (at least in the classical sense of the word 'politics'), such as those united by violence, by resentment, or by a state of necessity. In this respect, the urban attacks that occurred between May and June 2006 in the city of São Paulo, which were initiated by criminal organisations, whose jailed commanders instigated events from inside the prisons (and thus counted upon the support of the judiciary and the legislative and administrative state apparatus as well as the support of the entrepreneurial class), invite our critical reflection on the shifting character of the public sphere in the neo-liberal global era.

Art and Politics in 1960s Brazil

This brief digression into events of the last quarter of a century reconstructs in a general manner the context in which the term 'pop' became associated with an entrenched battle of ideological reconfigurations. In this respect, it is worth questioning whether, during the 1980s, the term still preserved the power that had marked its appearance 20 years before, when, above all, it designated an irreverent attitude towards new times, an attitude that signalled the historical impasse of once-revered institutions of bourgeois society – amongst which was nothing less than the institution of the public sphere itself, which became more central the more it was questioned and invalidated by contemporary technology of information.

So, against whom was the new 'world of culture' (that once claimed affiliation with pop)

directed during the 1980s? Should we attribute to that wave of neo-pop the power to undermine the assumed dominance of 'high-culture'? In the midst of the universalisation of mass culture, that created its own hierarchies and legitimation criteria, how could art have survived but as a parody of the notion of 'high-culture'? What 'high-culture' was this from which the ballast of bourgeois society had strangely disappeared, being already for so long only present in history books? In an attempt to turn such an artillery of questions *against* the present configuration of art and politics, I will address some aspects of the impasse that the contemporary act of thinking about art provokes.

In the cultural system that emerged in the 1980s, that brought numerous new protagonists to the fore, each in turn launching a new and complex power game, the configuration of art and culture attested to the fact that it was no longer possible to satisfactorily 'recount' the 'history' of art as an agreed narrative. What was called into question was not only that which had unfolded in art over the previous three decades, but also the entire history of art contained in books, museums and universities. The history of art hitherto available in the West showed itself to be inadequate when describing the wide range of artistic manifestations that emerged in the second half of the 20th century. As a discipline forged in the positivistic frame of the 19th century, art history was also ideologically inept with regard to the contemporary requirement of enquiring about so many other 'histories', so many different modernisms, and so many cultural experiences that responded with originality and in their own manner to the imperative of modernisation, which the canonical account would only register (if at all) as epigone

manifestations, as backward or simply as atavistic regional archaisms. From the critical evaluation of western history that began to be elaborated during the late 1970s, there emerged the suspicion that perhaps modernity did not represent the universal destiny of humanity, as canonical western history implied. The perception that the human aesthetic experience would not allow itself to be appropriated by the concept of 'art' that developed in the West since the 15th century meant that not all art could be reduced to its criteria.

It may well be the case that we still find ourselves in the crossfire of this discussion, from which will hopefully emerge new, complex and multi-focus possibilities for thinking about art as well as for understanding how art thinks about the world. Amongst such possibilities, there should be at least one that allows us to speak of 'pop' from a Brazilian point of view, or one that foregrounds the relevance of a local contribution in the understanding of pop as an international phenomenon, where local and global are strangely hybridised without being ostracised from the game of mutual tensions that nourishes them. Hence, in what follows I question the Euro-American patrimony that is tacitly ascribed to the pop phenomenon, as if the position of *lack*[12] in the case of peripheral countries (or from the culturally peripheral experiences that are in fact formed within the 'centre') was not the other side of the same coin that gives meaning to the affluence of central countries. In fact, we cannot ignore how the experiences of fast-paced accumulation that pop art presupposes can also be seen, according to an alternative point of view, as inscribing a lack of vacuity. Whether our focus is on central or peripheral regions, close attention to pop art strategies suggests that such

Next page:
Antonio Dias,
Anywhere is My Land,
1968

experiences are exchanged freely amongst themselves and that they actually overlap, once accumulation and lack are seen as different names that can be ascribed to the one and the same process.

A schematic and dualist vision has long placed centre and periphery in opposition, as if these were distinct formations that for reasons of their historic vicissitudes had reached unequal levels of development. Such an approach reveals itself to be inoperative in light of the diffused character of the centres of power in the era of globalisation. To counteract this, I employ the argument of the notable Brazilian sociologist, Francisco Oliveira, who renewed the study of the socio-economic expansion of capitalism in Brazil:

> In a theoretical level, the concept of underdevelopment as a singular historical-economical formation, dualistically constituted on the basis of a formal opposition between a 'belated' and a 'modern' sector is inconsistent as a singularity: one can find this kind of duality not only in practically all systems but also in practically all periods. In the other side, the opposition is but formal: as a matter of fact, the real process shows a symbiosis and an organicity, a unity of contraries, in which the so-called 'modern' grows up and nourishes itself from the very existence of the 'belated', if one really wants to keep this terminology. The 'underdevelopment' would seem to be the very form of the pre-industrial economies being pervaded by capitalism, therefore 'in transition' to its more advanced and consolidated forms; however, such a formulation elides the fact

that 'underdevelopment' is precisely a result of the expansion of capitalism. [...] in short, underdevelopment is firstly a capitalistic formation, and not simply an historical one.[13]

In the following section, these dynamics of global art and culture are discussed in light of the ambiguous inflections of pop in the work of the Brazilian artist Antonio Dias during the 1960s and 70s.

Antonio Dias: *Anywhere is My Land*
Anywhere is My Land is the intriguing title of a 1968 painting by Antonio Dias. The title at once affirms, by its very negation, the non-exchangeable character of a place and evokes the agonising memory of an old belonging. The use of the possessive pronoun accompanied by the word 'Land' is indicative of the fact that, in extreme conditions, where all would appear absolutely foreign, under such conditions the 'I' would remain as the missing element in order for something to make sense. One cannot avoid noting, nevertheless, that the manner in which the title is formulated transforms the 'I' into something relative and de-centred, that should not show itself unless summoned, and this undoubtedly makes its interminable saga of re-semanticisation of the world all the more striking. Finally, there is a thread of irony in the apparent delight that is enunciated in the title, since at the time in which the painting was produced, 'My Land' perhaps no longer existed anywhere. Thus, the uprooting that is ambiguously affirmed in this work refers not so much to the proclamation of the omniscience of the subject that makes the announcement, but to the mobility and transitoriness of the contemporary artwork.

ANYWHERE IS MY LAND

In any case, it is difficult to know whether 'land' evokes an imaginary geographical, territorial dimension or simply a remote horizon of localisation, a provisional re-encounter with an origin that is accessible only retrospectively and that tends to erase itself under the abstract indifferentiation of all and any place. What is certain is that if there is any reference to the notion of space in this title it has nothing of the phenomenological dimension that the term held for modernism: the diagrammatic, grid-like space, that is dryly exhibited on the surface of *Anywhere is My Land*, leaves no doubt as to the contemporary dilution of all naturalist presuppositions in art and of the ascendency of notions of 'system' and 'pattern'. For this reason, perhaps the 'I' referred to may show itself to be so oblique that it would only appear, in a manner of speaking, in the backstage of this painting, as an entity to be inferred over the announcement text on the external margin of the grid that occupies almost the total surface of the picture.

Instead of the immanent relation between the 'I' and the 'other', the 'here' and 'there', that a phenomenological experience of space precipitates, the contemporary logic of systems and patterns that has penetrated our representations of space shows itself to be adverse to the recesses, to the complicity and to the deferred and expanded time produced in the type of relation that Dias proposes – which is a twofold predicative relation where the terms incessantly switch in a reciprocated transformation. In a space that allows itself to be represented exclusively through a system or pattern, being reigns in a continuous and multidirectional flux of relations. In this manner, the fact that one is connected to this flux – immersed in a state of absolute 'relationality'

– does not imply being involved with the 'other', or in the superior plateaux of *experience*, to which one would expect inter-subjective relations to lead.

Thus, the systems, patterns and grids that can be observed in *Anywhere is My Land*, as well as in a series of canvases and installations that the artist produced into the 1970s suggestively entitled *The Illustration of Art* (1972–78), paradoxically presuppose an intensification of relations that can simply remain virtual and that do not require, therefore, ever being updated. In this sense, the painting demands of the spectator a hypnotic as well as a de-ritualised form of contemplation.

We belong to a world criss-crossed by a metastasis of relations, yet we live, strangely enough, in what could be described as an absolute horizontality. The canvas seems to declare that we have the teleological machine, but not the *telos*. With its dissonant voices that seem at times to affirm the 'I' whose singularity would constitute the differential value of 'a place', and which, at other times, seems to confront us with the abstract *design* of the canvas, which is liable to expand or contract indefinitely, this work makes all places (and all I's that are its vanishing point) equivalent.

The indifference, the banality even, with which the artist, in *Anywhere is My Land*, positions himself in the interior of the painting simply to show this work's rigorous externality to contemporary notions of space (as I have suggested regarding the title that reappears as an ultra-white logotype on the upper left-hand side of the picture) attests to the abyss that is installed between the presumed 'I' of the title-statement and the literality – in other words, the excruciatingly anodyne pedagogy – of the

'cartographic' representation printed on the surface. Polarities such as these gloss over the manner in which the entire work of Antonio Dias has drained its main concerns away from the cultural atmosphere of the 1960s[14] and from the impasses that the new 'state of culture' brought into the practice of art.

The somewhat bravado tone of these oppositions that arise with a closer observation of *Anywhere is My Land* suggests another irony that is at play: to go through with a pictorial performance that produces a random splash effect of paint on canvas, only to subsequently confine the 'field of action' to a laconic square in the grid scheme. One soon notes that oppositions of this nature are weak, boneless (as if they are jocular commentaries about themselves), and incapable of sustaining a dialectic. Many other works by Antonio Dias, produced in the late 1960s and early 1970s, also stage this 'dialectic disturbance' in an implacable manner – they establish the poles of an opposition that ultimately shows itself incapable of taking forth a dialectical movement of progression or development.

Amongst other things which this 'dialectic disturbance' seems to inform is the extent to which, in the late 1960s,[15] the universalising process of a pop culture had made redundant the old explicative power of oppositions, such as national versus international, periphery versus centre, provincial versus cosmopolitan, and for forth. Under the new conditions of culture, the meaning of the term 'influence' significantly changed. Traditionally used as a denunciation of the object's lack of content or the complacency of this object when confronted by the siege of 'external forces', the condition had emerged where it was possible for objects to exist in

absolute contiguity, such that it became difficult to determine priorities and to trace clear limits between self and other, 'internal' and external'. Additionally, in this new 'state of culture' one was no longer under the jurisdiction of a tradition in art that guaranteed 'belongingness' and 'filiations'.

To the extent that one of the possible connotations of *Anywhere is My Land* would be the new mobility and transience of the contemporary artwork, it is necessary to consider that such a reading not only alludes to the loss of the referent in the contemporary conception of space (and it is not by chance that since the 1960s this notion became better described through concepts such as 'site', 'situation' or 'context'), but also to a sort of epistemological agony of art. It is this aspect of Antonio Dias' oeuvre – especially the formative moment of his work in the late 1960s and 1970s – that can be further illuminated by a consideration of the problems of modernisation precipitated in the Brazilian context.

Brazilian industrial modernisation in the 1950s was the neuralgic point of the national developmentalist project with which the country confronted the pressures of internationalisation in the post-war period.[16] It produced extraordinary responses within the cultural field: across cinema, architecture, popular music, concrete poetry and the constructivist art movements. It is worth emphasising that it was under such pressures of this internationalising process that Brazil constituted a modern experience with its own issues and aspirations, a modern experience that with time came to demonstrate great daring in light of the centres of power, and something of a resistance to the inevitable homogenisation that, together with the cultural updating, arrived in the wake of this

process. In short, it was an experience that could not be simply explained as a foreseeable effect of the expansion of Euro-American modernity nor as an epigone version of it, showing no more than regional interest or relevance.

Following the second half of the 1960s, however, the winds of modernisation brought numerous impasses to Brazil, above all, with the spread of a culture on an industrial scale. Not infrequently unashamedly commercial, yet with an illuminating local accent, the new cultural forms were adopted by younger generations who were suspicious of the reprimands of the old left-wing circles irritated by 'the betrayal of our roots' that they saw among the new generation. Additionally, in recalling this period, one must take into account the fact that the military coup of 1964 had brought about a disillusionment with the project of modernisation to which an important stage in the national history had been consigned.

Having had the backing of the majority of the Brazilian left, the national-developmentalist project was cut short, and the stimulating cultural debate that had been previously achieved was confronted by a bitter political and social deception. Curiously, the military dictatorship thus witnessed, in the course of the two decades that followed, not the collapse of cultural production as such, but a vibrant culmination of a peculiar experience of modernisation in a peripheral context. It was precisely then, at that moment of high crisis, that the Brazilian experience of modernity that had matured in the 1950s became configured in a more complex manner and fully revealed its consequences. In fact the military dictatorship did not paralyse the situation, on the contrary, it had exacerbated it, taking to a new level a not negligible branch of

the global saga of modernisation that had not lost interest precisely due to the handful of contradictions that such an occurrence brought to the fore in a frank and exasperated manner – it unleashed elements of pathos and bizarreness that struck a contrast in comparison with the lyrical synthesis that the previous period searched for, when an elegant constructivist spirit dominated the arts.

The process of internationalisation, which had just begun in the 1950s and that a decade later had notably changed the character of life in the large Brazilian cities, certainly obliged a reformulation of the 'national issue' and the revision of the project of a local emancipated experience – yet these circumstances did not erase from the cultural debate the central concern with the dynamics of 'influence' that were now articulated in a new equation between the antagonistic poles of 'national' and 'international'. The artistic production of this period showed itself to be engaged in overcoming the harsh localism of the nationalist and populist ideology that had dominated the country's cultural life since the 1920s. Artists produced works of admirable experimental rigour, often in a grotesque and farcical tone, which built upon the intersections of materials emanating from the new internationalised culture that was in the process of becoming commonplace, and combined in unique assemblages with the best that the national tradition had to offer. All this occurred without discarding the incongruous idiosyncrasies of Brazilian society, which had been conveniently naturalised and perceived as national characteristics. Writing at the time, the literary critic and essayist Roberto Schwarz sharply summarised the heterodox procedures adopted

by one of the most important currents of artistic national production of the period – tropicalism – despite his reticence about the ambiguous ideology that, in his opinion, tended to dilute its possible critical reach:

> [...] perhaps one can say that the basic effect of tropicalism depends precisely on the subjection of such anachronisms, at first sight grotesque, but on second thoughts inevitable, to the white light of ultra-modernity, so that the result is transformed into an allegory of Brazil. The stock of images and emotions belonging to the patriarchal country, rural and urban, is exposed to the most advanced or fashionable forms and techniques in the world – electronic music, Eisensteinian montage, the colours and the montage of pop art, the prose of *Finnegan's Wake*, theatre which is at one and the same time raw and allegorical, with physical attacks on the audience. [...] The result of the combination is strident, like a family secret dragged out into the middle of the street, like treachery to one's class. It is literally an absurdity – this is the first impression it gives – however, the misfit reveals to the onlooker a real historical abyss, a junction of different stages of capitalist development. There are many ambiguities and tensions in this construction. The vehicle is modern and the content archaic, but the past is noble and present commercial; on the other hand, the past is atrocious and the present authentic, etc.[17]

In the mid-1960s, Antonio Dias, then in his 20s, produced the first significant works in his career. Works such as *Note on the Unforeseen Death* (1965) and *The Hero's Remains* (1966) were reliefs in painted wood, from which soft elements sprouted, projecting themselves into space and composing through an economical figuration printed onto the surface, a nonsense narrative permeated by allegories. Revealed in the totality of the composition is a violence, a longing and a schematisation that ostensibly refer to the desublimated frontality of cartoons and other clichés of commercial culture. Not by accident these works, with their truncated suggestions of bones, skulls, genital organs, severed limbs and bodies, emerged at the critical moment when the military regime was installed in 1964 and which lasted until 1984.

The elements that composed these scatological works, which tended towards 'formlessness', signalled a marked contrast from the limpid constructivist production of the previous decade. The latter, as is widely known, was characterised by the formal *tabula rasa* to which the concrete and neoconcrete constructivist movements aspired (albeit with respectively distinct meanings). Dias' works were a precocious sign of the new disengaged spirit – that paradoxically contained a purposeful critical violence – which would flourish in the country's cultural scene during the late 1960s and during most of the 1970s. It was not by chance that this disengaged spirit followed the collapse that the military coup inflicted upon the emancipatory expectations towards Brazilian modernity, which also coincided with the crisis that disrupted the modernist legacy from the inside. These undercurrents of crisis became manifest

Antonio Dias,
*Note on the Unforeseen
Death*, 1965

in initiatives in the field of art that symptomatically announced themselves as anti-art or anti-form.

In spite of the prodigal scenographic events that burst out of Antonio Dias' reliefs, with the warm and organic colours with which he painted his 'characters', there was an unequivocal Bretchian effect in play. One might observe that the artistic paradoxically extracted clear-cut results from all of the rhetorical elements that marked these reliefs. Most significantly, these works showed a homogenous treatment of surfaces – invariably white – which imposed a severe exteriority upon the 'drama' evolving from the combination of elements. Even the black grid that subdivided these surfaces, and that regulated the focus of a potential 'narrative', could be interpreted as much as a malevolent citation of Mondrian's grid as a quotation from the habitual scenery of comic books, which would be a more appropriate reference to the syncopated temporality found in this type of 'narrative'.

As I have argued, ideas about structure and system were already present in a germinal way in these early works and became recurrent features in Antonio Dias' production during the 1970s. From this moment onwards he produced works of an impressive formal austerity that seemed to refer to a subject that appeared to be on the edge of a blade, so to speak, incessantly tantalised by the adaptation to its surroundings while equally affected by the double-dealing of the standard grid, and stimulated by the exercise in self-irony. With respect to their contrast with his previous assemblages and reliefs, one cannot deny the fact that these apparently 'empty' works produced in the 1970s plunged into analytical elements of constructivist affiliation, while subtly emanating a melange of irony,

eroticism and a mute violence that was directed against the canonical forms of language.

Looking at his oeuvre as a whole, one might say that where the artist was formerly a director or actor in an abundant non-sense narrative, he subsequently achieved a sort of blindness in the world of art by raising to the surface the dazzling aridity of a rediscovered world of absences: an absence of meaning and of pathos, but also opacity and emptiness that is deliberately enjoyed, in a programmatic manner, in light of the saturation of cultural signs and their availability in the space of contemporary life. One might say that Dias was problematising the virtually unlimited space of a cultural system in which artworks could substitute themselves *ad infinitum* without interfering in the *design* of the system. The essential intervention of Antonio Dias during this period therefore consisted of designating his own work as a methodical process of *subtraction*, whereby this process could tend indefinitely towards a lack, to a simply demarcated space of something that in fact is not there.

I believe that there is no figure that better expresses the form of tension that deeply marked the work of Dias – between the clairvoyant procedure of montage, certainly anchored in the consideration that the constructivist tradition had for slightness and for the sobriety of minimal gestures, and the converse inclination towards nonsense and the humour of demolition – than the type of amputated cross that since the 1970s appears in so many paintings and installations, as an inoperative derivation of the grid. This recurring figure features in numerous works from *Do It Yourself: Freedom Territory* (1968), to *The Illustration of Art/Economy Model* (1975) and *The Illustration of Art/Art Society Model* (1975)

Antonio Dias,
*Do it Yourself: Freedom
Territory*, 1968

and *The Invented Country* (1976). It is as if the 'L'-shaped figure that results from the excision of a rectangle from the upper corner of a larger rectangle had undermined the dialectical machine that had animated – whether as a result of horror, religious ecstasy or both – all modern art produced in the first half of the 20th century, from Picasso to Malevich and Mondrian, from the constructivist to the surrealist strands of modernism. The recurring presence of this amputated cross in Dias' oeuvre seems to evoke the titanic mechanism of successive negations of modernity and through this process the figure ultimately reveals modernity finally achieved as pure positivity.

Conclusion

Having arisen at the confluence of the movements which marked Brazilian culture in such a decisive manner in the transition from the 1950s to the 1960s – neoconcretism and tropicalism – the work of Antonio Dias extracted its power and originality precisely from the contamination of these highly contrasting movements, from their respective notions of purity and excess, and from the discovery of unusual points of contact between them. From neoconcretism and the constructivist tradition of abstraction in general (and here it is worth remembering the proximity that Dias had with São Paulo's concrete poetry group), his work appears to have inherited the consideration of surface (to which the flat and diagrammatic physiognomy of the majority of the artist's works testifies), as well as the simplicity and frankness with which he exhibits his formal outline. This was always consistently combined and articulated, however, with his converse inclination towards interaction with whichever 'dirty' objects could

be found in his surrounding environment, which were dealt with on a distinctive spatial or ambient scale, that always implicated in questioning the institutional boundaries of art and paradoxically emphasising the irreducibility of the aesthetic experience to such boundaries. But it was probably the fact of having lived the atmosphere of tropicalism – whose distant matrix is the surrealist current and an entire tendency in art that established a critique of the rationalist tradition – that transmitted to Dias' work a sufficient lack of inhibition with regard to incorporating a hoard of second-hand images, clichés from commercial culture and the popular imaginary, in which the artist instilled his methods of estrangement and thus appropriated them into new poetic contexts and meanings. From both tendencies his work amassed a total sum of unconformity, an acute political consciousness and a sophisticated and aristocratic sense of form. One can assume that a biography such as that of Antonio Dias, characterised by intermittent journeys and by the displacement between diverse cultures, played a role in the advent of a planetary meaning that his oeuvre conferred upon the notion of space – always apprehended as *place* – that is, as a sort of portable and manoeuvrable point of view.

Translation of the original Portuguese by Michael Asbury

NOTES

1. I cite only two relevant authors in this debate whose work, with their eloquent titles about the mood of the period, posit Pop as a divisive moment: Arthur Danto, *The Transfiguration of the Common Place*, New York: Harvard University Press, 1981, and Hans Belting, *Das Ende des Kunstgeschichte?*, Munich: Deutscher Kunstverlag, 1983.

2. The artist continues: 'I started as a commercial artist, and I want to finish as a business artist. After I did the thing called "art" or whatever it's called, I went into business art. I wanted to be an Art Businessman or a Business Artist. Being good in business is the most fascinating kind of art'; cf. Andy Warhol, *The Philosophy of Andy Warhol (From A to B and Back Again)*, San Diego: A Harvest Book, n.d., 92. The chapter entitled 'Work', from which the above quote is taken, contains other passages equally provocative: 'So I was shot at my place of business: Andy Warhol Enterprises. [...] An interviewer asked me a lot of questions about how I ran my office and I tried to explain to him that I don't really run it, it runs me'. Ibid., 91–2, *passim*.

3. It does not matter whether those who defend an 'Art' promoted it to the level of 'philosophy' or to the pure concept would be at the extreme opposite of the ideological spectrum with regard to those who boasted about the recently achieved global/local community of culture (thus claiming the effacement of the boundaries between art and culture): by liberating itself from its objects 'Art' could not avoid affirming itself as such only by means of an incessant confrontation with the context of culture – be it to re-emerge in it or to re-assert its purity against it.

4. We agree on this issue with Yve-Alain Bois' argument in 'Painting: The Task of Mourning', in *Painting as Model*, Cambridge, Massachusetts: MIT Press, 1990.

5. I refer here to the contemporary advent of complex devices for cultural intermediation, which is highlighted in: Otilia Beatriz Fiori Arantes, *Urbanismo em fim de linha e outros estudos sobre o colapso da modernidade arquitetônica*, São Paulo: Editora da Universidade de São Paulo, 1998, and, as is frequently cited in Arantes, to Jeremy Rifkin, *L'age de l'accès – la revolution de la nouvelle economie*, Paris: La Decouverte, n.d.

6. T.J. Clark's article, 'In Defense of Abstract Expressionism', refers to the dissolution of the modern pathos through the death of art, at an earlier stage than that discussed here – the turn of the 1950s to 1960s: 'Not being able to make a previous moment of high achievement part of the past – not to lose it and mourn it and if necessary revile it – is, for art under the circumstances of modernism, more or less synonymous with not being able to make art at all. Because ever since Hegel put the basic proposition of modernism into words in the 1820s – that "art, considered in its highest

vocation, is and remains for us a thing of the past" – art's being able to continue has depended on its success in making that dictum specific and punctual. That is to say: fixing the moment of art's last flowering at some point in the comparatively recent past, and discovering that enough remains from this finale for a work of ironic or melancholy or decadent continuation to seem possible after all. [...] Therefore our failure to see Jackson Pollock and Clyfford Still as ending something, or our lack of a story of what it is they were ending, is considerably more than a crisis in art criticism or art history. It means that for us art is no longer a thing of the past; that is, we have no usable image of its ending, at a time and place we could imagine ourselves inhabiting, even if we would rather not', *October*, 69, Summer 1994, 25.

7. Already in the preface to his book, *The End of Art History, a revision ten years later*, Hans Belting emphasises the fact that exhibitions, more than works of art or institutions marked decisively the physiognomy of the art milieu during the final decades of the 20th century (São Paulo: CosacNaify, 2006).

8. From clothing to advertisements, from traffic signs to the furniture of the middle and popular classes around the world, from the pop music of the youth to the syncopated and elliptical spoken language of the crowds in large contemporary cities, had there not been after all a decantation of the modern poetics of collage and montage, of complementary procedures of construction and deconstruction that had been propagated by the modern avant-gardes? (Such a proposition owes a great deal to the suggestive insights brought to me through conversations with the film critic and historian Ismael Xavier.)

9. 'The public sphere, through which intellectuals moved like fish in water, became more inclusive, the exchange more intense than in any previous period. [...] The use of the internet simultaneously enlarged and fragmented the communication nexus. The internet thus produces on the one hand a subversive effect where regimes dispense an authoritarian treatment towards the public sphere, while on the other hand, the horizontal and informal communication interconnection weakens, at the same time, the achievements of the traditional public spheres...'; cf. Jürgen Habermas, 'O caos da esfera pública', *Folha de S. Paulo*, 13 de agosto de 2006, 4–5.

10. In this respect I refer to a statement by Caetano Veloso, where he remembers the creative process undertaken in the composition of the song 'Tropicália' of 1967 (whose title had been suggested by Hélio Oiticica): 'with my mind running at a vertiginous speed, I remembered that Carmen Miranda rhymed with "a Banda [the Band]" (I had for some time been thinking in proclaiming the image of Carmen Miranda), and I imagined placing side by side images, ideas and entities that

revealed the Brazilian tragicomedy, the adventure at once frustrating and brilliant of being Brazilian [...] I decided: Brasilia, without being named as such, would be at the core of this incongruous song-monument that I erected to our pain, to our deliciousness, to our ridiculousness [...] Suffice to say that this song [...] was what I could do that most approached my perception of *Terra em Transe* [Land in Anguish] [A film directed by Glauber Rocha]'. Cf. Caetano Veloso, *Verdade tropical*, São Paulo: Companhia das Letras, 1997, 184–7, *passim*.

11. For better or for worse, most of the historic populisms to this day have been marked by their compromise with the issue of national emancipation and evolved at some level a mythical faith in the collective redemption. This is why we encounter the extravagant character of global neopopulism, with its pragmatism, confident in the imaginary efficiency of its actions, that operates on a short-term basis and that aims at labelled communities.

12. With the purpose of ascribing a possible definition to 'a position of lack', I refer to the filmmaker Rogério Sganzerla, who belonged to the generation that followed that of *cinema novo*. Sganzela described his film *Bandido da luz vermelha* [the Red Light Bandit] (1968) as follows: 'I purposely made a pamphleteering, poetic, sensationalist, savage, badly behaved, cinematographic, blood-thirsty, pretentious and revolutionary film. The characters in this magical and vulgar film are at once sublime and *idiot*. Above all else, *idiocy* and *imbecility* are political facts, they reveal the secret laws of the soul and of the exploited body, which is desperate, servile, colonial and underdeveloped. My characters are all uselessly *idiot,* in fact like 80% of Brazilian cinema [...] Therefore, the Red Light Bandit is a political character in that he is an inefficient *imbecile*, an impotent rebel, a sad and repressed person who does not manage to channel his vital energies.', in *Arte em revista*, São Paulo, 1, 1, January – March 1979, 19.

13. Francisco Oliveira, 'Crítica à razão dualista', in Francisco Oliveira, *Crítica à razão dualista/O ornitorrinco*, São Paulo: Boitempo Editorial, 2003, 32–33.

14. The fact that there is a notable physiognomic contrast between the works initiated at the time of *Anywhere is My Land*, with their gestural and material economy, and the artist's prior production from 1963 to 1967, known for its high theatrical effect and eloquent rhetoric, is not important. It was precisely in the course of those two decades (the 1960s and 1970s) that Antonio's work established its poetic and formal nucleus, within which the ideas of lack and excess [*fastígio*] that are profoundly connected to the play of semantic alternation, and which naturally lead us to think about a homology with the oppositional scheme of lack versus excess that we use to describe the dynamics of capitalist modernisation in the 'periphery', during the first section of this chapter.

15. Emphasising the relevance of Latin-American authors within the field of study of 'underdevelopment' (as opposed to the dominant economics explanations until the 1950s), Fernando Henrique Cardoso remarked that '...the principle contribution by Latin-Americans was that of showing that from the mid-1950s [...] there was a new dynamic in international capitalism, propelled by multinational companies, and that would lead to a new international division of labor. This set in course the internationalization of capitalist production. The separation between internal and external market was being redefined: imperialism, that previously had been an obstacle to the industrialization in the periphery, became the propelling spring of a certain type of industrial development'. (See 'Introduction', in Fernando Henrique Cardoso, *As idéias e seu lugar. Ensaios sobre as teorias dodesenvolvimento. Petrópolis, Rio de Janeiro*, São Paulo: CEBRAP, 1980, 12.)

16. In an essay published in an edited book of 1964, and premonitorily entitled 'International Art and The New Globalism', Harold Rosenberg diagnosed the new situation of arts in the 1960s: 'Internationalism in art of the early twentieth-century type has been dead for thirty years, since the decline of Surrealism as the last of the Paris art movements and the fading of Parisian light-heartedness under the glare of the Depression, the War and the Occupation. The earlier internationalism has been superseded by a global art whose essence is precisely the absence of qualities attached to any geographical center.' (*The Anxious Object*, Chicago and London: University of Chicago Press, 1982, 206).

17. Roberto Schwarz, 'Cultura e Política, 1964–1969/ Alguns Esquemas', O pai de família, São Paulo; Rio de Janeiro: Editora Paz e Terra, 1978, 74. (The English version, from which the above quote is taken is: 'Culture and Politics in Brazil, 1964–1969', in John Gledson (ed.), *Roberto Schwarz: Misplaced Ideas – Essays on Brazilian Culture*, London, New York: Verso, 1992, 140.)

THE UNCOMMON UNIVERSE OF BHUPEN KHAKHAR

GEETA KAPUR

When seen as an aspect of the world-wide phenomena of popular visual culture, pop art gains – in the political circumstance of the 1960s – the dimension of a contemporary vernacular that opens out into a sequence of democratising tendencies. The process of deconstructing the universalist claims of modernism, already underway in post-war/ mid-century re-articulations of art and politics, was deeply conditioned by the century-long struggle for decolonisation and gave rise to powerful cultural alternatives. The current rewriting of cultural histories (including literature, cinema and art) shows why the 1960s break in modernist art practices requires an inscription of the unique role of artists from outside the western mainstream. If pop art had intentions to reclaim art from its ontological bind with high culture, such an agenda is best fulfilled when the claim of 'autonomy', based on an existential, near-metaphysical, form of self-sovereignty, is complicated by the emergence of new subjectivities that pose counter-claims and demand a revised historical status for the terms 'pop', 'popular' and 'vernacular'.

Bhupen Khakhar entered the art scene in the mid-1960s and set up radically different representational modalities in relation to existing tendencies in 20th-century Indian art. He also established a different set of equations between Indian and contemporary western art.[1] While the two-sided critique of Indian and western modernism is retrospectively readable in Khakhar's work, and may be collapsed into a single event – the 'crisis' within modernist art – such art-historical explanation hardly suffices. From within the clearly demarcated space of post-colonial and post-modern discourse, we learn to read against the grain and thus come

to see an artist like Bhupen Khakhar not as a local version of Anglo American pop art, but rather as a vantage point from which to 'provincialise' each sector of the amazingly hospitable category of pop. When reconfigured, the more complex, transcultural map of the contemporary popular will read as metropolitan, but not especially as western.

From the beginning of his career, Khakhar took a position against the dichotomous designation of aesthetic attitudes, as, for example, between *avant-garde* and *kitsch*.[2] Preferring the pop artists' option of a teasing ambivalence, Khakhar understood that the avant-garde is, in actual fact, produced precisely through contradictions between popular and high art codes. He took a decisive step by pushing the pop artists' mandate for making counter-commodities and radical fetishes into a *genre* where a new representational agency found its own narrative form.

In the 1960s, Indian art, like art in many other world regions, evaluated its modernist winnings in the manner of the School of Paris and sought a new turn. In 1963, Khakhar's peers had just launched Group 1890 and its exhibition was introduced by Octavio Paz and inaugurated by Jawaharlal Nehru: the event was seen as launching something of an avant-garde movement that was interested in indigenous uses of materials and surfaces, symbologies and signs. Interestingly, this group (led by the leftist ideologue-artist, Jagdish Swaminathan) excluded Khakhar on the grounds that he indulged in low art and poor taste. But history rapidly proved Khakhar to be one who, more than almost anyone else, defined the emerging artistic turn. Khakhar was a vanguard figure who thumbed his nose at high art, questioned its

modernist aesthetic and its progressive ideology. He did this through acts of masquerade performed by calling up neo-dada tactics widely current in the camp environment of the 1960s across the world.

In the early 1970s, Khakhar posed for photographs in absurd roles; wrote mischievous texts in catalogues; donned fancy dress; and held fake salon parties at his exhibitions. Upturning the cultural assumptions of modernist art, he also cocked a snook at the notion of the western avant-garde. In his characteristic role as 'double agent', he adopted ethnographic modes of a native (or nativist) painter, testing his skills before the metropolitan connoisseur. Opening up local geographies with mock-mythic or, more properly, allegorical narratives drawn from within the common culture, Khakhar thus came to occupy a peculiar 'political' position in the 1970s. Without actually knowing the developing theoretical discourse around nation and subject, Khakhar acted as the archetypal post-colonial artist by establishing *and* inverting his relationship to the twin legacies of the colonial and the modern in Indian art.

Khakhar's discomfort with the ontological status of modernist art – in the West and in India – and its final assimilation of both common culture and the avant-garde into a formalist reading, dovetailed into his much larger critique of the abduction of common culture into the national project in India: a modernising project constructed under the regimes of Jawaharlal Nehru and Indira Gandhi. The project was driven by a reformist-realist principle and a preferred representational schema that homogenised differing (linguistic, ethnic, caste and class) ideologies onto the national plane. This double antagonism made Khakhar a catalyst in defining the legitimacy of local knowledge/common culture, and for staking a counter-claim for an avant-garde based on marginal and eccentric sources. To such vernacular sources he added his agenda for coming out with the truth of his sexual preference and his exposure of gay pleasures. His outlook sought out the palpable vulnerability of a somewhat bewildered citizenry in the great Indian hinterland – that is to say, a 'people' who were just loosely linked to national/metropolitan centres of cultural, economic and political power. Not yielding to the spectatorial surveillance unconsciously practiced by the privileged citizen of a national vanguard, Khakhar challenged the available viewing protocols and bent the frame of what might constitute a 'national' art.

Early Pop

Khakhar came to Baroda from Bombay in 1962 to become an artist.[3] He brought an appetite for the popular from the lanes of Bombay's Khetwadi area – a lower-middle-class Gujarati neighbourhood – where his family lived in their small flat. In the Fine Arts Faculty in Baroda, he familiarised himself with the pop movement. His mid-1960s paint-dripped reliefs gained annotational pertinence when related to contemporary (American) painting in the matter of surface and support, gesture and relief. Robert Rauschenberg was a favourite, as he was seen to be a catalyst in the way he allowed the painting to accrete substances and in the way these crude eruptions demolished the very conventions of painterliness venerated in the late modernist camp.[4] In addition, Khakhar became familiar with the new aesthetic of English pop through the same art-historical route of reproductions, but also more keenly by direct

contact with a young English artist, Jim Donavan, who came to India in 1962 on a cultural exchange programme after finishing at the Royal College of Art and chose to live in Baroda for the next two years, sharing a room in one of the bazaar lanes of the city with Khakhar.

Donavan was flush with news of irreverences being practiced in 1960s London. (Another pop advocate, Derek Boshier, visited Baroda during the same period.) This first-hand 'dose' of pop was especially useful to Khakhar who was best prepared to translate it into the aesthetic of the Indian popular. Forays into the street linked Khakhar and his Baroda artist-colleagues to their local picture-making practices, to common culture and their lived environment.[5]

The 1960s were marked by a widespread anti-bourgeois phenomenon of 'beat' culture, and India – elected as conducive for rethinking conventional lifestyles and ideologies – was very much part of the itinerary. Allen Ginsberg stopped in India, and waves of hippies poured in for over a decade. India also became a site for testing the oncoming discursive shift in cultural readings that ultimately fed the post-modern phenomenon. Khakhar was scarcely aware of the actual political radicalism of the 1960s, but in his canny way he was able to imbibe the transgressive possibilities of the historical moment. He marked these within his own art practice, naïvely at first, then provocatively enough to destabilise the priesthood of artists and their modernist aesthetic as it prevailed in India.

Soon Khakhar was at the head of the new turn and became king of the popular domain. As prime mediator of India's urban culture, Khakahr made his initial breakthrough by referring to popular art in the form of calendars, posters, 'god pictures' and wall graffiti. He broke the barrier of taste and introduced popular language and iconography through a cut-and-paste approach: paper collages were combined with enamel paint, and sometimes plaster-relief on board made up rough ensembles that mimicked the wayside shrines of popular gods such as Hanuman. Producing a sign system for denoting, thus signifying, kitsch, Khakhar gave his version of pop art a definite local meaning long before the 'local' gained currency as a binary correlate of the global. Further, he historicised the phenomenon of pop as popular, and linked this to stylistic hybrids in the vernacular schools of Indian art.[6]

Ethnography:
Man with Bouquet of Plastic Flowers
The second phase in Khakhar's work appeared in 1972 when he developed a definite representational project. The emphasis now shifted from an interest in the *language* of popular culture to the *subject* appropriate to that language and, slowly, to the *subjectivity* that can be elicited from the depiction of that subject in the language appropriate to it. In creating what he called his 'trade series', he acknowledged the influence of 19th-century Company School paintings[7] produced by 'traditional' painters for their imperial patrons who wanted chronicles of the inhabitants of this bewildering and, for them, bizarre country. Often painted in a series, sometimes presented as albums, such paintings consisted of stereotyped subjects: Indian ethnic and religious 'types', scheduled tribes and castes, including 'untouchables'; and categories of humble artisans. Just as the depiction of lowly members of the social hierarchy gave a documentary value to Company School

paintings, Khakhar followed the naïvely 'naturalistic' conventions of this historical style to provide himself with a language of rudimentary skills and, analogically, to evoke a sense of comradeship with an unsung brotherhood of common men – including the painters themselves and their equally modest subject matter.

In paintings such as *Janata Watch Repairing* (1972), *Factory Strike* (1972), *Branch Manager* (1972), *Assistant Accountant: Mr. I.M. Shah* (1972), *View from a Teashop* (1972), *Man Eating Jalebee* (1974) and *Fishermen in Goa* (1985), Khakhar opened up the possibility of bringing various small-time professionals to attention. He also smuggled in considerable compassion – but not so much as to appear partisan in any radical sense of the word. Henri Rousseau in India! Khakhar admired Rousseau not only because his example supported Khakhar's interest in 'bad drawing', but also because such bad drawing supported a vulnerable form of representation that highlighted a cast of characters whose identities did not depend on the privilege of authority, nor on revolutionary credentials.

In his painting, *Man with Bouquet of Plastic Flowers* (1976), the frontal image of a man in a tinted white shirt, placed against a luminous orange surface painted in silk-soft strokes of the brush – gleaming fabric, flaming earth, bleeding sky, sheer aura – is set within a three-sided framing device that dovetails vignettes from the protagonist's private life. The man's forehead and phallic nose are touched by the light irradiating from the picture surface, but the eyes, glazed blue, are cast in a sick, nearly insane visage. A blue-black shadow creeps over his face and up to his eyes like a shimmering death mask. The image submits to, and then inverts, the

conventions of *darshana*, the protocol of viewing between icon and devotee in a face-to-face encounter.[8] This 'enshrined' figure, then, is the martyred icon, devoured by an iconophilia (an incipient necrophilia) of the desiring gaze, as much as he is a mere devotee with bent arms laid stiff against the pliant body – one reptilian hand clutching a wrapped bouquet of pink and yellow plastic flowers, the other pressed against the ribs – his tribute to the idol immortalised by the onset of rigor mortis.

Abjuring narrative, American pop had made for a new form of iconophilia where the image is a sign in lieu of a *consumed* subject and where the abbreviated image of the idol regains an aura of *absence*. This, for instance, was suggested by a work such as Andy Warhol's *Marilyn Diptych* (1962). Khakhar's image, too, signals itself to be both *evacuated* and *replete*. Here is a mortal foreboding in the entire physiognomy of the picture that will feature as an erotic sentiment in later paintings.

But the pictorial structure of *Man with Bouquet of Plastic Flowers* already has a post-Warholian and proto-narrative address. It shows nuggets of 'life' garlanding the main image, each of which comes from Indian popular prints that take over the sectioned surface of folk painting traditions and turn elaborate narratives into insets or vignettes that confirm the good deeds of the central figure, who is thus accorded iconic status. In this respect, Khakhar inserted himself into available iconographic traditions, but at the popular end of the spectrum – at the point where a vernacular makeover of mythic and sacral material into the mass-reproducible imagery of the bazaar takes place. Available via chromolithograph technology since the end of the 19th century (and produced, among many

Bhupen Khakhar,
*Man with Bouquet of
Plastic Flowers*, 1976

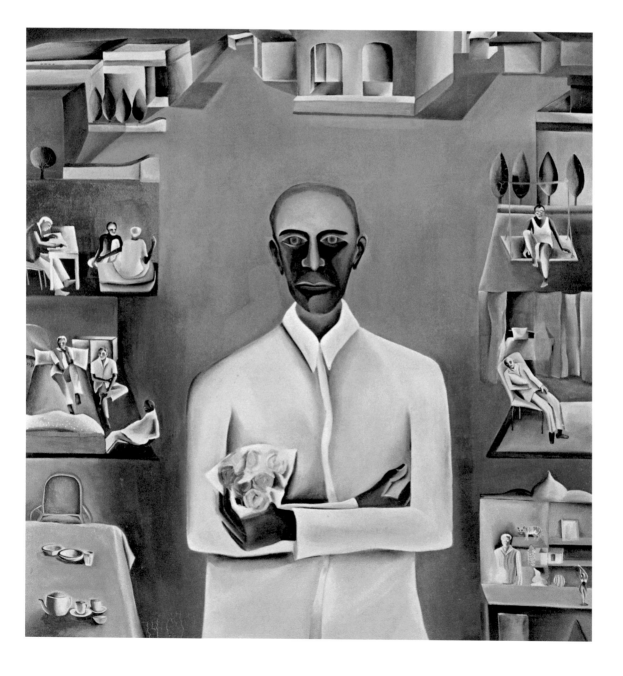

other centres, in the temple town of Nathdvara that Khakhar liked to visit), such visual materials are what Christopher Pinney calls, after the urban-rural consumers themselves, 'photos of the gods'.[9] But Khakhar was not one to make a simple self-inscription, and he placed himself between this sacred imagery and the evolving national iconography of citizenship that valorised legendary figures (Gandhi, Subhashchandra Bose, Nehru and the Dalit leader, Dr Ambedkar) in patriotic posters. These, interestingly, were churned out by the same artists and publishers who produced the mythological pictures. In addition, there were bazaar-style depictions of everyday life and common values – toiling farmers, soldiers, school-charts on civic life, baby-heroes in grown-up roles, all presented as signifiers of the nation's wealth and well-being – that amused Khakhar greatly, not to mention his delight with the counter-stream of glamorous film stars and sports personalities – supra-citizens – whose performative excess still excites the modernising (and now globalising) consumer fantasies of the middle class. Khakhar positioned his imagery within this (national) representational map of edifying and seductive depictions, using all of his wit to see them transposed in élite contexts where he, paradoxically but inevitably, exhibited his paintings.

Equally important is the *form* of the vignette. Khakhar derived this from several sources: from the pedagogy of the popular prints, with their chosen icon narrativised through cameo performances by a cast of supporting actors; from the divine *jhanki*, a glimpsed image of the deity, as famously performed in the worship of Shrinathji in Nathdvara;[10] and from early Christian paintings of the Russian Orthodox Church, and altarpieces and predellas of the Italian Trecento.

(The enthralling encounter with medieval and pre-Renaissance paintings came during his first visit to Russia and Europe in 1976 – tellingly he had already completed *Man with Bouquet of Plastic Flowers* before he actually saw what he knew from reproductions – and it was followed by several opportunities whereby he expanded his oeuvre ever more significantly.) What is revealing is that for all his dedicated pursuit of diverse sacred conventions, Khakhar translated the thrill of a *jhanki* – and indeed the visual recitation of a saint's or a hero's good deeds – *into a voyeur's pleasure*. He turned the narrative inset into a peep-hole, revealing the 'secret' life of the neighbour – fragments of a neat house, of middle-class homes with swing-beds and eating tables in rooms painted green, rose and sky-blue that are also mini-theatres for routine forms of male intimacy.

The vignettes puncture the *picture* surface and signal artistic liberties that puncture the *social* surface; the interstitial spaces that open up unsettle the contract of visibility and its allegiance with the *realist claim* that so privileges the morality of representation. This contract was revived in Marxist art-historical discourse during the 1970s; in art practice that spanned the space from pop to narrative painting (for example, in England, via Hockney and R.B. Kitaj); and, importantly, in non-western – Third World and post-colonial – representational projects, including, especially, modes of pictorial narration and auteur cinema. Within this larger context of debate regarding ideology and self-representation, Khakhar could be seen to play with classic binaries of private and public, sacred and profane, religion and state. Indulging in the new-found (post-modernist) sanctions, Khakhar offered dissembling modes of representation

that took recourse to particular types of theatricality found in India's conventional and kitsch icons. He staged characters who stared back at the viewer to interrupt the act of identification; he then devised a *spectatorial compact* that skirted the realist principle, even as it alluded to realism by way of ironical earnestness. Continuing to assume faux-heroic roles on behalf of the 'common man', Khakhar made bold to translate the classic binaries into that of *citizen* and *subject* – central to realism – but deployed contrary styles of obedience, evasion, subterfuge. He produced, thereby, *narratives in obverse of a 'rights' discourse of the good citizen*.

Clearly, the artist's attraction to popular visual culture was a declaration of class affiliation. In the early 1970s, Khakhar mimicked middle-class fantasies in his cheaply printed exhibition posters and catalogues (posing 'himself' as Lord Krishna, advertising model, Congress politician, James Bond et al.).[11] He performed a critical double-take on representation by spoofing his own class – sandwiched between subaltern and élite – and, simultaneously, acquiescing to its class-culture. An invitation to his dishevelled bed-sit-and-studio was a standing feature of Khakhar's hospitality, where the guests were a class within a class: always older men from working-class and middle-class backgrounds, usually lapsed householders idling with half-sanctioned perversions. Indifferent to retrograde customs and objectionable values on gender, religion, politics; offering no ideological or moral opprobrium, Khakhar gave unprecedented access to a wide range of lives and thus historicised, and humanised, the common culture that his art affirmed.

For all the masquerade, then, Khakhar had a deep-seated commitment to the popular.

But his popular did not translate into an inventory of commodity signifiers in the way of American pop; nor did he take up English-type narrative satire as suggested by, say, Richard Hamilton in his emblematic collage, *Just what is it that makes today's homes so different, so appealing?* (1956). Assuming options that were available within Indian visual regimes, Khakhar looped the iconic presence of the protagonist – interchangeably himself and/as the much reproduced 'common man'. In a variety of near-melodramatic (sentimental and lascivious) narratives, he produced deep discomfiture that is more in the manner of the surrealists (Magritte, for example) than Euro-American pop. This strategy gave to the vernacular, within which the popular is lodged, the significance of a language imbricated with the modern, yet distinct in its cultural and class affiliations.

Vernacular Realism: *You Can't Please All*
In 1981, Khakhar featured in a seminal group exhibition, titled *Place for People*, which privileged a form of narration that was socially specific, culturally replete.[12] From the mid-1970s onwards, Khakhar had expanded the pictorial field around and beyond his subjects and constructed a genre about everyday life in a provincial city where the townscape shades into the farmer's fields. Individual presence gave way to a notational definition of social life exemplified by the work of men – artisanal work for the most part, but also the labour of love in the performance of ritual in secular and religious ceremonies. Paintings such as *Rural-Industrial Landscape* (c.1976), *Death in the Family* (1978), *The Celebration of Guru Jayanti* (1980) and *Road Building Work at Kalka* (1984) added up to a full realisation of the genre in *The Godsmith* (1997).

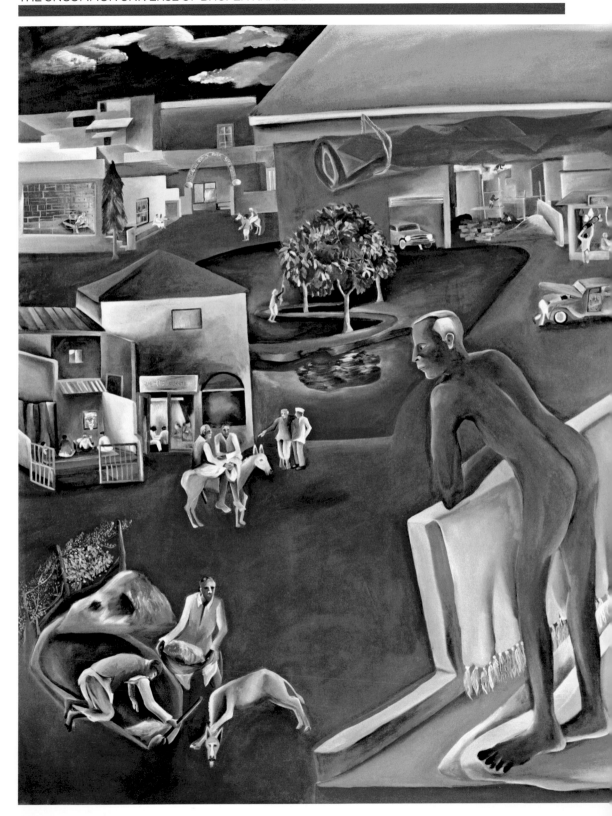

Bhupen Khakhar,
You Can't Please All, 1981

From 1980, the evidence of Khakhar's gay sexuality came to be included in the paintings. It is now that the modest, industriously garnered grace within and around his paintings began to quiver in a disturbing way.

Within the enlarged 'cosmos of the gaze', Khakhar splits the narrative apart in *You Can't Please All* (1981), so that when the naked man standing on his balcony in the right foreground of the picture takes off his clothes and turns his back to the viewer, he provides the privileged point of view for taking in a world-picture (the world-*as*-picture). Spread before him is a distant townscape, diminutive in scale, rich in detail, and self-evidently benign in that the continuous narrative takes the form of a parable: a humble father and son set out on a journey to the market taking along their donkey. Having listened too much to the gossips' taunts and solicitations about their behaviour towards the donkey, they inadvertently kill the poor creature. Painted by Khakhar to declare his homosexual preference to the world, the nude 'self-portrait' in *You Can't Please All* transmits the sort of gaze that god himself may bestow upon his fallible creatures, seeing them as miniature performers in the elaborate pantomime of the everyday in which this 'godly' artist/viewer is nonetheless deeply implicated.

We know that in 'coming out' Khakhar gained a peculiar generosity that valorised acts of loving – subversive, maudlin, timid, heroic. Abjuring satire but not irony, his love acts remained on the *edge* of respectability: this is signalled by the way that his earlier reference to the viewing protocol of sacred *darshan*, where the devotee and deity meet in a frontal gaze, is literally reversed here. If there is in the protagonist something of the tall, stark-naked, Jain avatars, or *jinas* (especially

lodged in the spiritual tradition of Khakhar's native Gujarat), then the turn-around of this ascetic-erotic figure is indeed contrary. He bends and reaches out beyond his secure perch that juts out at an acute angle above the world – his gold and magenta balcony-shrine fitted out with the provisions of solitary pleasures – and in what seems like a humble gesture of leaning over, he shows his posterior. He shows his posterior to the neighbour (presumably stationed on an adjoining balcony) and to the viewer, but note how differently from Hockney's bending figure in *Man Taking Shower in Beverly Hills* (1964).

You Can't Please All is a space for *this* artist's affective existence – for his sexual vagrancy lodged comfortably in a householder's environment without wife and children, his amoral provocations interleaved with a self-designation, by no means insincere, of a peaceable member of middle-class society, well adjusted within public life. The painting is also a replete illustration of provincial civic life and the little ironies that feed the centuries-deep pictorial aesthetic in which social space and allegorical narration coalesce. The aesthetic referred to here is that of the Italian primitives and other early Renaissance painters, as well as the manuscript illuminations in albums and folios from the Mughal and Rajput schools (and their provincial/popular versions in particular). These formed Khakhar's conscious resource for painting.

Khakhar's inspiration for *You Can't Please All*, and its slightly preceding twin, *Celebration of Guru Jayanti*, also came from Ambrogio Lorenzetti's 14-metre long fresco in the Palazzo Pubblico of Siena, titled, didactically, *The Well-Governed City* (1337–40). Khakhar had imbibed a love of the Sienese through the artist,

Gulammohammed Sheikh. From 1976 onwards, when Khakhar started travelling abroad, the English artist and critic, Timothy Hyman, became a common friend. Together, Sheikh, Hyman and Khakhar found allegiance with the Sienese tradition, particularly with the Sienese pictorial narrative that Hyman significantly designates, in generic terms, as 'vernacular realism'.[13] Over the years, Khakhar was able to translate, for his own purpose, the diffidence and pathos of the Sienese, and the paradox of their life-affirming vision. These qualities, which come not from sentimentality but from a sublimity worthy of the saints, never cease to surprise beholders of Khakhar's paintings.

The high horizon in *The Well-Governed City* allows the viewer to be both above and inside the city: to be able to see everything, and also move among the populace as they conduct their appointed business of trade, rituals, pleasures, pedagogy and labour – including the humble toil of men and animals. The narrative space in and around the homes, streets and public buildings spells a 'perfect city' that opens out to a landscape of cultivated fields, featuring peasants and pilgrims. In relation to the fresco's elaborately pictorialised, vernacular-style architecture, people appear like dolls, the proportionate structures cradle their rhythm of work, the *mise-en-scène* contains a carefully formed civility.

Two centuries later, Pieter Brueghel's genre paintings in his Netherlandish version of the vernacular style, while upturning the harmony of the Italian primitives, set the stage for another take on the populace. The bawdy makeover of peasant into proto-urban community gave an early mannerist twist to the themes of piety and harmony celebrated in the preceding centuries,

and offered an early critique of nascent burgher/bourgeois avarice in the new setting of the secular (as seen in *The Battle between Carnival and Lent* (1559), for example). Radically different from the early Italians in body language and spiritual temper, but withstanding nonetheless the order of classical style humanist culture imposed by the Renaissance, Brueghel's paintings offered plebeian sociability and sexual revelry almost as preconditions for a viable civic life.

Khakhar introduced the citizenry of a contemporary time and place in his paintings by harking back to Lorenzetti's splendid schema for structuring pedagogic narratives in public space, as well as invoking the inversions of such encounters in a Brueghelesque version of that space. In his definitive two-and-a-half-metre wide townscape, titled *Celebration of Guru Jayanti*, the sacred sanction that Khakhar deploys, through enshrining the figure of the simian-faced guru at the heart of the picture, also helps him support a company of idlers, including ageing citizens, habitual 'offenders' and practitioners of same-sex love, in relaxed states of sexual dalliance. Though notationally studded with conventional townsmen, prime space is usurped by citizens-as-drop-outs. The distant guru, left to himself by the lapsed devotees, shrinks into faux-divinity. Thus, while Khakhar narrativises urban India through a generic, delicately constructed, softly-radiant toy-townscape – in this respect more in the manner of a Sassetta, who he admired along with Lorenzetti and Brueghel – the full picture allegorises the absurdity that rituals of appeasement encourage in order to preserve established sanctities. It is the sublime haze of Prussian blue – the tonality, light and spread of the colour – that ultimately contains 'all': as profane love suffuses the ardent and placid moments of social existence, as it permeates the civic structure of the neatly laid-out town, the viewing gaze is elevated to a plateau where life's replete allegory of mortal longing prevails.

A cynical view could suggest that what Khakhar makes available to the metropolitan spectator-citizen are small-town views that expose what may be called representationally 'backward' subject matter,[14] or identities designated as 'backward' in professional and class terms or, for that matter, in terms of their queerly constructed gender-subjectivities. Do the fragments of the real that Khakhar elicits offer up data for ideological modification and recruitment? Do these in turn get annexed to a hegemonic regime of reality, to the assimilative appetite of the national? As film scholar Ashish Rajadhyaksha suggests, *You Can't Please All* is its own answer to this line of critique: in several successive *looks*, the snapshot simultaneity of the painting visualises a dovetailed narrative that confirms the libidinal economy of the total picture.[15] There is the seduced gaze of the neighbour-spectator, the naked protagonist's lofty view of the townscape, the idling spectators' mockery of the father-son duo as they behold the pitiful parable of the saintly donkey who, before he dies, gratuitously 'performs' an erection. In *You Can't Please All*, Khakhar appoints at its 'head' an artist-surveyor, ready to make himself vulnerable so as not to be in a commanding position *vis-à-vis* the wayward itineraries of the common people depicted. Correspondingly, he presents the town in minutely-detailed fragments: men and beasts in translucent grey, pink and green float up in Khakhar's subtly modulated grey-blue space, thereby lifting the scene to the level of a dream.

Here is an aquatic mirage so inviting that the protagonist on his terrace-perch quietly acts out the parable's lesson: the Khakhar *doppelgänger* decides to please himself (and strip).

Khakhar, a Gandhian, was bitterly against homogenising central command and its panoptic view of the modern nation state, that is to say, the Nehruvian model for India. He rather wishfully projected the lost ideal of a communitarian self-governance at the ground level and left it at that, at a part-mystical, part-social, that is to say, part-Gandhian allegory. If we recall how Khakhar went about in Baroda and joined hands with his humble subjects, this was precisely the style of life that he imagined in his pictorial genre – a place where country and town meet, where the proto-modern, modestly productive community of peasants, artisans, commercial and industrial folk still survives, where their sexual and social relations fold into an invisible form of (self)governance. This is, of course, nostalgic, but it is also a form of political idyll stubbornly planted as an alternative version of the imagined community within what, on a larger scale, was an already advanced formation of the Indian state. Khakhar himself succumbed, but only grudgingly, to the authoritative regime of the modern nation. Right up to 2003, when the face of India, of his native Mumbai, and even of his chosen city, Baroda, now Vadodara, had definitively changed in favour of capitalist globalisation, he was able to live a relatively unalienated life. Dedicated, subversive, enigmatic – a liminal figure in historical terms – Khakhar died as an artist momentously contemporary within and outside his time.[16]

Sacred and Profane

From Khakhar's gentle, puppet-like shoemaker, watch-repairer, barber or tailor, to the looming man holding his penis, there is at once a de-classification of social types into an existential rendering of gender identity and a re-classification of subjectivity on peculiar terms, where the maleness of the figure is crucial and yet heavily (dis)qualified. There is a presentation of lust that is, in a sense, a counterpart of heterosexual relations, but with a particularly transgressive twist. The older, frailer, deformed and pallid men lead the viewer right into Khakhar's private labyrinth, where a necromantic embrace awaits the pilgrim of forbidden love. In mythic terms, lust and necromancy might make a hallowed pair. In *Yayati* (1987), Khakhar paints this as his very subject.

Khakhar appears in the later paintings as both lover and beloved, and he is seen, in thinly camouflaged roles, giving and receiving pleasures (including anal sex and fellatio). The idiosyncrasy of the lovers in these paintings is the sign of true inter-subjectivity. A shared stigmata is worn with pride by the lover/beloved. If there is sexual sleaze heightened by the performative act of transvestite masquerade in *In a Boat* (1984), there is sentimental companionship between two men in *My Dear Friend* (1983), ardour in *Seva* (1986) and sweet play in *How Many Hands do I Need to Declare My Love to You?* (1994). The artist offers coy promiscuity in the manner of a beloved flirt committed to the vocation of dispersing and sharing amorous pleasure.

But why is the staging of male sexuality so often within a religious setting? In the sanctum-like space of these paintings, the guru and disciple meet intimately, stealthily, like forsworn lovers (as in *Seva*); there are encounters in the

Bhupen Khakhar,
*How Many Hands do I Need
to Declare My Love to You?*,
1994

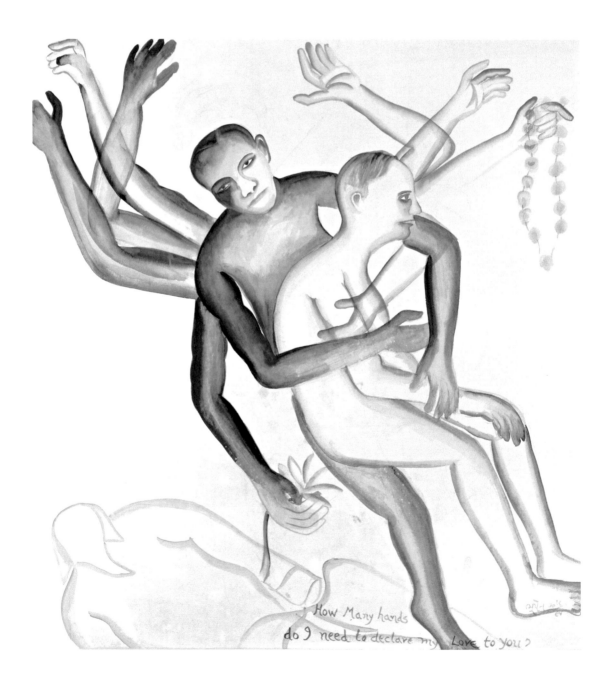

Bhupen Khakhar,
*Picture Taken on Their
30th Wedding Anniversary*,
1998

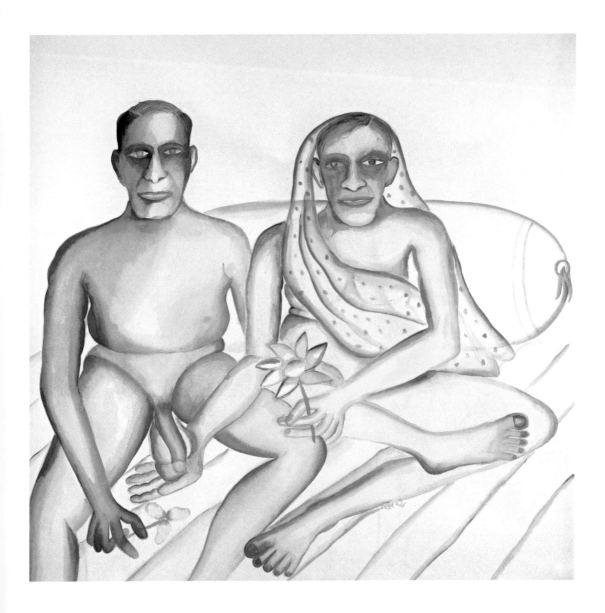

temple compound and in the courtyard in a pilgrims' encampment, as in *Jatra* (1997), in the vast *Yagna Marriage* (2000) and in *Muslims around the Mosque-I* (2001). This choice of setting could simply be part of a relentless hunt among strangers – temples and mosques, shrines and *dargahs* are what Khakhar unabashedly called 'pick-up' spots. For many years, and especially from the late 1970s onwards, when he started accompanying his dear companion Vallavdas Shah (Vallavbhai) to the *satsangs* of the Radhaswami sect (in Baroda and Agra), religious sites gave Khakhar the occasion to present a spectacle of suppressed promiscuity where, in the guise of a faithful flock, a shambolic populace acts out its follies. More likely, he cherished a secret desire to present god's devotee as 'sinful' (see *Ram Embracing Hanuman*, 1998). This intense, almost existential, need for linking holiness and degeneracy, sin and salvation, adoration and iconoclasm may be read as reparation of guilt through a penitent's canny surrender to the sacral order. Or could it be that the artist saw an irreversible overlap between homosexuality and sainthood; that the canonisation of Jean Genet by Jean-Paul Sartre haunted him, and that Khakhar hoped to gain redemption through openly confessing the 'sinful' truth?

Picture Taken on Their 30th Wedding Anniversary

Following the popular convention of going to a photographer's studio to get a picture taken after marriage or at an anniversary, Khakhar poses two men for such an occasion in *Picture Taken on Their 30th Wedding Anniversary* (1998), the implications of which are breathtaking. The celebration of a bond and the formality of the pose contrast with the intimacy of the setting to suggest not so much a contemporary reference (not Hockney's paintings of seated men seen from the front), but rather a 19th-century convention of bringing home the studio apparatus of the photographer for a sanctioned session of documentary and ceremonial (self)representation. As though it were set up in the privacy of the urban home in 19th-century 'Victorian' India – in the *zenana* quarters, the domain of women (which women were not supposed to cross but into which the outside world could discretely enter on the invitation of the patriarchal authority) – the couple are frozen into a self-chosen posture for the split-second when the timer will click the picture in place. But this, of course, is a painting and the domestic interior of the bedroom/studio is probably that of the painter, who is both proxy photographer and (surmising from the appearance and stance of the sitters) one of the two pictured. One can imagine him setting up the tableau by centring the beloved, readying the apparatus and then placing himself alongside – grandly, but just a little off-centre.

Even as the picture is ready to be sanctioned for posterity in a family shrine – in the hope that the couple will cherish the moment and, when they pass on, bestow their benediction on future generations – the entire scenic operation offers itself like a sacrilege. Not only is this is a homosexual marriage, but the colour of the naked bodies – indigo and yellow – could refer to the pictorial conventions relating to Krishna and his consort Radha. Or perhaps such colours refer not so much to the lord and his beloved (even though their scandalous love, their illicit yet sacred union, is splendid inspiration) as to Krishna's male devotees who woo the divine and

shower their lord with incarnate worship by assuming the role of the dressed-up *sakhi* (female companion in the mode of Radha). This fusion of male body and female soul, this act of impersonation through cross-dressing, produces in some versions of Vaishnavism a cultish consanguinity known as *sakhibhav*. In terms of masquerade, this is not so different from open transvestitism in gay communities; it may even shade into the existential and public stance of the hermaphrodite or eunuch who, while enacting the 'freak', also suffers the anguish of being the 'third sex'. Khakhar's paintings of men dressed as women, including *Sakhibhav* (1995) and *Pregnant Devotee* (*c*.1995), as well as *Picture Taken on Their 30th Wedding Anniversary*, have this shuddering ambiguity between means and ends, between piety and prostitution. Viewed in comparative terms, this is the point of transition from sodomy, as Foucault puts it, to a 'kind of interior androgyny, a hermophroditism of the soul'.[17]

What this watercolour does, then, is to use a popular convention of photography (sometimes called vernacular photography); a ritual celebration of eroticised worship (a sub-genre of a more hierarchical Hinduism); as well as a folk-urban mode of painting (the image is modelled by transparent washes with a softly emphasised body contour in the manner of Kalighat paintings that were a cross between village-*pat* painting and English watercolours – perfectly pitched as the pictorial vernacular for the rapidly anglicising Calcutta of the 19th century).[18] And it does all this to an end that is neither mere blasphemy nor mere style. By drawing into his painterly spectrum iconographic sources that confirm the presence of androgyny within Indian mythology, Khakhar endorses his

own invented, *inverted*, sacrament of a male couple's embrace. He not only gains erotic sanction for the 'obscene' display of same-sex bodies, but also the bodies themselves acquire a peculiar aura through such deep cultural resonance. This allows Khakhar to go beyond self-serving appropriations that are so well celebrated in the post-modernist milieu – of the kind practiced by Francesco Clemente,[19] who borrows erotic motifs from the Indian popular and often has them rendered by an artisanal hand within the frame of his signatured paintings. Through a trickster's intransigence, Khakhar is able to intervene in the politics of the culture at hand.

The overall whiteness of the paper, and the transparent washes of blue and gold, create a virtual state of levitation for this couple. These are lightly painted, self-effulgent bodies, and there is a queer promise in their hand gestures: both men have petalled flowers between their claw-like fingers, and the male figure that is half-draped in a transparent sari supports the genitals of the other who is stark naked. It is a gesture of protection and care rather like offering fruit and flowers to a deity or, vice versa, as a deity might offer itself for a graceful *darshan*. The twinned posture leaves no doubt about the fecundity of this 'aged' companionship: in other paintings of the same period, Khakhar painted an old man sprouting a bouquet of five penises and male devotees who are pregnant.

This is as far as the cultural reference goes. In *Picture Taken on Their 30th Wedding Anniversary*, one man is frank and the other demure, both look right at the camera and at the viewer with haunting 'smiles' that are formal grimaces set in large ungainly faces. They legitimate themselves before us with the

authority of a couple installed in the ritual form of the grotesque-sublime – a couple who have already passed into the album of 'primitive' ancestors ripe with oracular curses, oracular blessings and, also, with an inverted injunction of self-purification through illicit love.

Votives
Khakhar achieved his ends as much through devising figural and bodily forms as he did through the gross and subtle and ever-changing handling of actual paint matter, of pigment and medium, of surface and support (which was one among many factors that made Howard Hodgkin and Khakhar such good friends). His thickly, creamily, over-painted layers of oil paint on canvas carry the heavy breathing of an *idée fixe*. Released from the viscous, visceral, gleaming materiality of oils, his watercolours were always delicate, and when he took them up as an alternative in the 1990s, they appeared to float with backlit figures in an afterlife of fantasy. Not a trapped secret (or sin) but a glimpse of the voyeur's fleeting vision, the image in such works as *Bathing Man* (1995), quickly put down in a series of transparent washes, is at once luminescent, economical, graceful: its informality offers painterly transcendence. During the1990s, Khakhar's to-and-fro between watercolours and oils gave an ease to the bodily forms and they proliferated on the picture surface as loosely brushed-in figures – as seen in *Pink City* (1991) and *Rati Kanjar* (1992) – frolicking, sleeping, embracing, drowning and almost as if dying in the radiance of a would-be garden of earthly delights that might equally be a hellish vortex of permanent lust, often without gravity or horizon.

Some of the oils and watercolours of this period had the aspect of a votive image, such as

And His Son Also Had Black Teeth (1995), and the extraordinary freak-icon, *An Old Man from Vasad Who Had Five Penises Suffered from Runny Nose* (1995). The devotee seeking favours from a god presents him with a naïve image of wishes and desire, disease and suffering; he presents these in a totemic form that makes up a distinct genre of the holy macabre. Like the votive image-maker, Khakhar exaggerated the limb or object to which he wanted to call attention, foregrounding what fixated him with its 'magic' potency. Equivalent to the centuries-old obsession in the male heterosexual imagination with female breasts, belly, feet, vagina, ornamentally displayed, fetishised, stretched out for penetration, versions of male genitalia obsessed Khakhar and extended to all parts of the body – hands, mouth, nose and ear. Such body parts turned into a bouquet of dismembered limbs, a bunch of swollen penises. In the suggestive dovetailing of limb and object, a plethora of fetishes flourished in Khakhar's oeuvre, forming a metonymic chain that bound and held together a universe dominated by the phallus – the essential votive image that is at once toy, tool and emblem of homosexual desire. As if seeking redemption in the very narcissism of the masturbatory act, Khakhar's handling of the votive image connected him to a god of some kind, or to the persecutory superego whose sovereignty and authority, dreaded, hated and reviled in the heart of hearts, has somehow also to be always appeased.

Abjection: *Bullet Shot in the Stomach*
The year 1999 marked a phase in Khakhar's work that coincided with illness and the experience of hospitals and surgery. There was a major return to oils that confirmed, in some fortuitous way, the

Bhupen Khakhar
Bullet Shot in the Stomach,
2001

relationship of oil paint with visceral matters. There is a fascination among painters for a menacing form of mortality, the repugnant aspects of human existence, the blinding darkness of actual death. There is also a fascination with turning pigment and medium into a literal, material, metaphorical analogue for the body: its inner substances (spilt gore), outer deformation (skin eruptions) and wounded limbs (amputations). The desire to match painterly skills with such 'wonders of nature' is a perverse kind of hubris that artists have always practiced. In an open display of subjectivity *in extremis*, Khakhar made extravagantly ugly, perversely seductive portraits: already nascent in the *Gallery of Rogues* (1993), the grisly genre blew up in *Bullet Shot in the Stomach* (2001), and offered testimonials of death in such watercolours as *Blind Babubhai* (2001), *Manilal with Measles* (2001) and *Injured Head of Raju* (2001).

If, in earlier pictures, sexuality was evidence of soul, and the soul an irrepressible agent of pleasure, then this looped connection of body and soul now encloses within it such dark premonitions, such an excess of mortality, that Khakhar's final figures are, at their core, more about death than about life. It is remarkable that he elicits a confessional and indifferent subjectivity, which – like that of the 'existential man' of high modernity – evades the stake on unitary selfhood essential to such versions of modernity. The self, split into double, plural and socially autonomous 'selves', reunites through a proto-modern anthropomorphism into mutants who stake claims to a new kind of species phenomenon. Poised between the devolutionary impulse of human existence and its evolutionary potential, Khakhar melds the two tendencies and recasts his icons.

We are now with his last or what we may call his late paintings – and, after the manner in which the oeuvre of a master is viewed (posthumously) by Edward Said,[20] there is no reconciliation, no grand synthesis, no redemptive message in Khakhar's work but, rather, intransigence, difficulty and unresolved contradictions. The invented cast of characters, hovering between ambivalent subject and obedient citizen, dissimulating householder and brooding lover, transmutes into the face of the *other*, who is identifiable only through the mediations of the *abject self*. Like the chrysalis turning into a butterfly, the satirist in Khakhar turns into a guilty sinner, then into a martyr, the bearer of pain and fear. Indeed the subjective is not fully explored by Khakhar until the real and contrived sense of degradation is exteriorised. When accretions of the body – pox and fungus, wounds and lacerations – erupt and bloom on the face, these are like outgrowths of a malady afflicting the common features of social identity, an identity that stands in for the body politic in a state of suppressed trauma.

Genre painting treats subject matter as the lowest common denominator, and a narrative form derived from this basis has to accomplish an extraordinary catapulting act to arrive, like Khakhar, at a critique of taste, protocol and morality. This becomes, in effect, a critique of the conventional values of aesthetics, class and gender. In such a case, the painter opens a way to transgress the norms of genre painting and arrives at a paradoxical status: a representational regime with new forms of subjectivity. Once Khakhar succeeds in making his subject's meekness into theatre, the circumscribed setting of male sex in provincial, middle-class communities begins to signal a state of social entropy. Tableaux of mating men compensate the artist for the sexual (spiritual) wounds suffered in enforced secrecy. Presented in excess, the subject's body is seen in a state of exaggerated intimacy and recoil – in the outrageous *Next Morning* (1999), the abject (anti)hero acquires a performer's aura and tears open the seams of the wound.

In *Bullet Shot in the Stomach*, the gun-shooter has a wide, clean forehead, thin arms, a faraway look and ornamental wounds on cheek and neck. He barely looks at the white-haired, open-mouthed villain-victim, with his stomach in a gory mess. Snarling in pain like a shocked beast, this brutish 'being' is the avatar produced by the contemporary social, specimens of which abound in the popular imagination, courtesy of the Bombay films that Khakhar avidly watched. Indeed, with the scale and crudeness of its frontally- posed figures, its rough black ground and spotlit 'performers', *Bullet Shot in the Stomach* looks like those hand-painted cinema hoardings of B-grade films that were, not so long ago, before the digital takeover of the public image, emblematic of the visual culture of the Indian city. In this sense, the shoot-out is placed as in the genre of action-melodrama, a setting that might also have something to do with Khakhar's dedicated reading of detective novels. On a second take, it could also be a confessional painting: an expiation of unnamed sins where the man shot – an erstwhile lover? – is a desperately materialised projection of the gentle shooter. The Khakhar lookalike and the morbid lumpen could together make up a composite identity whereby the painting records a terrifying moment when the towering, janus-faced icon, imbued with the secret bond, is destroyed in a violent attack of self-loathing.

In *Bullet Shot* you see a casual, informal rendering of figures; a turn around to bad drawing (usually designated 'naïve'); a flaunting of a no-skills bravado that nevertheless aspires to a renewed iconicity. But there is a translucent application of Khakhar's otherwise much-laboured-over oil paint – almost as if Khakhar was using a water-based medium so that the wounds may be washed off – and the soft muslin shirt of the sturdy victim flies open to reveal a huge coil of bloody intestines. In all the force of a declared malediction, you realise how his spirit is in a state of profound submission – not any more to his sexual obsessions but, ultimately, to the *act of painting*. Following in the footsteps of Francisco de Goya, Théodore Géricault and Francis Bacon, whose darkest, most monstrous paintings are sometimes the most beautifully, that is to say, most lovingly, painted, he finds a form of redemption after all. It arrives through painterly choices where the autobiographical is rendered through the *high art* of cruel and cathartic painting as it is through crude and popular *genres*. Through the caricatural physiognomy of the popular icon chosen within a specific cultural climate, Khakhar makes a stunning conflation of self and other. Displaying a sleight of hand gained at the end of his life, he makes the state of abjection a universal state that he can but occasionally reverse with an eccentric, exotic glimpse of beatitude.

Concluding 'Saint Bhupen'

Afflicted with cancer, Khakhar developed an aesthetic of cruelty that matched his melancholy, and in his late paintings you realise that in the riddle of simultaneous births, the pairing of cruelty and melancholy anticipates *beauty* as a third child – a miracle of triplicates!

It could also be said, and this would be a more sustainable interpretation, that while Khakhar's sexuality swings from possession to alienation to re-socialisation, and while he pollutes social spaces with erotic excess, he seeks to rehabilitate the 'sinning' protagonists inside his given world with a full claim to normalcy. Indeed Khakhar, like other members of the gay community today, reclaims his place in the material and spiritual universe on his own terms. Some exceptionally tender late paintings from his oeuvre include *Ghost City Night* (1992), *White Angel* (1995), *Elephants Sporting in River* (1998) and his glorious, profoundly placid chronicle of art and life, *The Goldsmith* (1997). Thus, along with his exhibitionism, there is a sanguine equation with the actual practice of art. By sheer painterly labour that values the pleasure of the painted surface and its plastic and chromatic brilliance, the sacred and the profane merge; similarly, through suitably fuzzy gender categories, the victims of majoritarian morality insert their subversive claims to stoke the fire and survive. This also allows the artist to slip in a cunning indictment of the cruelty of heterosexual normalcy.

There may be something of an Indian contribution to the gay discourse here, where permissiveness flourishes in the default mode, where rights are never won yet are perhaps granted or bestowed by custom and a seemingly libertarian tradition. Homosexuality in India is part of the ubiquitous system of lies and deprivation, part of religious performance, part of married life, part of popular culture – especially of mass film culture, where same-sex love is intricately encoded.

The abject, or rather the state of *abjection*, is a marker of difference, but it is also a condition

of being. It is the place where identity is recognised, but where categorical claims for that identity collapse. In a way, the space of difference is the space of collapse, of an encounter with non-being. In that space between the pathetic and the spectacular – the well-known liminal space of the social outsider – also lies the ground for *debonding* with the social order, for untethering the self, and thereby gaining a bid for transcendence. Here, then, is a subjectivity so stressed that it can *will its own apotheosis*.

This is the space in which Khakhar finds a way to heal the wounds left by his masked torturers who appeared, he always said, in the early hours of his dream life, whip in hand; this is the space where he avenges his vulnerability, then leads his own persecutory instincts from malice into a state of indifferent grace. It is the space where the artist makes a bold, brave intervention in favour of a pragmatic truce with everyday life and the norms of social relationships that he translates, quite uniquely, into myriad forms of companionship. This is Khakhar's ultimate eccentricity and, after Mahatma Gandhi, his '*experiment with truth*'.[21] Khakhar often quoted Gandhi's gospel in this subversive style of dedication and held it in place by nothing more than the singular, irrepressible act of painting.

NOTES

1. I give here a selected bibliography of books and catalogues; detailed bibliographies are available in the sources quoted below. My earlier texts on Khakhar include: 'Bhupen Khakhar: View from the Teashop', in Geeta Kapur, *Contemporary Indian Artists*, New Delhi: Vikas, 1978; Geeta Kapur, 'Bhupen Khakhar', in *Six Indian Painters*, exh. cat., London: Tate Gallery, 1982; Geeta Kapur, 'Bhupen Khakhar: The Lightness of Being', in *The Other Self*, exh. cat., Amsterdam: Foundation for Indian Artists, 1996; and *Bhupen Khakhar* (with a shorter, early version of this present essay and an introduction by Enrique Juncosa), Madrid: Museo Nacional Centro de Arte Reina Sofia, 2002. For biographical interest see Mahendra Desai, *A Man Labelled Bhupen Khakhar Branded as Painter*, Baroda: The Identity People, 1983. A contextual study on Khakhar is located in Gulammohammed Sheikh ed., *Contemporary Art in Baroda*, New Delhi: Tulika, 1997. There is a major monographic exposition on the artist by an important English critic: see Timothy Hyman, *Bhupen Khakhar*, Mumbai: Chemould Publications and Arts/Ahmedabad: Mapin Publishing, 1998. See also *Bhupen Khakhar 1934–2000: A Retrospective*, exh. cat., Madrid: Museo Nacional Centro de Arte Reina Sofia, 2002, and *Bhupen Khakhar, 1934–2000: A Retrospective* (with a 1980 literary portrait, 'Candour and Secrecy', by Adil Jusawalla, and the artist's last interview), exh. cat., Mumbai: National Gallery of Modern Art/Mumbai: The Fine Art Resource, 2003. Ashish Rajadhyaksha provides a different vantage point for Khakhar's work in 'Bhupen Khakhar's List', *Cinema in the Time of Celluloid: Indian Evidence*, New Delhi: Tulika Books, 2007.

2. These were seen as opposed values in his famous essay of that title by Clement Greenberg, *Art & Culture*, Boston: Beacon Press, 1968.

3. Born on 10 March 1934, Khakhar was the youngest of four children. His father belonged to an artisans' family and became a woodwork instructor when the family moved from Daman to Bombay. Khakhar's maternal grandfather taught in Bombay while his mother's family were textile woodblock printers. Raised by the widowed mother, the matriarch Mahalaxmi, and an elder sister, Khakhar obtained several degrees from the University of Bombay and became a chartered accountant. His amateur interest in painting took him to Baroda in 1962, where Khakhar was encouraged by artist-teacher, Gulammohammed Sheikh, to join the art criticism department in the Faculty of Fine Arts, M.S. University. Although soon recognised as an artist, Khakhar, partly in compensation for his betrayal of the family's hopes, worked for a salary as a chartered accountant until the age of 50.

Baroda (Vadodara) played an important part in Kharkhar's artistic career. The medium-sized city, situated in the mercantile region of Gujarat, not far from the great metropolis of Bombay (Mumbai), developed a distinct cultural milieu during the reign of Maharaja Sayajirao Gaekwad-III (1881–1939). From the 19th into the 20th century, Baroda was known for its 'royal' patronage of music and painting; in the post-independence period for its progressive bourgeoisie and a small but lively intelligentsia. This set the stage for an enlightened Faculty of Fine Arts inaugurated in 1950 at the Maharaja Sayajirao (M.S.) University. With its modernist curricula, it soon superseded the British/colonial art school education of Bombay's J.J. School of Art and, with the help of a distinguished Faculty, it adapted the indigenist/ nationalist philosophy of Kala Bhavana, the Tagore-initiated art school at Viswa-Bharati University, Santiniketan. With national and international artists visiting the Faculty, Baroda acquired a cosmopolitan character and functioned like a laboratory for key developments of modern Indian art (see Gulammohammed Sheikh, op. cit.).

4. By way of cross-reference: in the mid-1960s, Rauschenberg was invited to Ahmedabad, the textile city of India, for an international workshop hosted by the Sarabhai family, members of the Indian national bourgeoisie who were connoisseurs of traditional Indian arts and, uniquely, of the American avant-garde as well. (Over the years, they invited other major artists from the West for similar experimental work but no interaction between the invitees and Indian contemporaries ever took place.) In 1967, Clement Greenberg accompanied an exhibition of post-war American painting toured by the Museum of Modern Art, New York; in Delhi, Greenberg participated in a lively, and at times contentious, symposium held on the occasion.

5. A 'contextual modernism' was underlined in Baroda by the pedagogy of K.G. Subramanyan (who was an alumni of Kala Bhavana). A range of India's 'living traditions', including the tribal, folk and popular, were seem to be imbricated with modern and contemporary art. This approach proved fortuitous in the 1960s when the popular, *as Pop*, came into focus. Khakhar, along with Vivan Sundaram, Jyoti Bhatt, Gulammohammed Sheikh, and others, launched on a dramatic makeover of the more conventional form of modernist painting into a consciously eclectic visual language; to this Subramanyan himself contributed brilliant painterly wit from the late 1970s (see Gulammohammed Sheikh, 1997, op. cit.).

6. Khakhar's MA thesis at the Fine Arts Faculty examined 18th- and 19th-century Company School paintings; the thesis also referred to the aristocratic painter, 'Raja' Ravi Varma (1848–1906), who trained himself to paint salon-style oils in a quasi-realist genre. Khakhar was perhaps the first modern painter to go on to appreciate kitsch images, mechanically reproduced through chromolithography for

a large-scale bazaar clientele since the 19th century. Right from the 1960s, Khakhar collected popular (oil and gouache) paintings of the 19th and early 20th centuries, as well as cheap (lithographic/oleographic) prints featuring subjects that ranged from genre scenes and landscapes to mythological figures, penny-icons and film stars. In subsequent years, Khakhar's oeuvre manifested the punctual appearance of all these languages, making him a masterful manipulator of the 'naïve' image as it was adapted for his own increasingly subtle forms of representation.

On Company School paintings, see Mildred Archer, *Company Paintings: Indian Paintings from the British Period*, London: Victoria and Albert Museum/Ahmedabad: Mapin Publishing, reprinted 1992; Stuart Cary Welch, *Room for Wonder: Indian Painting during the British Period, 1760–1880*, New York: American Federation for the Arts, 1978. On popular painting in India, see Mildred Archer, *Indian Popular Painting in the India Office Library*, London: Her Majesty's Stationery Office, 1977. Contemporary interest in urban popular imagery and kitsch has produced new research: see, Kajri Jain, 'Producing the Sacred: The Subjects of Calendar Art', *Journal of Arts and Ideas*, 30–31, 1997; Kajri Jain, 'India's Modern Vernacular – On the Edge', in Chaitanya Sambrani ed., *The Edge of Desire: Recent Art in India*, exh. cat., New York: Asia Society/Perth: Art Gallery of Western Australia, 2005. See also texts by Patricia Uberoi and Kajri Jain in *From Goddess to Pin-Up: Icons of Femininity in Indian Calendar Art (The Uberoi Collection of Indian Calendar Art)*, exh. cat., Fukuoka, Japan: Fukuoka Asian Art Museum, 2000; Neville Tuli ed., *The Historical Mela: The ABC of India, The Art, Book & Cinema*, exh. and auction cat., Mumbai: Osians, 2002; Jyotindra Jain, 'Morphing Identities: Reconfiguring the Divine and the Political', in Indira Chandrasekhar and Peter C. Seel eds, *body.city: siting contemporary culture in India*, New Delhi: Tulika Books/Berlin: House of World Culture, 2003; Erwin Neumaher and Christine Schelberger, *Popular Indian Art: Raja Ravi Varma and the Printed Gods of India*, New Delhi: Oxford University Press, 2003. The definitive study on popular visual culture in India is Christopher Pinney, *'Photos of the Gods': The Printed Image and Political Struggle in India*, New Delhi: Oxford University Press, 2004. On Ravi Varma, see E.M.J. Venniyoor, *Raja Ravi Varma*, Trivandrum: The Government of Kerala, 1981; essays by Tapati Guha-Thakurta and Partha Mitter in *Raja Ravi Varma: New Perspectives*, exh. cat., New Delhi: National Museum, 1993; Geeta Kapur, 'Representational Dilemmas of a Nineteenth-Century Painter: Raja Ravi Varma', in *When Was Modernism: Contemporary Cultural Practice in India*, New Delhi: Tulika, 2000.

7. On Company School, see the references in note 6 above.

8. *Darshana* is the formal viewing of deity, saint, icon and sacred object; by implication, it is the ecstatic worship (*bhakti*) and devotion (*seva*) offered by a devotee to gain the benediction promised in the very protocol of this encounter.

9. Christopher Pinney, op. cit.

10. What is special in the wall murals, cloth hangings and folio pictures of the 200-year old Nathdvara school of paintings portraying Krishna as Shrinathji, is the sweet degendering of the devotee in *Pushti Marga*, the Path of Grace; how each painting is signalled as public (pictorial) evidence of an opportune presence, and the fulfilment of the desire for grace in the moment of *darshan*; and how, at the same time, the priest-devotees (their portraits sometimes based on actual photographs) give equal emphasis to their worshipful desire and their social merit. See Amit Ambalal, op. cit.

11. I refer to the poster for his exhibition at the Kunika Chemould Art Centre, Delhi, 1970; see also *Bhupen Khakhar: 'Truth is Beauty and Beauty is God'*, a mini-booklet in the form of a clerk's diary, published on the occasion of his exhibition at Kunika Chemould Gallery, New Delhi, 1972. Continuing with the theme of masquerade, role-playing developed into the genre of satire when Khakhar's modest flow of fiction (short stories and plays in Gujarati) came to be recognised: *Mojila Manilal*, written and designed by Khakhar, was staged by a well-known director in Bombay in 1989. It is relevant that Salman Rushdie, master of masquerade, became an admirer of Khakhar and had his portrait painted by him – the two poseurs facing each other across the easel offering a performative aside of its own.

12. A group of Indian artists from Baroda and Bombay inaugurated a new phase of figuration in the mid-1970s, proposing something like a manifesto in a seminal exhibition titled, *Place for People* (1981). It featured Khakhar and his peers, Gulammohammed Sheikh, Jogen Chowdhury, Vivan Sundaram, Nalini Malani and Sudhir Patwardhan (see *Place of People*, exh. cat., with text by Geeta Kapur, New Delhi and Bombay, 1981). This exhibition belonged to the phase in post-modernism when artists in different cultures, engaged in tracking precedents for the vernacular, the popular and pop, renewed their interest in the *narrative* aspect of visual art. This in turn opened up legacies that had been marginalised by the universal (and homogenous) norms of a modernist aesthetic: Mexican Muralismo, German New Objectivity, Italian Neorealism, American Regionalism. Further, because narrativity underscored the argument in favour of regional/local art languages, *other* traditions came to the fore: during the 1960s and '70s, a 'meta-narrative' developed on the strength of the many narratives embedded in the traditions of non-western cultures (like India). This fulfilled a seminal function: what came to be known as Third world art, film and literature reclaimed a

politics of place, asserted the importance of 'difference' and revalidated the historicity of cultures in post-colonial societies. The *Place for People* artists, already referred to, had inherited the debates within national, progressive (also Marxist) politics, and they took a clearly partisan view on the narrative of class and gender-specific subjects.

By the late 1980s, the story of Baroda had split. Younger artists, coming to Baroda with the background of *ultra*-left-wing politics of Kerala, critiqued the ideology and aesthetic of *Place for People* (interestingly, Khakhar, even though he acted from a subversive/libertarian rather than a political position, was exempted from the critique for having so democratised the subject matter of Indian art). At the same time, the narrative schema broke up into complex (auto)biographical modes of self-representation whereby a new subjectivity was foregrounded. Social narratives were compressed into allegories of the *body*. A new aspect of the self was provided with Khakhar's 'coming out', by his asserting his gay identity (attributable to his travels, and friendships, in England, as well as to the death of his mother in 1980).

It can be argued that, as with the Pop connection, London played a part in the narrative turn: the distinct leaning towards narrative figuration in British art, designated as the School of London by R.B. Kitaj (see R.B. Kitaj, *The Human Clay*, exh. cat., London: Arts Council of Great Britain, 1976), found correspondences in India. Timothy Hyman made a link between London and a putative School of Baroda, and Khakhar featured among major British artists in Hyman's curatorial project around narrative art (see *Narrative Painting: Figurative Art of Two Generations*, Bristol: Arnolfini/London: ICA, 1979). Howard Hodgkin, at the top of his fame, invited Khakhar to teach briefly at the Bath Academy of Art, hosted him for that entire period and, later, showed him in the exhibition he curated for the Tate Gallery in 1982 (see *Six Indian Painters*, op. cit., in note 1). Well-introduced within the London art scene, Khakhar was given solo shows as, for example, by Knoedler Gallery in 1983.

International attention escalated in Khakhar's later career. I mention only two occasions in passing: he was the first Indian artist to be invited to show at the *Documenta IX* by Jan Hoet in 1992; and also the first Indian artist to be given a European museum retrospective, magnificently curated by Enrique Juncosa, at Madrid's Museo Nacional Centro de Arte Reina Sofia, in 2002 (see exh. cat., op. cit.).

13. Timothy Hyman's analysis of Sienese painting has been realised in a splendid artist/art-historian's study, in which the theme of vernacular realism is developed. His chronicle of Sienese painting is structured by Siena's Commune, its radical experiment in self-government where, over and beyond the bishop or feudal lord, the citizens themselves administered their city-state on a rotation basis, to ensure equity and justice. Ambrogio Lorenzetti was commissioned to celebrate and reinforce the virtues of this city-state and he allegorised the material manifestations of a good (and bad) government in a narrative that becomes, in Hyman's account, an unparalleled pictorial rendering of civic/political life for all times. See Timothy Hyman, *Sienese Painting: The Art of a City-Republic (1278–1477)*, World of Art, London: Thames & Hudson, 2003.

14. Ashish Rajadhyaksha, op. cit.

15. Ashish Rajadhyaksha, op. cit.

16. It might be added that, while Indian art since the 1990s, is characterised by the use of new media/technologies – photography, installation, video, digital and web-based works – all outside Khakhar's *oeuvre*, his astonishing yield of cruel and tender paintings places him among the contemporary masters of figurative painting, and of the painted image itself.

17. Michel Foucault, *The History of Sexuality*, vol. 1, Harmondsworth: Penguin, 1991, 43.

18. The Kalighat watercolours were exuberant penny-icons painted by dispossessed folk artists and sold in Calcutta's Kalighat temple bazaar to itinerant pilgrims. They offered Khakhar an extraordinary array of images – personages from Hindu mythology; avaricious and cowardly men; beautiful, adulterous women – and other such ephemera that established a fully-developed school of urban-popular picture-making characterised by its own proto-modern stylistics of pictorial abbreviation. For a recent study on Kalighat paintings, see Jyotindra Jain, *Kalighat Painting: Images from a Changing World*, Ahmedabad: Mapin Publishing, 1999.

19. While Khakhar's subjective efflorescence in painting was related to his increasing assertion of gay identity, its translation in art may also have been prodded on by the painterly excesses of (British, German and Italian) New Image painters of the period. It should be noted, however, that any further consideration of the relationship between contemporary Indian and western art should include a critique of the older notion of *influence* in the context of the unprecedented cultural eclecticism of the post-modern era. Further, any viable connection between such artists as, for example, Francisco Clemente and Bhupen Khakhar, requires an understanding of how, while employing similar source material (situated, in this case, within Indian 'culture'), each of them is pitched into eccentric forms of subjectivity from widely different biographies.

20. Edward Said, *On Late Style: Music and Literature Against the Grain*, New York: Pantheon, 2006.

21. The famous phrase is from M.K. Gandhi: *An Autobiography: The Story of My Experiments with Truth*, London: Jonathan Cape, 1966.

TROPES OF THE GROTESQUE IN THE BLACK AVANT-GARDE
KOBENA MERCER

Examining works produced by three African American artists in the period between the late 1960s and the mid-1980s, this chapter investigates the way that vernacular materials feature in the assemblage art of Betye Saar, the paintings of Robert Colescott and in conceptual works by David Hammons. Although each artist draws from disparate sources, just as each is aligned with distinct paradigms in post-war American art, there is a disruptive edge to the aesthetic strategies of their working methods. Such practices could be said to be avant-garde in the sense that they actively interrupt an 'official' consensus or orthodoxy by articulating a *double-voiced mode of address* that is as critical of conservative tendencies in black popular culture as it is pointed in its stance towards monocultural tendencies in national and international art worlds.

Drawing attention to semiotic qualities of ambivalence, equivocation and intertextuality, the notion of double-voicing put forward by Mikhail Bakhtin is pertinent to African American art history and to the study of the cultural formation of the modern black diaspora in at least two ways.[1] The view that language exists in a condition of heteroglossia – in which diverse social voices and accents are entangled and compete – not only addresses the linguistic hybridity that arises in social worlds shaped by slavery and colonialism, but also acts as a template for the study of cross-cultural dialogism in the arts as a whole. British colonialism, for example, did not simply impose Standard English as a dominant 'voice' in societies subordinated to its imperial rule (including colonial America), but also participated in a process of hybridisation whereby numerous variants – from African American vernacular speech to Caribbean patois and West African pidgin – have arisen

to differentiate themselves from the master-code of a given national language. For literary scholar Henry Louis Gates Jr, the dialogic method serves to reveal the creative tropes of African American literature, for what makes the language 'literary' in this tradition are the formal moves and devices that 'signify upon' the text of blackness in the dominant discourse of American national literature.[2]

Translating from the literary to the visual sphere, what aspects of this approach can be brought to bear on understanding the formal, stylistic and iconographic choices black artists made as they responded to the 'text of blackness' in the surrounding visual culture of modernity? Where the double-voiced qualities of African American art have addressed issues of 'race' and ethnicity in modern visual culture since the mid-19th century, while at the same time addressing a wider (transnational) community of interest formed by the historical dispersal of African peoples into the West, Bakhtin's mode of analysis lends itself well to the notion of 'double consciousness' that W.E.B. DuBois put forward in *The Souls of Black Folk* (1903) to define diaspora subjectivity as being both inside and outside the symbolic order of 20th-century modernity.[3]

It may seem strange to suggest that analytical tools developed by a group of Russian philology scholars – 'P.N. Medvedev, V.N. Volosinov and M.M. Bakhtin, who were in Vitebsk in the early 1920s and later worked in Leningrad' – may harvest fresh insights into works of art created out of the Black Power era of Afro-American life in the late 1960s. But when the late Raymond Williams called up 'the road to Vitebsk' as a flashpoint in the politics of 20th-century modernism, and did so to argue the authority of

academic formalism, his counter-argument, 'that the autonomous text, in the very emphasis on its specificity, is, as Voloshinov [sic] had shown, a work in language that is undeniably social',[4] is a view that speaks directly to current theoretical dilemmas in the historiography of black visual arts. Where Williams identified textualism and sociologism as the two principal contending forces in understanding relations between art and society, it may be said that the aesthetic specificity of works of art by 20th-century black artists rarely enjoys the benefits of the formalist emphasis on autonomy. Despite the welcome proliferation of surveys and monographs in recent years, the black art object is rarely a focus of attention in its own right.[5] Artists, art worlds, and artworks are three very distinct ontological categories, but a brief glance over the discourse of black art criticism at various moments in the 20th century – from the Harlem Renaissance of the 1920s, the Negritude movement of the 1940s, to the US Black Arts Movement of the 1960s – shows a consistent emphasis on the first and the second elements that tends to undermine the quality of attention given to the third.

In challenging the contextualist orientation that tends to subordinate aesthetic specificity to sociological issues of identity and institutions, the goal is not to revive the 'internalist' logic of formalist criticism but to examine how the social construction of blackness creates a condition of polyvocality in which visual signs of identity and difference are invested with a multitude of contradictory meanings and antagonistic values. On this view, the essentialist question – 'what is black art? – is the wrong question to ask, for it implies a search for a set of immutable qualities. Rather, once 'black' is understood not as a category of identity given by nature, but as a subject-position historically created by discursive regimes of power and knowledge in the social domain of 'race', then the goal is to explore how art produces a signifying difference in the cultural codes of collective consciousness and thus has the potential to alter or modify prevailing consensus in the symbolic construction of reality.

By grouping Saar, Colescott and Hammons as artists who contributed to a 'black avant-garde' during the shift from late-modernism to post-modernism, I am not primarily seeking a direct line of descent from the historical avant-garde associated with Russian constructivism, although I do want to foreground aesthetic forms and devices that can be said to 'de-familiarise' or 'estrange' the visual text of blackness. How might we account for 'shock' effects of perceptual disturbance and optical double-take that reveal blackness as a polyvocal signifier? While the category of 'avant-garde' was itself widely contested during the late 1960s and 1970s, can Bakhtin's notion of cultural hybridisation contribute to a deeper understanding of how black artists opened up a wider range of questions about 'race' and representation as a result of the crisis of modernism that came to a head during this period?

Where black modernism(s) could be said to be accommodated within bourgeois institutions of art (albeit on the margins) when cross-cultural dynamics are enclosed by primitivist, folkloric or ethnographic paradigms, Bakhtin's distinction between 'organic hybridisation' and 'intentional hybridisation' bears directly on the disruptive qualities of double-voicing found in various avant-garde strategies. Defining hybridity as 'a mixture of two social languages within the

limits of a single utterance', Bakhtin contrasts the 'mute and opaque' quality of organic hybrids with the dynamic qualities whereby 'intentional semantic hybrids are inevitably internally dialogic (as distinct from organic hybrids). Two points of view are not mixed, but set against each other dialogically.'[6] Whereas cross-cultural hybrids may be accommodated by bourgeois institutions of modern art as organic fusions that confirm the prevailing order, Bakhtin's account of intentional hybridisation identifies the point at which 'the authorial unmasking of another's speech'[7] has the potential to subvert the monologic voicing of institutional authority. In this sense, intentional hybridisation is both an apt description of the avant-gardist practice of institutional critique as well as a vivid description of the contestatory quality of cross-cultural practices that reveal the semantics of blackness as internally heterogeneous.

Betye Saar: Assemblage and Bricolage
Surveys acknowledge the important place *The Liberation of Aunt Jemima* (1972) occupies in African American art history as a political critique of the visual power of stereotypes, and yet the poetic agency of Betye Saar's assemblage methods has rarely been examined in depth.[8] As a three-dimensional collage, the work addresses the 'Mammy' image inscribed in three distinct material elements set within a box-like cabinet. While the garishly-painted ceramic figurine dominates the central plane, its lower bodily portion is indented by a postcard-size depiction of another Mammy (who holds a crying mulatto under her arm), and a third Mammy image is repeated on the rear plane of the cabinet in the registered trademark logo for Aunt Jemima Pancake Mix.

Bearing a rifle in one hand and a pistol in the other (as well as a broom), the central figurine has tended to dominate readings of this work, which argue that the ideologies of domestic servility and maternal duty invested in the Mammy stereotype are subverted by countervailing elements (including the Black Power salute) that signify a militant black consciousness confronting the symbolic codes of 'race' in American visual culture. While the juxtaposition of these elements certainly interrupts the semantic unity of the stereotype, I suggest that *The Liberation of Aunt Jemima* is best understood when placed within the thematic trajectory of Saar's oeuvre as a whole, which is centrally preoccupied with questions of fetishism. Taking account of the box-like cabinet as a consistent framing device, Saar's assemblages articulate cross-cultural hybridisation at the level of their formal construction, and, in this case, her artistic methods arrived at insights into the fetishistic power of racist stereotypes long before post-colonial theory.

In point of fact, the view that the docile and subservient status of Aunt Jemima is reversed into its opposite by the addition of guns and rifles indicates the least original aspect of this piece. As early as 1963, Chicago-based artist Jeff Donaldson had evoked irony and satire in *Aunt Jemima and the Pillsbury Doughboy*, which depicts a rotund black female figure with headwrap and apron – three essential iconographic elements in the Mammy stereotype – being assaulted by a truncheon-wielding policeman. Whereas Aunt Jemima and Uncle Ben are brands owned by the Quaker Oats corporation, the irony here turns upon the Pillsbury Doughboy as an iconic trademark of white bread Americana. Offering an equally

Betye Saar,
*The Liberation of Aunt
Jemima*, 1972

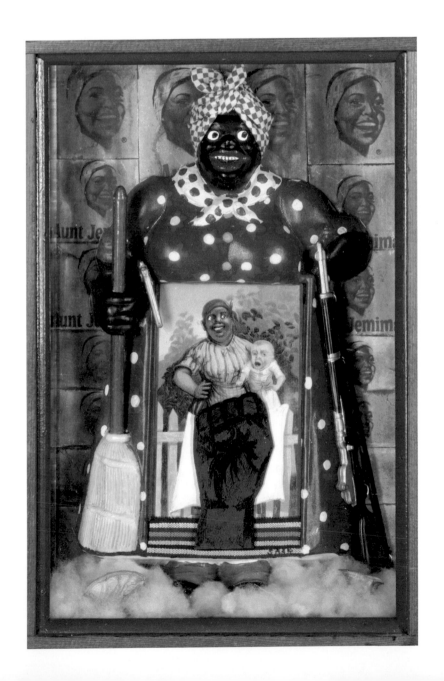

pointed comment on commodity packaging, Joe Overstreet's acrylic and plywood construction, *The New Jemima* (1964), is an over-sized box of pancake mix (enlarged in the manner of a Claes Oldenburg scuplture, as it were), upon which a black female figure fires a machine-gun beneath stencilled words that read 'Made in USA'. By 1968, Murray DePillars' pen and ink drawing, *Aunt Jemima, Section 22*, had empowered the Mammy figure to break out of her box (whose listed ingredients were now replaced by texts on Afro-American history), with one of her arms raised against an American flag in the background (whose stars were substituted by Chicago police badges).

Placed within this intertextual suite – which indicates how pop art concerns with commodity fetishism were modulated by the politics of representation in black cultural contexts – Saar's assemblage practice 'challenged the dominance of fine or "high" art by using found objects and recycled materials.'[9] In this respect, she departed from the parodic rendition of stereotypes in the painterly languages of expressive figuration, and opted instead for an act of appropriation in which the Aunt Jemima stereotype was approached as a found object or readymade. Where cubist collage disrupted the pictorial grammar of illusionism by 'setting one thing beside another without connective',[10] and dada and surrealism employed de-naturalised juxtapositions to generate open-ended semantic associations around pre-existing objects taken out of their embedded contexts, Saar's distinctive achievement was to adapt the modernist epistemology of bricolage to the exigencies of her time and place. Raised in Pasadena, Saar (b.1926) had graduated from the University of California, Los Angeles in 1949 and worked as a graphic designer. Producing prints and etchings at California State College at Long Beach, the key catalyst for her artistic medium of choice was a 1968 Joseph Cornell retrospective at Pasadena Art Museum.

Saar's encounter with Cornell was decisive for this was, 'the first kind of thing I had ever seen in a box'.[11] Where such early works as *Black Girl's Window* (1969) established an autobiographical reference for her emerging authorial voice, the framing device of an antique leaded window (found in Big Sur) laid out her distinctive interest in astrology, palmistry and tarot. These vernacular sources would later expand into vodun, shamanism and the ritual forms of Afro-American 'folk' religions to define the subject matter of Saar's oeuvre. Describing 'the window [as] a way of travelling from one level of consciousness to another',[12] this liminal symbolism can be understood as a formal means of constructing a 'container' for the work's contents, of which the artist has said:

> On the top are nine window panes in rows of three marked by the crescent, the star and the sun. But look what's at the center, a skeleton. Death is at the center. Everything revolves around death. In the bottom is a tintype of a woman. It's no one I know, just something I found. But she's white. My mother's mother was white, Irish, and very beautiful [...] And there's the same mix on my father's side. I feel that duality, the black and the white.[13]

Introducing a syncretic world-view that questions the either/or dualities of black identity in American national culture, Saar's artistic outlook overlapped with her contemporaries,

such as Faith Ringgold (b.1930) and Raymond Saunders (b.1934), who also contributed to a collage-based breakthrough into intentional hybridisation. Her citation of Joseph Cornell, however, underlines a distinctly surrealist influence that distinguishes Saar as an artist who has ventured into the psychic dimension of American hybridisation to explore the unconscious realm in which struggles over the signs of blackness are played out.

Writing about Cornell in the context of 'ethnographic surrealism' as a counter-tradition to modernist primitivism, James Clifford observes a point of contact between Cornell's 'magical boxes' and, 'the home altars, *ofrendas* constructed by contemporary Chicano artists', as he reflects upon, 'a local/global fault line opening in Cornell's basement, filled with souvenirs of Paris, the place he never visited. Paris, the Universe, basement of an ordinary house in Queens, New York, 3708 Utopia Parkway'.[14] Like Cornell, Saar made use of boxes and hinged cabinets as formal devices to mark out a threshold 'from one level of consciousness to another', but whereas Cornell's boxes contained a nostalgic archive of urban modernity, the family memorabilia accumulated in such assemblages as *Record for Hattie* (1975) and *Miss Hannah's Secret* (1975) points towards Saar's archival remembrance of ancestral figures otherwise lost from collective history. Adopting the altar form in such key works as *Mti* (1973) and *Indigo Mercy* (1975), Saar's dedicated exploration of Afro-diasporic spiritual belief-systems also addresses modern desires for 'magic' by way of re-membering (putting back together again) the lost body of the black diaspora's unknown ancestors. As she stated in 1979: '*the boxes are coffins. They're all coffins. They contain relics from the past.*'[15]

Once situated in relation to the psychoanalytic conception of the fetish as an arbitrary object invested with surplus emotion as a result of unconscious chains of substitution and displacement that cover over a primal loss or absence, we can understand the importance Saar attributes to a 1975 *Artforum* article on 'power objects' in African sculpture in which Arnold Rubin examined cultural phenomena similar to the BaKongo *nkisi* talismans studied by Robert Farris Thompson.[16] Such scholarship illuminates the broad terrain of the survival and retention of 'Africanisms' within the black diaspora. In contrast to Afrocentric tendencies that search for one-to-one correspondences between latent 'Africanisms' and the manifest forms of Afro-American 'folk' religions, or else search for idealised ancestral figures, the discursive framework that best suited Saar's intuitive procedures – 'I've been a collector all my life', she told artist Benny Andrews in 1975[17] – was one that placed a greater emphasis on the transformational agency of the diaspora imagination in addressing the 'lost' heritage of the ancestral past.

On this view, the artist that Betye Saar most resembles is novelist and writer Zora Neale Hurston, who 'collected' folk tales from the southern vernacular and 'collaged' these elements into her modernist fiction, in contrast to the 'preservationist' paradigm surrounding self-taught vernacular artists, such as sculptor William Edmonson – the first African American artist to receive a solo exhibition in an American museum of modern art – who were often perceived as quasi-anthropological specimens. Foregrounding the poetic transformation of found materials whereby her bricolage practice imaginatively re-assembles the lost body of

unknown ancestors, Saar's lifelong interest in ritual healing was predicated on the view that 'magic is the communication between material and spiritual worlds',[18] and joins onto an entire tradition of Afro-diasporic modernism(s) in which the body is the key site of imaginative re-assemblage – from Romare Bearden's paper montages of the 1960s to sculpture by Rene Stout and Alison Saar in the 1980s.

Returning to *The Liberation of Aunt Jemima* in light of this discussion, what we find is a critical practice of *counter-fetishism* that employs bricolage-epistemology to work through the emotions provoked by the found object. Far from eliciting a morbid sentimentality, the accumulated material does not 'romanticise' the relics from the past, for Saar's unflinching view that 'everything revolves around death' suggests a process of renewal whereby art-making is implicated in the de-cathexis (or letting go) through which the ego detaches itself from emotional ties to the lost object. Whereas most of the boxes created during the 1970s are 'coffins' that suggest a desire to protect memories of a past that the diaspora has lost, and their domestic scale cues a contemplative response (like a shoe-box containing family photographs), the abrasively frontal re-presentation of the Mammy figurine in *The Liberation of Aunt Jemima* makes it somewhat anomalous within Saar's oeuvre. However, once it is recognised that, 'the "political" boxes are mystical boxes too [and] that the mystical boxes are as "political" as Aunt Jemima',[19] we understand how the de-cathexis that transforms the emotional weight of the objects inside the container is a process that crucially depends upon the effects of distantiation provided by the box as a framing device. When seen as a vitrine or a 'cabinet of curiosities', *The Liberation of Aunt Jemima* acts as a coffin that metaphorically 'buries' the stereotype as a historical artefact. The dialogic juxtaposition of elements inside the box interrupts the semantic currency of the stereotype, but it is the box itself that plays a decisive part in signifying a counter-ethnographic move in which the Mammy figure is estranged as if it were an enigmatic artefact from an alien world. Saar made this archival enquiry explicit in *Is Jim Crow Really Dead?* (1972) and the box-as-coffin metaphor was further explored in a parallel piece, *Imitation of Life* (1975), in which a tiny Mammy figurine on the scale of a child's toy was placed into a little cabinet. Where the framing device fully contributes to the semiotic transformation of the material it frames, Saar's methods of poetic estrangement and critical distantiation opened up an imaginative excavation of modern American history that was followed up, some 20 years later, by the neo-conceptual installation strategy of Fred Wilson's *Mining the Museum* (1990).

The Dialogical Principle

Approaching the stereotype as an 'already read text', Henry Louis Gates gives important emphasis to the condition of 'answerability' in African American cultural production.[20] All art answers to models, precedents and exemplars, but the historical contexts in which blackartists made their individual choices were over-determined by the social construction of blackness as a sign of otherness within the visual culture of the West. The artistic decision to respond to such a pre-existing text of blackness thus differentiates the structural context-of-choice in which artistic intentions are forged. The historiography of African American art opens onto patterns of

call-and-response whereby works by black artists can be said to 'talk back' to depictions of blackness found in both fine art traditions and in popular visual culture, and in this respect Bakhtin's relevance to the study of black diaspora modernism is heightened by his category of 'the carnivalesque'.

In *Rabelais and His World* (1965, trans. 1968), Bakhtin examined the folk culture of European carnival to examine the point at which the official world-view of state and church authorities was ritually unmasked by the riotous, bawdy and exuberant voices of 'the people'. Studying patterns of topological inversion in the view that carnival 'turns the world upside down', he demonstrated how symbolic boundaries of 'high' and 'low' are thrown into crisis by the twists and turns of the carnivalesque. Bakhtin also went on to show that where such vernacular traditions were disciplined by the classical ideals of Enlightenment, and gradually suppressed by Protestant modernity, the iconography of 'grotesque realism' acted as a hidden resource for a counter-discourse that stretches from the 18th-century novels of Jonathan Swift and Laurence Sterne, to the absurdist theatre of Alfred Jarry and the dadaist cabaret of Tristan Tzara. While the OED offers, 'decorative painting and sculpture with fantastic interweaving of human and animal forms with foliage', or else defines grotesque as, 'comically distorted figure or design', Bakhtin reveals that the narrowing of the term to describe the 'distorted, bizarre, ludicrous from incongruity, absurd', was itself a historical outcome of official reaction to the 15th-century discovery of erotic drawings in Roman grottoes.[21] Two outstanding recent exhibitions – *Carnivalesque* (2000) and *Grotesque!* (2003) – show how Bakhtin's insights enrich our

understanding of this shadow-side tradition in visual modernity.[22]

Following the cultural studies approach put forward by Peter Stallybrass and Allon White, who mapped the symbolic anthropology of 'high' and 'low' onto the Freudian topography of ego and unconscious to reveal, 'a mobile, conflictual fusion of power, fear and desire in the construction of subjectivity: a psychological dependence upon precisely those Others which are being rigorously opposed and excluded at the social level',[23] my interest lies in the double-sided consequences that call for attention once we recognise the iconography of the grotesque as one of the primary visual languages of modern racism. Moving on from the analysis of blackness as a sign of the Other in western culture, we can regard the family of stereotypes created by 19th-century paternalism as a repository or container for 'comically distorted' and 'bizarre and ludicrous' imagery that was otherwise cast off by the process of modernisation that installed the Greco-Roman classical body as the authoritative symbolic ideal of the West. As Michael Hatt argues, the mid-19th-century strand of abolitionist imagery that sought to 'dignify' the figure of the Negro by assimilating the black body to the classical ideal set itself against the degraded and devalued iconography of the 'low' culture stereotype, even though both regimes of representation shared a paternalist ideology that denied freedom by portraying the black subject in a state of dependency. American Civil War sculptures, such as *The Freedman* (1863) by John Quincy Adams Ward or Thomas Ball's *Emancipation Group* (1875), reveal a contradiction in the politics of recognition. At issue was not simply how art might transform an 'other' into an 'equal', but how the libidinal currency of the black

body as an object of spectacle for the white gaze could be reconciled with the aspiration of official discourse to confer respectability on a class of newly emancipated 'citizens'. Bearing in mind that, 'it is *after* emancipation that racism becomes most intense and virulent', Hatt shows how such idealised figures were 'trumped' by caricatures such as Thomas Worth's *Darktown* (1882) prints that absorbed the contradictions of paternalism by re-doubling the otherness of 'the black body in its extreme grotesque definition as a symbol of the coherence of *white* America'.[24]

Hatt's discussion of 'the grotesque body and class transgression' makes gender a co-constituitive category in studying the relations of 'race' and representation, although my contention is that, like other equally insightful studies of the Other in the formation of whiteness, his approach ignores the issue of answerability on the part of African American painters and sculptors who 'talked back' to the visual codes of abolitionist art. As Gates argues, the struggle for access to the means of self-representation was negotiated, in slave narratives and early fiction, precisely by introducing a critical difference into codes and conventions that African American writers shared with their Anglo American counterparts. Rather than two fully-formed languages confronting one another in a single utterance, the entry of African Americans into the realm of 'high' culture was a socially dialogic process from the start: it is at the level of stylistics and rhetoric, as much as subject matter or genre, that Gates identifies a range of expressive features and formal qualities that make this literary tradition diacritically 'black'.

Mary Edmonia Lewis (1845–1911) and Henry Ossawa Tanner (1859–1937) each produced works within their oeuvres that suggest a vivid parallel in the visual arts. As art historians Albert Boime and Judith Wilson have revealed, the importance of a work such as Tanner's *The Banjo Lesson* (1894) lies, in part, in its critically dialogical relationship to the minstrelsy stereotype found across the vaudeville music theatre of the popular classes and in such populist genre paintings as Eastman Johnson's *Life at the South* (1859). In Gates' vocabulary, we might say that Tanner's intimate and dignified scene – a boy being taught to play the banjo – signifies an expressive differentiation from the hackneyed portrayal of the banjo player at the centre of Johnson's theatrical *mise-en-scène* (in which a white female figure peers around a corner as she steps into the scene and becomes a spectator to be entertained by the minstrel). There is both difference and sameness here in the encoding of authorial intention and in the grammar of the code.[25]

In parallel to Gates' account of the dilemma of self-representation found at the historical beginnings of the African American literary tradition – how could an ex-African self represent itself in the language of western letters?[26] – we might say that visual artists also came into agency by operating 'in-and-against' the dominant codes of the national culture. In the case of *Forever Free* (1867) by Edmonia Lewis, the account that Judith Wilson puts forward compares and contrasts this composition to Ball's *Emancipation Group* (both share the same subject matter), while also addressing the gender-specific constraints that 19th-century black female artists faced as they entered fine art professions. Far from suggesting that the artist's identity determines the meaning of their work, Wilson's close analysis of subtle differentiations refuses to reduce the interpretation of African American art to its

referential and contextual aspects for she highlights the signifying difference that Lewis encoded into the allegorical vocabulary of the classical ideal. Where *Forever Free* is a complex composition that suggests that the political contradictions of black emancipation remained unresolved after the Civil War, it is the work's accentuation of neo-classicism that signifies this muted dissent.[27]

The historicising excursus pursued in this section of my argument has removed us far and away from the late 20th century, but all the more so to return us to the present moment with a deeper understanding of the qualitative differences created by the signifying practices that define this modern artistic lineage as 'black'. To say that the Harlem Renaissance-era sculpture, *Forever Free* (1935), by the California-based artist Sargeant Johnson, answers to Mary Edmonia Lewis by self-consciously repeating the title of her 1867 work is to say that Johnson's modernist 'text' also signifies upon the Mammy stereotype by virtue of the way it restyles the morphology of the rotund black maternal body, replacing the apron that denotes a servant's duty of care with an indented frieze of children whose presence connotes their mother's capacity to protect her own.

Whereas Sargeant Johnson's call-and-response marked a black modernist practice at mid-century, Betye Saar's late-modernist entry into the intertextual signifying chain inscribed around the Mammy was able to bring out the hitherto 'mute and opaque' dynamics of dialogic hybridisation into the open. Aunt Jemima was being liberated from the economy of fear, power and desire that had imprisoned her in the codes of racial fetishism as an imaginary 'other' to someone else's 'self'. In Gates' theory, 'to signify'

upon the utterance of another is to use the verb in the manner of the black vernacular, which 'is to express (often with caustic wit) an unremitting critique of the referential effects of racial discourse in Standard English by means of using performative moves drawn from the rhetorical, lexical and semantic resources of the dominant code (or master-language) itself.'[28] Adapting Bakhtin's version of this dialectical approach, we can begin to sketch out the dialogical principle in African American art historiography:

> The word in language is half someone else's. It becomes one's own ... only when the speaker appropriates the word, adapting it to his own semantic and expressive intention. Prior to this moment of appropriation the word does not exist in a neutral or impersonal language ... rather it exists in other people's mouths, serving other people's intentions: it is from there that one must take the word and make it one's own.[29]

On this view, we can identify the different modalities of dialogue whereby the structuring principle of 'talking back' to someone else's 'image of the black' defines the double-voiced matrix of this artistic tradition. In a segregated world hemmed in by supremacist ideologies, the idealistic refutation of the stereotype among 19th-century black artists made classicism and naturalism key codes of choice; whereas in the New Negro era of the 1920s and 1930s, the wider variety of stylistic choices opened up by the cubist rupture with illusionism led to the ambiguities of a 'minor' modernism that sometimes played along with western primitivism and at other times began to

antagonise the equation of otherness and blackness in the visual culture of the high modernist moment. Primitivist, folkloric and ethnographic paradigms acted as major constraints in the mid-20th century contexts-of-choice in which African American artists negotiated various realisms, expressionisms and abstractions, but it was only in the 1960s that the dialogical principle came out into the open in confrontational choices that actively 'signified upon' the signs of blackness in American visual culture. 'This *inner dialectic quality* of the sign comes out into the open only in times of social crises or revolutionary changes', or so Volosinov argued with his concept of the multi-accentual sign.[30] Coming closer to our contemporary moment, it is the laying bare of these historical dynamics of dialogic appropriation that characterises the black avant-garde strategies that came to voice as a result of the crisis of modernism.

Robert Colescott: Parody and 'Bad Painting'

To the extent that the image of the black in western culture has rarely ever existed 'in a neutral or impersonal language', but has existed in other people's eyes as the ultimate icon of otherness, then the achievement of painter Robert Colescott was to act upon 'appropriation' in the active sense Bakhtin imparts to the term as an intervention that unmasks the authority of what is always already said. From as early as 1975, Colescott initiated a practice of parody that took as its targets key masterpieces from the western canon. Parody, pastiche, deconstruction and appropriation were all evolving keywords in the lexicon of post-modernist criticism that emerged during the late 1970s, and yet Colescott was studiously ignored until the belated recognition

that came in the 1990s, such as when he represented the US at the 1997 Venice Biennale. The reason for this delayed recognition was that Colescott's practice took place in the medium of painting and not in the photographic or image-text media preferred by the critics of modernism.

Whereas Fredric Jameson interpreted parody as a symptom of 'a world in which stylistic innovation is no longer possible', and, 'all that is left is to imitate dead styles',[31] literary historian Linda Hutcheon's nuanced account of the formal variety of parody shows how imitation is encoded on a spectrum that produces homage and tribute in its 'sincere' mode but which results in satire, mockery and travesty in its 'ironic' mode: the key issue is the degree of stylistic distortion that interposes a knowing distance between the source or the target and the enunciative intent of the authorial voice.[32] Discussing how Colescott 'signifies upon' Picasso by producing *Les Demoisselles d'Alabama: Vestidas* (1985) and *Les Demoisselles d'Alabama: Desnudas* (1985), art historian Sieglinde Lemke demonstrates how the selection of the target and the ironic style of the parodic version are jointly directed towards unmasking the cross-cultural dynamics of hybridity at the very origins of 20th-century modernism. Whether denuded or clothed, Picasso's instantly recognisable figures are subverted by fleshy replacements who also switch ethnicities: the lower right-hand figure is now substituted by a blonde vamp and the right-hand standing figure now appears mixed-race or Creole. As a result, the source image 'has lost its gloomy qualities and taken on campy features that call to mind the mocking playfulness and gaudiness of pop art'.[33] Colescott's targets, however, extend beyond the modern canon: they not only include Van Gogh, parodied in *Eat Dem*

Robert Colescott,
*George Washington
Carver Crossing the
Delaware: Page from
an American History
Textbook*, 1975

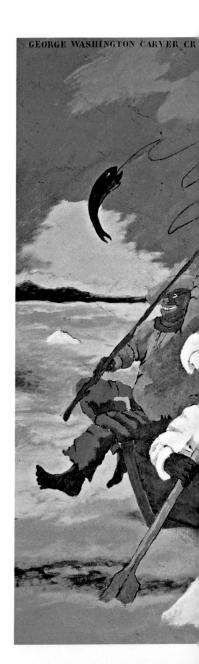

Taters (1976) and *Auvers-sur-Oise (Crow in the Wheat Field)* (1981), but also infiltrate the canonical archive in such works as *Homage to Delacroix: Liberty Leading the People* (1976) and *Knowledge of the Past is the Key to the Future (Love Makes the World Go Round)* (1985), which reworks Mantegna's *St Sebastian*. Viewed in the round, I suggest that pop played a decisive role in Colescott's practice of parodic appropriation.

In this respect, *George Washington Carver Crossing the Delaware: Page from an American History Textbook* (1975) stands out as a key work. As a 'spoof of Emmanuel Leutze's academic painting of 1851', Colescott's parody 'satirized the exclusion of blacks from history texts and ridiculed popular racist stereotypes',[34] as critic Irving Sandler observes, and yet many art historians seem oblivious to the fact that, by virtue of sharing the same source, this work also alludes to Larry Rivers' *Washington Crossing the Delaware* (1953). Rivers targeted Leutze for two reasons, for as he recalled: 'Year after year, as a kid in school, you see these amateurish plays that are completely absurd but you know they represent patriotism.'[35] Selecting a source that was 'so familiar that it appeared invisible as a subject and could serve the same purpose as pure form in an abstract composition',[36] Rivers also directed his irony towards the canon of 'good taste' that had institutionalised abstract expressionist painting as the apogee of high modernism. 'I was [...] cocky and angry enough', Rivers said, 'to want to do something that no one in the New York art world could doubt was *disgusting, dead* and *absurd*. So what could be dopier than a painting dedicated to a national cliche?'.[37]

Taking a sideswipe at 'the Harold Rosenbergs and Clem Greenbergs or whoever',[38] Rivers relates to Colescott in terms of a generational reaction to

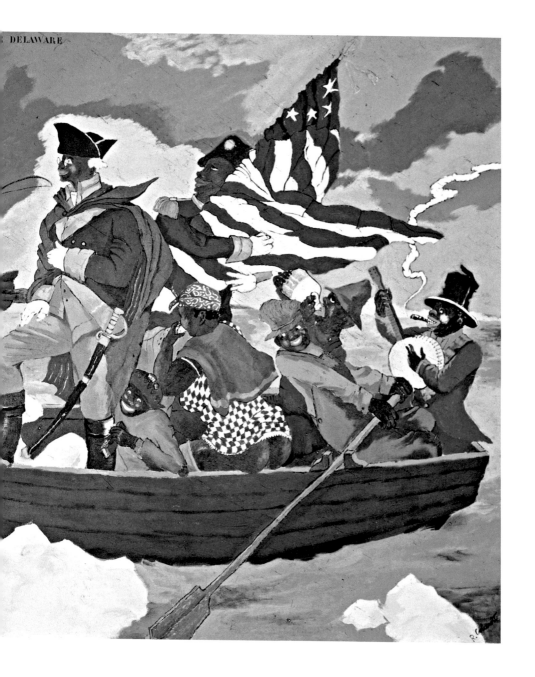

abstraction, but the turn to vernacular materials they shared with pop artists of the 1960s was differentiated by their pointed choice of targets. In contrast to pop's prevailing 'cool' sensibility, Rivers and Colescott were closer to Ed Kienholz, Wallace Berman, Bruce Conner and artists associated with the assemblage methods of so-called 'California funk'. Indeed, Colescott (b.1925) had graduated from the University of California, Berkeley in 1949 alongside multi-media artist Jay DeFeo, who was centrally involved in the Bay Area beat scene that also included the African American poet Craig Kauffman.[39] Grappling with the influence of his tutor Hans Hoffman, Colescott studied in the Paris studio of Fernand Leger from 1949–50 before returning to UCB for his Masters in Fine Art in 1952. Teaching at Portland State University (where Mark Tobey was on the faculty), Colescott also taught in Cairo before returning to California, where his first exhibitions were held in San Franscisco. Colescott has said about Leger that, 'There were some valuable things you learned from him [...] but the emphasis on limited pure colour and strong drawing added up to learning something about monumentality.'[40] Parody provided a means of subverting modernist monumentality, as well as the patriotic monument of Leutze's 1851 painting. Colescott's idiosyncratic path, then, was simply ahead of its time, for the double-voiced practice of appropriation he began with *George Washington Carver Crossing the Delaware* in 1975 anticipated by several years the late 1970s trend named as 'bad painting' and 'new image painting' in the US and referred to in Europe as 'neo-expressionism'.

Marcia Tucker, curator of *"Bad" Painting* (1978), defined it as, 'figurative work that defies either deliberately or by virtue of disinterest,

the classic canons of good taste, draftsmanship, acceptable source material, rendering, or illusionistic representation.'[41] Adding that, 'it is possible that the work [...] is functioning in an avant-garde manner',[42] it was precisely this aspect of Colescott's practice that was ignored in the polarised reception of the trend, which was rejected by critics contributing to the *October* journal in the US who regarded painting as a conservative medium now exhausted of any critical potential, which was the very reason why 'new image painting' was celebrated by the *Modern Painters* journal in the UK. Where the implications of the radical concept of 'appropriation' were primarily theorised in relation to photo-based practices among such artists as Cindy Sherman and Sherry Levine (who recapitulated upon pop's 'cool' distanciation from source materials), it was not until his paintings were aligned with late 1980s image-text works by African American artists such as Lorna Simpson – in a keynote essay, 'The Mirror, The Other', by curator Lowery Stokes Sims – that the critical edge to Colescott's post-modern carnivalesque could be clearly differentiated from the reactionary anti-modernist orthodoxies of neo-expressionism.[43]

More than a mere 'spoof', *George Washington Carver Crossing the Delaware* is a full-bodied act of 'signifyin'' in Henry Louis Gates' sense of deconstructing the master codes of the national culture to lay bare the structured absence of a black voice in the encoding of foundational narratives. The title entails a linguistic pun: one of the nation's founding fathers, whose profile is ubiquitously present on every nickel and dime, is homonymously replaced by the less well-known 19th-century black agricultural chemist who joined Booker T. Washington at

the Tuskegee Institute in Alabama. Colescott's motley crew of 'rowdy black down-home types – a mooning mammy, cooks, banjo player, corn-liquor-swilling roustabout, sporting life, and so on',[44] has not simply satirised Leutze's master text, but the pointed act of black substitution serves to reveal what the original has left out. The cartoon-like rendering of the tumultuous crowd makes a nod to the 'low' comic world of counter-culture artist Robert Crumb, but, above all, as Colescott's figurative vocabulary gradually loosened up into the sensual handling of painterly impasto, the carnivalesque iconography of his female figures began to subvert the classical norm by giving greater emphasis to what Bakhtin calls the 'material lower bodily stratum'. While the 19th-century visual language of American racism employed stylistic exaggeration to ridicule the black body as Other, Colescott used a homoeopathic strategy to blur boundaries among bodies of all ethnicities. The corporeal excess of his female figures not only reveals sexuality as the 'unspoken' locus of hybridisation – i.e. the occluded or hidden element in official narratives of modern art and national identity – but also entails a transcoding of grotesque realism in their formal rendering. 'The art of irony that I employ is based on exaggeration and art in general is based on distortion', he says.[45] Just as his *Demoisselles d'Alabama* are miscegenated hybrids who 'signify upon' the stylistic distortions of Picasso's primitivism so as to recode modernism and colonialism as interdependent rather than antithetical, Colescott does not combat the stereotype in an allopathic way but 'fights like with like' by further exaggerating the iconography of the stereotypical grotesque to the point where the 'image of the black' pushes

beyond credulity to reveal a ludicrous historical nonsense. Alongside reversal and inversion, Bakhtin identifies a quality of bodily blurring and merging whereby,

> grotesque realism imagines the human body as multiple, bulging, over- and under-sized, protuberant and incomplete. The openings and orifices of this carnival body are emphasised, not its closure or its finish. It is an image of impure corporeal bulk with its orifices (mouth, flared nostrils, anus) yawning wide and its lower regions (belly, legs, feet, buttocks and genitals) given priority over its upper regions (head, 'spirit,' reason).[46]

In works such as *Lipstick Lightning* (1994) it is as if the 'material lower bodily principle' has encouraged the woman's face to slip down from her head onto her abdomen: indeed, Colescott's compositional strategies often show a tendency for volume and mass to 'slump' downwards into potential formlessness. Unable to make sense of how such 'bad' painting techniques are addressed to the unmasking of interracial sexuality as a driving force (or 'desiring machine') of cross-cultural hybridisation,[47] many American critics have thus profoundly misread Colescott's unique sense of humour. Unlike satire, where irony interposes a cold or cruel distance between known target and 'knowing' parody, Colescott's 'carnival laughter', on the other hand,

> is, first of all, a festive laughter. Therefore it is not an individual reaction to some isolated 'comic' event. Carnival laughter is the laughter of all the people. Second, it

is universal in scope; it is directed at all and everyone, including the carnival's participants. The entire world is seen in its droll aspect, in its gay relativity. Third, this laughter is ambivalent: it is gay, triumphant, and at the same time mocking, deriding. It asserts and denies, it buries and revives. Such is the laughter of the carnival.[48]

Having a laugh at interracial anxieties on all sides, Colescott plays the part of the 'signifying monkey' who subverts the po-faced seriousness of WASP sobriety. If the painter he most resembles is Phillip Guston (whose clumsy KKK figures drive around LA in a car, just like everybody else), then the novelist he best approximates is Ishmael Reed, whose *Mumbo Jumbo* (1972) occupies a nodal place in Gates' account of late-modernist styles in African American signifying practices. Colescott's 'bad painting' subverts monocultural definitions of universality not merely by the all-inclusive character of its carnival laughter, but on account of the way alternative universals are encouraged to emerge or to be revived from the teeming elements of the black post-modern grotesque.

David Hammons: Performing Debasement

Asked in an interview with Louise Neri, 'whoare your African American forebears?', David Hammons was singularly unequivocal when he replied:

Robert Colescott's the force. Through his paintings – *Eat Dem Taters*, for example – I found a way of bringing humour to the seriousness of my work. I wanted to make sculpture with that same feeling in it.
LN: How is he generally regarded?

DH: It's a hot tater in the history of the sacred cloth! For black and white. He's playing with all these things, using himself as a subject and getting mixed up in the art world.
LN: Is Colescott's work post-modern then?
DH: PostToasties is the only 'post' I know.[49]

Evading an answer to avoid the risks of categorical self-labelling, Hammons (b.1943) has been an elusive figure in American art ever since he started exhibiting in the late 1960s, having left his Springfield, Illinois, hometown to study at Los Angeles City College, the Chouinard Art Institute and the Otis Art Institute of Los Angeles County. Often grouped, like Betye Saar, with practitioners associated with the Black Arts Movement, his early bodyprints were an emblematic focus for the survey exhibition *Turbulent Decade: 1963–1973* (1985), curated by Mary Schmidt-Campbell at the Studio Museum in Harlem, even though his artistic independence has always dis-aligned Hammons from movement-based approaches to art and politics.[50] Following his mid-1970s relocation to New York, where he exhibited in independent venues such as Linda Goode-Bryant's Just Above Midtown gallery, Hammons' fleet-of-foot mobility across sculpture, assemblage and site-specific installation also eluded mainstream critical attention until the late 1980s, in a striking parallel with Colescott's experience of deferred recognition. Taking the poetics of the found object as the core thread in Hammons' signifying practice, his emergence among first-generation American conceptual artists provides the most appropriate framework for identifying the critically avant-garde ruptures that are produced in his uniquely double-voiced performative acts.

Where *Injustice Case* (1970) enframes a monoprint of a black male body, bound and tied to a chair, with fragments of the US flag, Hammons could be said to 'signify upon' Bruce Nauman's photograph *Bound to Fail* (1967) by producing a political parody. The laconic visual pun performed in *Spade in Chains* (1973) underlines Hammons' light touch (the found objects are a garden shovel and iron chain), and his witty titles inflect the conceptualist concern with art and language to question the optical regime of visuality at the foundations of (modern) western art. In this respect, *The Door (Admission Office)* (1969) signals a watershed moment for the black avant-garde as it addressed the politics of exclusion challenged by the Black Power and student protest movements of its time by way of an intra-artistic reference to the readymade door frame of Marcel Duchamp's *Fresh Widow* (1920) (itself a pun on 'french window'). The rehabilitation of Duchamp by the American neo-avant-garde was as crucial as the late 1960s re-assessment of Russian constructivism in the institutional-critique that animated conceptualism. The key mediating figure in the dialogic translation that Hammons initiated was Jasper Johns. While classic pop such as *Flag* (1955) questioned the ontology of art by asking whether the viewed object was a flag or a painting – whether the signifier and the signified were identical – Johns' plaster casts of body parts were among elements involved in an enquiry into indexicality as an alternative mode of signification. Such neo-Duchampian strategies came to the fore in the conceptualist break with object-making. If Johns' *Device* (1964) had activated indexical poesis by incorporating the tool that accounts for the making of the painting, then it was his *Skin* drawings of 1962–63, in which

he transferred baby oil from his face to sheets of mechanical drafting paper, that were the true 'target' of the double-voiced utterance which Hammons inscribes in *Back to Black* (1969) and *Flag Day* (1968).

Together with *Injustice Case*, these early works – so routinely misclassified as protest art – articulate the unprecedented audacity of Hammons' ability to combine two languages into a single utterance. Accentuating avant-garde meta-referentiality with the double-edged nuance of African American vernacular speech, the indexical presence of his own skin and body performs 'blackness' as an equivocating sign that eludes fixity. The 'blackness' he inscribes not only introduced social and political dimensions to matters of indexicality, but also opened up an alternative enunciative modality in which, in contrast to other African American artists (including Colescott and Saar), Hammons found a strategy that slipped loose from biographical or identity-centred codes that tend to reduce the agency of artistic intelligence to a matter of expressive subjectivity.

Curator Ralph Rugoff observes that, having 'produced prints of his own body using margarine or grease, in the 1970s Hammons began making funky assemblages using collapsed inner tubes, grease-stained bags, half-eaten spare ribs, cuttings of nappy hair from barbershops, bottlecaps and empty bottles of cheap wine',[51] but many critics often seem to ignore how the choice of such vulnerable, non steady-state materials finds a cross-cultural parallel in arte povera, in which indexicality was also set to work socially. The adjective 'funky' aptly describes one pole of Hammons' intentional hybridisation, but here again many critics fail to notice that the strategic choice

of 'low' abject materials associated with perceptions of the black vernacular was also directed and targeted towards conservative definitions of 'blackness' among African Americans as well.

As the very title of Robert Farris Thompson's brief commentary – 'Hammons' Harlem Equation: Four Shots of Memory, Three Shots of Avant-Garde'[52] – attests, the dialogic principle at play here does not express a cross-cultural sensibility so much as it produces art that has been conceptualised 'inside' the hybrid logic of a cross-cultural epistemology: Hammons is a trickster figure whose funk intelligence introduces a 'way of knowing' the world that undermines the social doxa surrounding 'race' in America. The fried chicken wings in *Flying Carpet* (1990), like the bottles of cheap wine in *Night Train* (1989), open a poetics of transvaluation in which degraded and devalued materials are re-signified by dis-articulating the signifying chain and re-articulating its semantic equations in altered constellations. As Hammons put it in his own words, discussing his chosen sources and his methods of artistic transformation:

> Old dirty bags, grease, bones, hair ... it's about us, it's about me ... It isn't negative ... we should look at these images and see how positive they are, how strong, how powerful ... Our hair is positive, it's powerful, look at what it can do. There's nothing negative about our images, *it all depends on who is seeing it and we've been depending on someone else's sight* [...] We need to look again and decide.[53]

Spoken at the time of the *Contextures* (1978) exhibition at Just Above Midtown, these words carry an echo of Bakhtin's view that 'the word in language is half someone else's ... it is from there that one must take the word and make it one's own'. To 'depend on someone else's sight' is to be beholden to a gaze that regards the 'image of the black' as Other, but equally important are the artistic decisions whereby Hammons was able to 'go there' and transform signs of black abjection without seeking redemptive idealisation.

Hair Pyramid (1976) mimics the incongruous scarlet pigment set down on a forest floor in a photograph from *A Voyage...* (1968–71) by the German conceptualist Lothar Baumgarten, but Hammons' appropriated version is hardly a black nationalist retort, for the ancient Egyptian monuments often idealised in the Afrocentric imagination are now heaps of dust whose 'timeless' geometry is vulnerable to the smallest of changes in the air current. Bakhtin's carnivalesque fully plays its part in *Higher Goals* (1982–89), in which telegraph poles were taken as found objects, adorned with bottle caps in decorative patterns that evoke West African bead-work and then assembled to exaggerated heights (in a feat of funk-based engineering), first in an empty lot in Harlem and later in Cadman Plaza, Brooklyn, to explicitly 'signify upon' the limited aspirations available to young black men who seek escape from the inner city through sports.

The targets of Hammons' signifying strategies are multiple and the dialogue is open to all comers: double-voicing does not mean each utterance is addressed to two empirically separate audiences, but that multi-accentuality interrupts 'universals' in common-sense thought. Performative acts in which the 'high

David Hammons,
Hair Pyramid, 1976

David Hammons,
How Ya Like Me Now?, 1988

and mighty' are brought down 'low' – which Baktin explored in medieval carnival parodies such as *charivari* – give rise to a topsy-turvy literalism in *Pissed Off* (1982), in which Hammons urinated against Richard Serra's *Titled Arc* (1981), as installed in Lower Manhattan's business district. Documented by photographer Dawoud Bey as he evades arrest by a passing police officer, one may surmise that his stream of urine produced an ephemeral parody of corporate monumentalism, just as the little arc created by the laces on the sneakers that Hammons threw onto Serra's sculpture enacted a further gesture of critical 'debasement'.[54] Tom Finkelpearl, curator of *Rousing the Rubble* (1991), has intuited how 'the ideology of dirt' informs the semantic code-switching that Hammons performs across his body of work.[55] However, Bakhtin's conception of 'debasement' – so tinged with anxiety in the domain of 'race', for this is what dominant discourses 'do' to signs of blackness – brings out the avant-garde dimension whereby a work such as *How Ya Like Me Now?* (1988) inverted the blackface stereotype to pointedly provoke its black audiences on questions of identification and idealisation. As Ralph Rugoff writes,

> He continually pokes fun at stereotypes held by both white and black audiences. He will lampoon the black male's obsession with street cool, and then turn around and challenge the racist double standards of white America. His billboard *How Ya Like Me Now?* (188), which featured the title spray painted across a blond-haired, blue-eyed Jesse Jackson, confronted both audiences. When this work was first installed along a Washington D.C. commuter route, it mockingly taunted

passing suburban drivers. At the same time, it so angered a group of young African American men – who understood it as a disrespectful portrayal of Jesse Jackson – that they tore down the billboard with hammers.[56]

Strangely enough, considering the modernist valorisation of self-criticism, it seems that it is this black-on-black dimension to Hammons' signifying practice that gives rise to an altered conception of 'universality' in his art. As with Robert Colescott and Betye Saar, the disruption of consensual definitions of identity and difference does not replace one order of 'truth' with another but fundamentally questions the relations of 'race' and representation from which the social construction of 'reality' is negotiated as a struggle over signs and meanings. In light of the critique of essentialist definitions of blackness that emerged in the 1980s, it may be the case that black post-modernism came into being at the point at which the institutional-critique of the modernist white cube joined forces with an avant-garde strand of black-on-black self-criticism that also revealed an ongoing tension between Apollo and Dionysus *inside* the diaspora imagination itself.

NOTES

1. Mikhail Bakhtin, *The Dialogic Imagination* (1975), trans. C. Emerson and M. Holquist, Austin: University of Texas, 1981.
2. Henry Louis Gates Jr, *The Signifying Monkey: A Theory of Afro-American Literary Criticism*, New York and Oxford: Oxford University Press, 1988.
3. W.E.B. DuBois, *The Souls of Black Folk* (1903), New York: Signet Classics, New American Library, 1982.
4. Raymond Williams, 'The Uses of Cultural Theory', in Raymond Williams, *The Politics of Modernism: Against the New Conformists*, London: Verso, 1989, 166, 174.
5. A critique of autobiographical and institutional reductionism is developed in Kobena Mercer, 'Iconography After Identity', in David A. Bailey, Ian Baucom and Sonia Boyce eds, *Shades of Black: Assembling Black Arts in 1980s Britain*, Durham: Duke University Press and London: Institute of International Visual Arts (inIVA), 2005, 49–58.
6. Bakhtin, 1981, op. cit., 358, 360.
7. Robert J.C. Young, *Colonial Desire: Hybridity in Theory, Culture and Race*, London and New York: Routledge, 1995, 20.
8. The work is discussed in Lucy R. Lippard, *Mixed Blessings: New Art in Multicultural America*, New York: Pantheon, 1990, 234; Sharon F. Patton, *African American Art*, New York and London: Oxford University Press, 1998, 200–202; Richard Powell, *Black Art & Culture in the Twentieth Century*, London and New York: Thames and Hudson, 1997, 152–53. See also, Mary Schmidt-Campbell ed., *Rituals: Betye Saar*, exh. cat., New York: Studio Museum in Harlem, 1980, and Lucy R. Lippard ed., *The Art of Betye and Alison Saar: Secrets, Dialogies, Revelations*, exh. cat., Los Angeles: Wight Art Gallery, University of California, Los Angles, 1990.
9. Patton, 1998, ibid., 200.
10. Roger Shattuck, *The Banquet Years*, New York: Vintage, 1968, quoted in Peter Clothier, 'The Other Side of the Past', in *Betye Saar: Selected Assemblages/Oasis*, Los Angeles: Museum of Contemporary Art, Los Angeles, 1984, 14.
11. Betye Saar in Cindy Nemser, 'Conversation with Betye Saar', *Feminist Art Journal*, 4, Winter 1975, 13.
12. Betye Saar in Channing D. Johnson, 'Betye Saar's Voodoo World of Art', *Esssence*, March 1976, quoted in Clothier, 1984, op. cit., 11.
13. Betye Saar in Eleanor Munro, *Originals: American Women Artists*, New York: Simon and Schuster, 1979, 11.
14. James Clifford, 'Traveling Cultures', in James Clifford, *Routes: Travel and Translation in the Late Twentieth Century*, Cambridge MA and London: Harvard University Press, 1998, 18.
15. Betye Saar in Munro, 1979, quoted in Clothier, 1984, op. cit., 13.
16. Arnold Rubin, 'Accumulation: Power and Display in African Sculpture', *Artforum International*, 13, May 1975, quoted in Clothier, 1984, op. cit., 29; see also, Robert Farris Thompson, *Flash of the Spirit: African and Afro-American Art*

and Philosophy, New York: Vintage, 1984, 101–58.
17. Betye Saar in Benny Andrews, 'Jemimas, Mysticism and Mojos: The Art of Betye Saar', *Encore American and Worldwide News*, 17 March 1975, quoted in Clothier, 1984, op. cit., 15.
18. Clothier, op. cit., 24.
19. Ibid., 25.
20. Henry Louis Gates Jr, 'The Trope of a New Negro and the Reconstruction of the Image of the Black', *Representations*, 24, Fall 1988, 129–50.
21. Mikhail Bakhtin, *Rabelais and His World* (1965), trans. Helene Iswolsky (1968), Bloomington: Indiana University Press, 1984.
22. Timothy Hyman and Roger Malbert eds, *Carnivalesque*, London: Hayward Gallery Publishing/South Bank Centre, 2000, and Pamela Kort ed., *Grotesque!*, Munich, Berlin and New York: Prestel Verlag, 2003.
23. Peter Stallybrass and Allon White, *The Politics and Poetics of Transgression*, London and New York: Methuen, 1986, 5.
24. Michael Hatt, ' "Making a Man of Him:" Masculinity and the Black Body in Mid-Nineteenth Century American Sculpture' (1992), in Kymberly Pinder ed., *Race-ing Art History: Critical Readings in Race and Art History*, New York and London: Routledge, 2002, 210.
25. See Albert Boime: *The Art of Exclusion: Representing Blacks in the Nineteenth Century*, London and New York: Thames and Hudson, 1989, esp. 153–219, and Judith Wilson, 'Lifting "The Veil": Henry O. Tanner's The Banjo Lesson and The Thankful Poor', Yale University: *Contributions in Black Studies*, 9/10, 1990–92, 31–54.
26. Gates, 1988, op. cit., Chapter 4, 'The Trope of the Talking Book', 127–69.
27. Judith Wilson, 'Hagar's Daughters: Social History, Cultural Heritage and Afro-U.S. Women's Art', in Jontyle Theresa Robinson ed., *Bearing Witness: Contemporary Works by African American Women Artists*, New York and Atlanta: Spelman College and Rizzoli International, 1996.
28. This is a summary put forward in Kobena Mercer, 'Busy in the Ruins of Wretched Phantasia', in David A. Bailey ed., *Mirage: Enigmas of Race, Difference and Desire*, London: Institute of International Visual Arts (inIVA), 1995, 54.
29. Bakhtin, 1981, op. cit., 293–94.
30. V.N. Volosinov, *Marxism and the Philosophy of Language* (1929), trans. L. Matejka and I.R. Titunik (1973), London and Cambridge MA: Harvard University Press, 1986, 23.
31. Fredric Jameson, 'The Nostalgia Mode and Nostalgia for the Present', in Peter Brooker and Will Brooker eds, *Postmodern After-Images: A Reader in Film, Television and Video*, London: Arnold, 1997, 21.

32. Linda Hutcheon, *A Theory of Parody: The Teachings of Twentieth Century Art Forms* (1985), Urbana and Chicago: University of Illinois, 2000.
33. Sieglinde Lemke, *Primitivist Modernism: Black Culture and the Origins of Transatlantic Modernism*, London and New York: Oxford University Press, 1998, 57.
34. Irving Sandler, *Art of the Post Modern Era: From the Late 1960s to the Early 1990s*, New York: Harper Collins, 1996, 205.
35. Larry Rivers in Sam Hunter, *Larry Rivers*, New York and London: Arthur A. Bartley Publishers, 1989, 16.
36. Sam Hunter, ibid., 17.
37. Larry Rivers in Hunter, ibid., 16.
38. Ibid., 17.
39. See Mona Lisa Saloy, 'Black Beats and Black Issues', in Lisa Phillips ed., *Beat Culture and the New America: 1950–1965*, New York: Whitney Museum of American Art, 1996, 153–65.
40. Constance Lewallen, Interview with Robert Colescott, 22 October 1998, University of California, Berkeley: bampa.berkeley.edu/exhibits/colescott/int.
41. Marcia Tucker, *"Bad Painting"*, New York: New Museum, 1978, quoted in Sandler 1996, op. cit., 198.
42. Ibid.
43. Lowery Stokes Sims, 'The Mirror, The Other', *Artforum International*, XXVIII, 7, March 1990, 111–15. A rounded assessment of Colescott's oeuvre is offered in Lowery S. Sims and Mitchell D. Kahan eds, *Robert Colescott: A Retrospective, 1975–1986*, San Jose: San Jose Museum of Art, 1987.
44. Sandler, 1996, op. cit., 205.
45. Robert Colescott, 'Cultivating a Subversive Palette', in Mark O'Brien and Craig Little eds, *ReImagining America: The Arts of Social Change*, Philadelphia: New Society Publishers, 1990, 301.
46. Bakhtin, 1968, op. cit., 9.
47. Interracial anxieties are examined in Kymberly Pinder, 'Biraciality and Nationhood in Contemporary American Art', in Pinder, 2002, op. cit., 391–401.
48. Bakhtin, 1968, op. cit., 11–12.
49. David Hammons and Louise Neri, 'No Wonder', *Parkett*, 31, 1992, 51.
50. Mary Schmidt-Campbell ed., *Turbulent Decade: 1963–1973*, New York: Studio Museum in Harlem, 1985.
51. Ralph Rugoff, 'David Hammons: Public Nuisance, Rubble Rouser, Hometown Artist', in *David Hammons: In the Hood*, exh. cat., Springfield: Illinois State Museum, 1994, 11.
52. *Parkett*, 31, 1992, 20–21.
53. David Hammons quoted in Patton, 1998, op. cit., 261.
54. See Jonathan Weinberg, 'Urination and its Discontents', in Whitney Davis ed., *Gay and Lesbian Studies in Art History*, New York: Harrington Park Press, 225–43.
55. See also the contribution by Kellie Jones in Tom Finkelpearl ed., *Rousing the Rubble*, New York: Institute for Contemporary Arts, P.S.1 Museum, New York City and MIT, 1991.
56. Rugoff, 1994, op. cit., 12–13.

OFF THE WALL: MR PEANUT AND OTHER MOD CONS
COLIN RICHARDS

But is [translation] no less about ... groping along and clawing at dividing walls, about floundering in an opaque stickiness?[1]

Enza lo ston-wal nga lo mompara kupela /
Klipmure word net van afvalrots gebou /
Stone Walls are built only of waste Rock.[2]

At first, the questions posed by this project seem straightforward. The key ideas are 'pop' and 'vernacular', and the aim is to identify and elaborate on the presence of 'pop' in post-1945 South African visual art. But 'pop' is as capricious as it is capacious; at once a process, an attitude, an iconography, a style and sensibility, an impulse. The word is sharp and snappy, suggesting an aesthetic of lightness and speed, of media savvy urbanity. Pop gestures to the cosmopolitan cultures of the street, the city, the everyday.[3] In one local vernacular, it might be called 'clever' (or 'klevaa', 'majieta', 'manotja').[4] It also signals a 'popular' culture: but whose 'popular'? Is popular culture people's culture? These questions become urgent in situations of cultural conflict.[5]

'Vernacular'[6] looks more stable, more benign, registering inflections of the local. We speak readily of vernacular architecture and linguistic vernaculars. Both encompass city and countryside, industry and agriculture, the entanglements of 'foreignness' and 'indigeneity'. South Africa has 11 official languages and many vital vernaculars; key examples are the lingo of the legendary District Six in Cape Town, and the 'tsotsitaal' of the equally legendary 'Chicago of South Africa' called Sophiatown in Johannesburg.[7] Both sites were sundered by forced removals during Apartheid. A dead vernacular would be 'fanagalo', developed in

the 1920s and 1930s for use by migrant workers and their 'bosses' on the goldmines of the Witwatersrand reef. In the same dark register is Houston Baker's view that 'the 'vernacular' in relation to human beings signals 'a slave born on his master's estate'.[8]

'Post-1945' acts as a temporal marker for multiple experiences of 20th-century modernities after a world war, but 'post-war' in South Africa really only ended with the advent of democratic South Africa in 1994. Perhaps this question of periodisation extends to Africa generally, as implied by Okwui Enwezor's *The Short Century: Independence and Liberation Movements in Africa 1945-1994*.[9]

Finally, our subject is visual art, generously understood. Generous in the sense that discourse on 'pop' opens onto the broader question of 'visual culture' so as to short-circuit sterile philosophical debates about what art is; about what the difference might be between art (presumably high and heavy) and craft (presumably low and light). For each of these reasons, this project has felt at times like what Maurice Blanchot said of the everyday: 'it allows no hold. It escapes.'[10] To make this search legible, I have chosen to choreograph critical 'moments' that throw light on 'pop' as a phenomenon in South African art and the 'figure' I have chosen to do this with is the wall.

Walls
The wall is a site, a structure, a surface, a semiotic field. It partitions public and private places and offers a field on which to advertise and advocate – graphically – forms of resistance and desire. For W.J.T. Mitchell the wall is 'a physical field of play' and he considers images of walls, the spaces within (doors and windows) as 'architectural

manifestations of the scopic drive as a push-and-pull between ... refuge and prospect', between 'the impulse to see and show ... and to conceal and hide.'[11]

Two historical structures loom large in our global imaginary of the wall. One would be the Berlin Wall, which fell almost in concert with the slipping of Apartheid into terminal crisis. The Berlin Wall was insistently a visual field, the ground and support of graphic action and attention throughout its life.[12] The second wall is as yet incomplete: the so-called 'peace wall' or 'security wall' under construction by Israel. For John Berger, this wall is 'is bureaucratic – carefully planned ... prefabricated and preemptive'. Once complete, it 'will be the 640-kilometer-long expressionless face of inequality.'[13]

A link with Apartheid is more direct here. For architect Lindsay Bremner, Apartheid 'conjures up, in the global popular imaginary, visceral images of walls, fences, palisades, and barbed wire keeping black and white South Africans apart.'[14] She reflects on the Israeli 'wall of separation' and extends the symbolic reach of the wall to the body. In *Border/Skin*, she refers to Apartheid as a 'biopolitics of discrimination and disqualification at the level of skin ... the site where the categories of violence associated with borders were performed.'[15] For Bremner, the skin is 'a moving signifier – a wall, so to speak'. The skin/wall embeds the body in a place 'that granted or denied access ... opened or closed doors ... determined where or with whom one might socialize, work, shop, or fornicate'. We carried this wall around and within with us.

A Post-War Mr Peanut (*c*.1947)

Esmé Berman's *Painting in South Africa* (1993)[16] was perhaps the last attempt at a 'national' art history and was published in South Africa just three years after the 'end of the beginning' of Apartheid. A section titled 'A Unique Indigenous Tradition' includes a photograph by Constance Stuart Larrabee (*c*.1947) of the painted external walls of an Ndzundza Ndebele village.[17] This was an auspicious time; a year later the first Afrikaner Nationalist Government came to power by 'popular' vote, that is, the majority of a white minority.

The caption reads '*Peanut Man' mural, 'Mapogga Village', Pretoria North, 1947* and Berman writes that this arresting image

demonstrates the responsiveness of the Mapogga community, even then, to visual stimuli in their environment. The stylized figure framed between the conventional motifs – a figure that recurred in variation over several years – is derived from the trademark of the Planter's Peanut Corporation.

Berman then asks the art historian's question: 'Could [Mr Peanut] be cited as a prototypical example of Pop Art?'. H.J. Bruce, writing much earlier, places Mr Peanut in a wider iconographic field, which would affirm Berman's perhaps rhetorical question:

Some of the representational motifs seen on Ndebele houses include railway trains; towers and minarets – presumably inspired by a city mosque; and houses – sometimes a full façade is showing, including panelled doors complete with hinges and knockers and windows set in

Constance Stuart
Larrabee, two Ndebele
children seated next to
painted wall motif of
'Mr Peanut', South Africa,
1936–49

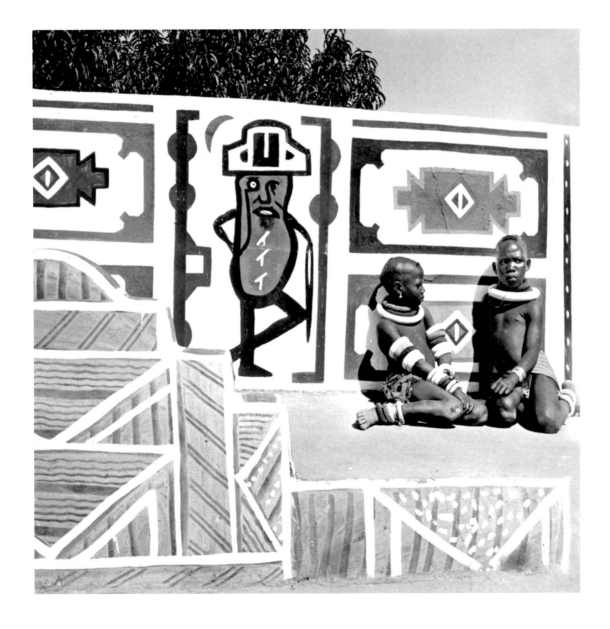

a frame of tiny panes of coloured glass and a sill beneath. Other popular motifs are electric lights – the old-fashioned sort with white shades; shapes suggested by wrought-iron and crosses seen on churches. Scenes from the natural environment, animals and people, are very rare, the humorous Planter's peanut man seen on one wall being most unusual.[18]

Whether 'Mr Peanut' is 'most unusual' or 'recurred in variation' over the years, his stage is global and his disposition is that of the commodity form: branded on stickers, T-shirts, buttons, mugs, stationery, cards, posters and (in the last word on global connectivity) the computer mousepad. Mr Peanut also served in the war. Clearly he had the right pop and period pedigree.[19]

Perhaps nothing escapes commodification and branding, including cities, those machines for making mass pop culture. Johannesburg – my home town – is a brand, and 'now part of a new transnational, global space'.[20] Once isolated, South Africa is now

> already a source of global emissions ... 'emitting' management, culture, products, and people into the African continent. Johannesburg is ... a highly desirable 'brand name'... Fashions and trends that are American or Western in initial provenance are [...] translated into South African fashions with a local flavor and then spread into Africa.[21]

Berman's question as to whether Mr Peanut is precocious South African 'pop art' is answered by her glossary. There, 'pop' is described as a 'style that flourished in the UK and USA during the 1960s' and 'made use of the precoded signs – ready-made images and symbols – of urban popular and public culture.'[22]

In his *Ndebele: A People & Their Art* (1995), Ivor Powell includes a section titled 'Ndebele Pop Styles of the 1960s', and suggests that 'architectural motifs become far bolder. Flatblocks, electric lights and the other hallmarks of modernity became more dominant and common as motifs.' While Powell is referring to beadwork, and the transposition of adornment to wall surface needs to be handled with care, the point remains relevant, and also has the virtue of referring us back to Bremner's powerful figure of the wall as skin.

Berman's concentration on style and iconography does not adequately address the geo-cultural location of such practices: peri-urban, semi-rural, rural. Notwithstanding André Magnin's and Jacques Soullilou's inflated claims for the controversial *Magiciens de la Terre* (1989) exhibition – that it 'exploded the accepted definition of contemporary art' – and notwithstanding their pre-lapsarian view of culture 'not yet fallen prey to adulteration, compliance, and compromise', the various works Magnin and Soullilou address suggests a contradictory but robust interaction between what we might call 'indigenous genius', so-called traditional rural practices, and popular visual cultures in the city. Magnin collaborated on the *Magiciens de la Terre* exhibition, and is curator of Jean Pigozzi's contemporary African art collection (CAAC).[23]

In the wake of the *Magiciens* and *Out of Africa* (1991–92) exhibitions, Clémentine Deliss points to the increasingly artificial division between so-called 'academic' and so-called 'self-taught'

artists. This artificiality has, for Deliss, become 'a framing device to establish criteria of a new authenticity, quality, and ultimately marketability for a western-led audience suddenly keen on "zippy, energetic, narrative billboard art", "*le look africain*".'[24] This clutch of words 'zippy, energetic, narrative' defines pop as much as anything else.

In terms of periodisation, the tradition of wall painting that Larrabee's photograph of 1947 documents is recent. Powell, for example, notes that much of the material culture

> identified as 'traditionally' Ndebele had a far shorter history than the word 'traditional' implies ... nearly all of the so-called 'characteristic' styles and designs of Ndebele art have emerged since the 1920s. The history of the colourful geometric wall-painting of the Ndebele is even shorter, the first ... dating from the late 1940s.[25]

This said, it is easy to overstate the case, as Jean-Michel Rousset seems to do when he observes that 'for a few years now, highly stylized figurative elements have appeared on the walls (staircases, airplanes, television antennas, electrical light bulbs), transcribing images brought back from frequent visits to the city or conveyed by the tales of the men around [the artists] Mahlangu and Ndimande.'[26]

This invented tradition of Ndzundza Ndebele wall painting was clearly embedded in processes of urbanisation and industrialisation. It also has a political dimension. Sandra Klopper, for example, notes that mural painting was 'motivated by a desire' in the Ndzundza Ndebele 'to proclaim their difference from other South African groups living in present day Mpumalanga.'[27] The intensity

of this desire arises from an unhappy history of dispossession amongst the Ndzundza Ndebele in the late 19th century.

While Berman acknowledges the complexities of Ndebele history, her reading of the wall paintings is often fundamentally formalist. Referring to an Ndebele homestead in 1971, she writes that,

> the mural scheme has been constructed out of traditional formal elements, and its colouring derives solely from available natural pigments. It weaves a harmonious tapestry of ochre, grey-green and terra cotta into the co-ordinating framework of white lime.[28]

Reference to the 'natural' and the 'traditional' tends to suggest a stable, almost static, ahistorical cultural indigeneity, akin to André Magnin's primitivist discourse of purity and innocence.

Berman also follows the primitivist logic of the 'fall', where modernity means corruption and history means cultural catastrophe. Speaking of three-dimensional illusionism, perspective and 'the Mercedes emblem on the end-posts' of one of her references, Berman wonders whether 'the irresistible appeal of Western pictorial conventions' would 'have led naturally and inevitably to its decline?'.[29] Elizabeth Ann Schneider similarly laments what she sees as the demise of Ndebele wall 'decorations' from 1946 to 1986, referring to 'the modest beginnings of wall decorations, through the efflorescence of the middle period, to the flamboyant, overripe style that marked the final stage.'[30] The subtext is that of progress, and the form of historiography associated

with this subtext is familiar in western art history, being what James Elkins calls the 'organic model'.[31]

Casting art as 'pop' is itself a historiographical gesture. The very idea of 'pop' tends to fit with a narrative open to cosmopolitanism and to the idea of progress. Greenbergian modernism is perhaps the prime (if disputed) model here. A counter-narrative to this cast to modernism would be one that emphasises 'photography, Surrealism, Dada, and contemporary Conceptual, feminist and gender work.'[32] Both narratives enjoy an anxious, uneven existence in the local nexus of modernity and aesthetic modernism.[33]

Mr Peanut speaks to the historical unfolding of modernist logic in South Africa as well as to its hesitations, leakages and gaps. Following the second narrative suggests that a case might be made for seeing a relation between modernism and magic that the rationalist progressive narrative tends to disallow. Certainly the link between a neo- or post-colony and magic would be no less haunted by the spectre of primitivism than Greenberg's modernist doxa. Speaking speculatively, linking modernism, magic and violence might have more to offer by way of art historiography.[34] Here we might, for example, consider more closely the relations between the rhetoric of dreams, visions, violence and television (TV only started in 1976, having been banned prior to this in serial fits of what Rob Nixon calls 'cultural protectionism').[35] Noria Mabasa's wood carving, Carnage II (1988), for example, sourced its imagery from an amalgam of 'the news media, mythology and history and, interestingly, not in dreams.'[36] The interface between electronically mediated imagery, commodity fetishism, visions and dreams could reconfigure and challenge our knowledge of these phenomena.

At any rate, perhaps three interlinked elements run counter to the prelapsarian romance and support, instead, a view that locates Ndzundza Ndebele wall painting within the purview of 'pop'. One is iconographic and indicates a responsiveness to and incorporation of rapidly diversifying networks of transport, habitation and communication. Another would be the use of newly available paint technologies, with relatively cheap and durable PVA (Polyvinyl acetate) becoming available in the later 1940s.[37] Yet another is the appropriation of the specific signage and materials associated with urbanisation and industrialisation, including buttons, keys, plastic letters of the alphabet, plastic medical paraphernalia, coloured plasticised telephone wire, safety pins, rubber rings and gaskets.[38] There are many artists who use industrial debris, and good examples would be Kagiso Pat Mautloa's Progress Wall (1995), Metamorphosis Wall (1995), and Wall (1995).[39]

While Berman can be severely formalist, she also advocates an iconographic perspective in which iconography becomes the 'other' of form. Her view, for example, that pop art is 'essentially concerned with subject matter' reveals this modernist bias. 'Style' too has a complicated history and usage in relation to both iconography and form. For Berman '[in] many cases style as such was nonexistent; readymade articles replaced interpretive design and composition; and the deliberate vulgarity which was often intrinsic to the message [...]'.[40] The mention of 'vulgarity' also suggests a modernist formalism's hostility to populist kitsch.

In important ways, Berman underestimates the complex responses to developments in communication technology and changes in material conditions in the 1950s and 1960s.

These responses vary, but an instructive example would be a carved wooden transistor radio (late 1960s) mentioned by the late gallerist and art enthusiast, Jo Thorpe, of the African Art Centre in Durban. Thorpe describes this work as 'the first very special piece', a radio being 'something which in 1968 every young person yearned for'. Thorpe exhibited this work next to a 'beaded transistor radio made by Sizakele Mchunu in 1985'. Mchunu also made a wry beaded doll portrait of her dealer (Thorpe) titled *The Cultural Broker* (undated), which suggests a consciousness of the market and the political economy of the art world.[41]

Such works prefigure an important and much debated moment in South African art of the 1980s: the phenomenon of 'transitional' art. Much 'transitional' art sported a 'pop' patina by appropriating and recycling popular imagery and making liberal and inventive use of industrial materials and urban debris.[42] One of the earliest recorded instances of 'transitional art', named retrospectively, is a metal, rubber and glass car made by a young boy in 1929 in Johannesburg.[43] Transitional art peaked in the later '80s, energised by the *Tributaries* exhibition curated by Ricky Burnett in 1985.[44] The genre included images of politicians, sports and media celebrities, and kitsch biblical images derived from popular religious prints.

'Transitional' seems a dubious description. It surfaced in a South Africa deep in a political state of emergency.[45] The word itself (and the white-driven economy associated with it) felt like an alibi for those of us unable or unwilling to actually engage a crisis of authority. For some, 'transitional' meant the reconfiguring of 'traditional' practices into a predominantly white, urban art world. For others, it marked a new fluidity between art and craft, or between period and stylistic oppositions: rural/urban, 'traditional'/'contemporary', and so on. A recent publication on 'craft', for example, places Ndebele mural painting in a 'traditional' category, while artist Jackson Hlungwane is 'transitional'.[46]

Hlungwane – a major South African artist – is included in Magnin and Soulillou's exhibition *Contemporary Art of Africa*, as well as other 'transitional' artists: Johannes Maswanganyi, Johannes Segogela and Thomas Kgope.[47] Contemporary quasi-rural or peri-urban black artists who referenced modern modes of travel and communication were also considered 'transitional', notably the late Tito Zungu. Zungu drew elaborate flying machines and various emblems on envelopes – often modelled on franking marks and stamps – as used by migrant workers writing home.[48] Artists referencing popular mass media in otherwise 'traditional' practices seemed to attract the label 'transitional'.

The phenomenon of 'transitional' may have been part of a new intimacy between art, its markets and the domain of the popular. The 'Mercedes emblem on the end-posts' of an entrance to a homestead in the Msiza tourist village (c.1974), which was cited by Berman, anticipates Ndebele artist Esther Mahlangu's design for the paintwork of a BMW (1991).[49] Reproducing the BMW in her book, Berman asserts that Mahlangu 'learned her craft as an active member of a rural community' and adapted 'the traditional forms of Southern Ndebele mural painting to the purposes of urban exhibition.'[50] In the case of the BMW, Mahlangu's meshing of social aspiration and commodity form places her in august pop artist company, Andy Warhol and Roy Lichtenstein having done the same.

Esther Mahlangu,
Art Car, 1991

Mahlangu's work also embodied commodification in a more traditional art world sense. Her first international exposure was in the *Magiciens de la Terre* exhibition held at the Centre de Georges Pompidou in 1989. Two years later she was included in the 'Magiciens de la Terre revisited' exhibition, *Africa Now: Jean Pigozzi* (1991), at the Centro de Arte Moderna in Las Palmas de Gran Canaria, Spain.[51] Her contribution to *New Identities: Zeitgenössische Kunst Aus Südafrika* (2004), held at the Museum Bochum, involved the transfer of large-scale works from homestead wall to gallery wall.[52] Mahlangu also developed portable easel paintings, as in *Abstract* (2003), which is significantly not painted in acrylic, but 'natural pigment' on canvas.[53] According to Jean-Michel Rousset, Mahlangu 'decided of her own accord to transpose onto canvas paintings that until then were exclusively reserved for the walls of houses.'[54]

Another example of the portable easel form appears in the recent catalogue for the *Picasso and Africa* exhibition held in Johannesburg and Cape Town in 2006. Also titled *Abstract* (2005, but the date on the work is 2004) is a work on paper, again with 'natural pigments'. Marilyn Martin, in an essay in which the image appears, promotes a soft-focus pluralism typical of a long-standing liberal discourse that pacifies and commodifies difference.[55] According to Martin, Ndebele women,

> continue to work within their traditions and at the same time they respond to and renew their practice through a crossover of cultures. 'Traditional' Ndebele art is still immediately recognisable, while an artist like Esther Mahlangu has also established an international reputation as an individual.[56]

What is marked here is the rhetoric of cultural exchange (as a voluntary, organic, passive kind of product mix and match) that previously permeated writing about 'transitional' art. Power was masked in this discourse, allowing a beleaguered hegemonic art world breathing space in a sector of visual art beset by crises of legitimacy.[57] Other views would recognise the brutal reality of such exchange in situations of conflict, as recent debates about 'Picasso and Africa' have dramatised.[58] The contested character of 'transitional' art as classificatory category reveals the complexities of re-writing 'pop' in the South African context, both at the time and retrospectively.

Pop Corn

'Pop' art cultures in the United States and England in the mid 1950s to the early 1960s coincide with the rise of Grand Apartheid in South Africa. Apartheid had an obvious and decisive impact on relations between the vast majority of South Africans and the cultures of the city and products of industry. There is a profound slipperiness between the cosmopolitan 'pop' cultures and the widely different experiences of modernity and aesthetic modernism on the black periphery of the cities.

Sophiatown is a case in point, being home to gangsters called 'The Americans' (est. 1947) comprised of young black males dressed in 'America-style clothing'.[59] Novelist and intellectual Es'kia Mphahlele recalls that the '[the Odon] cinema, dancing, American culture and jazz were very important in the cultural life of Sophiatown.'[60] More recently, Nakedi Ribane comments that since 'the 1950s Sophiatown era, and even before that, from the time that films and magazines such as *Ebony* made American

culture accessible, Black South Africans have looked up to Black Americans in everything.'[61] The period of the 1950s onward was relatively open and free by South African standards, mythologised by one commentator as the 'debonair decade for darkie South Africa!'.[62] This did not last.

During Grand Apartheid, the figure of the wall becomes profoundly ambiguous, slipping incessantly between social concrete and social control, between coercion and seduction, defensive and assertive self-possession. Deep into Apartheid, the emergence of 'people's parks' in the late 1980s in the black urban margins of the major cities speaks to these slippages.[63] One sign in a park in Soweto advertised the fact that 'the people have their own style', a style that appropriated and recycled anything and everything to hand – material and symbolic – in what might be called an aesthetics of scarcity – popular signs, road markers, painted stones, industrial throwaways.[64] The walls built from the rubble of broken-down houses in some parks were destroyed and the rubble removed by the security forces, as these became arsenals for stone-throwers.

An exhibition held at the then King George VI Art Gallery – now the Nelson Mandela Gallery – in Port Elizabeth in the watershed year of 1989 was conceptualised through the notion of the wall. Sponsored by Plascon Paint, the exhibition was improbably titled *From San to Sandton: A Pictorial Survey of Southern African Wall Graphics Through the Ages.* Curator Franco Frescura cut a wide swathe through aeons of visual culture from the 'painted pictographs on the walls' of the cave shelters of the San through to the symbolic 'decorative patterns' of 'the rural women of the highveld and Southern Transvaal',

from 'capitalist businessmen' paying 'signwriters and painters to draw attention to their enterprises' to 'yuppie Cape Town couples' who commissioned domestic 'trompe l'oeils ... to demonstrate their social mobility and good taste'.[65] Pop is part of Frescura's sweeping wall culture: 'from the stencils and spray cans of street guerrillas to the post-modernist kitsch of Pretoria roadhouses ... from the daubs of township children to socialist realism of the Plascon project in Soweto'; all in the service of proto-nationalism.[66]

The title is no friend of modesty and probably says more than it intends. The San are amongst the oldest groups to inhabit southern Africa, while Sandton (*c.*1989) is a massive complex of upmarket shopping malls, recently engorged by businesses fleeing from the blighted Central Business District of Johannesburg.[67] Sandton's malls – 'cathedrals of post-war culture' in cultural commentator William Kowinski's words – are at once machines for producing, packaging and presenting pop culture.[68] The mall is also a 'fortress with dozens of obscure entrances [which] provide protection from the disenfranchised. No homeless traffic here.'[69] But homeless traffic is but a stone's throw away in the impoverished Alexandra township. The recent evacuation of the CBD to Sandton has been attributed to a post-Apartheid crime, but the decentralisation of retail activities 'in search of the white consumer' actually began in the early 1960s, casting 'doubt on the current tendency to blame "crime and grime" for pushing retail out of the CBD.'[70]

Just down the street from where I live is a conventional stop sign: the word 'fear' has been painted below the word 'stop'. A vast visual culture (present from the early 1990s) has indeed grown out of urban anxieties about

security. Lindsay Bremner comments on the mushrooming of security enclaves in the city, and the activation of 'new signifiers, borders, and modes of discrimination between the national and the alien, between different categories of migrants, different categories of citizens'.[71] Referring to islands of urban (in)security, Bremner elaborates:

> Walls, booms, razor wire, electrified fencing, security gates, intercoms, concealed cameras, armed guards – an entire security arsenal – had pried zones of the city from the public realm, transforming them into a patchwork of militarized borders and quasi-virtual worlds… While Johannesburg today is a city of new fluidities and encounters, these are contained and directed by countless, often hastily erected walls and physical barriers that score its landscape. Moving around the city involves constantly negotiating gates, booms, intercom identifications, and security checks, transforming life in the city into that of a permanent frontier zone.

Walls that bear such elaborate and sophisticated semiotics of anxiety have become material for a number of artists, but mostly since 1994, as in Kendell Geers's *Suburbia* series of 1999.[72]

Walls are also garnished with electrified fences or elegant rolls of barbed/razor wire, and these more baleful industrialised products have also found their way into art. Historian Alan Krell writes about barbed wire's critical role in the modern experience, where it features in 'territorial expansion and settlement, regional and international conflicts, incarceration and extermination. The most vicious tool of control, however, has other histories, constructed through image and text in the art, media and popular culture.'[73] Many artists use barbed wire, including Sandile Zulu and Kendell Geers. In the latter's *T.W. (Deployed)* (1999) a South African patented razor mesh (Cochrane Steel) is the wire of choice.[74] South Africa can probably claim the creation of one of the most sophisticated visual cultures of walls and warnings.

At another level, the celebrity dimension of 'pop' and wall culture finds improbable but illuminating expression in the *Culture in Another South Africa* event held in The Netherlands in 1989.[75] In the catalogue, some photographs of a wall painting taken in 1978 show members of the Junction Avenue Theatre Company (so active in resurrecting the culture of Sophiatown in the 1970s) producing a collective mural.[76] We see a very young William Kentridge drawing a dog on a box with the able assistance of meths drinker 'Samson' 'who had the reputation of being an abortionist'. Once completed, the obligatory discussion 'on issues relating to culture and politics' ensued, no doubt leavened by talk about popular and progressive people's culture, walls, the dubious seductions of methylated spirits, future fame and much else besides.

During the states of emergency in the late 1980s, public spaces became ever more intensely contested. Popular resistance was a very skilful hit-and-run affair. In the 1985 state of emergency, art students and others would brave the curfew and – amongst other things – alter street names associated with Afrikaner nationalism and Grand Apartheid. Ephemerality became an aesthetic condition, a means of challenge and escape. In some cases, images were pre-produced in an underground factory and hastily posted on

walls, billboards, lampposts and traffic lights.[77] Some images were light-hearted, and others would have been at home in a gallery. The caption for one image, in an article on this phenomenon, reads: 'Opposite the Piccadilly Cinema, a policeman with a quirt lays into what appears to a giant amoeba.'[78] According to Ivor Powell, through these acts the city's graffiti had 'undergone a radical transformation' and 'putting up a graffito has become an act of aggression as the political activists have taken over the walls. It's not a game any more.'

The urgent and painful effects of this late stage of the liberation struggle under successive states of emergency meant that political discourse (elsewhere repressed and distorted) took to older forms of urban expression. As Powell points out, the question 'who killed Goniwe?' that was scrawled on walls in and around Yeoville (Johannesburg) during the late 1980s was a pointed one. Who would ask this? 'Not the SABC [South African Broadcasting Corporation]. Not the major dailies. Certainly not the average white South African – these are precisely the questions that the average white South African wants, at all costs, to avoid asking. So the questions get asked on the public walls.'[79]

Powell also touches on the aesthetic dimension of some of these 'brooding' wall works; he suggests 'when they work (and they don't always) they avoid propagandising, but present realities in a startlingly effective and oddly humanistic way.' Many appear to have been created by pairs or groups of collaborators. Where the literal imagery of violence is juxtaposed with 'relatively unspecific images executed in comic-book style (chameleons, bats, ghosts)', such unexpected combinations, says

Powell, catch tensions that are essential to this conflicted situation.

Like walls, billboards are also sites for such work. In fact political images (bats and quirts) were simply pasted on the visuals of 'capitalist realism'.[80] Billboards were also subjects for contemporary artists, the primary example here being Santu Mofokeng's township billboards, and work by Jo Ractliffe and Minette Vári.[81]

More portable graphic surfaces for pop include the mass-produced popular print and the tourist card or brochure. A number of popular images originating in these commodified formats found their way into the white cube. In *South African Postcards* (1995), for example, Penny Siopis manipulated popular postcards of 'traditional' 'tribal' girls, casting a plastic pall over both kitsch and 'tradition'.[82] At around this time Candice Breitz was also concerned with a dystopic 'pop' culture in her early *The Rainbow Show* (1996). All these works became controversial.[83] Quite different but equally apt in this context is Brett Murray's *Oros Goes Ndebele* (1994).[84] Murray's irony sours in Lisa Brice's *Sex Kittens: Don't Fuck with Me* (1993) and *Sex Kittens: (You Want to) Have Your Cake* (1993).[85] It seems from these works that there was a new 'pop' energy and attitude involved in the public sphere in the period immediately before the first general elections in 1994.

Jo Phokela, a protégé of the late Durant Sihlali, referenced cheap prints of old masterworks of European art which 'were and still are popular and often used domestically in Soweto' in his early parodic work, such as various versions of *Fall of the Damned* (1993).[86] Phokela had in fact painted a 'pop' mural – simplified, flat forms, static outline, highly keyed colour – for the

Federated Union of Black Artists in the mid-1980s. His work also suggests that the popular culture of cartoons might be distinctive in its importance for contemporary African visual culture.[87] The agit-pop practice of contemporary young artist Robin Rhode also draws on this history; for as one critic writes, 'a self-styled aesthetic terrorist, Rhode continues the modernist tradition of Dada and Graffiti art by insisting that art be experienced in the public realm of urban walls, streets and pavements.'[88]

In her book on Ndebele art, Margaret Courtney-Clarke also documents the other, private face of the walls of homesteads, a face that perhaps expresses the more nuanced interplay of convention and desire. And here the 'raw' material (actually cooked) comes directly from mass visual culture, and is formally reminiscent of, and, dare one say, haunted by, Warhol's wallpaper works.

The domestic interiors of informal settlements have been documented by Zwelethu Mthethwa's photographs since c.1995, that is, towards the end of the period addressed by this essay.[89] In many of his images, highly-coloured labels, flattened soft-drink cans, wrapping papers and similar materials are used to construct 'wallpaper' that also often supports the structure of the dwelling itself. This practice is long-standing: a Jürgen Schadeberg photograph from 1955 shows singer Miriam Makeba posing for a cover for *Drum* against the backdrop of serried ranks of record labels.[90]

Of course Mthethwa's photographs also raise questions of interpretation. Annie Coombes, for example, observes that these photographs could be 'be understood in terms of the interior or metonymic of the individual or group', and 'clearly embrace the creative ways in which individuals extend the limited means at their disposal for expressing individuality ... by projecting an ideal personality via the small spaces that do remain in their control – in this case their shacks'. But Coombes also notes the risks of romanticising poverty in such work, already a possibility in the local fashion phenomenon called 'shackchic'.[91] Mthethwa is sensitive to the tarnished brightness of consumerism in a context of poverty:

> I'm not being romantic. The richness of the colour might create an impression of surface tranquility, but the details of decay in the images are often overlooked. If you look closely ... you'll see paint on a woman's hand, a man's ulcerous legs, broken shelves, sagging mattresses, and wallpaper held together with brown packing tape. These are the small things in pictures that really tell you about the people. But in spite of these details, there is a sense of dignity that I wanted to capture in the photographs.[92]

By way of contrast, Seopedi Ruth Motau's photographic essay, *Making an RDP House a Home* (2003), offers a different and perhaps more pointed view of similar social phenomena, for the subject of Motau's photographs is the 'malevolent geographies' of the hostels that remain a legacy of the Apartheid migrant labour system.[93]

Zwelethu Mthethwa,
from *Untitled*, 1995–98

Contra-Pop

The presence of pop in South African art is also a function of counter-traditions in art. However unevenly, the New York art world was hegemonic here for part of the period under review. This hegemony was mediated in many ways over time, but one decisive moment occurred in 1987–88, when our final states of emergency foreshadowed the fall of formal Apartheid. Berman provides a sense of what we might have encountered at that time:

> an enriched medley of styles and forms, from the traditional to the contemporary; from 'high' art to 'low', or popular, media and iconography. Although ethnicity was a newly accredited facet of the scene, the stylistic distinctions were not drawn solely along the lines of racial or cultural identity. The paintings of black artists David Koloane and Tony Nkotsi, for instance, shared family affinities with the output of white artists such as Bill Ainslie, Kevin Atkinson and Jenny Stadler ... who were exploring colour-fields and related abstract styles.[94]

What concerns me here are precisely these 'family affinities', and how they played out in an event at the Johannesburg Art Foundation in late 1987. It is these affinities that provide a counterpoint to pop and, indeed, with it, a counterpoint to figurative 'resistance art'.[95]

The event was an illustrated lecture by Graeme Peacock, an English artist then resident in Edmonton, who was associated with the Thupelo (trans. 'teach by example') International Artists' Workshop programme. The programme was established in Johannesburg in 1985 by Bill Ainslie and David Koloane and funded by

the United States – South Africa Leader Exchange Program (USSALEP) for 1985, 1986 and partially 1987.[96]

Peacock's presentation focused on various forms of abstraction, including a number from Ndebele wall painting. At that time the KwaNdebele 'homeland' was in deep conflict. Peacock had no interest in this conflict, nor indeed any interest in the history of the forms of abstraction he showed to us. Nor was he concerned with any possible referential figuration (from Mr Peanut to electricity or telephone posts), or indeed the social embeddedness of the practice of wall painting as such. Peacock's exclusive interest was pure 'visuality' and form, or perhaps a crude version of the ideas that had underpinned the controversial 1984 exhibition, *Primitivism in 20th Century Art: Affinity of the Tribal and the Modern*, at MoMA, New York.[97]

The relation between cultural practices and living history had in fact been taken up by photographer David Goldblatt in two successive forewords to Margaret Courtney-Clarke's book *Ndebele: The Art of an African Tribe*.[98] Goldblatt himself had earlier documented the historical trauma of the Ndebele in his 1983 series *The Transported of KwaNdebele*.[99] In his first foreword of 1985, he queried Courtney-Clarke's overall project and asked whether her largely formal aesthetic approach to Ndebele art, 'would be adequate … in view of the unspeakable things being done to the Ndebele.' Goldblatt concluded that, 'something more [seemed to be] required than a pretty piece of coffee-table art. Irrelevance would be bad enough; irreverence would be unforgivable.'[100]

History changed quite radically in the interim, and Goldblatt's second foreword of 2002

registers this.[101] He mentions Courtney-Clarke's direct involvement with the conservation, diversification and continuity of Ndebele art practices in post-Apartheid South Africa and the response of the community to market differentiation. He speaks of young students of well-known artist Franzina Ndimande and her daughter, Angelina, learning 'to draw and paint and to work with traditional patterns, employing materials derived from mud' while the older children 'decorate ostrich eggs, tins, bottles, and greeting cards'. Emphasising the fact that designs 'are screen printed onto fabrics or hand painted and stitched into colourful sarongs, cushions, and table linen', he also refers to the risk of cultural vulgarisation, as found in airport curio shops, that comes with market differentiation.[102] The visual practices of the Ndebele are clearly responsive to historical processes and changes in material conditions.

Many of us listening to Graham Peacock speak about Ndebele wall painting that night in 1987 felt something like Goldblatt's first critical response to Courtney-Clarke's enterprise. This feeling was intensified by Peacock's indifference, and the fact that no images of works *in situ* or works with iconographic references were included. The popular dimension of these works was simply expunged from Peacock's formalist account.

Critic and museum curator Kenworth Moffett, also associated with Thupelo, described Peacock's pedigree as part of a group that 'looks past – or through – the second generation, the "colour field" painters, to the first generation, the Abstract Expressionists'.[103] Work from the early Thupelo workshops indeed owed a major debt to American abstract expressionism: David Koloane's *Untitled* (1987), *Untitled* (1988)

Next page:
David Koloane,
Untitled, 1988

and *Untitled* (1989) are ideal examples.[104] Yet Koloane felt obliged to deny this lineage, insisting the Thupelo did not have 'any specific aesthetic program in mind; its concerns were wholly pragmatic.'[105]

According to Bill Ainslie, Moffett strongly praised the work of the Thupelo workshop, seeing it as 'representing the first indication that South African artists can play a role in international developments.' Such discourse is haunted by the spectre of Clement Greenberg, but there is more to this.[106] Greenberg actually visited South Africa some ten years earlier in 1975, a visit announced as 'a very important "happening" in our art world'.[107] Described locally as 'the prime spokesman for the Abstract Expressionist school', Greenberg's seminars in Pretoria and Cape Town dismissed, 'the Pop art school ... as a "novelty art"'.[108] During his visit, Greenberg touched on many issues and tramped on toes (for which he deserves credit), but for our purposes one of his comments on taste and aesthetic value relates directly to Peacock's anti-contextual position. Speaking of 'primitive art', Greenberg asked:

> What do you know about Magdalenian or Aurignacian hunters who did very good paintings in the South of France and the north of Spain or about the so-called Bushman art, some of which is very good? What do we know about their culture? Does that prevent us from experiencing and getting a lot of satisfaction from a lot of the art?[109]

Such cultural myopia – like periodic inflammations of imperial hubris – might well secure satisfaction of a surface kind. But a more open view that recognises the seepage between expressive form, materiality and the social registers of the senses would counter this superficiality, this obsession with surface.[110] Moffet's 'internationalism' also contrasts starkly with Greenberg's plea for an almost parochial nationalism. For Greenberg what mattered most 'is what South Africans themselves think of their art... South African art will have to make it on its own, in South Africa and with South Africans – just as art in the United States had to, with Americans and in America.' The fact that he was addressing an increasingly anxious and isolated white minority community of artists may have had something to do with his perversity, expanded in his comment that those 'South African artists who go after an "African identity" seem to me to be overrated, as gifted as they are.'[111]

Greenberg's advice to South Africa appeared in one journal in June 1976, the month and the year of the Soweto uprising.[112] The South African defence force had also undertaken 'Operation Savannah' against Angola and had been supported by the United States as part of the Cold War.[113] These conjunctions were telling. Those of us who questioned the Thupelo initiative a decade or so later were also aware of American support for the Apartheid state. But perhaps more important in this context was our awareness – in 1987 – of research on the use of abstract expressionism as part of the Cold War in post-War Europe. This was, for us, nothing less than the political use of apparently apolitical 'free expression' associated with abstract art.[114]

This critical moment brought into focus by Peacock's lecture was not simply about the presence of a particular aesthetic tradition, but the relationship of that tradition to current

politics on the one hand, and the attitude it presented to popular culture (often characterised as kitsch) on the other. The pragmatist art-for-art's sake ideology of art as anti-ideology was sharpened by Bill Ainslie's comments about the Thupelo workshop:

> Ideology is a dead end. True power comes from a clean discovery of the most unexpected possibilities in the most unexpected places, creating the unexpected… An art workshop is a place where this can happen. For one, there is the direct involvement with the material needing to be shaped, for another there is no pressure on it to be shaped for any purpose other than inner necessities…[115]

Such values of direct involvement, clean discovery and 'inner' necessity all constitute an ideology of anti-ideology that was supported by Koloane's 'pragmatism'.

Reaction to criticisms of Thupelo proved instructive.[116] Many criticisms were considered by Koloane and other workshop participants as racist, with some critics apparently preferring black artists to make 'resistance art', or so-called 'township art' or art in the tourist market. For Koloane there is a 'tendency in South Africa art circles to expect that black artists should not express themselves in a non-representational mode'.[117] For those in these critical circles, it 'would seem that only artists from other race groups are capable of transcending realistic expression.' But Koloane's argument also goes beyond his immediate focus, and points to a conjunction between 'pop' and politics in the resistance art of the last two decades of Apartheid. Popular forms – cartoons, graffiti,

the symbols of Apartheid economy, T-shirt imagery, banners, posters – all made up the lexicon and syntax of art as resistance in a public sphere responding to successive states of emergency.[118] There were any number of usable traditions along the continuum of figuration and abstraction that were available to artists during this moment, and the criticism of the Thupelo workshop did not advocate any specific tradition in this regard.

Koloane's response tended to entrench a very American opposition between abstraction and figuration, and so reiterated the founding tenets of the kind of modernist practice Bill Ainslie and others proselytised for. In a 1979 interview, Ainslie argued that 'one of the challenges to artists is to use art to define the limits of art – to establish the area of competence of art', which was an uncannily Greenbergian formulation.[119] For Ainslie, the artist is free 'from any ideological standpoint' and yet has an ideological hostility to mass culture on the grounds that, 'mass culture … means people not speaking for themselves' but conforming to social norms and conventions which smothered their creativity.[120] Taking a broader view, I would suggest that what is actually smothered by such modernist fundamentalism are the strands of popular, performance and conceptual practice, as well as all the other contending histories of modernism.

But we can move in a different, more positive direction with Koloane's response. Elsewhere Koloane has argued that Apartheid 'was a politics of space… Claiming art is also reclaiming space.'[121] This is literal and embodied space, lodged in the scale of the works, and the fact that many were created outdoors on the ground, that is on a horizontal rather than vertical plane. In this last respect, such works follow the aesthetic

logic of 'flatbed' painting described by Leo Steinberg.[122] Now space is clearly linked to all the Apartheid legislation regulating association, habitation and movement. Reading space as social semiotic recalls T.J. Clark's reading of the brute fact of modernist 'flatness', which was a key term in the archive of modernist painting out of which Graham Peacock practiced. For Clark, the key question concerning flatness was about how 'a matter of effect or procedure' could stand for a value. Arguing that flatness, when historically situated, could be 'imagined to be some kind of analogue of the "popular" ... plain, workmanlike, honest manual labour', Clark also suggests that, on the other hand, flatness 'could signify modernity, with the surface meant to conjure up the mere two dimensions of posters, labels, fashion prints and photographs.'[123]

A similarly fruitful convergence of literal and symbolic space could be articulated in early Thupelo work, an articulation in which social space is mapped onto pictorial space, and in which pictorial space is to be read as an arena for artistic acts. Seen in this way, it is easier to see the act of painting as liberating, a view that follows critic Harold Rosenberg's view of action painting rather than Greenberg's formalism, which had become rather mannered in the practice of Graham Peacock and other artists of his ilk.[124]

Reading this way raises questions about the relations between creativity and intellect. The artistic rhetoric of Ainslie and Peacock carried an air of anti-intellectualism. Indeed, glossing Greenberg's local presentations, Susan van Schalkwyk approved of Greenberg's comments about the crisis of studio teaching, 'where discourse, thought and intellectualizing are defeated'.[125] This complex matter of creativity, imagination and intellect played out in ways

which did not always serve the workshop participants well. Local black artists would not, for example, have had access to formal institutions of learning and, furthermore, the conditions for developing vocal organic intellectuals were not promising during the late 1970s or the 1980s.

Both Koloane and Sihlali emphasise this lack of access and question the assumptions about intellectual work as a creative obstacle. Referring to the Polly Street Arts Centre in the late 1950s, Ivor Powell notes that teachers 'encouraged white artists to work in one way and black artists in another.' Koloane suggests that black artists were infantilised in such settings, and were pressured to work

in a primitive, untutored way. If a black artist was referred to as primitive, that meant he was going in the right direction. Blacks weren't encouraged to pursue an academic training... What I find ironic is that artists were not encouraged ... to read further, to find out about artistic modes or artistic movements.[126]

Powell also recalls a statement from Sihlali, who commented on Polly Street that, 'The thing is the whites around the place all had university educations. But they refused to share their knowledge with us. They wanted us to be different, we wanted to have access to the same resources they did. There was conflict.'[127] This problematic is captured by artist, teacher and Polly Street Art Centre director Cecil Skotnes, in his 1960 review of work by John Hlatwayo. Here a relation between primitivism and intellect is contorted by references to European but not African practices. For Skotnes, Hlatwayo's

work has developed ... from a strict ... derivative ... realism to an individuality which is very striking. This individuality is primitive, but entirely in the European sense: I mean that in his simplification of forms, in his subject matter and in his choice of strong, single tones of colour, he more resembles European primitives like Douanier Rousseau than the primitives of central Africa. In composition and drawing he always resolves his problems intellectually: nothing is fortuitous.[128]

From this perspective, and that of the Thupelo experience, those aspects of modernism that fetishised 'authenticity' – directness, spontaneity, instinct, purity and innocence (which were associated with the child, the other, the insane, the untutored, women) – would have limited engagement with the pop culture of the modern city.[129] A photograph reproduced in a recent book on Polly Street shows a young Ernest Manana painting in front of a wall that is adorned by an amalgam of ersatz Ndebele imagery and generic African masks that were painted by Larry Scully.[130] The difficulty is that well-intended pedagogy in South African art education seemed to be predicated on a form of 'primitivism' that was mediated by the West, in this case the imaginary 'West' of a settler community eternally anxious about its relation to 'home'.

Recalling Greenberg's comment about 'African identity' and pop novelty, other artists relevant here are the late Walter Battiss and Norman Catherine. The eccentric Battiss was perhaps more conventionally 'pop' focused, and involved himself with curio culture, kitsch, media manipulation and performance art.[131]

Norman Catherine has proved rather more orthodox. According to critic Ashraf Jamal, writing in 2004, Catherine remains

> South Africa's foremost Pop artist, that is an artist who, over thirty years, has conveyed a distinctly populist imaginary; he is also, by virtue of his dynamic fusion of European/American and African styles, one of the first South African artists to locate his art in a strikingly hybrid international arena. The root of this feat lies in the temperament of his art and its urban vernacular, a feat which, today, cannot be underestimated.[132]

There is a darker 'africanesque' or even primitivist reading of Catherine's work offered by the late Raymund van Niekerk (then director of the South African National Gallery). Van Niekerk took the view that Catherine, 'has deliberately taken into his work the acculturated art products of his black fellow countrymen – they temper his own western virtuosity.' 'Transitional' art seems to have drawn from the same well. Thomas Kgope, once an assistant to Catherine, developed into a 'transitional' artist who merged aspects of popular culture and, amongst other things, Ndebele wall culture.[133]

The play of pop was clearly complex for the post-war, Apartheid era. There were contending cultural mediations and power plays, all of which registered in everyday life: from the brands and iconographies of Ndebele paintings on walls in the 1940s and the visual culture of gangsters in townships in the 1950s, to aesthetic liberation from politics in the era of high modernist abstraction. The vexed articulation of a 'primitivist' outlook haunts the critical

understanding of how 'popular' or 'vernacular' materials and iconographies have been deployed among South African artists.[134]

A Painter of Modern Life

As director of Polly Street, Cecil Skotnes and the young artist Durant Sihlali had their differences. For Skotnes, '[i]nstead of representational art, modernism deriving from expressionism, fauvism, cubism and classic West and Central African expressions were favoured', while Sihlali firmly believed that it was most important to record faithfully the people and places where he lived, as well as neighbourhoods from which people had been removed.[135]

Sihlali's essentially popular documentary inclinations went back to the late 1940s and the European-mediated 'primitivism' he encountered at Polly Street, which inhibited the kind of urban historicity and everydayness that he sought in his paintings and which was so vital for developing a 'pop' sensibility. Decades later, the aesthetic orientation of the early Thupelo workshops also proved prescriptive for Sihlali, who frankly doubted that '[at] a time of intense political pressure, abstraction offered artists in South Africa a space in which to work freely and without prescription.'[136]

An off-hand remark by newspaper critic Samantha James about Sihlali's workshop paintings unintentionally touches on an important issue: 'Sihlali has created elaborate textures and marked them with esoteric symbols. Such obliquely hinted-at knowledge, as opposed to the display of actual understanding, introduces wayward objectives and a spurious tone.'[137] What this view fails to see is that Sihlali's rather melancholic 'abstraction' was shot through with signs from a world under threat. The hints, the obliqueness, the 'wayward objective', even the 'spurious tone' are functions of Sihlali's artistic independence and his inclination to allegory, bearing in mind that allegory, along with all things 'literary', including representation were aesthetic *bêtes noires* of American-type modernism.[138]

Doing violence to history, it strikes me that Sihlali's practice resonates with Charles Baudelaire's 'painter of modern life'. For Baudelaire, 'modernity is the transient, the fleeting, the contingent; it is one half of art, the other being the eternal and the immoveable.'[139] Importantly, Baudelaire's model for this view – one Constantine Guys – was less artist than illustrator.[140] Sihlali's self-described artistic mission, his status as *umtwana omhlope* (a white child), his connectedness as a medium for the *idlozi*, and his role as a documenter of the transient passing of history, make this link to Baudelaire especially fertile.[141]

Sihlali was a cultural conservationist. His early explorations into 'wall' culture include *Ndebele Homestead*, and *Ndebele Village I* and *II*, all from 1960.[142] He had an abiding interest in the visual culture of walls, some of which he expressed, but much of which was suppressed between 1960 and 1985. He wrote that because of the, 'socio-economic and political climate, as well as the artistic dictates of the country, I had to shelve the wall impressions'.[143] Sihlali subsequently described the political climate between the later 1970s and 1989 as a 'nightmare trauma'.[144]

The conjunction of the popular and the political finds distinctive expression in his practice during this latter period. In 1975 Sihlali produced a watercolour, *Looking In (Padda Vlei) Kliptown*. At the time, this work would have risked being labelled 'township art', a term

Durant Sihlali,
Rhini Walls, 1995

applied somewhat indiscriminately to much of the production of black urban artists in the 1960s and 1970s, and which restricted the production and reception of their work. The township genre was, for the cognoscenti, a market-driven picaresque art in a minor medium: lightweight, populist, aesthetically compromised and, often, kitsch.

'Township art' is directly linked to Polly Street. Steven Sack curated the important *The Neglected Tradition* exhibition at the Johannesburg Art Gallery in 1988. For Sack, the 'art produced at Polly Street' formed two distinct streams: a 'township style' and a 'neo-African style'.[145] What Sack calls 'neo-African' is what I would call a formally elaborate, even overwrought, quasi-abstraction. Sack goes on to divide 'township' into two styles: first, 'accurate recordings of specific places in the township' (and here he includes Sihlali), and second, 'township scenes of a more generalized nature, leading to a repetitious stylization of picturesque "shantytowns"'.[146]

David Koloane specifically mentions 'township art' in his response to the criticism of the Thupelo project and, in doing so, he structures an opposition similar to Greenberg's avant-garde and kitsch. For Koloane, the criticism of Thupelo implies 'that only artists of other race groups are capable of transcending realistic expression', something which has 'succeeded in creating a submarket in so-called "Township Art", a sentimental expression which has imprisoned many artists in a sterile and repetitive cycle.' For Koloane, Thupelo's goal, on the contrary, was to create conditions for genuine self-exploration amongst artists, not 'sentimental expression' and the traps of sterile stylistic repetition.[147] Popularity and aesthetic gravitas are not mutually exclusive.

But we might look at Sihlali's works of the period differently: that is, as a human-scale form of history painting. Numbers chalked or painted on the wall that frames a seated woman lost in reading in *Looking In (Padda Vlei) Kliptown* (1975) marks the house for demolition, and the woman for forced removal. This is not simply a bucolic and sentimental romance, or a visual treatise on human dignity under threat, or the virtues of solitude. The masked signs previously noted by Samantha James were a feature of later works: as in the three bonded fibre works, all titled *Ancient Signs* and shown in 1993, or, slightly earlier, the reduction lino prints entitled *Ancestral Wall* (1991), *Wall Impressions* (1991) and *Fragments of the Ancient Wall* (1991).

The early wall works – of Ndebele, Sotho and Xhosa visual cultures – were Sihlali's sources. An undated lithograph titled *Mapoga*, a gouache of the same title, a reduction colour lino in the same direct, almost comic-book or cartoon mode titled *Mapoga Wall Series II* (1991), and an oil and acrylic painting on hessian titled *Mapoga Wall Patterns* (1993), were all part of the creative outflow of a liberating six-month Associate Study grant at the University of Nice in 1986.[148] The somewhat hard-edged, economic and linear style of some of these works points to the graphic modes of popular culture. Sihlali's sources were not only the observed world, but also popular media. When interviewed he cited as key sources a 'beautifully illustrated' volume of trains and the South African landscape, as well as books on local fauna and flora, snakes, spiders and the indigenous 'tribes' of South Africa.[149]

Sihlali's wall works of 1993 and later, including *Graffiti Signatures*, *Carnage Wall* and *Peace Wall*, all explore signage deposited in the public domain. These works contain myriad graphic

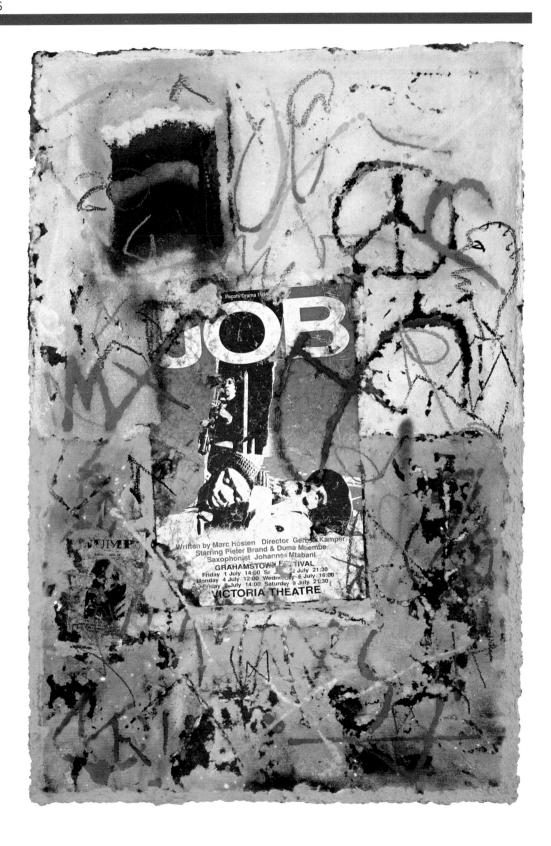

signs that are both linguistic (words, sentences) and non-linguistic (skull and crossbones, male and female). Perhaps the most simple and complex of these graphic signs is Sihlali's use of the figure 'x', which straddles the space between the linguistic and the iconic, between the literal and extended metaphor.[150] All of this ambiguity is prefigured in the writing on the wall in Sihlali's *Looking In* (1975) and other works of the mid-1970s.

Wall inscriptions in his later works are private and public, personal and collective, popular and arcane, legal and clandestine. Sihlali's walls are complex visual accretions of communication, palimpsests bearing the scripts of popular history: 'you can read through the surfaces of the walls. Magnify it, and you can read volumes, right back to the first mark made by humans on a rock surface. It is a chronicle of continuity.' The artist also adds that the walls contain 'prayers, messages and secret maps, love songs and poems, political protests and sloganeering, religious symbols and graffiti [signatures of the sick]' which 'talk about things ... which should have been seen.'[151]

Graffiti provides an archive of sorts. Speaking on the reclaiming of the old Johannesburg prison complex by the new Constitutional Court, writer Mark Gevisser laments that the continuous repainting of the Johannesburg Fort and the Women's Jail means that 'we lost, forever, the most potent prison records available: the graffiti. There are two kinds of prison records – the story from above, the official documents, and the story from below, the graffiti.'[152]

Sihlali's wall works involve both his desire to document passing history and his desire to fulfil his metaphysical mission, for he has stated that 'the spiritual power of my work related to the past, immediate [present] and future, echoing our beliefs in a Trinity (*umveilinqangi*) which encompasses our ancestral connection with the past, present and future.'[153] His earliest encounter with wall works was as a very young child, and for him this was foundational to his artistic mission His interest persisted: 'for me there was no other art except the wall. I'll do the wall, say what I have to say, but it will remain the wall. At one stage they were saying that the wall was not art, hence my sticking to the wall ... the beginning of art.'[154]

These works often betray an ambivalence, as the couplet *Peace Wall* (1993) and *Carnage Wall* (1993) suggests. In *The Scarred Wall* (1992) we find traces infused with human import in a way that returns us to Bremner's equation of wall and skin. This work also returns us to an earlier wall work of 1987, *Reminders of Past Apartheid*. Here the laceration and scarring of the surface is violent and intense, a quality also apparent in his *Fragments of the Ancient Wall* (1991). In this work, Sihlali's primary material was a scarred piece of linoleum recovered from the old Afrikaner Museum (since transformed into MuseuMAfrika). When the building was being gutted, Sihlali asked the foreman if he could have the lino before it was too damaged to use. The foreman declined, and the artist had to retrieve pieces of lino from under mounds of the masonry. Sihlali decided to use a piece as it was, debris scarred by use and abuse, which 'seemed to have a life of its own, like some animal'. *Fragments of an Ancient Wall* is literally a print taken off the charged surfaces of everyday life. It is clear that 'pop' is embedded in Sihlali's creative work, though not always in obvious and orthodox ways, and I would suggest that this heterodox approach applies beyond his individual case, and points to a need to

reconfigure our understanding of popular culture in this part of the world.

This point also relates to another, more obviously 'popular', dimension of Sihlali's working life. During the 1950s and 1960s he also made curios and jewellery, designing and decorating lampshades, and creating greetings cards for the tourist market. There were elements in his 'township art' practice that could also figure here. Curator Julia Charlton recalls Sihlali saying he was known as 'the curio master', a maker of quality pendants and brooches of painted stone and shells, showing miniature creatures, landscapes and flowers.[155]

The inclination to see this kind of activity as artistically without merit is strong. However, in a conversation in the late 1990s, Sihlali distinguished what earned bread and butter and what was creatively rewarding. While he had some reservations about these dual aspects of his working life, he did not consider his curio work as an aesthetic dead loss, as mere populist kitsch. The 'popular' market and the 'discerning' market were not always so distant or distinct, and indeed the phenomenon of transitional art expresses their anxious intersection.

Fellow artist and friend Joachim Schönfeldt made an honorific work, *Untitled (Tribute to Durant)* (1994), which acknowledges the complex relationship between Sihlali's popular production and his so-called fine art.[156] Schönfeldt's work is a weatherbeaten found object – perhaps an old slatted door – reshaped into a hexagon of roundels. The inner edge of each roundel is a painted landscape of the kind one might indeed find for sale on the roadside, or on a postcard. The roundel at the top of the structure has the phrase 'Authentic Works of Art and Curios' painted on it, while the lower two roundels have inscriptions that read, 'Pioneers of the Materialist View of Art' and 'Joachim Schönfeldt'.[157]

Conclusion: Butisi Tart?

Pop – and the idea of the popular – in art is a complex phenomenon that registers directly in the lived experience of modernity in the everyday. This phenomenon was and remains conflicted and unevenly developed throughout the everyday. It is a cultural drive, a pulse, a contradictory adventure in cultural alterity and accommodation, at once a source for cultural energy and a resource for cultural engagement, however fraught. Tracing this drive, this pulse, this energy in the creative lives and work of many artists from the early 1950s of the Polly Street era to the phenomenon of 'transitional' art and the development of the Thupelo workshops of the mid- to late 1980s demonstrates a great deal about the reception and production of aesthetic modernity in once colonised nation-states.[158]

The twists and turns of modernist aesthetics passing through the period of high apartheid (1948–94), the decline of which coincided with the peaking of post-modernism elsewhere (as Homi K. Bhabha has it), suggest how a general mapping of modernism and its sequelae post-modernism might be rendered legible in the interface between locality and the forms and forces of globalisation.[159] Any such mapping would need to consider as much indigenous resistance as processes of assimilation in our experience of modernity. And, to put not too fine a point on it, how we do this is a matter of art politics.

Many of the artists mentioned in this essay engage with the vicissitudes of the vernacular in mapping modernism, of which 'pop' is such a

crucial (and often repressed) part. In retrospect, the perspectives, practices and processes of the 'popular' engage with and undercut the great narratives of modernism that we might read off the artistic practices and presences of Skotnes, Peacock and Greenberg. Mapping and, with it, signing, are also profoundly emblematic of post-modern and post-colonial energies and commitments that figure powerfully in South African art. A public culture project for the District Six museum in Cape Town offers one set of insights into those experiences of orientation and disorientation so central to acts of mapping and signing.

District Six started life as a home for 'freed slaves', and developed into a home town of 'poets, stevedores, doctors, gangsters, choristers, domestic maids, wash women, jazz musicians, crooners, noisy children and quiet ones, moffies, crane operators, opera singers and councillors.'[160] In 1966, the site was declared a white residential area and its inhabitants were forcibly removed over the next 16 years, destroying the vibrant popular culture that had thrived there and in the larger Cape Town area during the 1940s.[161] For the 1997 sculpture project, Liza Hugo's *Stop/Go* (1997) comprised road signs placed not in a street but in an open piece of ground. The curators of the project observed that 'three road signs enforce the idea of the absurdity of laws. The images on the site reflect certain aspects of life in District Six as it was before it was turned into an urban failure. The signs of social order are now devoid of logic.'[162]

Another work, by Dorothea Kreuzfeldt, Andrew Porter and Nicola Jackson, titled *Reserved / Reversed* (1997), also made use of road names and directional signs. Photographs of people, streets, houses and graffiti were 'collaged, cut, or torn, fragmented and combined with texts (taken from original graffiti, songs and poems on District Six)' and 'wallpapered onto lamp-posts and pavements' and other surfaces.[163]

Another practitioner of signs was the late Johannes Fanozi (Chickenman) Mkhizi (1959–1995). Mkhizi passed away in 1995, but his work was included in David Elliott's groundbreaking exhibition, *Art from South Africa* (1990), held at the precise juncture of what became the moment of radical historical change in South Africa.[164] Mkhizi's work has also been collected by the South African National Gallery, for example, *Gonefis hing* (1981). These linguistically eccentric road signs appear to be driven by 'pure' vision (by default, as the artist was held to be 'illiterate'), even though there is an acknowledgment of social power encoded in such signage as well as artistic savvy about the needs of a particular cultural market. Mkhizi too, became a 'transitional' artist.

The summer 1995 cover of the journal *Third Text* sports an image of one of Mkhizi's signs, titled *Savetheworl Dgogreen* (1995).[165] In many ways this is a fitting coda for our discussion of 'pop'. But even more fitting perhaps is a photograph inside the journal, taken by the late photographer Andrew Meintjies, himself a casualty of a shooting in Johannesburg. Meintjies' photograph shows a teddy bear against the backdrop of a painting by Esther Mahlangu. The image – or the whole scene – has the quality of a form of hallucinogenic commodity fetishism that loops us all into circuits of sensation, complicity, corruption and cultural contamination even as we seek critical distance. The wall offers a visible public moment in that loop, and is also an obstacle in the flow on which any such looping would depend. It is a

popular if sometimes sinister place, absorbing and exposing the iconography of the clandestine wants and wishes of the marginal: a place which recalls the title of Moshekwa Langa's work (appropriately), for the 2nd Johannesburg Biennial, *Temporal Distance (with criminal intent): You will find us in the Best Places...* (1997).[166]

NOTES

1. Sarat Maharaj, '"Perfidious Fidelity" The Untranslatability of the Other', in Jean Fisher ed., *Global Visions: Towards a New Internationalism in the Visual Arts*, London: Kala Press/The Institute of International Visual Arts, 1994, 28.
2. *Miner's Companion in English, Afrikaans and Fanakalo*, Johannesburg: Swan Press, 1953, 78.
3. There is a complicated relation between academic and popular culture: see Kopano Ratele, '*Re tla dirang ka selo se ba re go ke ghetto fabulous?* Academics on the Streets', *Agenda*, 57, 2003, 50. The phrase in English reads: 'So what are we going to about this thing called ghetto fashion fabulous?'.
4. Louis Molamu, *Tsotsitaal: A Dictionary of the Language of Sophiatown*, Pretoria: University of South Africa, 2003, 19. Molamu's entry reads: 'The term refers to a streetwise young male African in the urban areas. The literal English meaning of the term is "skillful, talented, quick to understand and learn, ingenious, cunning" ...'.
5. See Stuart Hall, 'Notes on Deconstructing "The Popular"', in Stephen Duncomb ed., *Cultural Resistance Reader*, London: Verso, 2002.
6. For 'vernacular' in architecture, see Victor Papanek, 'The Shaman and the Developer: An Essay on the Causes of Vernacular Buildings', Franco Frescura, 'The Colonial Factor: The Development of Southern African Indigenous Vernacular Architecture, 1881–1910', and Paul Oliver, 'Conserving the Vernacular: Some Cultural Considerations', all in *South African Journal of Art & Architectural History / Suid-Afrikaanse Tydskrif vir Kuns- & Argitektuurgeskiedenis*, 4, 1–4, February 1994. For a much earlier discussion, see James Walton, 'Art and Magic in the Southern Bantu Vernacular Architecture', in Paul Oliver, *Shelter, Sign & Symbol*, London: Barrie and Jenkins, 1975.
7. For the tsotsietaal associated with Sophiatown (née Triomph) in Johannesburg, see Louis Molamu, *Tsotsietaal: A Dictionary of the Language of Sophiatown*, Pretoria: University of South Africa, 2003, and more generally on Sophiatown, Ulf Hannerz, 'Sophiatown: The View from Afar', in Karin Barber ed., *Readings in African Popular Culture*, Bloomington/Oxford: Indiana University Press/James Curry, 1997. For District Six, see Kay MacCormick, 'The Vernacular of District Six', in Crain Soudien and Renata Meyer eds, *The District Six Public Sculpture Project*, Cape Town, 1997. For Fanagalo (sp. Fanakalo in 1953), see note 2.
8. Houston A. Baker Jr, *Blues, Ideology, and Afro-American Literature*, Chicago: University of Chicago Press, 1984, 2. Baker is discussing what he terms Afro-American art. Using the example of Keats' *Ode on a Grecian Urn*, he observes that 'contrasting with Keats's romantic figurations are the emergent faces of a venerable ancestry. The shift

from Greek hydrias to ancestral faces is a shift from high art to vernacular expression.'
9. Okwui Enwezor ed., *The Short Century: Independence and Liberation Movements in Africa 1945–1994*, Munich: Prestel, 2001.
10. Maurice Blanchot, 'Everyday Speech', *Yale French Studies*, 73, 1987, 14.
11. W.J.T. Mitchell, 'Christo's *Gates* and Gilo's *Walls*', *Critical Inquiry*, 32, 4, Summer 2006, 587.
12. Serge Schmemann, *When the Wall Came Down*, London: Kingfisher, 2006.
13. John Berger, 'Undefeated Despair', *Critical Inquiry*, 32, 4, Summer 2006, 606.
14. Lindsay Bremner, 'Border/Skin', in Michael Sorkin ed., *Against the Wall*, New York: The New Press, 2005, 122. The link between Apartheid and Israel is controversial; but see Norman Finkelstein, *Beyond Chutzpah: On the Misuse of Anti-Semitism and the Abuse of History*, London: Verso, 2005, 49–51.
15. Bremner, ibid., 131.
16. Esmé Berman, *Painting in South Africa*, Halfway House: Southern Book Publishers, 1993. The phrase comes from Michael Morris, *Every Step of the Way: The Journey to Freedom in South Africa*, Cape Town: HSRC Press, 2004, 243.
17. Figure 110, Berman, ibid., 174. The photographer, Constance Stuart Larrabee, is worth a closer look in this context. Brenda Danilowitz, writing on the photographer, suggests that she probably documented a settlement in Hartebeesfontein near Tswane (Pretoria): page 83, see Brenda Danilowitz, 'Constance Stuart Larrabee's Photographs of the Ndzundza Ndebele: Performance and History Beyond the Modernist Frame', in Marion Arnold and Brenda Schmahmann eds, *Between Union and Liberation: Women Artists in South Africa 1910-1994*, Aldershot: Ashgate, 2005. But Larrabee produced a much wider range of photographs, from formal studio settings to her work as a war correspondent. Concerning the Ndzundza Ndebele photography, Danilowitz queries the dating, and it seems that the period between 1936 and 1949 is the most precise. Critically, Danilowitz tends to argue from strong, sometimes simplistic, oppositions, in this case mostly under the primary opposition 'form' against 'content' and 'context'. She overstates the case, and with it her view of Larrabee's practice as 'formalist'. Danilowitz's uncritical overvaluing of artistic intention, and her dependence on liberal possessive individualism (artistic agency), also undermine her 'formalist' argument. Perhaps more pertinent here (from a different angle) is Larrabee's description of the peanut image: '"*Planters," American canned peanuts, inspired this wall decoration. The Ndebele have retentive minds for new*

designs. They paint on their walls any designs that catch their fancy. The woman who painted this probably found an empty can discarded by a picnic party.' (Constance Stuart Larrabee manuscript collection, Ndebele folder 12, Document no.233, Eliot Elisofon Photographic Archives, National Museum of African Art, Smithsonian Institution, Washington). Whatever else can be said about these words (there is much), they do not suggest the kind of hardened formalism that Danilowitz seeks to ascribe to Larrabee. I should finally note that Danilowitz does not reproduce the peanut image (perhaps because it might complicate her argument). The peanut image was most likely painted on a wall to the right of the structures photographed on page 85 in her text (image no. EEPA 1998-060676; the peanut image – from a different visual angle – is EEPA 1998-060653 in the Eliot Elisofon Photographic Archives, National Museum of African Art, Smithsonian Institution, Washington).

18. H.J. Bruce, 'The Arts and Crafts of the Transvaal Ndebele', in Anna H. Smith ed., *Africana Byways*, Johannesburg: Ad. Donker, 1976, 147.

19. http://www.angelfire.com/ca6/uselessfacts/food/001.html and http://www.cafepress.com/w2arts/35119.

20. Bremner, op. cit., 133.

21. Ann Bernstein, 'Globalization, Culture, and Development: Can South Africa Be More than an Offshoot of the West?', in Peter L. Berger and Samuel P. Huntington eds, *Many Globalisations: Cultural Diversity and the Contemporary World*, Oxford: Oxford University Press, 2002, 241–42.

22. Berman, 2004, op. cit., 384. See also Esmé Berman *The Story of South African Painting*, Cape Town: A.A. Balkema, 1975, 314–15. Elsewhere Berman emphasises a 'wry consciousness' in 'highly urbanised situations' where 'the tradesmark has become the modern icon, the billboard and the comic book substitutes for church and temple friezes of the past.' Pop imagery is a direct reflection 'of the extraordinary visual clutter of ... shop windows and display counters, the traffic lights and neon signs, the posters and advertisements'. In a statement that indicates and historicises her aesthetic predispositions, she observes that 'in many cases style was nonexistent; readymade articles replaced interpretive design and composition; and the deliberate vulgarity which was often intrinsic to the message...'.

23. André Magnin with Jacques Soullilou eds, *Contemporary Art of Africa*, New York: Harry N. Abrams, 1989, 7, and André Magnin, *Arts of Africa: The Contemporary Collection of Jean Pigozzi*, Monaco/Florence: Grimaldi Forum/Skira, 2005.

24. Clémentine Deliss, '7 + 7 = 1: Seven Stories, Seven Stages, One Exhibition', in Clémentine Deliss ed., *Seven Stories: About Modern Art in Africa*, London: Whitechapel, 1995, 15.

25. Ivor Powell, *Ndebele: A People & Their Art*, Cape Town: Struik, 1995, 8.

26. Jean-Michel Rousset, 'Esther Mahlangu, Francina Ndimande', in Magnin with Soullilou eds, op cit., 46.

27. Peter Magubane, *Homesteads*, Struik: Cape Town, 2001, 14.

28. Plate 48, Berman, 1993, op. cit., 175.

29. Ibid.

30. Elizabeth Ann Schneider, 'Art and Communication: Ndzundza Ndebele Wall Decorations in the Transvaal', in Anitra Nettleton and David Hammond-Tooke eds, *African Art in Southern Africa: From Tradition to Township*, Johannesburg: Ad. Donker, 1989, 103.

31. James Elkins, *Stories of Art*, London: Routledge, 2002, 31.

32. The kind of narrative that James Elkins summarises as stressing 'Cubism, Abstract Expressionism, Pop Art, Minimalism...', ibid., 81. Clement Greenberg, in his presentation at the University of South Africa in July 1975, implicitly reiterated this idea of historical logic and progression, and also the connection between aesthetic modernism and the culture of urbanisation and industrialisation. Qualifications notwithstanding, he articulated the (for him) fundamental (one is inclined to say fundamentalist) aesthetic antagonism between mass-produced kitsch and the unique, autonomous, autotelic art object.

33. For some useful critical discussions of modernity/modernism, see Jani Scandura and Michael Thurston eds, *Modernism Inc. Body, Memory, Capital*, New York: New York University Press, 2001, and Dilip Parameshwar Gaonkar ed., *Alternative Modernities*, Durham: Duke University Press, 2001.

34. I am thinking along the lines here of Rachel Moore's *Savage Theory: Cinema as Modern Magic*, Durham: Duke University Press, 2000, and Walter Kaladjian, 'The Edge of Modernism: Genocide and the Poetics of Traumatic Memory', in Jani Scandura and Michael Thurston eds, *Modernism Inc. Body, Memory, Capital*, New York: New York University Press, 2001. In some recent papers I have attempted to link trauma, violence and new humanisms: see my 'New Humanisms in Contemporary South African Art', in Philippa Hobbs ed., *Messages and Meanings: The MTN Art Collection*, Johannesburg: MTN Foundation/David Krut Publishing, 2006.

35. See Rob Nixon, 'The Devil in the Black Box: The Idea of America and the Outlawing of TV', in his *Homelands, Harlem and Hollywood*, London: Routledge, 1994.

36. Rayda Becker, 'Mixed Messages: Noria Mabasa and the Art Market', in Karen Press ed., *Noria Mabasa*, Johannesburg: David Krut Publishing, 2003, 72, and see figures 20–22.

37. Antoinette du Plessis ed., *Esther Mahlangu*, Kommetjie: Vgallery, 2003, 25.

38. This kind of appropriation of materials has a long history. See Anitra Nettleton, Julia Charlton and Fiona Rankin-Smith, *Engaging Modernities: Transformations of the Commonplace*, Johannesburg: University of the Witwatersrand Art Galleries, 2005.

39. Mautloa constructs his own walls from recycling obsolete materials in urban culture and he has created installations of shacks with such material, as happened for the *Colours: Kunst Aus Südafrika* exhibition held at Haus der Kulturen der Welt in Berlin in 1996; see Alfons Hug and Sabine Vogel eds, *Colours: Kunst Aus Südafrika*, Berlin: Haus der Kulturen der Welt, 1996, 122–24.

40. Berman, 1975, op. cit., 314–15.

41. Jo Thorpe, *It's Never Too Early: African Art and Craft in Kwazulu-Natal 1960–1990*, Durban: Indicator Press, 1994, 8. The dating of this work is unclear, but it was probably made in the mid-1980s.

42. See my 'That Authentic African Look Fades into Glib Cliché', *Weekly Mail*, 28 August–3 September 1987, 21, and 'Desperately Seeking Africa', in David Elliott ed., *Art From South Africa*, Oxford: Museum of Modern Art, 1990. See also Anitra Nettleton, 'Myth of the Transitional: Black Art and White Markets in South Africa', *South African Journal of Cultural and Art History*, 2, 4, 1988.

43. Figure 16, Elda Grobler and J.A. van Schalkwyk, *Spieëlbeeld van 'n Versameling / Reflections of a Collection*, Pretoria: Nasionale Kultuurhistoriese en Opelugmuseum/ National Cultural History and Open-Air Museum, 1989, 30.

44. A number of works included in this exhibition queried 'high art' conventions and the problem of both 'traditional' production and the production of curio market. There are also a number of such artists in Steven Sack's *The Neglected Tradition: Towards a New History of South African Art (1930–1988)*, Johannesburg: Johannesburg Art Gallery, 1988. While the 'high art' economics of 'transitional' art ultimately proved unsustainable, there is still interest in current work which could be seen as continuing the 'tradition' of transitional art. See, for example, Koto Bolofo, *Sibusiso Mbhele and his Fish Helicopter*, New York: Poerhouse, 2002, and Koto Bolofo, 'Wings of Desire', *Art South Africa*, 4, 4, Winter 2006.

45. The first state of emergency was declared on 25 July 1985, and the next on 12 June 1986, this last specifically targeting communication. There are many accounts of these emergencies. For a useful, consolidated discussion of the years 1985–90, see Christopher Merrett, *A Culture of Censorship: Secrecy and Intellectual Repression in South Africa*, Cape Town/Pietermaritzburg/Macon: David Philip/ University of Natal Press/Mercer University Press, 1995.

46. Susan Sellschop, Wendy Goldblatt and Doreen Hemp, *Craft South Africa*, Hyde Park: Pan Macmillan, 2002, 77–124.

47. Magnin with Soullilou eds, op. cit., 61–67, 96–98, 139–41.

48. See my 'Mr. Tito Zungu's Art of the Middle Smile', in *Mr. Tito Zungu: A Retrospective Exhibition*, Durban: Durban Art Gallery, 1997.

49. Andries Loots and Fred de Jager, *Esther Mahlangu*, Cape Town: VGallery, 2003, 19.

50. Berman, 1993, op. cit., 356.

51. See the Smithsonian Institution's 'Modern African Art: A Basic Reading List' at http://www.sil.si.edu/SILPublications /ModernAfricanArtn / maaprint.cfm?subcategory=1

52. Hans Günter Golinski and Sepp Hiekisch-Picard eds, *New Identities: Zeitgenössische Kunst Aus Südafrika*, Bochum: Museum Bochum/Hatje Cantz Verlag, 2004, 180–85.

53. Loots and de Jager, op. cit., 10.

54. Jean-Michel Rousset, 'Esther Mahlangu / Francina Ndimande', in Magnin with Soullilou eds, op. cit., 48.

55. This is a commonplace in critical discourse in colonial and post-colonial situations: see, for example, Deborah Root, *Cannibal Culture: Art, Appropriation, & the Commodification of Difference*, Boulder: Westview, 1996.

56. Figure 4, Marilyn Martin, 'All Encounters Produce Change: Africa, Picasso and Beyond', in Laurence Madeline and Marilyn Martin eds, *Picasso and Africa*, Cape Town: Bell Roberts, 2006, 155–56.

57. I touched on this tendency in my 'Desperately Seeking Africa', in David Elliott ed., op. cit.

58. 'Picasso in Africa', *Art South Africa*, 4, 4, Winter 2006, 30–40. For a response by Marilyn Martin, see 'A Disappointing Debate', *Art South Africa*, 5, 1, Spring 2006. For some background, see also Michael North, 'Modernism's African Mask: The Stein-Picasso Collaboration', in Elizabeth Barkan and Ronald Bush eds, *Prehistories of the Future: The Primitivist Project and the Culture of Modernism*, Stanford: Stanford University Press, 1995.

59. Louis Molamu, op. cit., 2.

60. Es'kia Mphahlele in Pippa Stein and Ruth Jacobson eds, *Sophiatown Speaks*, Johannesburg: Junction Avenue Press, 1986, 56.

61. Nakedi Ribane, *Beauty: A Black Perspective*, Scottsville: University of KwaZulu-Natal Press, 2006, 16. See also Jurgen Schadeberg ed., *The Fifties People of South Africa*, Johannesburg: Bailey African Photo Archives Production, 1987. It is important to remember that this publication was produced in a State of Emergency (see p.259).

62. Jacky Heyns, 'The Fifties', in Jurgen Schadeberg ed., ibid., 11.

63. See Steven Sack, '"Garden of Eden or Political Landscape?" Street Art in Mamelodi and Other Townships', in Anitra Nettleton and David Hammond-Tooke eds, *African Art in South Africa: From Tradition to Township*, Johannesburg: Ad. Donker, 1989. See also Santu Mofokeng and Sam Raditlhalo, *Santu Mofokeng*, Johannesburg: David Krut Publishing, 2001, 58. Another example is Jo Ractliffe's billboard images of donkeys which formed part of her *End of Time* (1999), see Brenda Atkinson, *Jo Ractliffe*, Johannesburg: David Krut Publishing, 2000, 48, 56; and Minette Vári's *Selfportrait (The Billboard)* (1995), in Hug and Vogel eds, op. cit., 144–55.

64. On recycling see, *inter alia*, Corinne Kratz, 'Rethinking Recyclia', *African Art*, 18, 3, Summer, 1995, Suzanne Serif, 'Recycled, Re-Seen: Folk Art from the Global Scrapheap', *African Arts*, 29, 4, Autumn 1996, and Allen F. Roberts, 'Chance Encounters, Ironic Collage', *African Arts*, 15, 2, April 1992.

65. See Franco Frescura, *A Pictorial Survey of Southern Africa Wall Graphics Through the Ages*, Port Elizabeth: University of Port Elizabeth Department of Architecture and King George VI Art Gallery, 1989.

66. Ibid., 5.

67. See Keith Beavon, *Johannesburg: The Making and Shaping of a City*, Pretoria/Leiden: University of South Africa Press/Konklijke Brill NV, 2004, 204–8.

68. Quoted in Anne Friedberg, 'Window Shopping', in Michael J. Dear and Stephen Flusty eds, *The Spaces of Modernity: Readings in Human Geography*, Oxford: Blackwell, 2002, 447. See also See Jeanne van Eeden, 'All the Mall's a Stage: The Shopping Mall as Visual Culture', in Jeanne van Eeden and Amanda du Preez eds, *South African Visual Culture*, Pretoria: van Schaik 2005.

69. Janice Williamson, 'Notes from Storyville North: Circling the Mall', in Rob Shields ed., *Lifestyle Shopping: The Subject of Consumption*, London: Routledge, 1992, 216.

70. Richard Tomlinson and Pauline Larsen, 'The Race, Class, and Space of Shopping', in Richard Tomlinson, Robert A, Beauregard, Lindsay Bremner and Xolela Mangcu eds, *Emerging Johannesburg: Perspectives on the Apartheid City*, London: Routledge, 2003, 44.

71. Bremner, 2005, op. cit., 132.

72. Laurence Barbier ed., *Kendell Geers: My Tongue in Your Cheek*, Auxerre: Les Presses du Réel, 2002, 40–51.

73. Alan Krell, *The Devil's Rope: A Cultural History of Barbed Wire*, London: Reaktion, 2002, 7.

74. Ibid., 173.

75. Willem Campschreur and Joost Divendal eds, *Culture in Another South Africa*, London: Zed Books, 1989.

76. Figures 22, 23, 24, ibid., 8.

77. This activity was referenced by Sue Williamson, 'Posters Anonymous', in her *Resistance Art in South Africa*, Cape Town/London: David Philip/Catholic Institute for International Relations, 1989, 91.

78. Ivor Powell, 'Prophets of the Concrete Walls', *Weekly Mail*, 25–31 October 1985, 20.

79. Goniwe was one of the so-called Cradock Four, and the question asked on the walls remains partly answered. The representations at the Truth and Reconciliation Committee led to the granting of amnesty for only two individuals – Eugene de Kok and Jaap van Jaarsveld. The other six involved were deemed not to have made a full disclosure, and so were denied amnesty. See Christopher Nicholson, *Permanent Removal: Who Killed the Cradock Four?*, Johannesburg: Wits University Press, 2004.

80. I have taken the phrase from Joan Gibbons, *Art & Advertising*, London: I.B. Taurus, 2005, 55–73.

81. Hans Günter Golinski and Sepp Hiekisch-Picard eds, *New Identities: Zeitgenössische Kunst Aus Südafrika*, Bochum: Museum Bochum/Hatje Cantz Verlag, 2004, 64–70.

82. *On the Road: Works by 10 Southern African Artists*, with text by Ivor Powell, London: The Delfina Studio Trust, 1995, 36–37.

83. See Christy Lange, 'Crazy for you: Candice Breitz on Pop Idols and Portraiture', *Modern Painters*, September 2005, and Martin Sturm and Renate Plöchl eds, *Cuttings*, Linz: OK Centre for Contemporary Art Upper Austria, 2001. Her work on popular postcards was documented in Tumelo Mosaka and Octavio Zaya (curators), *Black Looks : White Myths*, Madrid: Tapapress, 1995, 18–20. This exhibition was part of the first Johannesburg Biennial. For the controversy created by these and similar works, see Okwui Enwezor, 'Reframing the Black Subject: Ideology and Fantasy in Contemporary South African Art', in Marith Hope ed., *Contemporary Art from South Africa*, Oslo: Riksutstillinger, 1997, subsequently published in a revised form in *Third Text*, 40, Autumn 1997; Olu Oguibe, 'Beyond Visual Pleasures: A Brief Reflection on the Work of Contemporary African Woman Artists', in Salah M. Hassan ed., *Gendered Visions: The Art of Contemporary Africana Women Artists*, Trenton/Asmara: Africa World Press, 1997; and Brenda Atkinson and Candice Breitz eds, *Grey Areas: Representation, Identity and Politics in Contemporary South African Art*, Sandton: Chalkham Hill, 1999.

84. Figure 11, page 58 in Ivor Powell, 'Brett Murray's Reconciliations', in Frank Herreman ed., *Liberated Voices: Contemporary Art from South Africa*, New York/Munich: The Museum for African Art/Prestel, 1999, 96–99.

85. Important here are the somewhat later works by Thembinkosi Goniwe involving representations in popular

magazines: *Face Value Thandi* (1999), *Face Value Pace* (1999), *Face Value Drum* (1999) and *Face Value Bona* (1999). See Khwezi Gule, 'Thembinkosi Goniwe', in Sophie Perryer ed., *10 Years 100 Artists: Art in a Democratic South Africa*, Cape Town: Bell Roberts in association with Struik, 2004, 131.

86. See my 'Johannes Phokela', in Sophie Perryer ed., ibid., 290. See also *Oil Paintings and Drawings by Johannes Phokela: 'The Age of Enlightenment'*, Johannesburg/London: Gallery Momo/Simon Mee Fine Art, 2003.

87. See my 'Drawing Blood: Conflict and Caricature in Contemporary South African Art', in Elvira Dyangani Ose, Tracy Murinik, Gabi Ngcobo and Khwezi Gule eds, *Erase Me from Who I Am*, Gran Canaria: Centro Atlántico de Arte Moderno, 2006.

88. Emma Bedford ed., *Tremor: Contemporary South Africa*, Brussels/Cape Town: Centre d'Art Contemporain/Iziko, 2004, 76.

89. Okwui Enwezor ed., 2001, op. cit., 144–45. See Mthethwa's *Untitled* (1996), in Pierre-Laurent Sanner ed., *Eye Africa: African Photography 1840–1998*, Cape Town: South African National Gallery, 1998, 30, and Jan-Erik Lundström and Katarina Pierre, *Democracy's Images: Photography and Visual Art after Apartheid*, Umeå: Bildmuseet, 1998, 82–89.

90. http://www.artnet.com/artwork/424377163, Pep Subirós, *Africas: The Artist and the City*, Barcelona: Centre de Cultura Contemporània, 2001, 201–3, and Frank Herreman ed., *Liberated Voices: Contemporary Art from South Africa*, New York/Munich: The Museum for African Art/Prestel, 1999, 74, 77.

91. Annie E. Coombes, *Visual Culture and Public Memory in a Democratic South Africa*, Durham: Duke University Press, 2003, 189–90. For a general treatment, see Michael Godby, 'The Drama of Choir: Zwelethu Mthethwa's Portraits', *Nka*, 3, Spring/Summer 1999. For 'shackchic', see Sandile Dikeni, *Shackchic: Art and Innovation in South African Shack-Lands*, Cape Town: Quivertree, 2002.

92. Lundström and Pierre, op. cit., 82–83.

93. Seopedi Motau, 'Making an RDP House a Home', in Edgar Pieterse and Frank Meintjies eds, *Voices of the Transition: The Politics, Poetics and Practices of Social Change in South Africa*, Sandown: Heinemann, 2003, 267–70. The date for this series could not be confirmed. See also 'Ruth Motau', in Hug and Vogel, op. cit., 168–71. On hostels, see Glen Elder, *Hostels, Sexuality, and the Apartheid Legacy: Malevolent Geographies*, Athens: Ohio University Press, 2003.

94. Berman, 1993, op. cit., 356. The italicised names are in the original, and refer to works reproduced in the book.

95. See Sue Williamson, op. cit. See also the various references to high art conventions and images in *Images of Defiance: South African Resistance Posters of the 1980s*, Braamfontein: Ravan Press, 1991.

96. After Ainslie and Koloane had attended Triangle New York Workshops at Tony Caro's invitation that year and the year before. The first workshop took place at the Alpha Training Centre in Broederstroom about 15 km from Johannesburg. For further background, see Robert Loder, 'Epilogue', in Jennifer Law ed., *Cross-Currents: Contemporary Art Practice in South Africa. An Exhibition in Two Parts*, Somerset: Atkinson Gallery, 2000. See also http://www.trianglearts.org/europe/southafrica/jburg/ and Robert Loder, 'An International Workshop Movement', in *Persons and Pictures: The Modernist Eye in Africa*, Johannesburg: Newtown Galleries, 1995. For funding, see 'Training Programs: Black Artists', *USSALEP*, 1985 Program Report.

97. We had access to parts of this debate at the time, including most of the essays eventually collected in Russell Ferguson, William Olander, Marcia Tucker and Karen Fiss eds, *Discourses: Conversations in Postmodern Art and Culture*, New York/Cambridge Mass.: The New Museum of Contemporary Art/MIT, 1990.

98. The cover bears the one-word title *Ndebele*, with the full title appearing only inside on the title page. This suggests an entirely appropriate anxiety about the language of 'tribe' and the homogenisation of 'African' cultural practices. Margaret Courtney-Clarke, *Ndebele: The Art of an African Tribe*, London: Thames & Hudson, 2002.

99. See Omar Badsha ed., *South Africa: The Cordoned Heart*, Cape Town: The Gallery Press, 1986, 34–41. The series was finally published as David Goldblatt, *A South African Odyssey: The Transported*, New York: Aperture, 1990.

100. David Goldblatt, 'Foreword', in Courtney-Clarke, op. cit., 13. At the time, Goldberg acknowledges the possibility that 'we in South Africa are obsessed by apartheid and tend to look askance, particularly in the arts, at work that is not in some way relevant to our central concerns. Perhaps I was succumbing to this attitude.'

101. See Colleen McCaul, *Satellite in Revolt. KwaNdebele: An Economic and Political Profile*, Johannesburg: South African Institute of Race Relations, 1987.

102. Goldblatt, in Courtney-Clarke, op. cit., 15.

103. Kenworth Moffett, '[Extract] Post-Colour Field Painting', in *Graham Peacock*, Victoria: Hughes Art, 1986.

104. See Jennifer Law ed., op. cit., 24, 81; Figure 2, David Elliott ed., op. cit., 58; and Figures 22 and 23 in *Persons and Pictures: The Modernist Eye in Africa*, Johannesburg: Newtown Galleries, 1995, 43–44.

105. The pedagogical value of the workshop format impressed David Koloane after his two-year experience at

the University of London. See David Koloane, 'The Thupelo Art Project', in David Elliott ed., op. cit., 84.

106. Graham Peacock, in email correspondence with James Elkins, suggested (not without qualification) that in New New Painting (NNP) 'there is indeed a strong link [between] the NNP and Greenberg': James Elkins, *Master Narratives and Their Discontents*, London: Routledge, 2005, 77. Elkins puts the origins of New New Painting in the early 1990s. He also mentions Kenworth Moffett as being involved in this 'movement' (p.74, note 38).

107. See notice, cover, *Arts Calendar / Kunskalender*, July 1975.

108. 'A Portrait of Clement Greenberg', *Arts Calendar / Kunskalender*, July 1975, 3. Greenberg gave presentations in Pretoria and Cape Town: Susan van Schalkwyk, 'Clement Greenberg and Art Education', *de Arte*, 26, September 1976, 25. See also Clement Greenberg, 'Complaints of an Art Critic', in Charles Harrison and Fred Orton eds, *Modernism, Criticism, Realism: Alternative Contexts for Art*, London: Harper & Row, 1984.

109. 'Seminar with Clement Greenberg at UNISA, Pretoria, July 1975', transcribed and edited by Susan van Schalkwyk, *de Arte*, 26, September 1976, 20.

110. In a bizarre twist, Greenberg actually seems to have inverted the kitsch/avant-garde relation while in South Africa, betraying the aesthetic modernism so dominant here, which owed so much to the man himself. Adjudicating the National Competition, ART – SOUTH AFRICA – TODAY in July 1975, what caught his practiced eye was an assortment of Sunday painters and popular genres, even kitsch wildlife painting! This information comes from a variety of sources involved in the exhibition. See also Esmé Berman, 'Greenberg, The Catalyst', *Arts Calendar / Kunskalender*, September 1975.

111. *S.A. Kunskalender / S.A. Arts Calendar*, 1, 5, June 1976, 10.

112. See Ali Khangela Hlongwane, Sifiso Ndlovu and Mothobi Mutloatse eds, *Soweto '76: Reflections on the Liberation Struggles*, Houghton: Mutloatse Arts Heritage Trust, 2006.

113. See Sophia du Preez, *Avontuur in Angola: Die Verhaal van Suid-Afrika se Soldate in Angola 1975–1976*, Pretoria: J.L. van Schaik, 1989, 144–55 and Hilton Hamann, *Days of the Generals: The Untold Story of South Africa's Apartheid Era Military Generals*, Cape Town: Zebra Press, 2001, 1–45.

114. The sources available at the time were: Max Kozloff, 'American Painting During the Cold War', *Artforum*, 11, 9, May 1973; Eva Cockroft, 'Abstract Expressionism, Weapon of the Cold War', *Artforum*, 12, 10, June 1974; David Shapiro and Cecile Shapiro, 'Abstract Expressionism: The Politics of Apolitical Painting', *Prospects*, 3, 1977; and Serge Guilbaut, *How New York Stole the Idea of Modern Art: Abstract Expressionism, Freedom and the Cold War*, Chicago: University of Chicago Press, 1983.

115. Bill Ainslie, 'An Artists Workshop – Flash in the Pan or a Brick that the Builders Rejected', *Proceedings: The State of Art in South Africa Conference July 1979*, Cape Town: University of Cape Town, 1979, 81–82.

116. See my 'Alternative, Abstract Art? Its All in His Mind', *Weekly Mail*, 23–29 October 1987.

117. David Koloane, 'The Thupelo Art Project', in David Elliott ed., op. cit., 84. In Magnin with Soullilou eds, Koloane mentions Thupelo, and speaks of his paintings of that period as 'largely nonobjective as I experienced various techniques, colours, and formal concerns', op. cit., 146.

118. Sue Williamson, op. cit., 96–97.

119. I am thinking here of Greenberg's characterisation of modernist painting: 'The essence of Modernism lies, as I see it, in the use of characteristic methods of a discipline to criticize the discipline itself, not in order to subvert it but in order to entrench it more firmly in its area of competence.' Clement Greenberg, 'Modernist Painting', in John O'Brian ed., *Clement Greenberg: The Collected Essays and Criticism Volume 4 'Modernism with a Vengeance 1957–1969'*, Chicago: University of Chicago Press, 1993, 60.

120. Avril Herber, *Conversations: Some People, Some Place, Some Time, South Africa*, Johannesburg: Bateleur Press, 1979, 105, 107.

121. David Koloane and Ivor Powell, 'David Koloane and Ivor Powell, in Conversation', in Clémentine Deliss ed., op. cit., 265.

122. As Steinberg observed, '[s]omething happened in painting around 1950 … pictures no longer simulate vertical fields, but opaque flatbed horizontals.' Leo Steinberg, 'Other Criteria', in his *Other Criteria: Confrontations with Twentieth-Century Art*, Oxford: Oxford University Press, 1972, 82–85.

123. 'there is no fact without metaphor, no medium without its being made the vehicle of some sense or other.' T.J. Clarke, 'The Painting of Modern Life', in Francis Frascina and Jonathan Harris eds, *Art in Modern Culture: An Anthology of Critical Texts*, London: Phaidon, 1992, 45–46.

124. See Harold Rosenberg, 'The American Action Painters', in his *The Tradition of the New*, Chicago: University of Chicago Press, 1960, and 'Action Painting: Crisis and Distortion', in his *The Anxious Object*, Chicago: University of Chicago Press, 1966.

125. Susan van Schalkwyk, 'Clement Greenberg and Art Education', op. cit., 23.

126. Koloane and Powell, op. cit., 262.

127. Ivor Powell, '"Us Blacks" – Self-Construction and the Politics of Modernism', in Ricky Burnett ed., *Persons and Pictures: The Modernist Eye in Africa*, Johannesburg: Newtown, 1995, 16. On Polly Street, see Elza Miles,

Polly Street: The Story of an Art Centre, and Johannesburg: The Ampersand Foundation, 2004.
128. Quoted in Miles, ibid., 36–39.
129. As photographer Santu Mofokeng has it: 'oumense, vroumense, kaffirs en kinders'. For an account of the African city and modernism, see Gwendolyn Wright, 'The Ambiguous Modernisms of African Cities', in Enwezor, 2001, op. cit..
130. Miles, op. cit., 50. As Miles explains, 'In a way, Skotnes and his students re-enacted what happened in Europe at the turn of the 20th century. They started on their own doorstep by studying the clay vessels made by the Pedi caretaker's wife and taking rubbings of the designs she had incised on them. Other local designs they studied included Ndebele beadwork and murals, urban murals on shanties in Moroka and Western Township, Shona headrests, Barotse and Tswana carvings and Lesotho clay modeling. Further afield, they paid attention to Ashanti gold weights of which Skotnes made line drawings, masks from the Bateke and Baule as well as carved wooden bowls of the southern Congo.'
131. See his silkscreen work *Liza* (1973) in Lesley Spiro, 'From Karoo Landscapes to Human Mutants', in Kendell Geers, *Contemporary South African Art: The Gencor Collection*, Johannesburg: Jonathan Ball, 1997, 30.
132. Ashraf Jamal, 'Now and Then', in *Norman Catherine: Now and Then*, Johannesburg: Goodman Gallery, 2004, 4. For Walter Battiss, see Andries Oliphant, 'Modernity and Aspects of Africa in the Art of Walter Battiss' and Kathryn Smith, 'Accidental Situationist, or, What Happened When Battiss Thought Out Loud', in *Walter Battiss: Gentle Anarchist*, Johannesburg: Standard Bank Gallery, 2005. For Andrew Verster, see *Mapping Terra Incognita: A Retrospective Exhibition of Work by Andrew Verster from 1957 to 1997*, Durban: Durban Art Gallery, 1997.
133. *Norman Catherine 1986/1987: Recent Paintings, Sculptures and Assemblages*, Hyde Park: The Goodman Gallery, 1987.
134. 'Thomas Kgope: The Ndebele Tradition', in *Revue Noire: South Africa Art & Literature*, 11, December 1993–February 1994, 18–19.
135. Miles, op. cit., 42. The same documentary impulse is present – however unevenly – in works by Gerard Sekoto, for example, *Yellow Houses: A Street in Sophiatown* (1940): figure 162, Sack, 1988, op. cit., 13. George Pemba's work, *No Work* (1948), speaks to a common condition for black workers seeking a livelihood in the cities, while his *The Birth of Site and Service* (1930) presents an early image of the urbanisation of the rural poor. Interestingly, Pemba also illustrated a number of literacy projects and other texts early in his career: Sarah Huddleston, *Against All Odds*, Jeppestown: Jonathan Hall, 1996, 107, 95, 23–24 and *passim*.

136. http://www.trianglearts.org/europe/southafrica/jburg/
137. Samantha James, 'Blacks' first abstract show implies teachers are at fault', *The Star TONIGHT!*, 16 October 1985, 10.
138. See my 'The Double-Agent: Humanism, History, and Allegory in the Art of Durant Sihlali (1939–2004)', *African Arts*, 34, 1, Spring 2006.
139. Charles Baudelaire, 'The Painter of Modern Life', in *Charles Baudelaire: Selected Writings on Art & Artists*, with introduction by P.E. Charvet, Cambridge: Cambridge University Press, 1981, 403.
140. Ibid., 395, 459, note 9. See also my 'Illustration: Antagonising Chauvinisms', *SA Journal of Art & Architectural History*, 3, 1–4, February 1993.
141. Durant Sihlali, *Discovering My True Identity*, Braamfontein: Skotaville, 1989, v–vi.
142. Marc Sarrazin ed., *Durant Sihlali: Mural Retrospective*, Soweto: Alliance Française de Soweto, 1994, 16–18.
143. Ibid., 15.
144. Unpublished interview with the author, 1995 and 2000.
145. Sack, 1988, op. cit., 16.
146. For Esmé Berman, 'township art' was akin to a 'movement' 'characterized by descriptive scenes of animated street activity amid the shanties of sprawling peri-urban African townships': Berman, 1975, op. cit., 243. E.J. de Jager suggests Sihlali 'painted what he knew best, township life … with insight and sensitive attunement' and considers him as 'one of the most successful painters of the township genre'. But de Jager is unable to see more in these works. His insistence on 'faithful recording' suggests, like Berman's 'visual reportage', a certain poverty of approach: E.J. de Jager, *Images of Man; Contemporary South African Black Art and Artists*, Alice: Fort Hare University Press, 1992, 52.
147. Koloane, in Elliott ed., op. cit., 84.
148. Sihlali, op. cit., 15, 20.
149. Unpublished interview with the author, 2000.
150. For a discussion of 'x' see my *Cross-Purposes: Durant Sihlali's Art of Allegory*, Johannesburg: Jonathan Ball, 1997.
151. Unpublished interview with the author, 1996.
152. Mark Gevisser, 'From the Ruins: The Constitution Hill Project', *Public Culture*, 16, 3, 2004, 513. For graffiti in local popular culture, see Nontsikelelo Veleko, 'These Words are Like Words…', *Agenda*, 57, 2003; Tumelo Mosaka, 'Nontsikelelo Veleko', in Sophie Perryer ed., *10 Years 100 Artists: Art in a Democratic South Africa*, Cape Town: Bell Roberts in association with Struik, 2004; and Sandra Klopper, 'Hip-Hop Grafitti Art', in Sarah Nuttall and Cheryl-Ann Michael eds, *Senses of Culture: South African Culture Studies*, Cape Town: Oxford University Press, 2000.
153. Unpublished interview with the author, 1994.
154. Unpublished interview with the author, 1995.

155. Julia Charlton, 'Personal Column: Notes On a Selection of Works from the Gencor Art Collection', in Kendell Geers ed., *Contemporary South African Art: The Gencor Collection*, Johannesburg: Jonathan Ball, 1997, 116.
156. Figure, ibid., 115.
157. Ibid., 114–15.
158. Valmont Lane, 'Whom It May, or May Not, Concern, but to Whom this appeal is Directed Anyway', in Soudien and Meyer eds, op. cit., 4.
159. See Homi K. Bhabha, 'Postmodernism/Postcolonialism', in Robert S. Nelson and Richard Shiff eds, *Critical Terms for Art History*, Chicago: University of Chicago Press, 1996.
160. See Shamil Jeppie, 'Popular Culture and Carnival in Cape Town: the 1940s and 1950s', in Jeppie and Soudien eds, op. cit.
161. Ibid., 28.
162. Ibid., 48.
163. Elliott ed., op. cit., 50; see also Susan Woolf, *Common and Uncommon Ground: South African Art to Atlanta*, Atlanta: City Gallery East, 1996.
164. *Third Text*, 31, Summer 1995.
165. Ibid., 84. The teddy bear in question is a work by French artist Bernard Lavier, *Teddy* (1995).
166. See my 'Secular Sacriledge: The Space of Representation in *Graft*, 2nd Johannesburg Biennale', in Yukiya Kawaguchi and Kenji Yoshida eds, *Representing African Art and Cultures*, Osaka: National Museum of Ethnology, 2005, 41.

75% RED, 20% BLACK AND 5% WHITE: POP AESTHETICS IN POST-REVOLUTIONARY CHINA

MARTINA KÖPPEL-YANG

Everything is beautiful. Pop is everything.[1]

There is in fact no such thing as art for art's sake, art that stands above classes, art that is detached from or independent of politics. Proletarian literature and art are part of the whole proletarian revolutionary cause.[2]

Chairman Mao is the reddest, reddest sun in our hearts.[3]

This chapter starts with three quotations: the first by Andy Warhol, the second from the *Yan'an Talks on Literature and Art* of 1942, and the third is a slogan from the Cultural Revolution. The juxtaposition of these statements, each stemming from disparate periods and contrasting ideological and political backgrounds, may seem incongruous but is indispensable if one is to examine the pop aesthetics that emerged in the People's Republic of China in the 1980s and 1990s.

There are three major reasons why such a juxtaposition of citations from western pop art and from the Chinese revolutionary tradition is plausible. First, such a configuration of signs and stylistic elements from both traditions is evident in the work of the artists who emerged in the 1980s within a decade of the end of the Cultural Revolution, and who were part of a trend referred to as 'new wave' or 'Movement '85'. Second, the Chinese revolutionary tradition played an important role in the creative imagination and practice of those artists who were the main agents in the alternative art scene of the 1980s. Such artists as Wu Shanzhuan and Wang Guangyi grew up during the period of the Cultural Revolution between 1966 and 1976 and were deeply involved in and moulded by China's

revolutionary tradition. In spite of the official condemnation of the Cultural Revolution in the late 1970s, and the often painful experiences and memories of the recent past, it is important to note that, throughout the 1980s and 1990s, the legacy of the Cultural Revolution was not merely a source of negative fixation for Chinese artists. Third, my three citations indicate conceptual and visual affinities between western pop art and Chinese revolutionary and propaganda art. Western pop art fell on fertile ground when it arrived in China through international art journals that Chinese art students studied in the libraries of the art academies. More significantly, with the impact of a large-scale exhibition of Robert Rauschenberg in the National Gallery in Beijing in November 1985, many Chinese artists discerned unexpected conceptual and visual affinities between pop art and their own Chinese revolutionary tradition. Pop art not only provided new insights with regards to artistic practices in a variety of media – such as installation or the use of objects – but also functioned as a kind of cross-cultural catalyst for the revival of revolutionary imagery in the arts and thus inspired the emergence of a 'Chinese-style' of pop with many different individual variants.

Examining the most important of these affinities serves to reveal the individual artists' strategies of translation. To begin with, we can observe the similar claims whereby both pop art and Chinese revolutionary art sought to abolish the categories of 'high' and 'low' in the sphere of visual culture. When translated into the Chinese context, the conception of art that is inspired by popular culture and that employs popular symbols and signs of consumer culture (as exemplified by Warhol) would be equated with the view that 'all our literature and art are

for the masses of the people', hence the western category of 'popular culture' translates in Chinese contexts into the culture of the masses (*qunzhong wenyi*). The idea of the culture of the masses was first conceived by Qu Qiubai, China's leading Marxist literary theorist. To bring together peasants and urban Marxist intellectuals, Qu proposed a mass cultural revolution (*dazhong wenhua geming*). Already in the early 1930s he had tried to create a popular national vernacular language in the so-called rural cultural revolution in Jiangxi. 'Culture of the masses' here included folk art, local operas, folklore and puppet theatre – forms that had been excluded from the national canon of literati culture and of the élite until then. In the 1940s, with the *Yan'an Talks on Literature and Art*, Mao Zedong established the culture of the masses as an integral part of the Chinese Revolution. Evidently, since the early 20th century, the revolutionary tradition had been an important part of Chinese culture and vice versa, for culture played an equally important role in the modern politics of the Chinese Revolution. As the critic Liu Kang points out, 'Cultural and aesthetic forms and their transformation lay at the heart of Mao Zedong's revolutionary vision'.[4] When placed in a historical perspective, the creation of a national art form that sought to reflect the identity of the new People's Republic entailed the 'vernacularisation' of the Chinese form of Marxism, and this 'sinification' of Marxism resulted in the production of revolutionary imagery that was much indebted to Chinese folk traditions. New Year prints provide a good example of this process: acting as 'lucky charms' among the rural population, such mass-produced prints were enriched with the patriotic and revolutionary iconography of

the Communist Party of China since the Yan'an period of the early 1940s.

Relatedly, just as traditional folk imagery infiltrated China's revolutionary culture, so revolutionary imagery permeated the vernacular and entered into the collective consciousness. Mao's strategy of replacing foreign stereotypes with 'the refreshing lively Chinese styles and tunes that are palatable to the tastes and ears of the common folks of China'[5] was a success, when judged within its own terms. The transformation, or translation, of western ideas, art forms and styles into the Chinese context, or sinification, however, did not start with Mao Zedong's ideological and cultural programme. The mutual adaptation of foreign content and autochthonous form (and vice versa) is a constant feature of Chinese culture; one early example is Indian Buddhism and the Chinese form of Buddhism – Chan – that integrated elements of autochthonous Chinese beliefs, such as Daoism. The reception of pop art in the 1980s followed a similar process of sinification: western forms or rhetoric were combined with Chinese content. Western and Chinese concepts merged at a certain point, but a fundamental difference lies in the fact that western popular culture, its practices and theories, are that of a commercial popular culture, while Chinese pop is developed from the revolutionary culture of the masses, just as Liu Kang points out: 'it is this legacy of the culture of the masses that is the radical "other" of China's popular culture'.[6] In China, commercial popular culture and consumer culture only started to play a role in the late 1980s and early 1990s, especially after Deng Xiaoping's legendary journey to the South in 1992 that confirmed the Party's course of a Chinese-style Marxism, hence after the definitive adoption of a market-oriented economic policy.

Furthermore, both the vernacularisation of Marxism – the integration of vernacular and of low culture into the official canon of national culture – as well as the permeation of popular culture with revolutionary imagery, led to the levelling of culture and thus created a kind of consensus culture. As part of the official culture and as a mediator of political discourse, the 'culture of the masses' could not serve to express deviant discourse and thought until the late 1970s and early 1980s, when artistic styles formerly regarded as bourgeois, such as expressionism or abstraction – and in 1980s China such forms were subsumed under the notion 'expression of the self' in contrast to the 'expression of the people' – were gradually integrated into the consensus culture.[7] Only after this point could the foreign rhetoric of western pop art start to act as a necessary tool of divergence and dislocation that allowed artists to express new content and to reinterpret autochthonous concepts. In addition, the integration of popular culture into the official national canon, after the Cultural Revolution, delayed the integration of a new kind of popular culture, that of the emerging consumer culture as well as that of a locally-embedded vernacular, into the alternative art trends of the 1980s. With the wide-ranging social changes brought about by China's subsequent involvement in the global economy, both the emerging consumer culture and the locally-embedded vernacular developed in urban agglomerations such as Beijing, Shanghai and the Pearl River Delta. This new kind of popular culture was already anticipated in artworks of the early 1990s – in cynical realism, political pop, hooligan literature or pop music – and became increasingly important after the mid-1990s. Contemporary artists such as Zheng

Guogu (based in the Pearl River Delta) and Shi Yong (based in Shanghai) produce a kind of pop aesthetic and attitude that reflects the impact of such contemporary materials as fast-paced television commercials and drama serials from Hong Kong. Although such practices fall outside the focus of my analysis, I do, however, give close attention to the strategies of appropriation that preceded them in the 1990s.

A second important affinity between western pop art and Chinese revolutionary art concerns the aspiration to abolish the aesthetic distanceof art and everyday life. While this was evident in Warhol's artistic production, when translated into the Chinese context, the goal of merging art and life can be seen to underpin the view that, 'artists have to study and to authentically reflect the life of the people', a maxim that goes back to the *Yan'an Talks on Literature and Art*.[8] Here Mao claimed that 'Chinese artists and writers must go among the masses of workers, peasants, and soldiers [...], they must go to the sole, the broadest, and richest source, to observe, experience, study, and analyse all the different kinds of people'. Nevertheless, in terms of reflection theory, the reflection of the life of the people had to be made not through 'art in its natural form',[9] but through a processed literature and art that aspired to depict the life of the people on a higher, idealised, more typical and universal level. This kind of processing implies the application of a socialist world-view that guarantees an authentic reflection of reality (*zhenshi de fanying xianshi*). This concern with the 'authentic reflection of reality' was further developed in the aesthetic theory of the People's Republic, where it was strongly contrasted with the 'subjective reflection of reality' that could not be authentic

Shen Raoyi,
Portraits of Mao Zedong,
c.1965

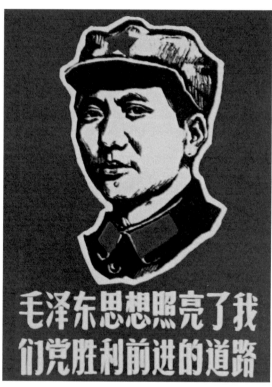

if the dialectical pair – expression of the people (*biaoxian renmin*) and expression of the self (*biaoxian ziwo*) – was imbalanced. Authenticity remained a key issue in Chinese art criticism until the late 1980s, as it was identified with a 'correct' ideological vision and thus actually meant ideological authenticity. Its counterpart, subjective perception and expression, which was understood as a manifestation of a bourgeois consciousness, was also, however, the focus of western artists, such as Warhol, who trieto subvert romantic-modernist notions of authenticity and individuality through the use of media such as photography, which were mechanical, reproducible and indelibly tainted with mass culture and industrial production. Despite the extreme contrast in social context, it is important to observe that the 'authenticity' in question here is that of an individual subjective authenticity.[10]

A third area of similarity is the iconoclastic stance both of pop art and of the art of the Cultural Revolution where the latter took the attitude that 'revolt is reasonable' (*zaofan you li*), which was a common slogan during the Cultural Revolution. This critical or rebellious stance informed the kind of collective spirit that still acts as a dynamic factor in Chinese art today. At the level of formal analysis, I would add that the aesthetic emphasis which western pop gave to the frontal presentation and flatness of unmodulated and unmixed colour that was bound by hard edges, also appears as a distinct feature of Chinese propaganda painting, which adapted elements of flatness and frontal presentation from traditional Chinese New Year prints. As well as the repetition of pattern and signs, these formal similarities suggest a 'depersonalised' process of mass production.

In this respect, the serial aspect of mass production as a means of artistic creation aims at the elimination of the notion of subjectivity and of individual creativity and expression, which is another perhaps unexpected area of overlap between western pop and Chinese propaganda art of the 1960s and 1970s.

Having identified so many similarities, I nevertheless want to point out one fundamental difference. Whereas the assimilation of folk art elements and visual idioms from everyday life into Chinese propaganda art was part of the implementation of art for political aims, and thus confirmed the 'official' status quo, the assimilation of popular culture in western pop art was highly subversive and questioned the political status quo in western societies. However, this important difference became modified in the period of opening that created a climate of relative liberalism in China during the 1980s. With the ending of the Cultural Revolution – as confirmed by the approval of Deng Xiaoping's reform policy at the Third Plenary Session of the XI Central Committee in December 1978 – China's tradition of revolutionary imagery was seen as 'outmoded'. The image of Mao as 'the reddest sun in our hearts', that is evoked in my third epigraph, thus underwent a semiotic transformation for it came to be seen as a kind of popular myth, and once such imagery was no longer felt to be contemporary with China's changing economic and political realities, the entire tradition of revolutionary art became a pool of images and idioms ready for artistic assimilation, deconstruction and appropriation.

Surveying the artistic landscape in the period after the official ending of the Cultural Revolution, we can identify assimilation, deconstruction and appropriation as the three primary strategies

whereby Chinese artists sought to transform source materials derived from earlier traditions. Where 'assimilation' refers to approaches adopted by artists during the late 1970s and early 1980s who automatically employed the aesthetic principles and practices of the Cultural Revolution, despite their desire to overcome the limitations of this world-view, my analysis focuses on methods of deconstruction and appropriation that emerged in the late 1980s and early 1990s for they reveal a range of local and global factors that Chinese artists have negotiated in seeking to create an 'alternative' space for critical artistic intervention.

Taking a close look at Wu Shanzhuan's *Red Humor – Red Characters, 75% Red, 20% Black and 5% White* (1987) and at Wang Guangyi's *Mao Zedong – Black Grid* (1988), this chapter first examines the deconstructive strategies that articulate a position of cultural critique. Like their fellow contemporaries since the mid-1980s, including Gu Wenda, Huang Yongping and Xu Bing, these artists have developed strategies oriented towards a deconstruction of everyday cultural icons and signifiers – from the image of Mao Zedong to the Chinese script, which was traditionally a symbol of political power and the main vehicle of political agitation during the Cultural Revolution – and each of their artistic strategies demonstrates a critical distrust in culture as an 'official' system of meanings. However, instead of simply rejecting the legacy of the Cultural Revolution, such artists have expressed fearless critiques of imposed patterns and structures in cultural life that not only reveal their shared generational background in the era of the Cultural Revolution, but also demonstrate their on-going conviction that revolt is reasonable (*zaofan youli*). By employing

deconstructive strategies in relation to material associated with the recent past, such artists combat like-with-like in order to free Chinese visual culture from redundancy and their strategies propose instead a critical aesthetic of semantic emptiness.

Once the icons and imagery of the Cultural Revolution were emptied of meaning, artists of the 1990s found themselves free to employ them in alternative ways that proposed new readings of familiar visual signs. Building on the work of forerunners such as Zhang Peili and Geng Jianyi, the artistic strategy of appropriation critically engaged with the signifiers of China's newly emerging consumer society alongside the legacy of the Cultural Revolution. Where appropriation is one step in the formation of a new cultural self-consciousness among Chinese artists of the 1990s, who now faced the challenges of dealing with the international art market, the visual repertoire of the overall artistic landscape also gave rise to 'cynical realism' and 'political pop', and it is in this context that I present a detailed analysis of works by Wang Guangyi.

Deconstruction
Choosing the distribution of colour used in the 'big character posters' (*dazibao*) associated with the Cultural Revolution, Wu Shanzhuan's installation *Red Humor – Red Characters, 75% Red, 20% Black and 5% White (Hongse youmochi zi)* (1987) creates a scenario in which scripted political slogans are omnipresent. The installation's distortion of the scripted characters appears to be similar to the writing of the Cultural Revolution, but certain strokes are omitted and complicated characters are replaced by simpler homonymous ones. In any case, the writings represented in the installation are a nonsense

Wu Shanzhuan,
*Red Humor – Red
Characters, 75% Red,
20% Black and 5% White
(Hongse youmochi zi)*,
1987

medley of single characters, excerpts from classical poetry, slogans and price notices, advertising captions, painting titles, jokes and vernacular phrases, which the artist chose at random with the help of some friends. The juxtaposition of incoherent sentences and the disruption of signs from their original context cause a loss of meaning: the writings deteriorate into meaningless inscriptions as the signifier loses the signified, and this strategy generates the semantic emptiness of the text as a whole. The combination of influences from the Cultural Revolution and from pop art is evident in the prescribed distribution of red, black and white colours and in the technique that employs ink and poster paints on paper, while the process of creating the installation itself, in which the artist invited ordinary people to participate in the choice of slogans, is a kind of combine.

As well as the effect of semantic emptiness, this installation shows how Wu's critique of culture is further articulated through the deconstruction of the Chinese script itself, which is the epitome of culture and power in official discourse. Bearing in mind how the big character posters of the Cultural Revolution were an important reference point, we can find all kinds of deconstructive effects in Wu's handling of the Chinese script: characters are misspelled or simplified, strokes are omitted, complicated characters are replaced through simpler homonymous ones, words are scribbled out, some are turned upside-down to express disapproval, important or dramatic passages are underlined, and when certain signs are crossed out, often in red, this is taken to signify the expression of political disgrace.[11] Moreover, all of the scripted elements are grouped around a central sentence –'No one can interpret it

(*wu ren shuo dao*)' – which self-reflexively foregrounds Wu's working method of juxtaposing contradictory and unrelated sentences from diverse domains: 'This afternoon no water', for example, or, 'The Last Supper'.

Viewed from a cross-cultural perspective, Wu's meaningless assemblage thus recalls aspects of Chan Buddhists' koans (epigrams) as well as Dadaist language games.[12] The character 'red (*chi*)' that features in the title also signifies 'deficit (*kuikong*)', thus implicitly attributing a degree of semantic emptiness to the big character posters themselves.[13] As the writings do not transmit any intelligible meaning, all that is left is their pragmatic dimension as a means of 'circulation of social discourse'.[14] Since the circulation of social and political discourse is also directly related to the style and aesthetic appearance of the Chinese script, the viewer is confronted with a paradox. The aesthetic appearance of the writing – that of propaganda art, and the Cultural Revolution in particular – connotes a context that is contradicted or annihilated by Wu's nonsense characters and sentences, which imply that such a context no longer exists. Thus Wu's writing is already generated into a myth. With an artistic strategy similar to Huang Yongping and Wang Guangyi, Barthes' notion of myth comes into play: the empty signifiers can be endowed with new meaning and therefore appear completely relative. As Huang wrote in 1989: 'The only thing we can do is to change old and new myths into a completely empty signifier.'[15]

Taking Wu's related installation into account, *Red Humor Series 2 – Red Stamps* (*Hongse youmo xilie zhi er – chi yin*) (1987), I would suggest that his deconstructive strategy with regard to the use of Chinese script is similar to

the use of comic strip 'thought balloons' and other fragments of advertising script in American pop art. Wu makes his commentary on society by using the very images that helped to create that society, which is similar to practices in western pop art but which also shows the influence of Cultural Revolution practices on Wu, such as the notion of fighting like-with-like.

Describing his concept for this body of work in the following statement, it is clear that for Wu the Chinese script is equated with Chinese culture: 'Culture is a kind of sign, characters are signs that express a sign. They are the last strongholds of culture. [...] We use 75% red, 20% black, 5% white. Regular bold print characters are our expression, to have no expression is the best expression.'[16] This outlook is echoed by critic Gao Minglu, who argues that, 'The appearance of the characters is the appearance of culture. The critique of the characters is the critique of the culture, the reorganization of the characters is the reorganization of the culture.'[17] Wu Shanzhuan's method of employing distorted signs and senseless sentences thus reveals the 'redundancy' of the Chinese written language, which was given prominence in both the Cultural Revolution and in the many theory-laden works produced during 'Movement '85' (where the integration of diverse concepts and theories in one work of art and the over-interpretation of the artworks was a frequent tendency). Redundancy here refers to the repetitive quality of Chinese script, which can – by its structure – be conceived as a modular system par excellence. When used as societal agent, as a vehicle of political agitation and, above all, as an instrument of cultural hegemony, this modular system unfolds its normative characteristics.[18] The semantic emptiness generated by Wu is therefore not only

to be read as a vehement cultural critique, but is also a means of reflecting upon the 'subject's place in discursive regimes' and 'the operation of power within individual subjects'.[19]

The artist refers to the absurdity of his works by evoking what he calls 'serious absurdity' (*yansu de huangdan*). Alluding to his critical distance from societal norms, as well as the inflammatory and subversive attitude with which the Red Guards set out to fight institutionalised thought – which is similar to pop's critique of western bourgeois society – he also calls the humour, with which he paraphrases Chinese culture and society, 'red humour'. Re-enacting propaganda practices of the Cultural Revolution, Wu's 'serious absurdity' is a paradoxical notion as such, for it further incorporates the practice of combating like-with-like. The alignment of the notion of seriousness, standing for the signified, and of absurdity, standing for the loss of the signified, defines the paradox of 'serious absurdity' as an important critical intervention in the politics of language, as can be seen from the reception of Wu's installations.

The unique ideographic nature of the Chinese characters and the central position of writing in Chinese history and politics explain the vehement official reactions to artworks concerned with the deconstruction of the Chinese script. Generally, these works were criticised as nihilist by the official side. Where language is regarded as the epitome of Chinese culture and the medium of the transmission of orthodox thought, the distortion of its signifiers was unacceptable and could only be understood as a mockery of the official ideology and world-view. The illegibility of Wu Shanzhuan's characters was thus considered the expression of extreme subjectivism, and hence of

Wang Guangyi,
Mao Zedong – Black Grid,
1988

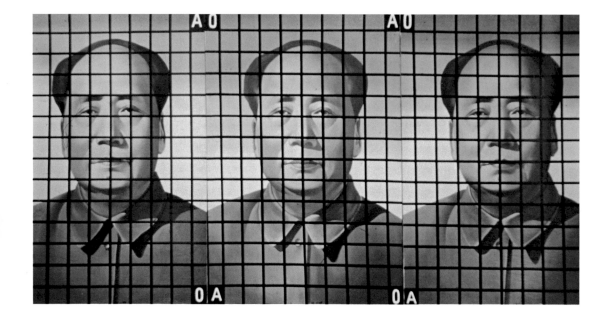

bourgeois liberalism. The response of the general public was ambivalent. Viewers often reacted in a way that was contrary to the artist's hopes, and rather than accept the illegibility of the characters, they tried to read them by forcing them into intelligibility. Audiences were not used to seeing scripted characters reminiscent of big character posters in an art exhibition, although in the case of *Red Humor* it seemed that many were especially interested in the 'serious absurdity' generated through Wu's transformations and juxtapositions and accordingly joined in what they considered to be a language game.

Wang Guangyi used a similarly deconstructive strategy in his painting, *Mao Zedong – Black Grid* (1988), which makes a commentary on society again by using the very images that helped to foster that society. *Mao Zedong – Black Grid* consists of three nearly identical copies of the standard photographic portrait (*biaozhun xiang*) of Mao Zedong that circulated widely during the Cultural Revolution. Superimposing a regular black grid onto the pictorial surface of the portrait, Wang has added the letters 'O' and 'A' in white paint, which are placed in the corners of the painting. As a result of these modifications, the well-known portrait of Mao, now reproduced in grey scale and coming into sight behind a grid, appears strange – Mao's familiar smiling face has turned into a stiff, expressionless mask. This effect of estrangement is underlined by the way that the artist did not explain the exact meaning of the letters 'O' and 'A', although they could be merely designations in a coordinate system.[20]

Mao Zedong – Black Grid is linked to Wang Guangyi's slogan – 'Liquidate humanist enthusiasm' (*Qingli renwen reqing*) – that he formulated at the Huangshan Symposium in

1988. He subsequently reformulated his thoughts in an article entitled 'On Liquidating Humanist Enthusiasm', published in 1990.[21] The slogan expressed a prevalent sentiment among the avant-garde artists in the second half of the 1980s for it acted as a call for the change of paradigms. The humanist attitude, which Wang refers to as 'humanist enthusiasm', was considered to be an obstacle to the overcoming of normative patterns when such attitudes became adopted as part of the official discourse of the so-called modern consciousness (reform consciousness). In addition to his slogan, Wang Guangyi produced a new series of paintings, of which *Mao Zedong – Black Grid* is representative, and which also included a triptych that was shown in the exhibition *China Avant-Garde* in the National Gallery in Beijing in February 1989. In this setting, Wang's provocative stance became a focus for participating art critics and artists: even before the exhibition had opened, Wang's deconstruction of the standard portraits of Mao Zedong had caused a sensation.[22]

Both the public and the official critique reacted to the distance between Mao and the viewer created by the grid and considered the work a critical rendering of the historical figure. Articles reflecting public opinion were published in the major daily newspapers. The official critique focused primarily on the grid and the letters. To obtain permission to exhibit the paintings, Wang was obliged to write a declaration in Chinese and English stating his respect for Mao Zedong. This declaration was to be placed next to the painting. Wang Guangyi also was required to do a little retouching: he had to change the letters 'A' and 'O'. The official side claimed that the letters' meaning was indistinct, and that they put one in mind of a current joke with the title

'I am not AQ; I am AO'. Wang therefore added some black paint and turned the 'O' into a 'C'.[23]

Aware that his series *Mao Zedong – Black Grid* would be politically explosive, it is important to bear in mind that Wang's decisions regarding subject matter and painterly process were neither arbitrary nor speculative. On the one hand, the subject was chosen as a critical response to the prevailing Mao Fever (*Mao Zedong re*) of the late 1980s – the quasi-religious worship of the image of Mao Zedong and its commercial ramifications. On the other hand, despite the paradoxical outcome that Wang describes, we can also see that his deconstructive method of painting was employed as part of his strategy to initiate a change of paradigms in the field of Chinese avant-garde art. Reflecting on the public reception of his 1989 exhibition, the artist has stated that: 'My original intention was to provide, through the creation of the *Mao Zedong* [paintings], a basic method for the liquidation of humanist enthusiasm, but after it had been exhibited in the *Modern Chinese Art* exhibition [i.e. the *China Avant-Garde* exhibition] the onlookers, with hundredfold humanist enthusiasm, endowed *Mao Zedong* with even more humanist connotations.'[24]

For Wang Guangyi, humanist enthusiasm comprised two elements: the dominance of the aesthetic and conceptual principles of western modernity and classicism (beginning with the Renaissance), and the belief in the indivisible union of the individual and his or her feelings. His critical campaign therefore was directed against the tradition of western modernity, which according to him had developed in the light of humanism. Wang argued that this tradition and its metaphysical concepts amounted to a myth, which, in his view, had, 'totally penetrated artistic creation and appreciation and dominated the Chinese art scene'.[25] To overcome the myth of 'humanist enthusiasm', as well as the linguistic, aesthetic and conceptual limits of the Chinese alternative art scene that developed alongside the 'modern consciousness' associated with official reforms, Wang proposed a revision of cultural schemata that was inspired by Gombrich's concept of schema and correction. Gombrich's *Art and Illusion* had been translated in 1986–87 by Fan Jingzhong, then a teacher at the China Academy of Fine Arts.[26] Fan was also the editor-in-chief of the Academy's magazine, *Compilations of Translations in Art* (*Meishu yicong*), and had published several translations of Gombrich's works in this magazine. Gombrich's theories had a great influence on the Chinese avant-garde of the 1980s, and are particularly evident in the works of students of the China Academy of Fine Arts in Hangzhou, for example Huang Yongping, Wu Shanzhuan and Wang Guangyi.

The concept of modern consciousness (*xiandai yishi*) was the official guiding principle for the modern national culture of Deng Xioaping's reformed China throughout the 1980s. The concept had been formulated at the Third Plenary Session of the XI Central Committee in 1978, and designated a self-reflective consciousness and reform consciousness (emphasising change and progress) that had been adopted in the art world in the early 1980s. Deng Xiaoping's slogans, 'Let a hundred flowers bloom' and 'Liberate your thinking', invited Chinese intellectuals to participate in this project. Facing the opening to the West and the Party's programme of modernisation, the primary task for artists and intellectuals was to redefine the nature of a modern Chinese cultural

identity. And indeed, for a while, the utopian concepts advocated by artists and intellectuals closely coexisted with the official ideology of modernisation. It was this utopian and humanist attitude, as well as the mythification of the notion of modernity, that situated the artists close to the official programme of modernisation. Nevertheless, the understanding of modern consciousness evolved over time and official rectifications were undertaken, such as the campaign against Spiritual Pollution in 1983–84, and again in late 1987.

Wang's revision of cultural schemata is to be seen therefore as an attempt to make visible, and to break away from, this new cultural hegemony that slowly came into force. To carry out his revision, Wang employed two methods. First, the 'objectification' of the subject of the painting – Mao Zedong – through the choice of the colour grey, the use of flat and unmodulated colours, and through the superimposition of a regular black grid. The grid creates a distance between the viewer and the painting, and also serves as a gauge or an analytical framework that liberates the artist's perception from subjective expectations and hence from the realm of individual emotions. The process of objectification performed in the painting thus permits the recognition of the representation of its subject that has been laid bare of any connotations. As Gombrich put it: 'But is this not precisely what Ruskin wants the artist to do in front of his motif? To empty the prospect of meaning in order to see it for what it is?'.[27] Second, *Mao Zedong – Black Grid* is a stylistic résumé of Wang's earlier paintings, the so-called rational paintings, which started with the series *Frozen North Pole* (1984–85) and extended to his *Post-classical* series (1986–87) which had

been created in the light of the artist's developing critique of humanist enthusiasm. In this respect, the black grid, which also features prominently in Wang's series *Black Reason* and *Red Reason* (1987–89), connotes the mind-set of rationalism *per se* or, as Wang put it, 'a positive force that signifies the negation of bad elements within cultural history'.[28]

Rather than a critical statement about the historical figure of Mao Zedong himself, it is crucial to understand that *Mao Zedong – Black Grid* is a provocative comment on the prevailing cultural climate of the late 1980s. In this respect, the target of the artist's critique is the irrational and quasi-religious worship of political leaders. Such populist worship had once made Mao the icon of the People's Republic and it was this tendency that was revived by 'Mao Fever' in the late 1980s. As writer Lü Peng relates: 'The modern myth created by Mao Zedong once again made him a trans-historical, political and cultural factor throughout 1988 and early 1989. [...] The image of Mao Zedong, including all its social, economical, political, and cultural connotations, again exerted a general influence on the people.'[29] Taking Mao's iconic status into account – during the political and economic uncertainties of the late 1980s when the Communist block faced numerous global challenges – I would argue that Wang Guangyi's strategy was actually quite similar to Warhol's use of idols such as Mickey Mouse, Marilyn Monroe or Mick Jagger: for with the iconic portrait of Mao as his source material, Wang deconstructed a popular symbol that shapes the common unconsciousness. In this regard, *Mao Zedong – Black Grid* and *Mao Zedong – Red Grid* (*Mao Zedong – hongge*) (1988) evoke Warhol's ambiguous portraits of superstars.

Wang Guangyi's interest in American pop aesthetics informs in the way he took Mao Fever as a subject into the domain of contemporary art but, in contrast to Warhol, Wang's intention was less the integration of popular images into high art but rather the revision of a political icon that embodies an 'outmoded' social and cultural tendency.

Seen in this perspective, Wang associates the myth of 'Mao Zedong' with myths established by cultural schemata, and he deconstructs the excess of meaning involved in such myths by confronting the icon with the semantic emptiness of subordinate signs. Wang's painting is built up from individual squares of colour, marked by the lines of the grid. Because the effect of the grid is to give equal weight to each square as a signifier, the result creates an effect of semantic emptiness, which can also be seen as a refusal of socialist realist art and propaganda art, whose narrative mythologies and cultural schemata are also made redundant. Finally, the ensemble of these squares, of which the portrait of Mao is composed, does not add up to an iconic 'wholeness', but rather lays bare the mere representation of a historical figure who has been passed by. In fact, the grey scale portrait recalls photographs of the deceased as they are used in Chinese funeral ceremonies and published in obituaries. Such signs are derived signs, the artist seems to imply, and they refer to the representation of a reality that exists only as a myth. By drawing attention to the combination of signifying elements involved in his painterly deconstruction of Mao's portrait, the referential aspect of signification is displaced by a politics of representation in which the viewer starts to question perception and reality.

Where the famous portrait had became an archetype in the collective consciousness of Chinese society, and had degenerated into a consumer item during the nostalgic moment of Mao Fever, we can see that this archetype nonetheless moulds and shapes social and cultural reality. By replacing the icon that embodies the 'myth' of Mao Zedong with a painting that stages the critical re-presentation of the icon, one might say that Wang's deconstructive strategy – achieved through objectification and the use of the grid – actively demystifies the cultural schema of the official discourse that was dominant in the late 1980s.

Appropriation

Mao Zedong – Black Grid became a kind of reference work for political pop and cynical realism as two major tendencies to emerge in the 1990s. On a conceptual level, Wang's outlook anticipates the dystopic attitude and cynical distance that replaced the utopias of humanist enthusiasm and the cultural euphoria of the 1980s. In this respect, Wang Guangyi can be considered the father of Chinese pop art and a central figure in contemporary Chinese art of the early 1990s. The second campaign against Spiritual Pollution in 1987 had clearly shown that the ideal of the Chinese intellectuals of the 1980s, namely the productive dialogue between intellectuals and government, had been only a farce. Artists and intellectuals became aware that they were excluded from any actual influence on the country's modernisation. What some had already guessed in 1987 became a dramatic reality with the Tian'anmen massacre of June 1989. Artistic creation in the early 1990s was thus impregnated by cynicism, which found its expression in the so-called hooligan literature, in rock music and the painting styles of cynical realism and political pop, a notion coined by art

critic Li Xianting in 1990.[30] Cynical realism and political pop were first mainly practiced by the young generation of art school graduates – in particular graduates from the Central Fine Arts Academy in Beijing – and by some veterans of the '85 movement, for example Wang Guangyi, or Shanghai-based Li Shan and Yu Youhan.

The cultural climate following 4 June 1989 was tense. Nevertheless, throughout 1990 and 1991 several exhibitions of young artists of the so-called new generation were held in official institutions, such as the Gallery of the Central Fine Arts Academy and the Chinese History Museum in Beijing.[31] The style represented was a combination of academism with pop and cynical elements. Under tense political circumstances, the Chinese government voted for reconciliation with the intellectuals and admitted that 'cynicism' was an outlet for the prevailing pessimistic mood and a means of expressing criticism of the government and the Communist Party. On 1 March 1991, Party General Secretary, Jiang Zemin, stated in a speech made on the occasion of a meeting with 40 leading cultural figures that 'comradely and well-intentioned criticism and self-criticism' should be encouraged.[32] Finally, the end of the period of extreme political conservatism and restriction was marked by new guidelines aimed at the re-construction of the so-called Chinese-style socialism into a market-oriented socialist system, and Deng Xiaoping's symbolic *Journey to the South* in 1992. As in the late 1970s, the development of the country once again entailed its economical and political opening to the West and the participation of intellectuals in the official project was indispensable. The government continued a policy of détente and its tolerance of superficially critical styles such as cynical realism

and political pop was a strategic step in an attempt to regain face. Numerous exhibitions held abroad, organised by western art galleries or museums that preferred to present these new artistic styles, further helped the Chinese government to regain face internationally. Cynical realism and political pop indeed shaped the cultural image of China in the 1990s to such an extent that the majority of western audiences considered them to be the embodiment of contemporary Chinese art. In addition, the move to a market-oriented society, and the success of these trends on the international art market, brought the official discourse and part of the alternative art scene into line, as did the attempt to create an inner-Chinese art market during this period.[33]

Cynical realism and political pop incorporated the signs of the new consumer society – as well as those of the old Communist China – in their artistic repertory and thus helped to reflect the identity of the new China characterised by a liberal and pluralist consumerism. The influence of the international art market and the taste of an international art public became increasingly important factors within the inner workings of the Chinese art scene. The task for the artists was thus double-edged: on the one hand, they had to relocate their position as artists in a market-oriented art scene, and, on the other hand, they had to redefine their identity as Chinese artists working in a global environment. The appropriation of 'typical' Chinese imagery seemed to be one appropriate strategy.

Political pop and cynical realism therefore adopted imagery that stemmed mainly from the visual culture of the Cultural Revolution and the image of Mao was especially popular. The Mao Fever (*Mao Zedong re*) of the early 1990s further

Wang Guangyi,
Great Criticism – Coca Cola,
1992

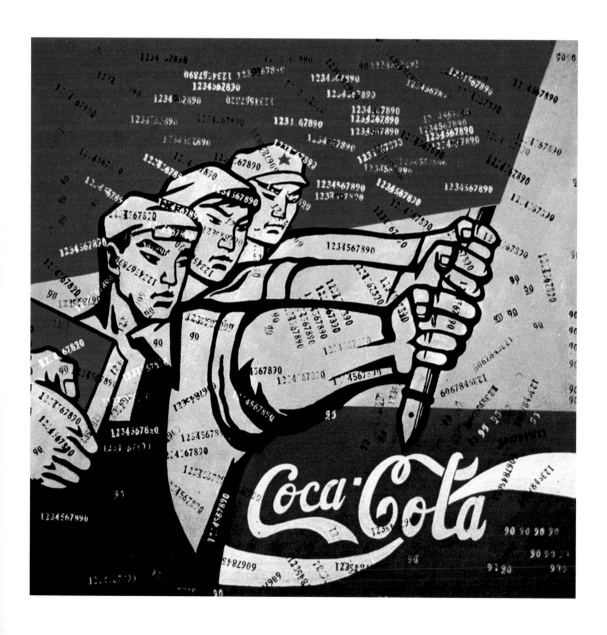

enhanced this approach. Often found among the repertory of elements are the collage-like combinations of syntactic elements of pop art, characterised by bright flat colours, alongside aspects of New Year prints that feature black or grey outlines and the repetition of decorative elements, as well as the imagery of the Cultural Revolution, such as the representation of revolutionary heroes with signs of the new emerging consumer society, including brand names. This scheme is visible in paintings such as *Mao Zedong at Tian'anmen* (1990) by Yu Youhan, or in Wang Guangyi's series *The Great Critisim* (1990 and ongoing), and again the Luo Brothers' *Welcome to the World's Famous Brand Series* (1997 and ongoing). In *Great Criticism – Coca Cola* (1992), Wang combines the traditionally codified representation of the three classes – soldiers, peasants and workers – with the brand name 'Coca Cola' using bold black outlines and a distribution of colours, both of which are reminiscent of propaganda posters. As with *Mao Zedong – Black Grid*, Wang expresses his concept of criticism through the use of a regular black grid and a series of numbers that are arbitrarily printed on the painting. Indeed, looking at Wang's *Great Criticism* series as a whole, from 1990 through to the 2000s, it reads like a critical report on the economic policy of Chinese society after 1992, as the works record the arrival of different corporate brands into the domestic market and even acknowledge China's entry into the World Trade Organisation in 2001. The overlapping of such disparate traditions – the autochthonous revolutionary tradition and the imported tradition of consumer culture – that is evident in Wang's painting exemplifies the strategy of appropriation: the free reintegration of concepts, visual patterns and idioms that

were already emptied of their original meaning through deconstructive strategies, or through the course of history, and which are now revealed to be nothing more than a myth, in Barthes' sense of the term. Western pop, China's revolutionary mass culture and global consumer culture are now employed as equal terms, showing that the artistic attempt to digest the recent past through assimilation – in the art of the late 1970s – and to surmount western modernism – through deconstruction in the 1980s – were successful. Ultimately, the appropriation of the imagery of the Cultural Revolution, of pop, and of signs of consumer culture in the 1990s, can be read as an articulation of the quest to relocate Chinese art and culture as post-modern. As I have shown above, western pop art functioned as a catalyst in the complex transformations of the 1980s and 1990s.

Conclusion

The appropriation of visual idioms and stylistic elements from the art of the Cultural Revolution and from western pop not only shaped alternative Chinese art and Chinese 'modernity' from the 1980s to the mid-1990s, but also aesthetically prepared the coming into effect of post-modernism in the 1990s. The notion of post-modernity arrived in China in the mid-1980s, in particular with the reception of Jameson and Habermas who both gave lectures in China (in 1985 and 1988 respectively), and who were readily received by intellectuals and artists, such as Huang Yongping. Huang had published a text entitled 'Xiamen Dada, a Kind of Postmodernity' in 1986.[34] Nevertheless, the shift from a culture based on a modern consciousness to one referring to post-modernity could only take place after a change in the official

guidelines. Once Chinese policy sought to enter the international community on an equal footing – 'to join the world' as a common slogan of the early 1990s announced – by seeking entrance to the WTO, for example, the official guiding principle became that of the realisation of a pluralist Chinese society, which meant that here 'postmodernity and postmodernism therefore is a state project'.[35]

As Zhang Xudong and Arif Dirlik have suggested, 'in China in the 1980s, the issue of postmodernism first emerged not as a theoretical challenge but as an aesthetic expectation'. According to their view, 'this observation, […] should open up discussions of the historical and theoretical implications of the expectation for a *houxiandai zhuyi* (postmodernism) as a self-fulfilling prophesy and should unravel the aesthetic complex that becomes the surest sign, indeed a conspicuous stage, of the change of economic, social, political and cultural relations in post-Mao China.'[36] If, as they claim, Chinese post-modernity should 'be grasped not only in its relationship to modernity in general but also in its relationship to a socialist and revolutionary modernity'[37] – since Chinese society experienced modernity as the history of revolution – then the aesthetic appropriation of the revolutionary legacy provides this kind of 'surest sign' that rings in the enormous changes to be found in post-Mao China. Further, as we have seen in examining the work of Wu Shanzhuan and Wang Guangyi, such contemporary artists felt that the aesthetics, imagery and visual culture of their revolutionary tradition, being evocative of a socialist society that at an earlier stage was a challenge to the capitalist world-system, could provide critical potential for commentary on the contemporary culture of a market-oriented China with her emerging consumer society. The contradiction inherent in the official claim of adhering to the socialist tradition while driving the country into a high-speed economic development and a kind of 'Manchester-capitalism' is reflected in the appropriation of signs from these disparate domains in political pop and cynical realism. While Chinese post-modernism may be 'most striking as an antirevolutionary repudiation of a socialist modernity',[38] as claimed by Dirlik and Zhang, in the domain of the visual arts, it nevertheless embraces the socialist and revolutionary tradition on an aesthetic and conceptual level. The reception of western pop created the necessary dislocation that allowed the artistic reinterpretation of the revolutionary tradition as a critical tool.

NOTES

1. Andy Warhol (1958), here cited from, www.artlex.com/ArtLex/p/popart.html.
2. Bonnie S. McDougall, *Mao Zedong's Talks at the Yan'an Conference on Literature and Art*, University of Michigan, 1980, 75.
3. Slogan of the Cultural Revolution (1966–1976).
4. Liu Kang, 'Popular Culture and the Culture of the Masses', in Arif Dirlik/Zhang Xudong eds, *boundary 2, an international journal of literature and culture*, 24, 3, Fall 1997, 110–11.
5. Mao Zedong: 'Lun xin jieduan', in Takeuchi Minoru ed., *Mao Zedong ji*, 6, Hong Kong: Po Wen Book Co., 1976, 260–61.
6. Liu Kang, op. cit., 102.
7. One exception is the hand-copied entertainment fiction circulated among the population during the Cultural Revolution. See Perry Link, 'Hand-copied Entertainment Fiction from the Cultural Revolution', in Perry Link ed., *Unofficial China, Popular Culture and Thought in the People's Republic*, San Francisco and London: Westview Press, 1989, 17–37.
8. Here cited from McDougall, op. cit., 69–70.
9. McDougall, op. cit., 70.
10. One could understand the claim for the abolishment of an aesthetic distance of life and art as the aestheticisation of politics, society and everyday life, evident in concept and practice of the Cultural Revolution. One could even think of this decade as an overall artistic performance, or Gesamtkunstwerk and social sculpture in the sense of Joseph Beuys.
11. The distortion of language, as well as the revision, simplification and misspelling of the characters, is a common practice in the course of political campaigns; the Cultural Revolution being the most recent and most violent one. See also Francesca Dal Lago, 'Images, Words and Violence: Cultural Revolutionary Influences on Chinese Avant-Garde Art', in Chinese-art.com, online magazine, 3, 4, 2000.
12. For the conceptual and aesthetic equation of western art trends and concepts with native Chinese concepts, see my *Semiotic Warfare: The Chinese Avant-Garde, 1979–1989. A Semiotic Analysis*, Hong Kong: Timezone8, 2003, 132–51.
13. Wu Shanzhuan describes this installation in 'The Emergence of the Red Characters (*Chi zi de dansheng*)', unpublished manuscript. See also Gao Minglu, *Zhongguo dangdai meishu shi 1985–1986*, Shanghai: Shanghai People's Publishing House, 1991, 203.
14. N. Bryson, 'The Post-Ideological Avant-Garde', in Gao Minglu ed., *Inside Out, New Chinese Art*, Berkeley/Los Angeles/London: University of California Press, 1998, 55.
15. Huang Yongping, '*Wanquan kongde nengzhi* ', in *Meishu (Art)*, 1989, 3, 32.

16. Wu Shanzhuan, 'Process and people, work of art, numbers and characters', unpublished manuscript. Citation from Gao Minglu, *Zhongguo dangdai meishu shi 1985–1986*, Shanghai: Shanghai People's Publishing House, 1991, 191–92. See also *Zhongguo meishubao* (*Fine Arts in China*), 1987, 40, 1.
17. Bryson, op. cit., 55.
18. For module and mass production in Chinese culture see Lothar Ledderose, *Ten Thousand Things, Module and Mass Production in Chinese Art*, The A.W. Mellon Lectures in the Fine Arts, 1998, Bollingen Series XXXV, 46, Princeton: Princeton University Press, 2000.
19. Bryson, op. cit., 55.
20. Letters also appear in his *Red Reason* and *Black Reason* series, as well as in his later Mao portraits, *Mao Zedong – R*, *Mao Zedong – H* and *Mao Zedong – P2*.
21. Wang Guangyi, '*Guanyu qingli renwen reqing*', in *Jiangsu Huakan* (*Jiangsu Pictorial*), 1990, 10, 17–18.
22. Wang had to write a statement concerning his work and the image of Mao. This statement had to be hung next to his triptych: 'A great figure should obtain an objective and earnest evaluation (*Yi ge weida de renwu yinggai dedao keguan er yansu de pingjia*).' This declaration can also be read in the sense of Wang's concept of objectification.
23. Lü Peng, '*Tushi, xiuzheng yu wenhua pipan*', in Yan/Lü eds, *Dangdai yishu chaoliu zhong de Wang Guangyi*, Sichuan Fine Arts Publishing House, 1992, 48. The different titles of the paintings relate to this retouching.
24. Citation from Yan/Lü eds, ibid., 36.
25. See Yan Shanchun, '*Wang Guangyi he wo tan shenhua yu youxi* ', in Yan/Lü eds, ibid., 74–81.
26. The Chinese title is *Yishu yu cuojue*, published at Zhejiang Photography Publishing House in 1987.
27. E.H. Gombrich, *Art and Illusion, A Study in the Psychology of Pictorial Representation*, The A.W. Mellon Lectures in the Fine Arts, 1956, Bollingen Foundation Series XXXV, 5, 2nd edition, New York: Pantheon Books, 1961, 305.
28. Wang Guangyi, *On Black Reason – Analysis of the Disease A* and *Red Reason – Revision of the Idol*. Citation from Li Xianting, 'Xinchao yishujia (2) Wang Guangyi', in *Zhongguo Meishubao* (Fine Arts in China), 1987, 39, 1.
29. Lü Peng, in Yan/Lü eds, op. cit., 36.
30. Li Xianting, 'Dangqian Zhongguo yishu de wuliaogan – xi wanshi xianshizhuyi chaoliu', in *Ershiyi Shiji*, 9, February 1992, 69–75.
31. See for example Lü Peng, *Zhongguo dangdai yishushi 1990 –1999* (*90s Art China*), Hunan Fine Arts Publishing House, 2000, 64–109.
32. Cited from Geremie Barmé, *In the Red, On Contemporary Chinese Culture*, New York: Columbia University Press, 1999, 35.

33. Lü Peng initiated the Guangdong Art Fair that took place in 1992 and 1994. Several art magazines focusing on the art market, such as *Art and Market* (*Yishu yu shichang*), emerged. Nevertheless, his project did not bring the expected results. An inner-Chinese art market developed only in the second half of the 1990s.

34. Huang Yongping, 'Xiamen Dada yizhong houxiandai', in *Zhongguo meishubao* (*Fine Arts in China*), 1986, 46, 1.

35. Arif Dirlik/Zhang Xudong, 'Introduction: Postmodernism in China', in Dirlik/Zhang eds, *boundary 2, special issue: Postmodernism and China*, 24, 3, Fall 1997, 5.

36. Ibid., 9.

37. Ibid., 8.

38. All quotes here are from Arif Dirlik/Zhang Xudong, ibid.

p. 123
Bhupen Khakhar,
*How Many Hands do I
Need to Declare My Love
to You?*, 1994
Watercolour on paper,
48 x 48 inches
(122 x 122 cm)
Collection of Bodhi Art

p. 124
Bhupen Khakhar,
*Picture Taken on Their
30th Wedding Anniversary*,
1998
Watercolour on paper,
43.3 x 43.3 inches
(110 x 110 cm)
The Estate of Bhupen
Khakhar

pp 128–29
Bhupen Khakhar,
*Bullet Shot in the
Stomach*, 2001
Oil on canvas (diptych),
90.6 x 139.4 inches
(230 x 354 cm)
The Estate of Bhupen
Khakhar

p. 140
Betye Saar,
*The Liberation of
Aunt Jemima*, 1972
Mixed media,
8 x 11.75 x 2.75 inches
(20.3 x 29.8 x 7 cm)
University of California,
Berkeley Art Museum
Purchased with the aid
of funds from the
National Endowment
for the Arts (selected
by The Committee for
the Acquisition of
Afro-American Art)
Photograph by
Benjamin Blackwell

pp 148–49
Robert Colescott,
*George Washington Carver
Crossing the Delaware:
Page from an American
History Textbook*, 1975
Acrylic on canvas,
84 x 108 inches
(213.4 x 274.3 cm)
Collection of Mr and
Mrs Robert H. Orchard

p. 155
David Hammons,
Hair Pyramid, 1976
Hair,
Dimensions variable
Installation view

p. 156
David Hammons,
How Ya Like Me Now?, 1988
Tin, plywood,
sledgehammers, paint,
American flag,
144 x 216 inches
(365.8 x 548.6 cm)
Installation view from
*David Hammons: Raising
the Rubble*, 17 August to
10 November 1991, Museum
of Contemporary Art
San Diego

p. 163
Constance Stuart Larrabee,
Two Ndebele children
seated next to painted
wall motif of 'Mr Peanut',
South Africa, 1936–49
Photograph, Image
No. EEPA 1998-060675
Constance Stuart Larrabee
Collection
Eliot Elisofon
Photographic Archives
National Museum of
African Art
Smithsonian Institution

p. 168
Esther Mahlangu,
Art Car, 1991
BMW 525i painted with
Ndebele decorations
Image courtesy of BMW AG

pp 174–75
Zwelethu Mthethwa,
from *Untitled*, 1995–98
Colour photograph,
47.2 x 66.9 inches
(120 x 170 cm)
Collection Marco Noire
Contemporary Art

pp 178–79
David Koloane,
Untitled, 1988
Oil on canvas,
29.1 x 65 inches
(74 x 165 cm)
Private Collection

p. 185
Durant Sihlali,
Rhini Walls, 1995
Pigment on paper,
57.1 x 39 inches
(145 x 99 cm)
BHP Billiton Art Collection

p. 202
Shen Raoyi,
Portraits of Mao Zedong,
c.1965
Woodcut
Reproduced in Wang
Mingxian and Yan
Shanchun eds, *Xin
Zhongguo meishushi
The Art History of the
People's Republic of
China 1966–1976*, Beijing:
Zhongguo Qingniqn
Publishing House, 2000

p. 205
Wu Shanzhuan,
*Red Humor – Red
Characters, 75% Red,
20% Black and 5% White
(Hongse youmochi zi)*, 1987
Installation, poster colour
and ink on rice paper,
c.19.8 x 32.10 x 13.1 ft
(c.6 x 10 x 4 m),
Institute of Mass Culture,
Zhoushan, PR China,
Courtesy the artist
Reproduced in Minglu Gao
et al., *Wu Shanzhuan:
Red Humour International
(in collaboration with Inga
Svala Thorsdottir)*, Hong
Kong: Asia Art Archive,
2005

p. 208
Wang Guangyi,
Mao Zedong – Black Grid,
1988
Oil on canvas, triptych,
each 59.1 x 47.2 inches
(each 150 x 120 cm)
Private collection
Courtesy the artist

p. 214
Wang Guangyi,
Great Criticism – Coca Cola,
1992
Industrial oil on canvas,
80 x 80 inches
(200 x 200 cm)
The Farber Collection,
New York, Courtesy of
China Avant-Garde Inc.

Lawrence Alloway, 'The Long Front of Culture' (1959), *Cambridge Opinion*, 17, reprinted in Clocktower Gallery and Institute of Contemporary Arts Boston, *Modern Dreams: The Rise and Fall and Rise of Pop*, 1988, 31–33

Lawrence Alloway, 'The Development of British Pop', in Lucy R. Lippard, *Pop Art*, London and New York: Thames and Hudson, 1966, 32–36

Kwame Anthony Appiah, 'The Postcolonial and the Postmodern', in Kwame Anthony Appiah, *In My Father's House: Africa in the Philosophy of Culture*, New York and London: Oxford University Press, 1992, 137–57

Reyner Banham, *Los Angeles: The Architecture of Four Ecologies*, London and New York: Penguin, 1971

Roland Barthes, *Mythologies* (1957), London: Paladin, 1972

Holly Barnet-Sanchez and Eva Cockcroft eds, *Signs from the Heart: California Chicano Murals*, Venice, CA: Social and Public Art Resource Center, 1990

Walter Benjamin, 'The Work of Art in the Age of Mechanical Reproduction' (1934), in Walter Benjamin, *Illuminations*, London: Fontana/Collins, 1970

Iwona Blazwick ed., *An endless adventure ... an endless passion ... an endless banquet: A Situationist Scrapbook*, London: Institute of Contemporary Arts/Verso, 1989

Benjamin Buchloh, 'Andy Warhol's One Dimensional Art: 1956 – 1966' (1989), in Benjamin Buchloh, *Neo-Avantgarde and Culture Industry: Essays on European and American Art from 1955 to 1975*, Cambridge, MA and London: MIT, 2000

Peter Burger, *Theory of the Avant-Garde* (1980), Minneapolis: University of Minnesota, 1984

Gavin Butt, *Between You and Me: Queer Disclosures in the New York Art World, 1948 – 1963*, Durham: Duke University Press, 2005

Dan Cameron, 'Neo-This, Neo-That: Approaching Pop Art in the 1980s', in Marco Livingstone ed., *Pop Art*, London: Royal Academy of Arts, 1991, 260–66

Iain Chambers, *Popular Culture: The Metropolitan Experience*, London: Macmillan, 1986

James Clifford, 'On Collecting Art and Culture', in James Clifford, *The Predicament of Culture: Twentieth-Century Ethnography, Literature, and Art*, London and Cambridge, MA: Harvard University Press, 1988, 214–51

Clocktower Gallery and Institute of Contemporary Arts Boston, *Modern Dreams: The Rise and Fall and Rise of Pop*, Cambridge, MA and London: MIT, 1988

Donald John Cosentino, 'Afrokitsch', in Susan Vogel ed., assisted by Ima Ebong, *Africa Explores: 20th Century African Art*, New York and Munich: Center for African Art/Prestel-Verlag, 1991, 240–55

Douglas Crimp, *On the Museum's Ruins*, Cambridge, MA and London: MIT, 1990

Guy Debord, *The Society of the Spectacle* (1967), Detroit: Red and Black, 1983

Gina Dent ed., *Black Popular Culture*, A Project by Michele Wallace, Seattle: Bay Press, 1992

Manthia Diawara, 'Afrokitsch', in Gina Dent ed., *Black Popular Culture*, 1992, 285–91

Hal Foster ed., *Postmodern Culture*, London: Pluto, 1985 (aka *The Anti-Aesthetic*, Seattle: Bay Press, 1983)

Hal Foster, *The Return of the Real: The Avant-Garde at the End of the Century*, Cambridge, MA and London: MIT, 1996

Simon Frith and Howard Horne, *Art Into Pop*, London and New York: Methuen, 1987

Suzi Gablik and John Russell eds, *Pop Art Redefined*, London: Hayward Gallery/Thames and Hudson, 1969

Stuart Hall, 'Encoding and Decoding', in Stuart Hall, Dorothy Hobson, Andrew Lowe and Paul Willis eds, *Culture, Media Language*, London: Hutchinson, 1980, 128–38

Stuart Hall, 'When was the "Post-colonial"?: Thinking at the Limit', in Iain Chambers and Lidia Curti eds, *The Post-Colonial Question: Common Skies, Divided Horizons*, London and New York: Routledge, 1995, 242–59

Stuart Hall and Paddy Whannel, *The Popular Arts*, London: Hutchinson, 1964

Michael D. Harris, *Colored Pictures: Race and Visual Representation*, New York: Columbia University Press, 2002

Barbara Haskell, *Blam! The Explosion of Pop, Minimalism and Performance, 1958–1964*, New York: Whitney Museum of American Art/W.W. Norton, 1984

Dick Hebdige, *Subculture: The Meaning of Style*, London and New York: Methuen, 1979

Dick Hebdige, 'In Poor Taste: Notes on Pop', in Dick Hebdige, *Hiding in the Light: On Images and Things*, London: Comedia/Routledge, 1988, 116–43

Dick Hebdige, 'Staking Out the Posts', in Dick Hebdige, *Hiding in the Light: On Images and Things*, 1988, 181–207

Robert Hewison, *Too Much: Art and Society in the Sixties, 1960–1975*, London: Methuen, 1986

Andreas Huyssen, 'Mapping the Postmodern', *New German Critique*, 22, 1981, 10–21

Andreas Huyssens, *After the Great Divide: Modernism, Mass Culture and Postmodernism*, London: Macmillan, 1986

Fredric Jameson, 'Post-modernism, or the Cultural Logic of Late Capitalism', *New Left Review*, 146, 1984, 53–92

Fredric Jameson, *Post-Modernism or the Cultural Logic of Late Capitalism*, London: Verso, 1991

Charles Jenks, *What is Post-modernism?*, London: Academy Editions, 1986

Geeta Kapur, *When Was Modernism: Essays on Contemporary Cultural Practice in India*, New Dehli: Tulika, 2000

Sidney Kasfir, 'African Art and Authenicity: A Text with a Shadow', *African Arts*, 25, 2, 1992, reprinted in Olu Oguibe and Okwui Enwezor eds, *Reading the Contemporary: African Art from Theory to the Marketplace*, London and Cambridge, MA: inIVA/MIT, 1999, 88–113

Ken Knabb ed., *Situationist International Anthology*, Berkeley: Bureau of Public Secrets, 1981

Martina Köppel-Yang, *Semiotic Guerilla Warfare: The Chinese Avant-garde 1979–1989*, Hong Kong: Timezone 8, 2003

Lizetta LaFalle Collins, *19Sixties: A Cultural Awakening Re-evaluated*, Los Angeles: California Afro-American Museum, 1989

Lucy R. Lippard (with contributions by Lawrence Alloway, Nancy Marmer and Nicolas Callas), *Pop Art*, London and New York: Thames and Hudson, 1966

Sarat Maharaj, 'Pop Art's Pharmacies: Kitsch, Consumerist Objects and Signs', in Marco Livingstone ed., *Pop Art*, London: Royal Academy of Arts, 1991, 20–23

Marshall McLuhan, *Understanding Media*, Harmondsworth: Penguin, 1967

Angela McRobbie, 'Postmodernism and popular culture', in Lisa Appignanesi ed., *Postmodernism* (ICA Documents 4/5), London: Institute of Contemporary Arts, 1986, 54–58

Kynasron McShine ed., *Andy Warhol: A Retrospective*, New York: Museum of Modern Art, 1989

José Esteban Muñoz, 'Famous and Dandy Like B. ' n' Andy: Race, Pop and Basquiat', in Jennifer Doyle, Jonathan Flatley and José Esteban Muñoz eds, *Pop Out: Queer Warhol*, Durham, NC: Duke University Press, 1996

Lisa Phillips ed., *Beat Culture and the New America: 1950–1965*, New York and Paris: Whitney Museum of American Art/Flammarion, 1996

Ned Polsky, *Hustlers, Beats and Others* (1967), Chicago and London: University of Chicago, 1985

Colin Richards, 'Graft', in Okwui Enwezor ed., *Trade Routes: History and Geography*, exh. cat., 2nd Johannesburg Biennale, Johannesburg: City Council, 1997, 234–37

David Robbins ed., *The Independent Group: Postwar Britain and the Aesthetics of Plenty*, Cambridge MA and London: MIT, 1990

John Roberts and Dave Beech eds, *The Philistine Controversy*, London: Verso, 2002

Andrew Ross ed., *Universal Abandon? The Politics of Postmodernism*, Minneapolis: University of Minnesota, 1988

Andrew Ross, *No Respect: Intellectuals and Popular Culture*, New York and London: Routledge, 1989

Mike Sell, *Avant-garde performance and the limits of criticism: approaching the Living Theatre, happenings/Fluxus, and the Black Arts Movement*, Ann Arbor: University of Michigan Press, 2005

Karen Smith, *Nine Lives: The Birth of Avant-Garde Art in New China*, Zurich: Scalo Verlag, 2005

Susan Sontag, 'Notes on Camp', in Susan Sontag, *Against Interpretation and Other Essays*, New York: A Noonday Book/ Farrar, Strauss and Giroux, 1964, 275–92

Julian Stallabrass, *High Art Lite: British Art in the 1990s*, London: Verso, 1999

Peter Stallybrass and Allon White, *The Poetics and Politics of Transgression*, London and New York: Methuen, 1986

Leo Steinberg, 'Other Criteria', in Leo Steinberg, *Other Criteria*, New York and London: Oxford University Press, 1972, 55–91

John Storey, *Cultural Theory and Popular Culture: An Introduction*, Harlow: Pearson Education, 2001

Calvin Tompkins, *Robert Rauschenberg and the Artworld of Our Time*, New York: Doubleday, 1980

Paul Taylor ed., *Post-Pop Art*, Cambridge, MA and London: MIT/Flash Art Books, 1989

Kurt Varnedoe and Adam Gropnik, *High and Low: Modern Art, Popular Culture*. New York: Museum of Modern Art, 1990

Robert Venturi, Denise Scott Brown and Steven Izenour, *Learning from Las Vegas*, Cambridge, MA and London: MIT, 1977

John A. Walker, *Cross-Overs: Art Into Pop, Pop Into Art*, London: Comedia/Methuen, 1987

Brian Wallis ed., *Art After Modernism: Re-Thinking Representation*, New York: New Museum of Contemporary Art, 1984

Steve Watson, *The Birth of the Beat Generation: Visionaries, Rebels and Hipsters, 1944–1960*, New York: Pantheon Books, 1998

Cécile Whiting, *A Taste for Pop: Pop Art, Gender and Consumer Culture*, Cambridge and New York: Cambridge University Press, 1997

Paul Willemen, 'An Avant Garde for the 90s', in Paul Willemen, *Looks and Frictions: Essays in Cultural Studies and Film Theory*, London and Bloomington: British Film Institute and Indiana University Press, 1994, 141–61

Raymond Williams, *The Long Revolution*,
London: Chatto and Windus, 1961

Raymond Williams, *The Politics of Modernism:
Against the New Conformists*, London: Verso,
1989

Peter Wollen, 'Into the Future:Tourism, Language,
Art' (1990), in Peter Wollen, *Raiding the Icebox:
Reflections on Twentieth-Century Culture*,
London: Verso, 1993, 190–212

Holly Barnet-Sanchez

Holly Barnet-Sanchez is an Associate Professor of Latin American and Chicano/a, Latino/a art history at the University of New Mexico, Albuquerque, and Associate Dean for Student Affairs for the College of Fine Arts. She participated in creating the exhibition, *Chicano Art Resistance and Affirmation, 1965–1985*, for The Wight Art Gallery, UCLA. She served as curator at the Mexican Museum in San Francisco in the early 1990s. Barnet-Sanchez worked on the documentation project for the Mural Resource Center at the Social and Public Art Resource Center (SPARC) and subsequently co-edited, with Eva Cockcroft, *Signs from the Heart; California Chicano Murals*, based on that slide collection. As one of the curators for *¿Just Another Poster? Chicano Graphic Arts in California*, she contributed the essay 'Where are the Chicana Printmakers? Presence and Absence in the Work of Chicana Artists of the *Movimiento*'. Currently, she is writing, with Tim Drescher, on Chicano murals in East Los Angeles, and working on a book about the work of Judith Baca, Ester Hernandez and Amalia Mesa-Bains.

Gavin Butt

Gavin Butt is Senior Lecturer in Visual Cultures at Goldsmiths College, University of London. He works on issues of performance and performativity in the contemporary visual arts, as well as on queer theory, queer cultures and their histories. His book on gossip and homosexuality in US art, *Between You and Me: Queer Disclosures in the New York Art World 1948–1963*, was published by Duke University Press in 2005. He is also editor of *After Criticism: New Responses to Art and Performance* (Blackwell, 2004). He is currently working on a new book project, *You Cannot Be Serious! Flirtatious Acts in Contemporary Culture*, of which a number of essays have been published: 'Joe Brainard's Queer Seriousness, or, How to Make Fun Out of the Avant-Garde', in David Hopkins ed., *Neo-Avant-Garde* (Rodopi Press, 2006); 'Scholarly Flirtations', in Angelika Nollert et al. eds, *A.C.A.D.E.M.Y.* (Revolver, 2006); and 'Why I Died for Kiki and Herb: Some Thoughts on Queer Seriousness', in Henry Rogers ed., *The Art of Queering in Art* (Article Press, 2007). The essay in the present volume also comprises part of this project. In 2006 he collaborated with curators Rosie Cooper and David Lillington on an exhibition held in London, *Wild Gift*, which showcased new art with an expressly theatrical approach to serious subject matter.

Geeta Kapur

Geeta Kapur is a critic and curator living in New Delhi. Her writings include artists' monographs, exhibition catalogues, the book *Contemporary Indian Artists* (Delhi, 1978), and a set of widely anthologised essays on art, film and cultural theory in national and Third World contexts, published under the title *When was Modernism: Essays on Contemporary Cultural Practice in India* (Delhi, 2000). Another collection of essays, framed by a critical contemporaneity and titled *Iconographies for the Present* (Delhi, forthcoming 2007), deals with representational, mediatic and curatorial practices within (Indian) metropolitan culture.

Her curatorial work includes, besides several exhibitions in India, the co-curated *Bombay/ Mumbai* for the multi-part exhibition, *Century City: Art and Culture in the Modern Metropolis*, at Tate Modern, London, 2001; and *subTerrain: artworks in the cityfold* at the House of World Cultures, Berlin, 2003. She was a member of the International Jury of the 51st Venice Biennale and of the 9th Dakar Biennale, 2006.

She is one of the founder-editors of *Journal of Arts & Ideas* and advisory editor to *Third Text* and *Marg*. She has lectured world-wide in university and museum contexts, and held Fellowships at the Indian Institute of Advanced Study, Shimla, Clare Hall, University of Cambridge, Nehru Memorial Museum and Library, Delhi, the Jawaharlal Nehru University and the University of Delhi.

Martina Köppel-Yang

Martina Köppel-Yang is an independent art historian and curator with a PhD in East Asian Art History and Sinology from the University of Heidelberg. She studied in Heidelberg, Beijing and Paris and has been involved in contemporary Chinese art since studying at the Central Fine Arts Academy in Beijing in the mid-1980s. She has written extensively on the subject and is a member of the editorial boards for *Yishu Journal for Contemporary Chinese Art* and *Red Flag Collection*, a compilation of contemporary Chinese artists' projects published in Hong Kong. Together with her husband, Yang Jiechang, she created Mühlgasse 40, Centre for Contemporary Chinese Art, which opened in Heidelberg during 2003.

Her publications include *Semiotic Warfare: The Chinese Avant-garde 1979–1989* (Hong Kong: Timezone 8, 2003), *Living in Time – 29 zeitgenössische Künstler aus China*, exhibition catalogue (Berlin, 2001) and *Gebrochene Bilder, Junge Kunst aus China* in V. Drachenbrücke ed. (Bad Honnef: Horlemann, 1991). Recent articles include 'From Glittering Stars to Shining Eldorado', in *Yishu Journal for Contemporary Chinese Art* (December 2005) and, 'The Ping Pong Policy of Contemporary Chinese Art' in *Yishu Journal for Contemporary Chinese Art* (June 2004), as well as contributions to *Stop Over Hong Kong*, exhibition catalogue (Hong Kong: Hanart Tz, 2004) and Wu Hung ed., *Chinese Art at the Crossroads: Between Past and Future, Between East and West* (Hong Kong: New Art Media, 2001).

She has curated and co-curated numerous exhibitions including *Leased Legacy. Hong Kong 1997* (Frankfurt, 1997), *Odyssey(s) 2004* (Shanghai, 2004), *Black Extreme Vigorous Figurative* at Shenzhen Fine Arts Institute (Shenzhen, 2005), *Infiltration: Idylls and Visions* at the Guangdong Museum of Art (Guanzhou, 2005), *Surplus Value* and *Accumulation – Canton Express, the Next Stop* at Tang Contemporary Art Centre (Beijing, 2006) and, most recently, *Ink – Life – Taste* at the 5th Shenzhen International Ink Painting Biennial (Shenzhen, 2006). Her next research project, *Performing Identity – Political Directives and Contemporary Chinese Art since the 1980s*, focuses on the cultural policy of the People's Republic of China.

Kobena Mercer

Kobena Mercer is Reader in Art History and Diaspora Studies at Middlesex University London. He is an inaugural recipient of the 2006 Clark Prize for Excellence in Arts Writing, awarded by the Sterling and Francine Clark Art Institute to scholars whose critical writing has had significant impact on public appreciation of the visual arts.

He has taught at New York University and University of California at Santa Cruz and received fellowships from Cornell University, University of California at Irvine and the Vera List Center for Art and Politics at the New School University in New York. His articles have appeared in such journals as *frieze*, *Artforum*, *Screen*, *Third Text*, *Ten.8* and *Camera Austria* and many are featured in several anthologies including *Out There: Marginalization and Contemporary Culture* (1990), *Cultural Studies* (1992), *The Lesbian and Gay Studies Reader* (1993) and *The Sub-Cultures Reader* (1997). Recent contributions to exhibition catalogues and edited collections include 'Alan De Souza' in *Fresh Talk, Daring Gazes: Conversations on Asian-American Art* (2003), 'Moshewa Langa' in *Looking Both Ways: Art of the Contemporary African Diaspora* (2004), 'Diaspora Aesthetics and Visual Culture' in *Black Cultural Traffic* (2005) and '"Diaspora Didn't Happen in a Day": Reflections on Aesthetics and Time' in *Black British Aesthetics Today* (2007).

Colin Richards

Colin Richards is Professor in the Division of Visual Arts in the Wits School of Arts, University of the Witwatersrand, Johannesburg, where he lectures in art criticism, studio practice and art theory. He was educated at the University of South Africa, Goldsmiths College at the University of London, and University of the Witwatersrand, where he was awarded his PhD in 1995.

Richards has curated a number of major exhibitions including *Taking Liberties: The Body Politic* (1995) for the Africus Johannesburg Biennale, *Siyawela: Love, Loss and Liberation in South African Art* (1995) for the *africa95* season in the United Kingdom and *Graft* (1997) for the 2nd Johannesburg Biennale. He has published widely on contemporary South African art in such journals as *Third Text*, *Nka*, *African Arts* and *Art South Africa*, and his most recent publication is a book-length monograph on the artist Sandile Zulu (Johannesburg: David Krut Publishing, 2005). He is currently completing a second book on artist Durant Sihlali and has contributed a chapter to *Modernity and Contemporaneity: Antimonies of Art and Culture after the 20th Century*, edited by Terrence Smith, Okwui Enwezor and Nacy Conde (forthcoming 2007).

He has presented conference papers on South African art in Botswana, Nigeria, India, Australia, the United States, England, Scotland, Spain, Switzerland and Sweden, and was also an African delegate for the 2001 Study Tour Program in Japan. He is currently participating in the *Art History and Contemporary African Art* project jointly organised by the Mellon Foundation and the Sterling and Francine Clark Art Institute.

Richards is a practising artist who has exhibited in South Africa, Europe and North America and his works are represented in the major public collections in South Africa. Recent work has featured in *10 Years of Democracy* (2004) and exhibitions in 1998 and 2006 held at Iziko, the South African National Gallery in Cape Town, that relate to the Truth and Reconciliation Commission. He is currently working towards a solo exhibition in Johannesburg in November 2007.

Sônia Salzstein

Sônia Salzstein is Professor of Modern and
Contemporary Art History at the Universidade
de São Paulo. She has written extensively on
Brazilian modern and contemporary art,
including comprehensive essays on such artists
as Antonio Dias, Iole de Freitas, Mira Schendel
and Waltercio Caldas, as well as on cultural issues
connected with modernisation in peripheral
contexts, a key theme in her doctoral dissertation
presented in 2001 at the Department of
Philosophy of the Universidade de São Paulo.
She worked for more than 15 years in cultural
public institutions in Brazil, and founded in the
Secretary of Cultural Affairs of the State of
São Paulo, between the years 1989 and 1992,
an experimental space dedicated mainly to the
work of young artists. She curated several
projects in contemporary art, involving
publications and theoretical art courses and
workshops, as well as exhibitions and the
installation of works in urban sites. She published,
amongst others, several studies focusing on
Brazilian Modernism, and books on the modernist
painter Alfredo Volpi (Rio de Janeiro: Silvia/
Roesler/Campos Gerais, 2000), on Franz
Weissman (São Paulo: CosacNaify, 2001), a
sculptor belonging to the carioca Neo-Concrete
movement, on Mira Schendel (São Paulo: Galeria
de Arte do Sesi/Marca D'Água, 1997), and on
Iberê Camargo (São Paulo: CosacNaify, 2003).
She belongs to the board of curators of The
Museu Iberê Camargo, in the city of Porto Alegre
and to the Council of Directors of The Instituto
de Estudos Brasileiros of the Universidade de
São Paulo. She is currently working on an essay
about Waltercio Caldas' recent works.

We would like to thank the series editor Kobena Mercer for shaping the critical framework for this volume in the series *Annotating Art's Histories* and all the authors for their insightful texts and commitment to this project. We would also like to thank the artists, estates and copyright holders for their permission to reproduce the images in this volume.

We are extremely grateful to The Getty Foundation for their generous support without which this series would not have been possible. We would also like to thank Middlesex University for their continuing support of the project. Additional thanks to Jon Bird, Sarah Campbell, Indie Choudhury, Douglas Crimp, Roger Conover, Okwui Enwezor, Laurie Ann Farrell, Kate Hall, Glenn Howard, Uwe Kraus, Marc Lowenthal, Adrian Rifkin, Janet Rossi, Linda Schofield, Shela Sheikh, Judith Wilson.